PRESIDENT DONALD J. TRUMP

OUR JOURNEY TOGETHER

WINNING TEAM
PUBLISHING

To my great parents,
Mary and Fred, my wonderful
wife, Melania, the incredible
patriots of our Nation, all
members of my spectacular
family and, importantly,
the Deplorables, because
you got me here!

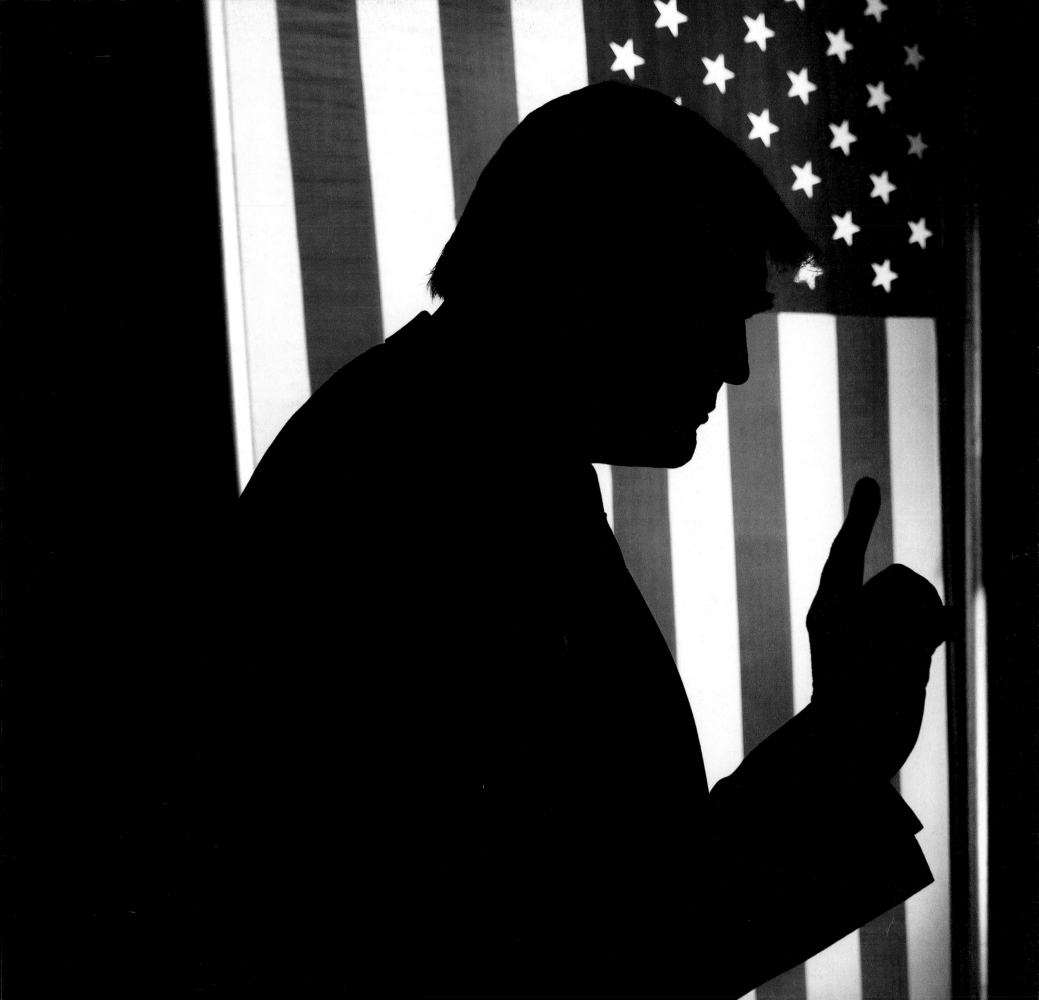

No Dream is too Big,
No Challenge too Great,
Nothing we want for our
future is Beyond our
Reach —

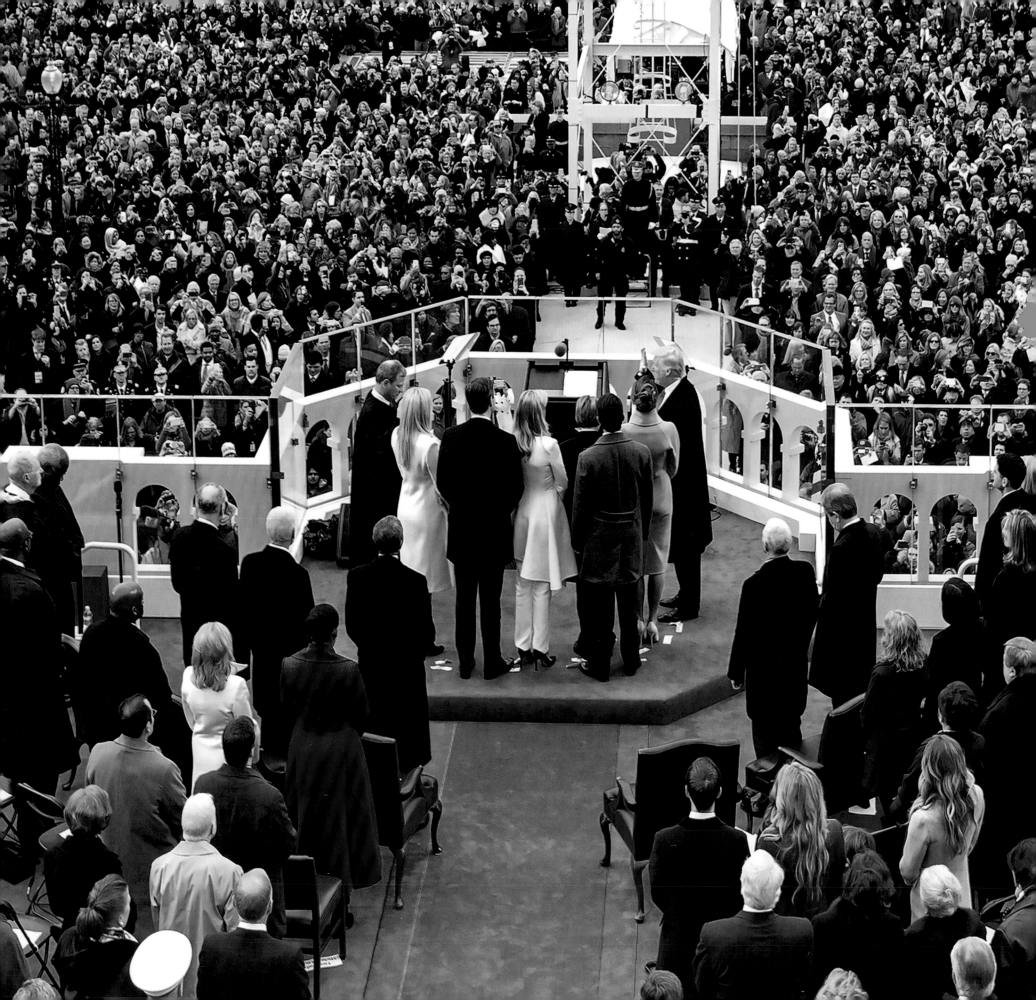

Inauguration Day, 2016.
I ran even better in 2020.

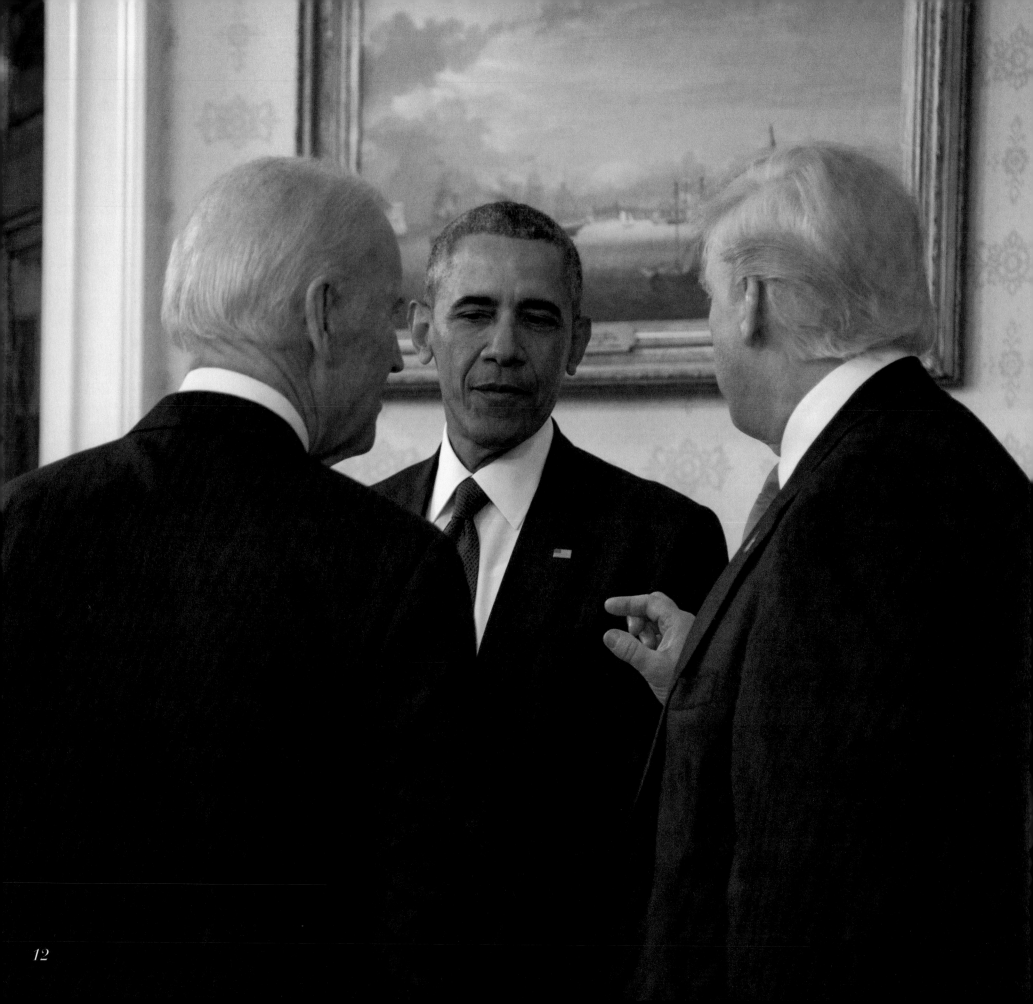

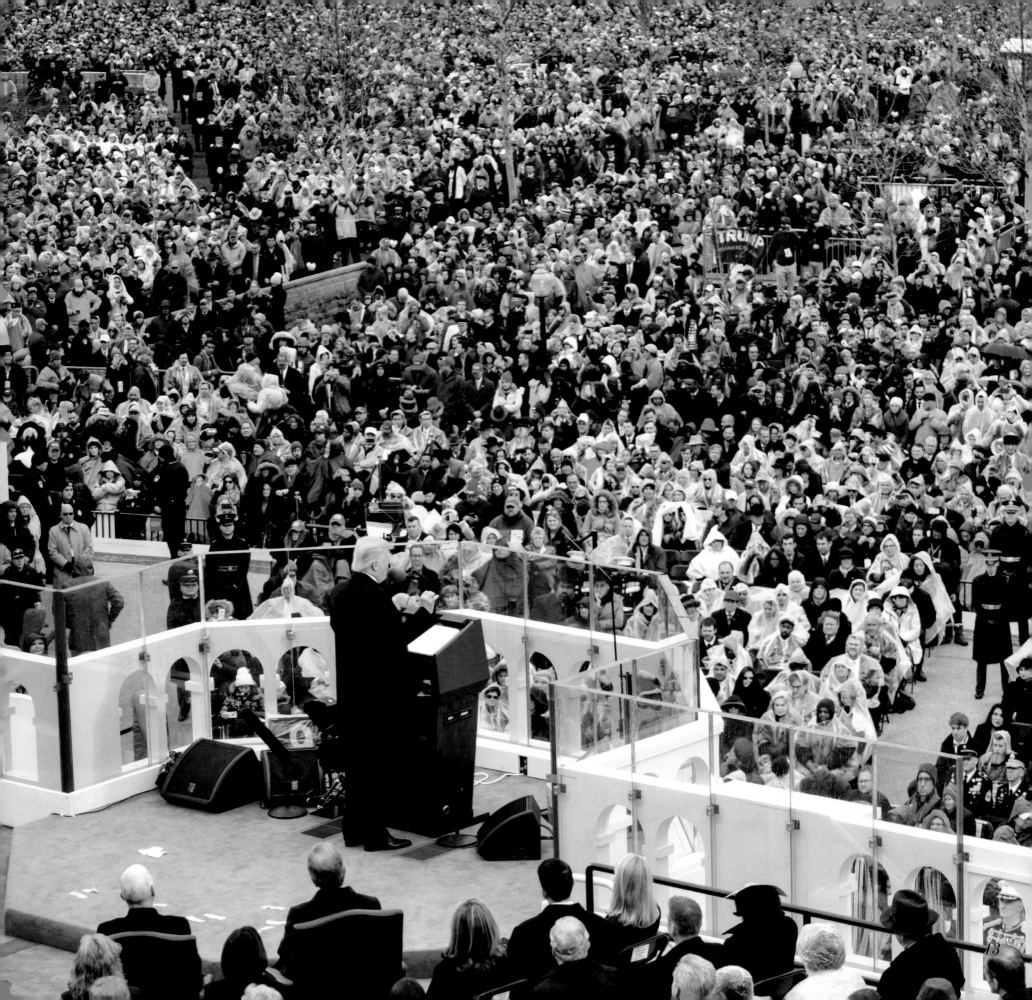

15

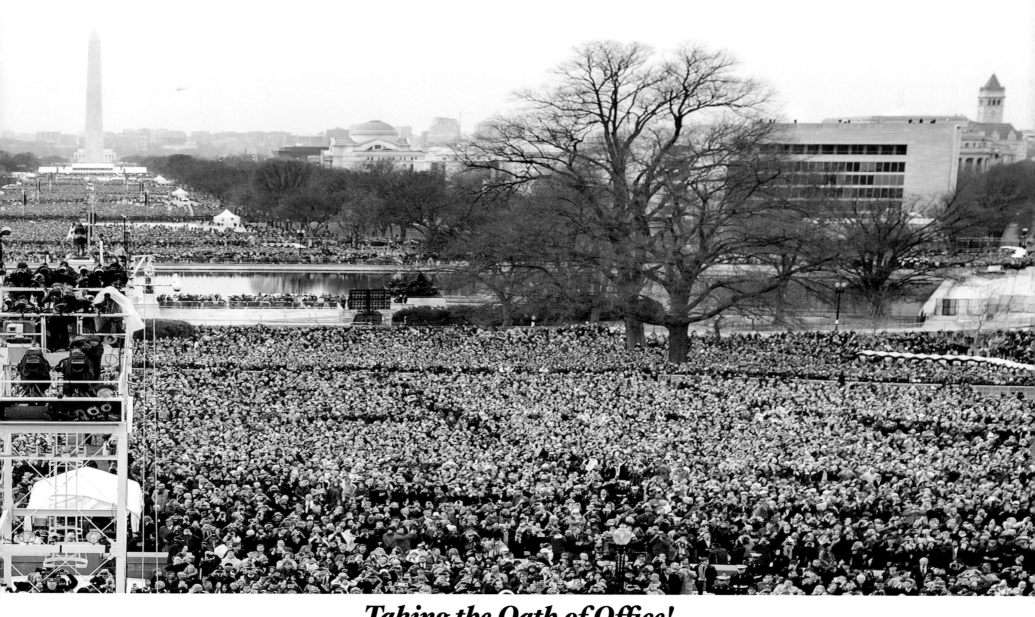

Taking the Oath of Office!
America was ready for GREATNESS after eight years with very little results.

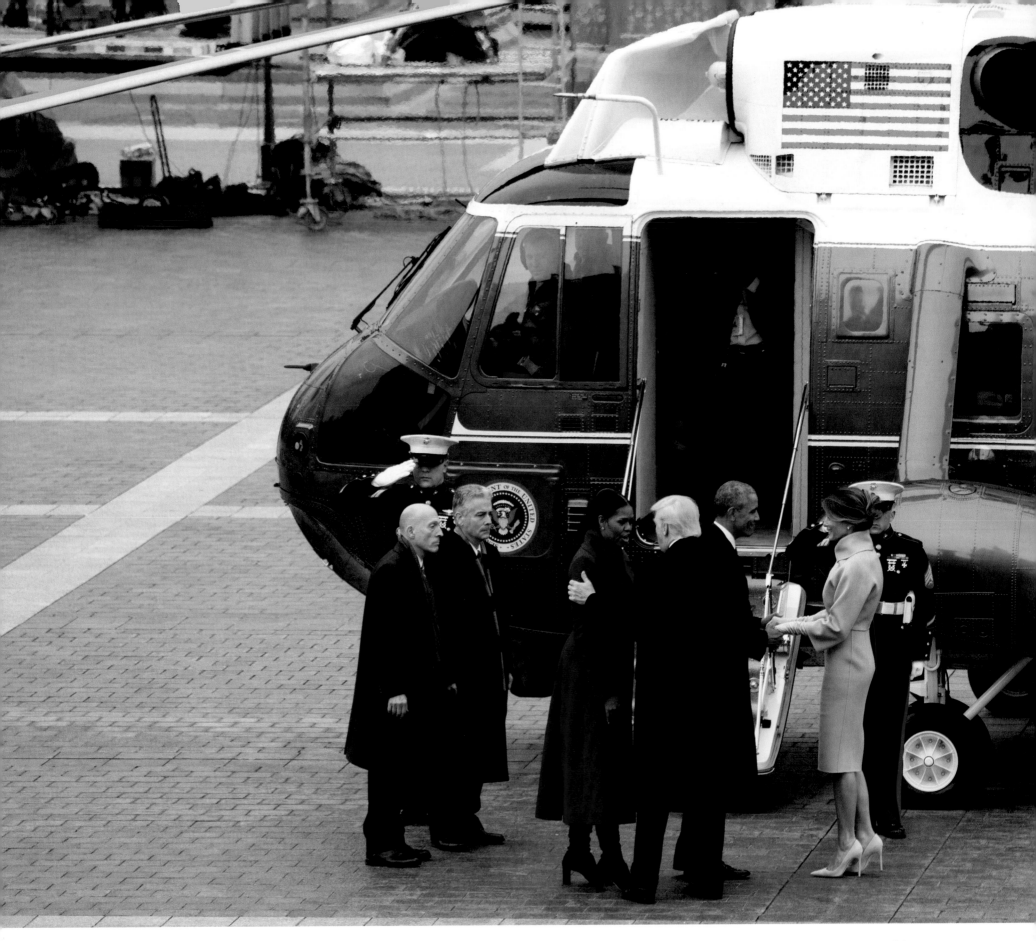

Barack and Michelle Obama get ready to depart Washington. Goodbye!

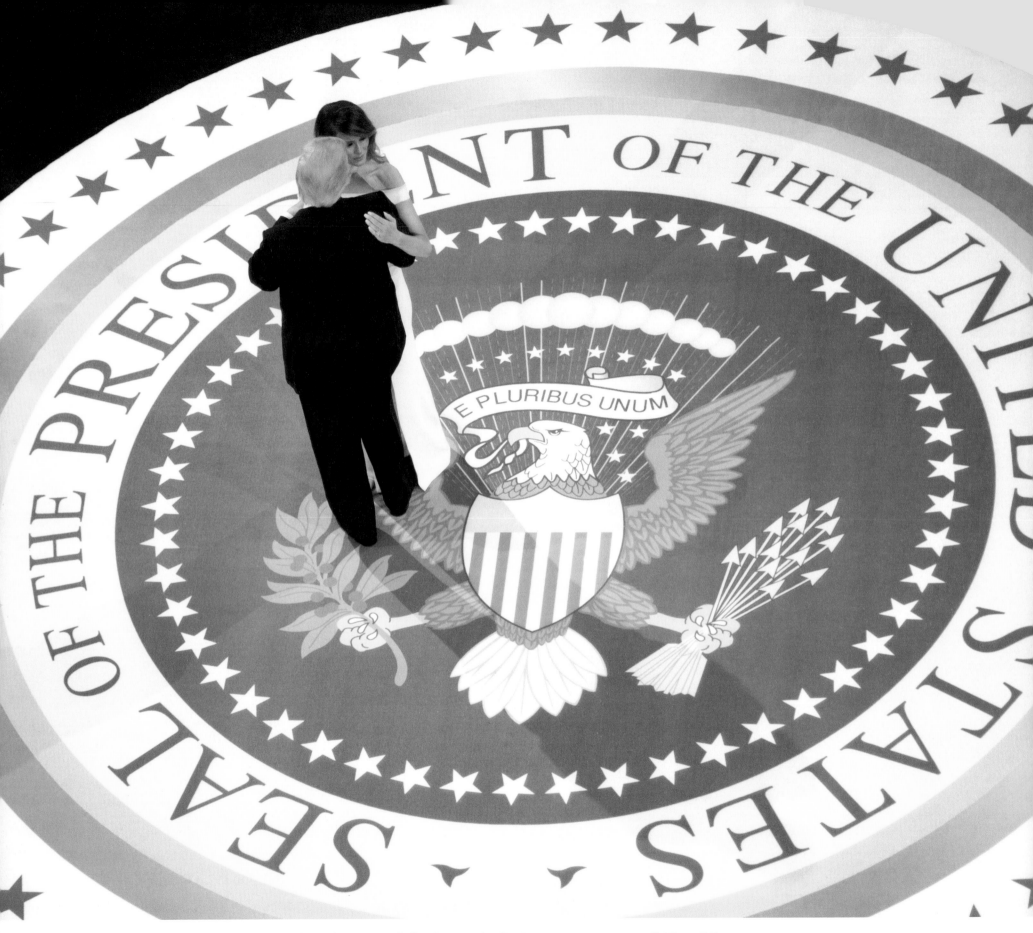

18 ***The beautiful MAGA Inaugural Ball.***

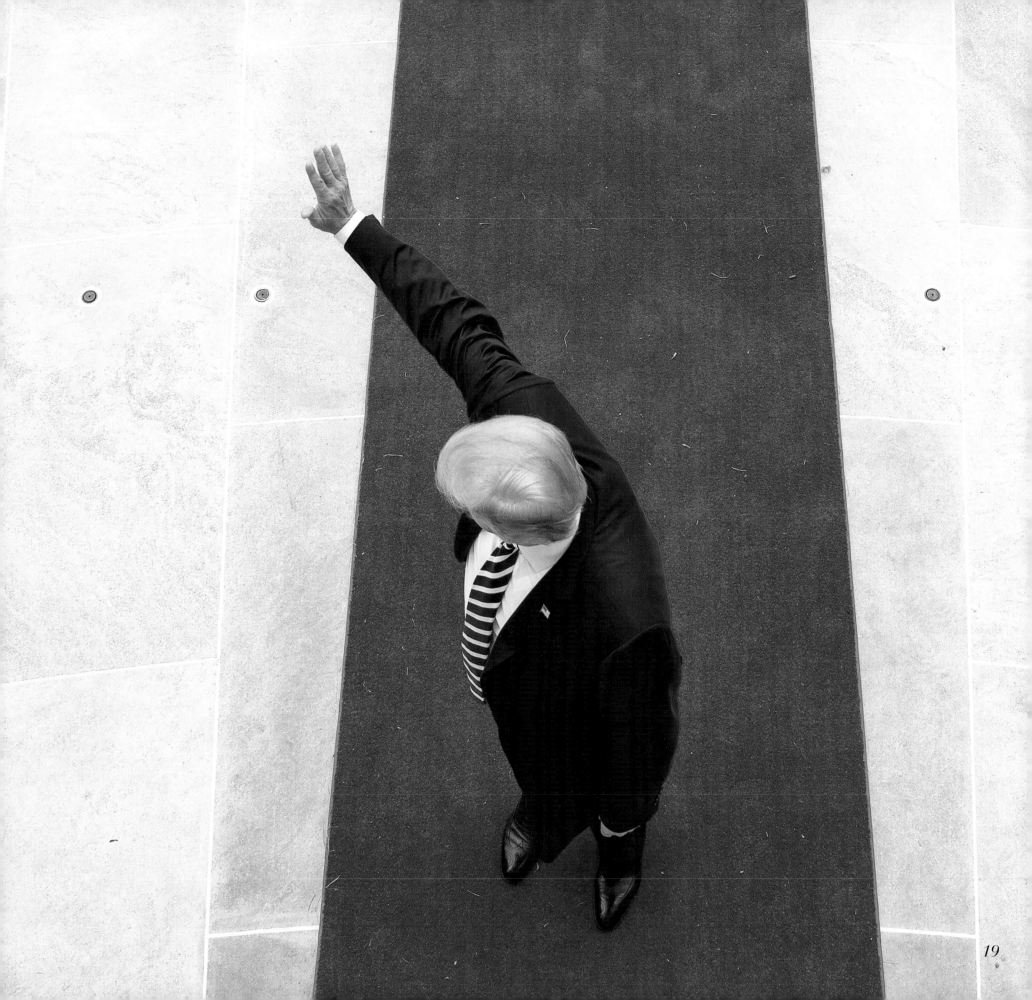

19

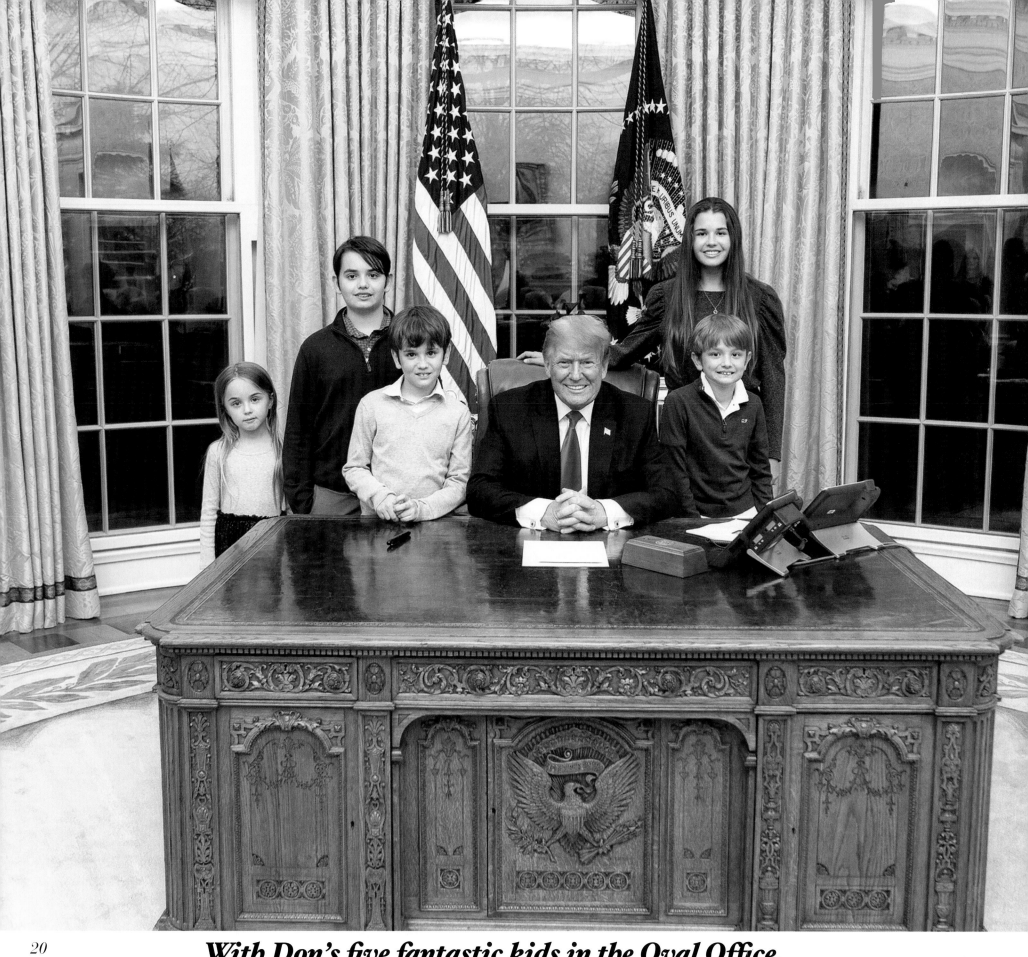

With Don's five fantastic kids in the Oval Office.

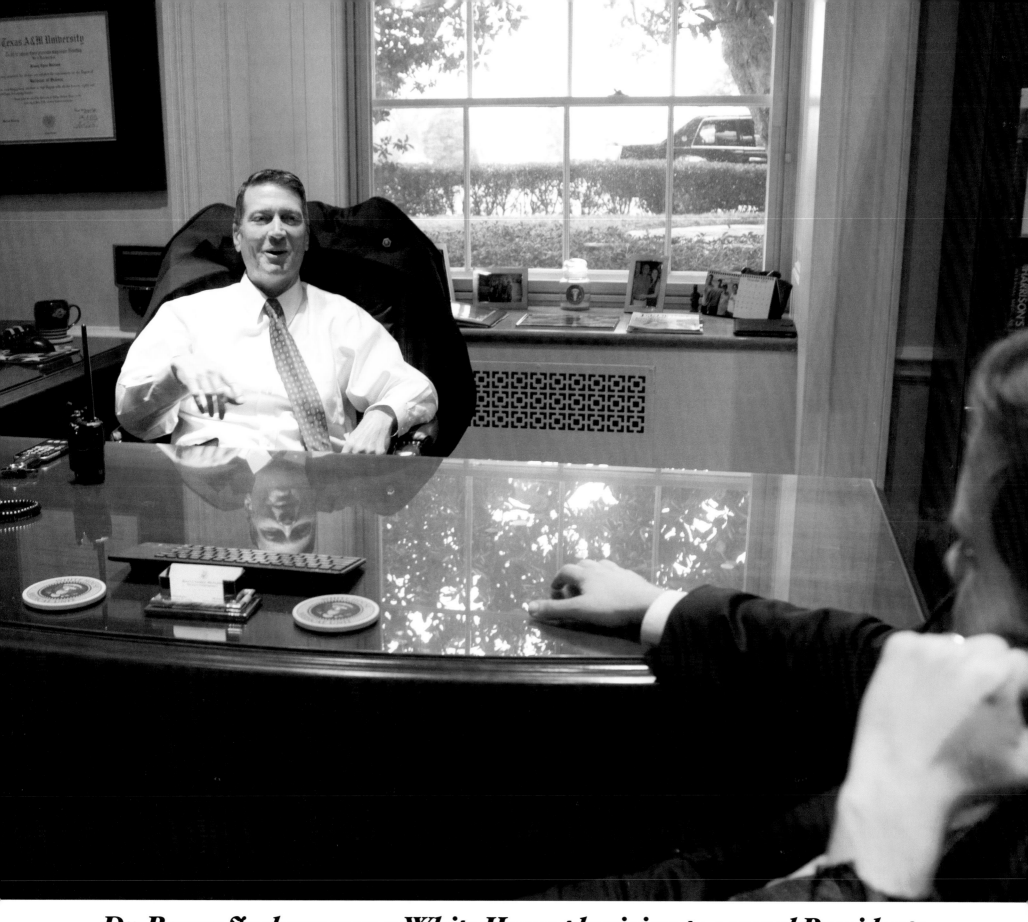

Dr. Ronny Jackson was a White House physician to several Presidents. Today he is one of the best members of Congress, always fighting for America first.

***After eight years of President Obama, we needed to make
the White House GREAT again, so we spruced the place up.***

23

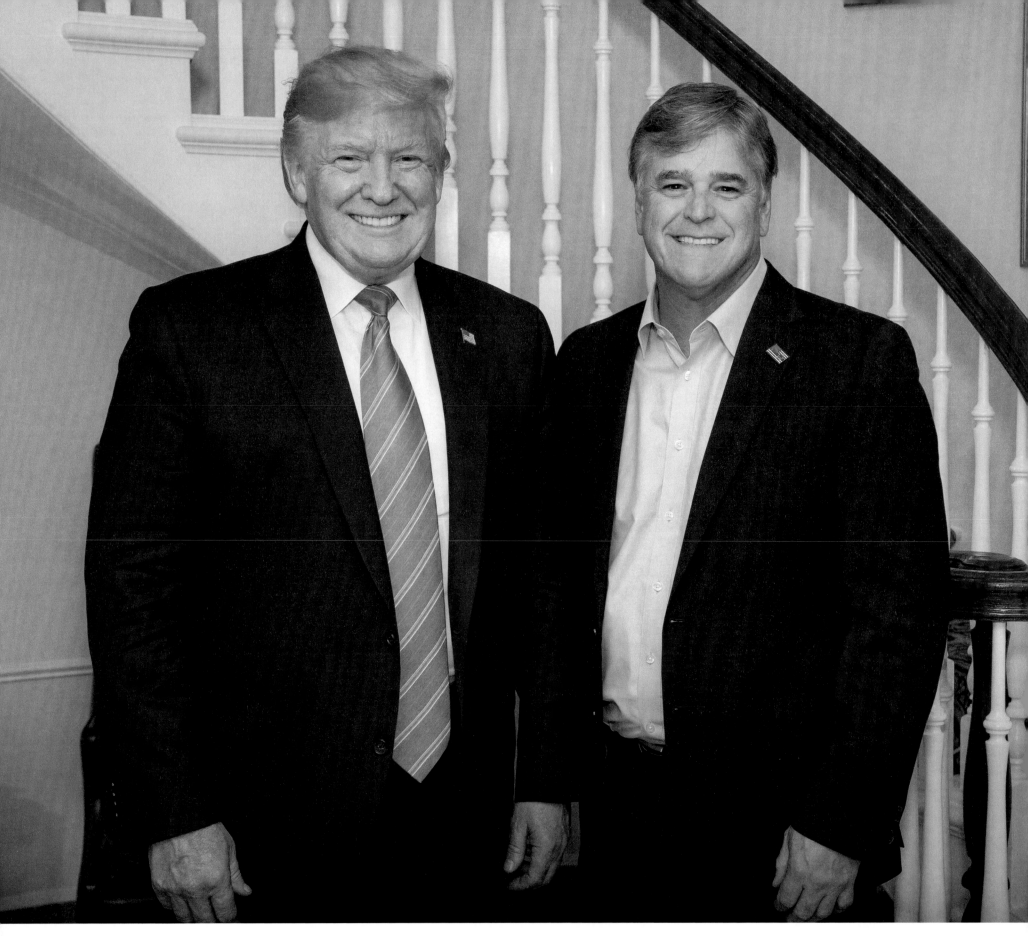

An American patriot, Sean Hannity.

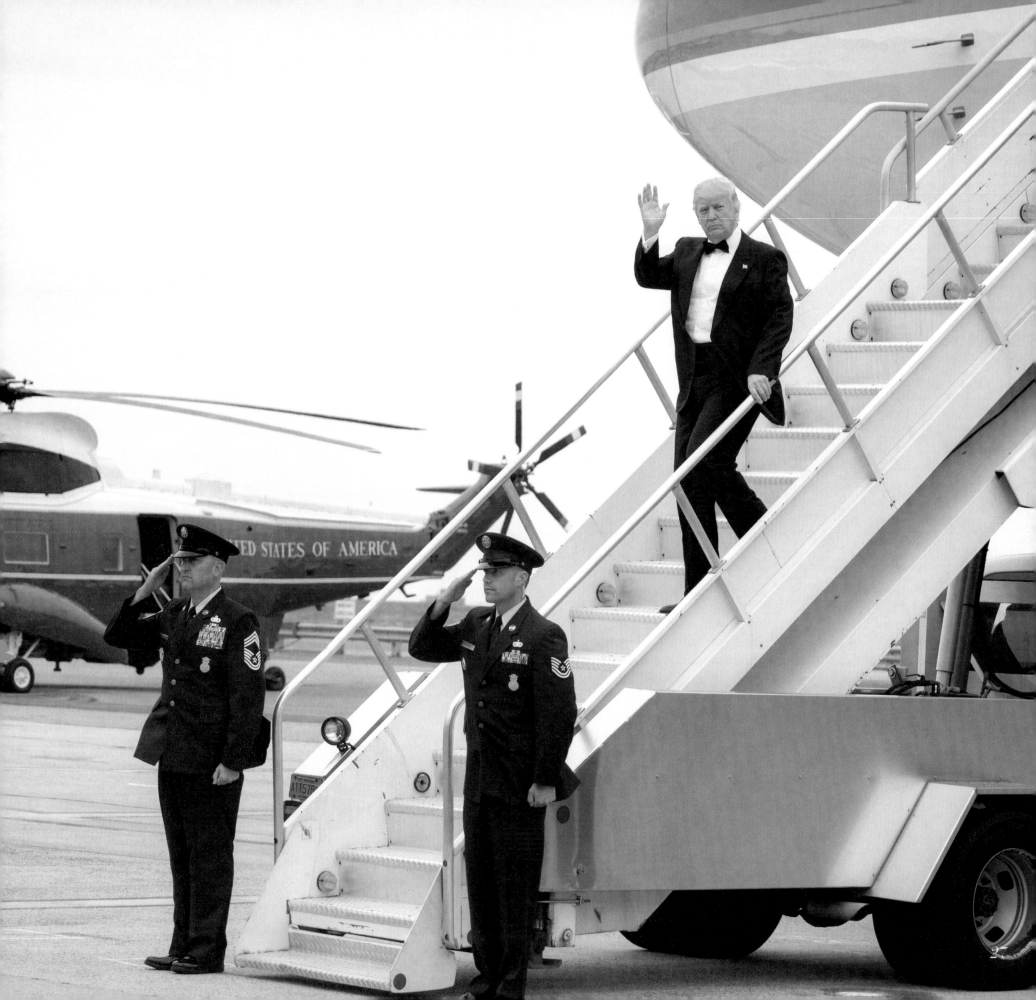

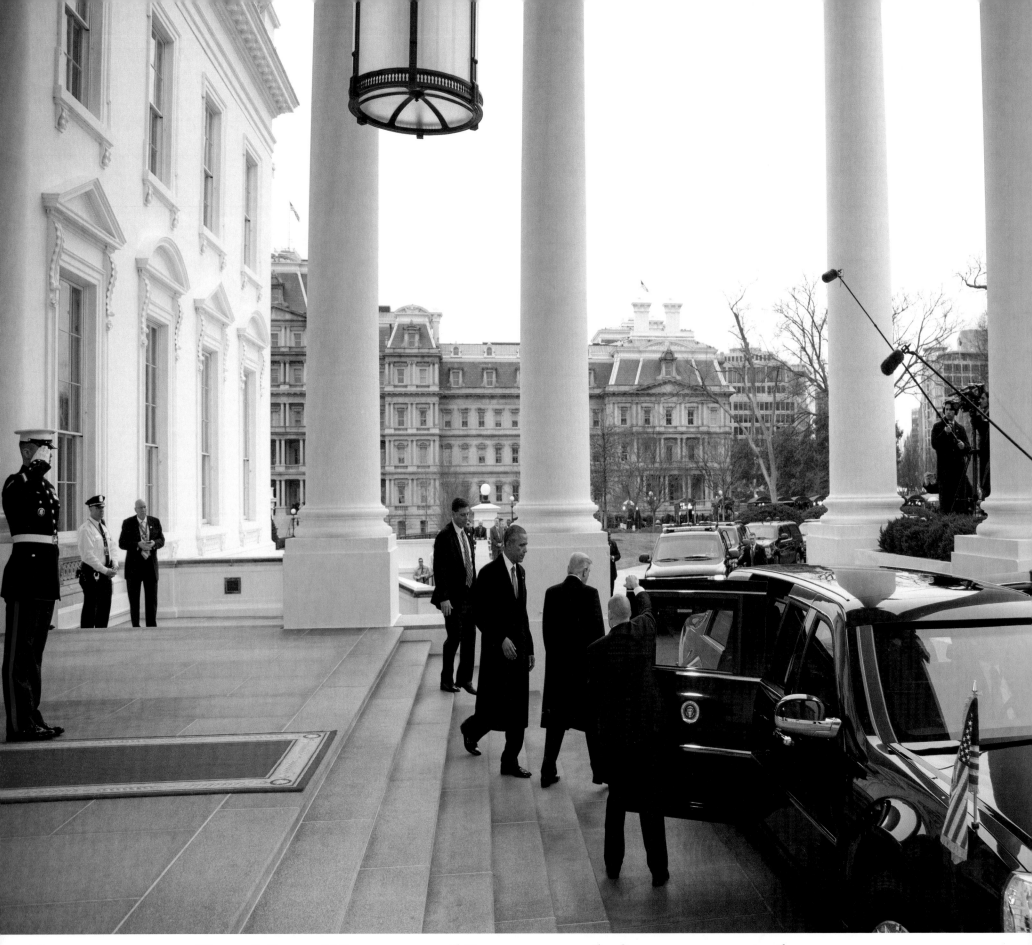

President Obama and I on our sole journey together.

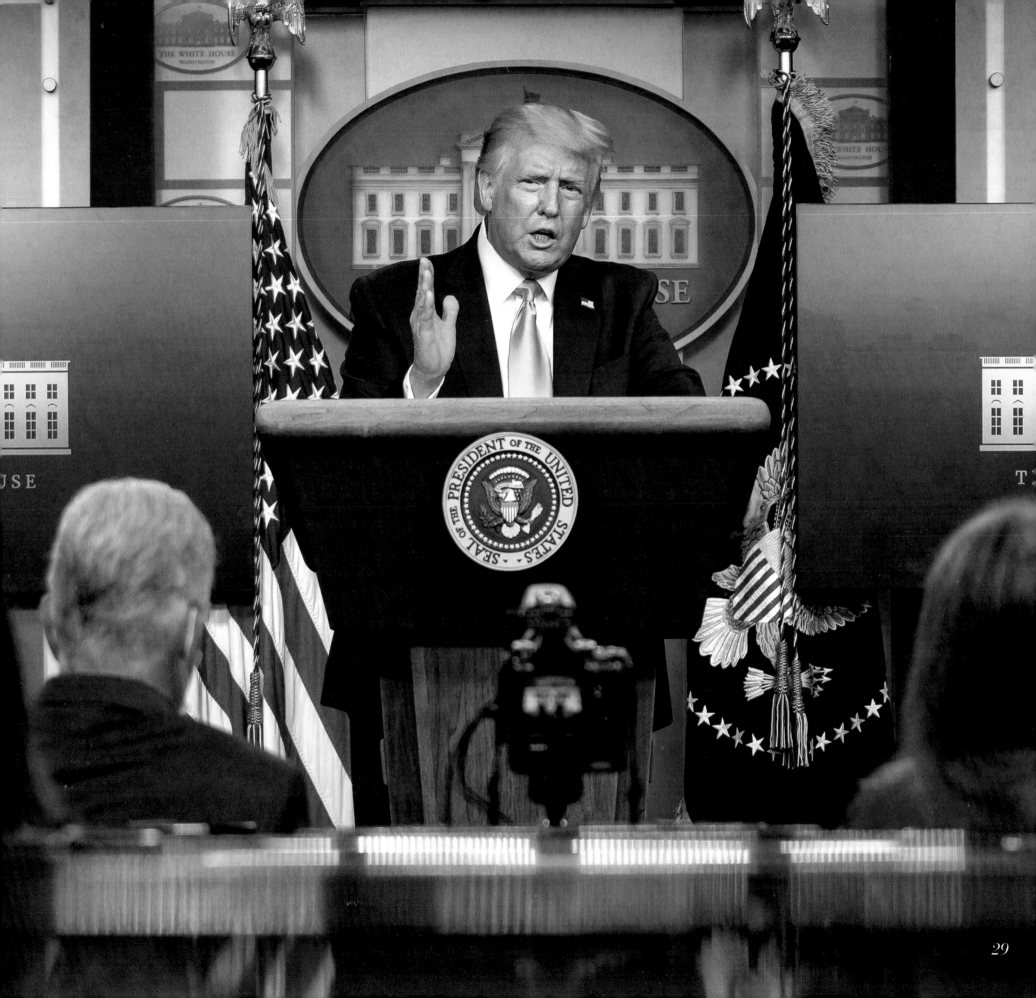

My WONDERFUL IVANKA WANTED NOTHING BUT TO HELP PEOPLE!

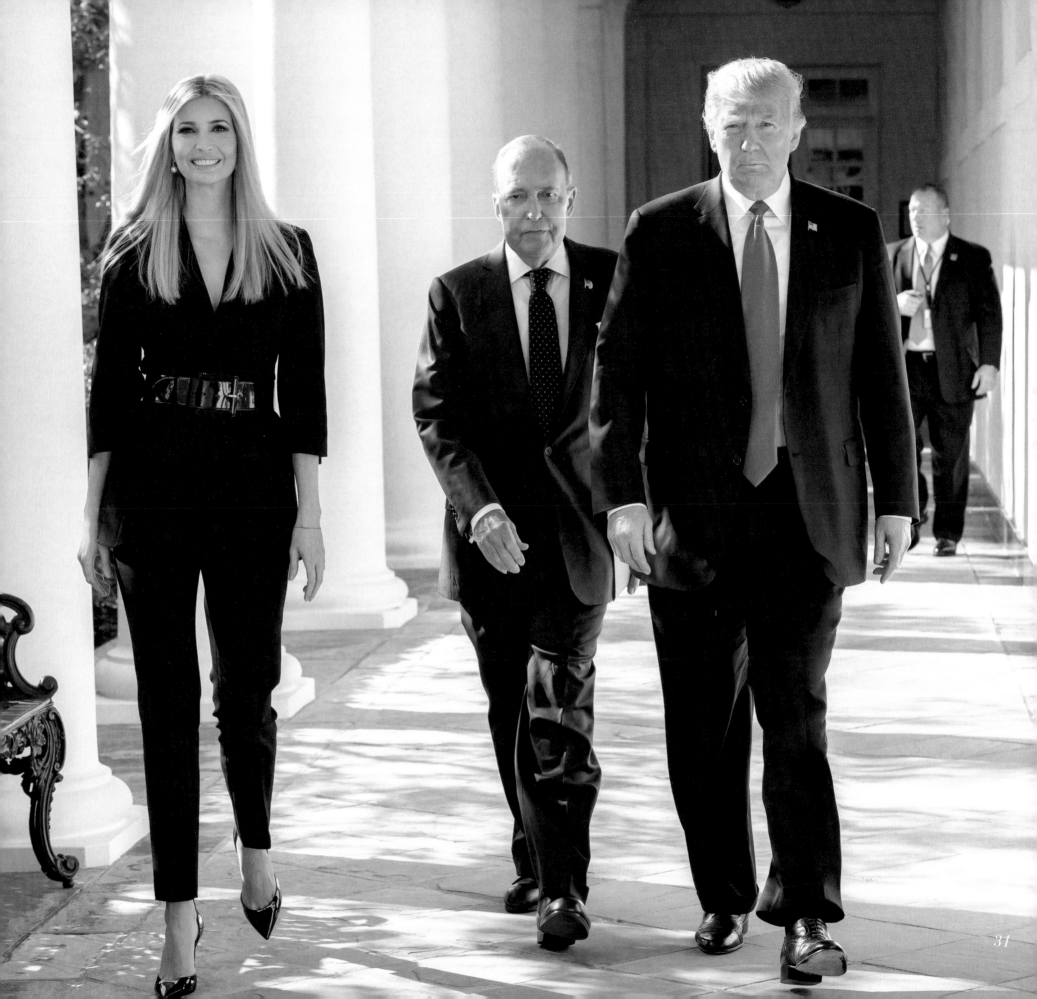

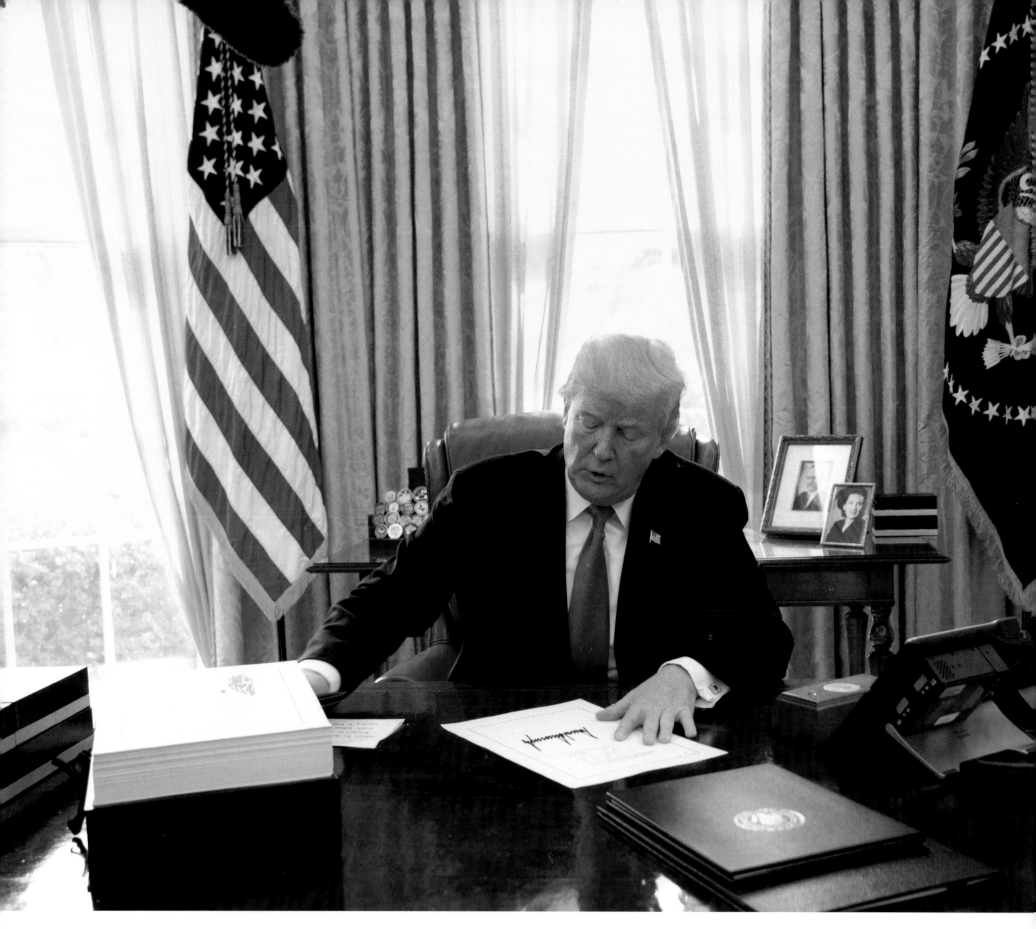

Signing the largest tax cut in history!

TAX RELIEF FOR THE MIDDLE CLASS

Passed $3.2 trillion in historic tax relief and reformed the tax code.

Signed the Tax Cuts and Jobs Act – the largest tax reform package in history.

*More than 6 million American workers received wage increases, bonuses,
and increased benefits thanks to the tax cuts.*

*A typical family of four earning $75,000 received an income tax cut
of more than $2,000 — slashing their tax bill in half.*

Doubled the standard deduction – making the first $24,000 earned by a married couple completely tax-free.

Doubled the child tax credit.

Virtually eliminated the unfair Estate Tax, or Death Tax.

Cut the business tax rate from 35 percent – the highest in the developed world – all the way down to 21 percent.

Small businesses can now deduct 20 percent of their business income.

Businesses can now deduct 100 percent of the cost of their capital investments in the year the investment is made.

*Since the passage of tax cuts, the share of total wealth held by the bottom half of households has increased,
while the share held by the top 1 percent has decreased.*

Over 400 companies have announced bonuses, wage increases, new hires, or new investments in the United States.

Over $1.5 trillion was repatriated into the United States from overseas.

*Lower investment cost and higher capital returns led to faster growth in the middle class, real wages,
and international competitiveness.*

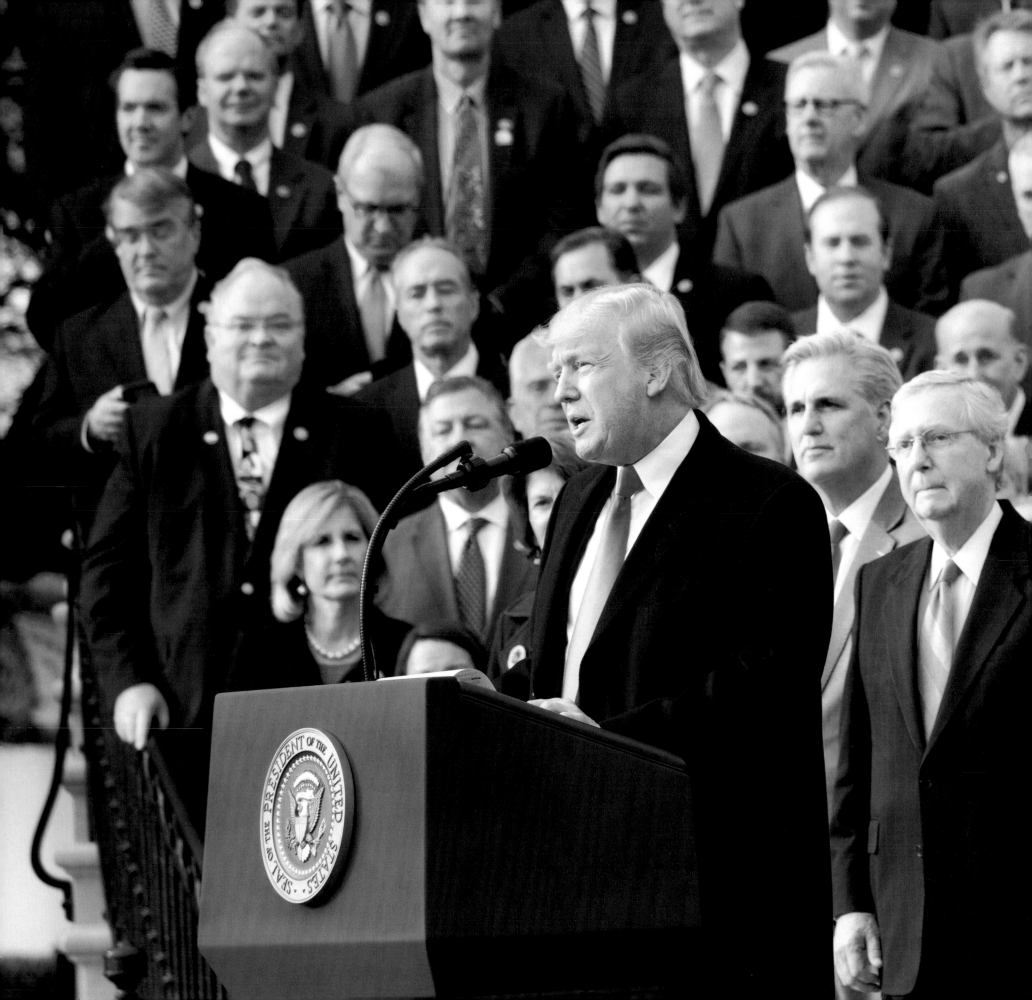

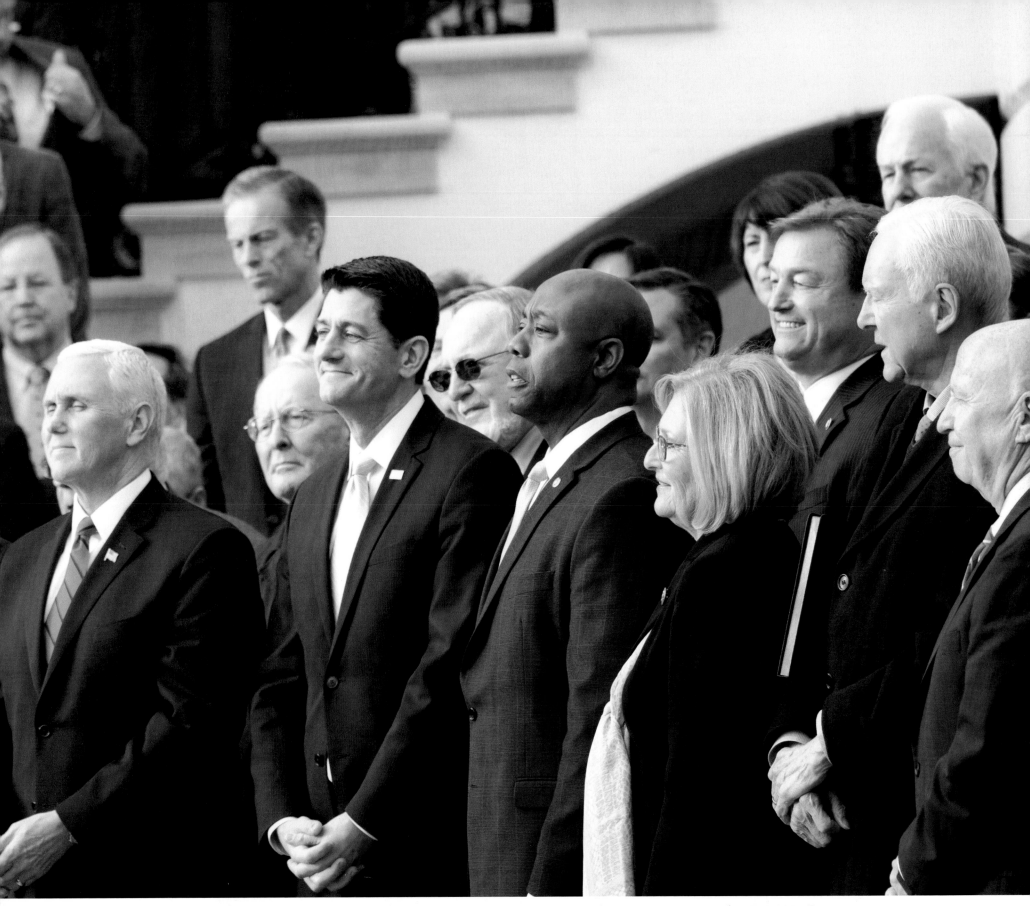

Some conservative patriots and some weak RINOs joined me at the White House to advocate for our tax cut.

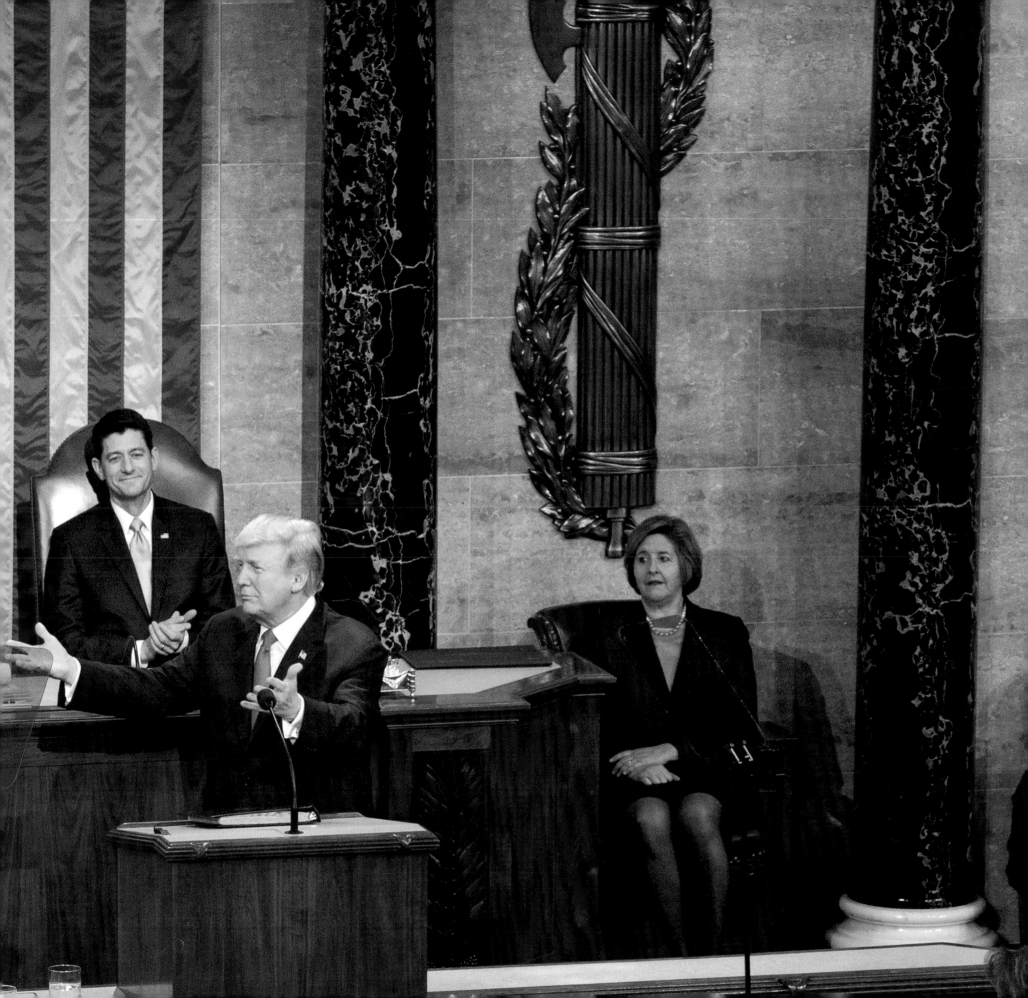

THERE WAS NOTHING I COULD HAVE
DONE TO MAKE THE RADICAL LEFT
LADIES IN WHITE SMILE — BUT I TRIED!

OUR great FirstLady is ABSOLUTELY
LOVED. SHE is BEAUTIFUL BOTH INSIDE
AND OUT!

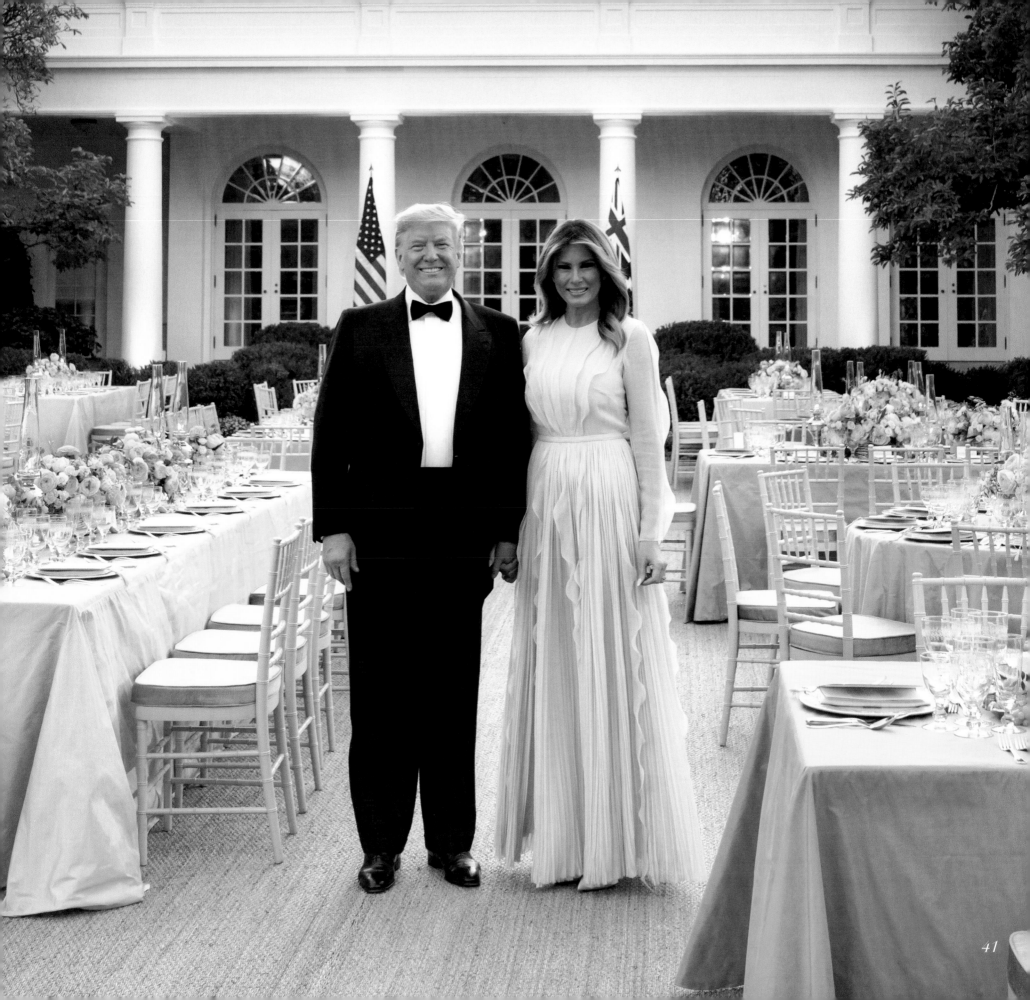

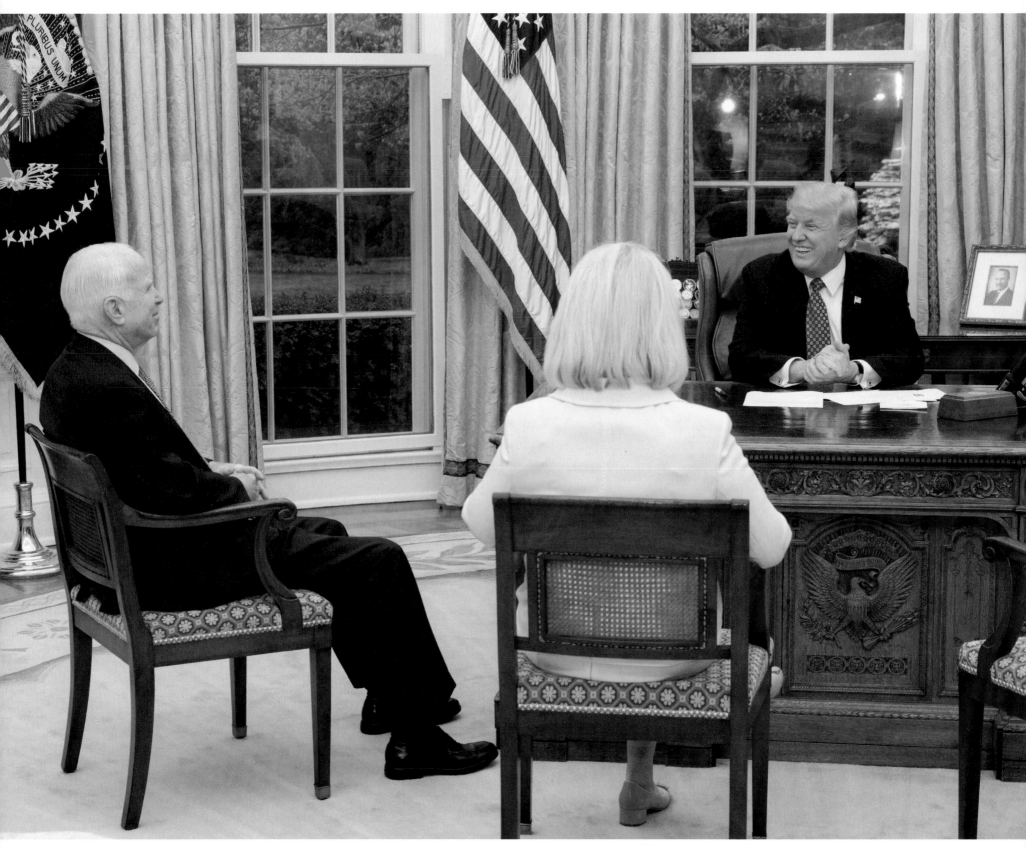

John McCain visited me in the White House, asking for a job for his wife.
I am smiling, but I didn't like him even a little bit.

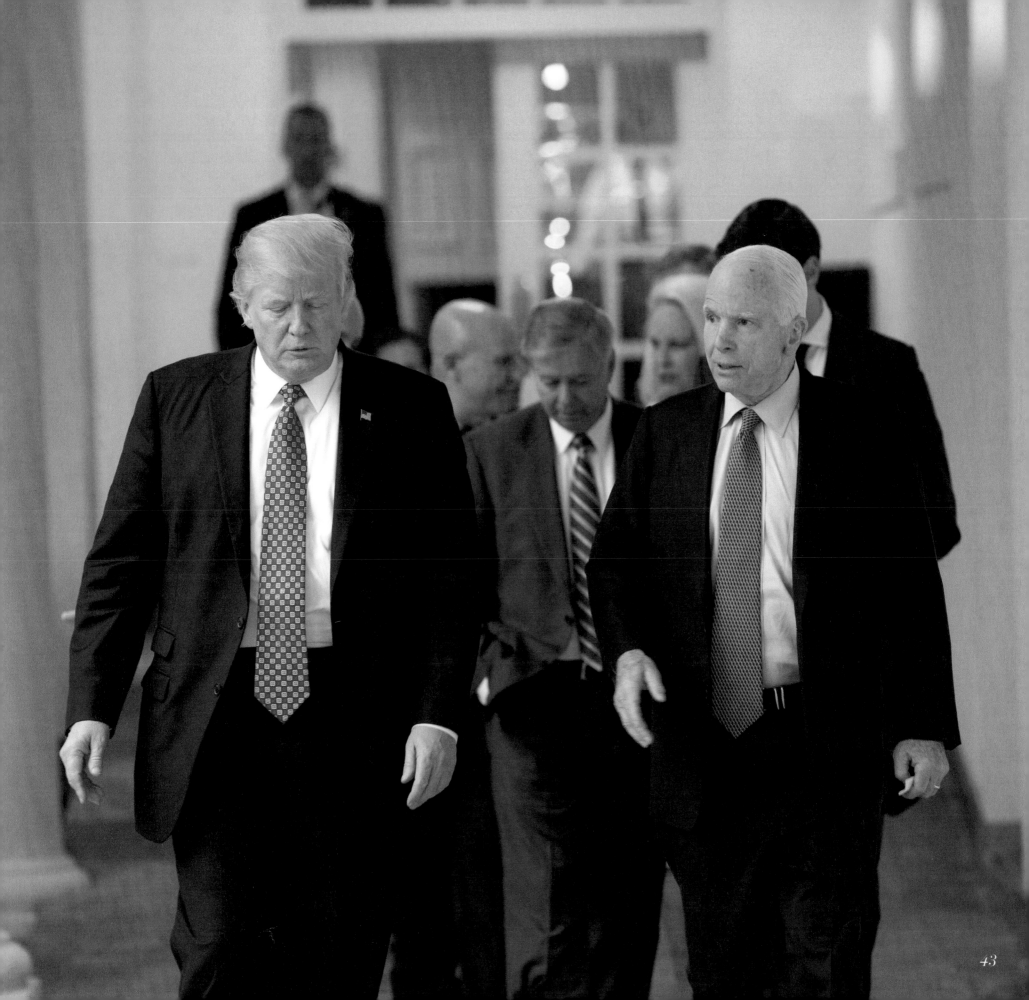

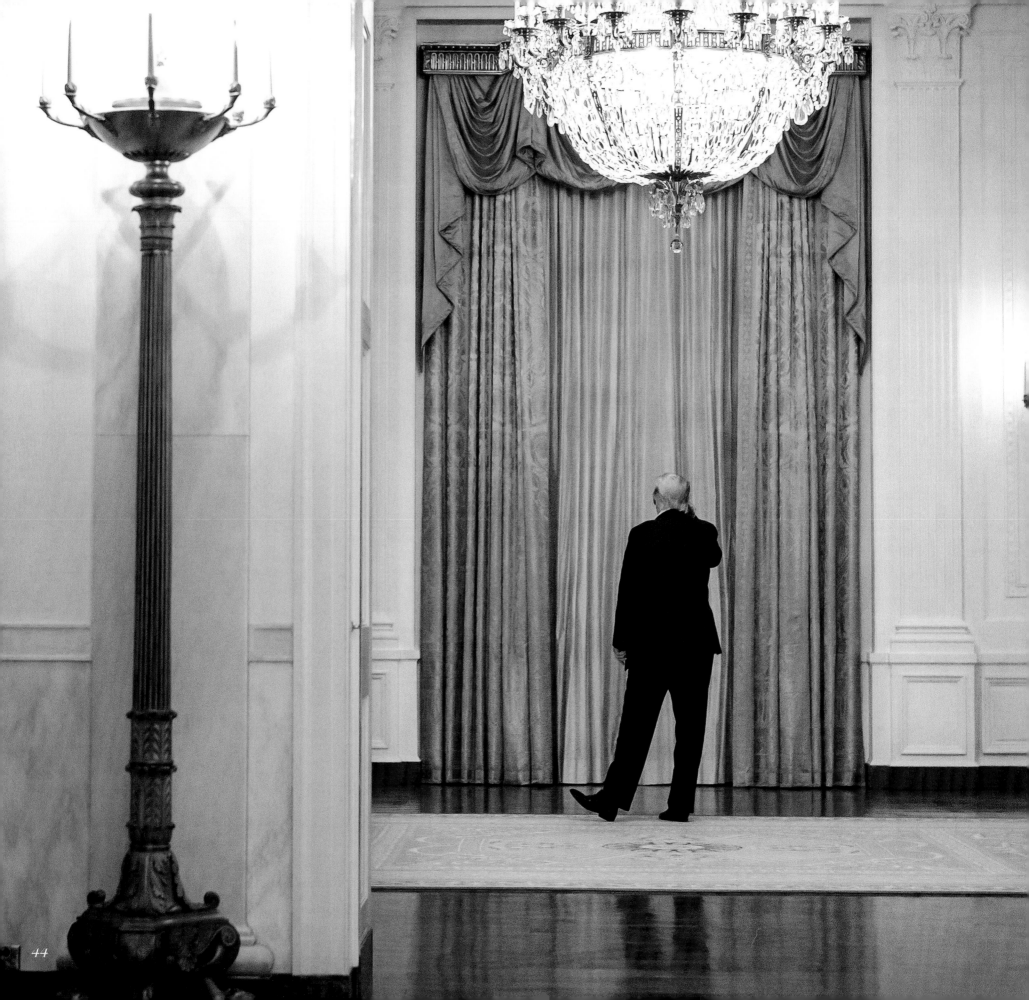

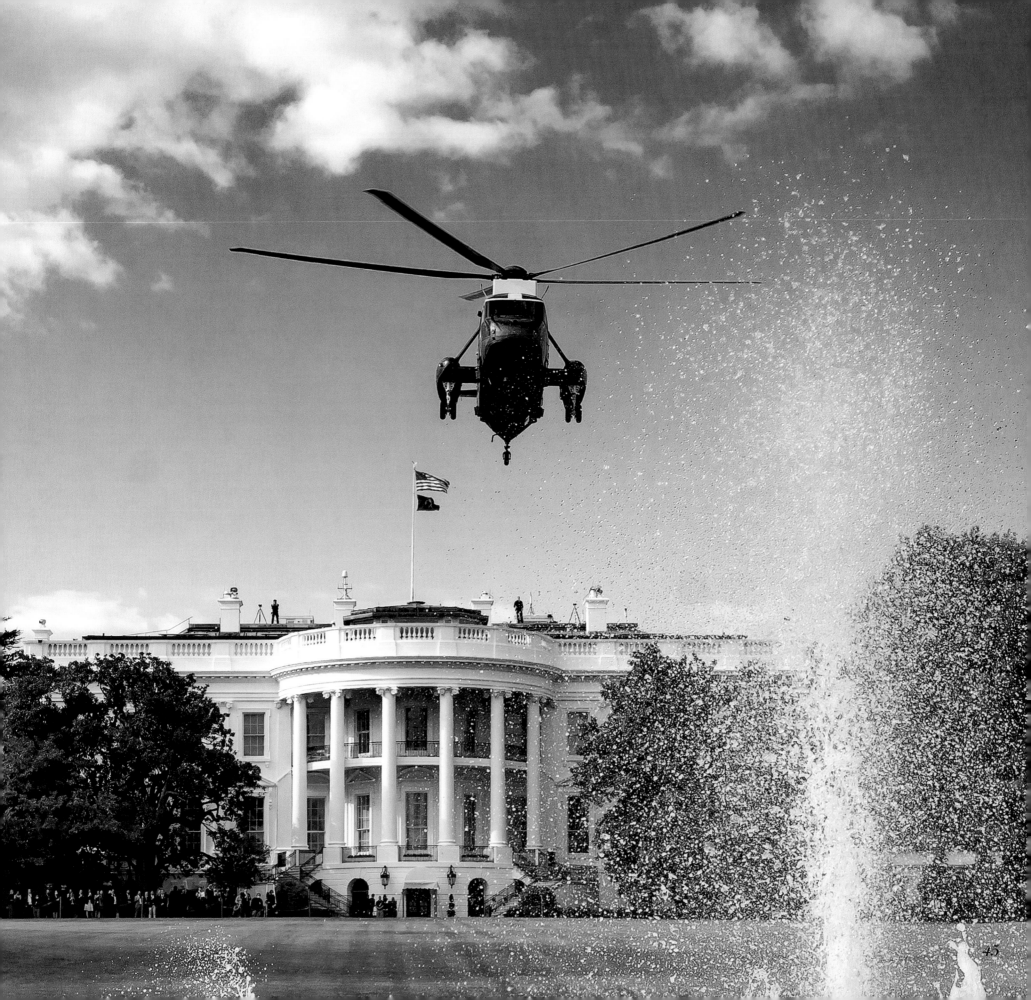

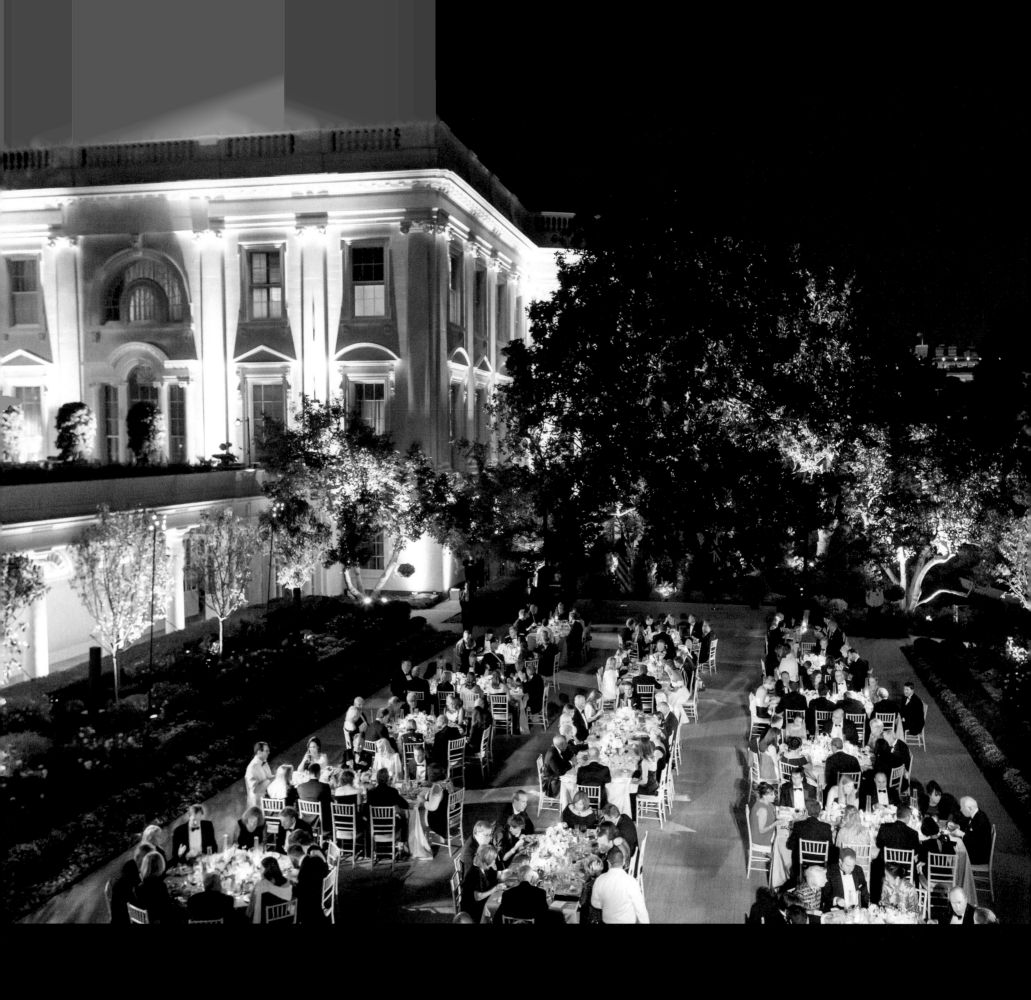

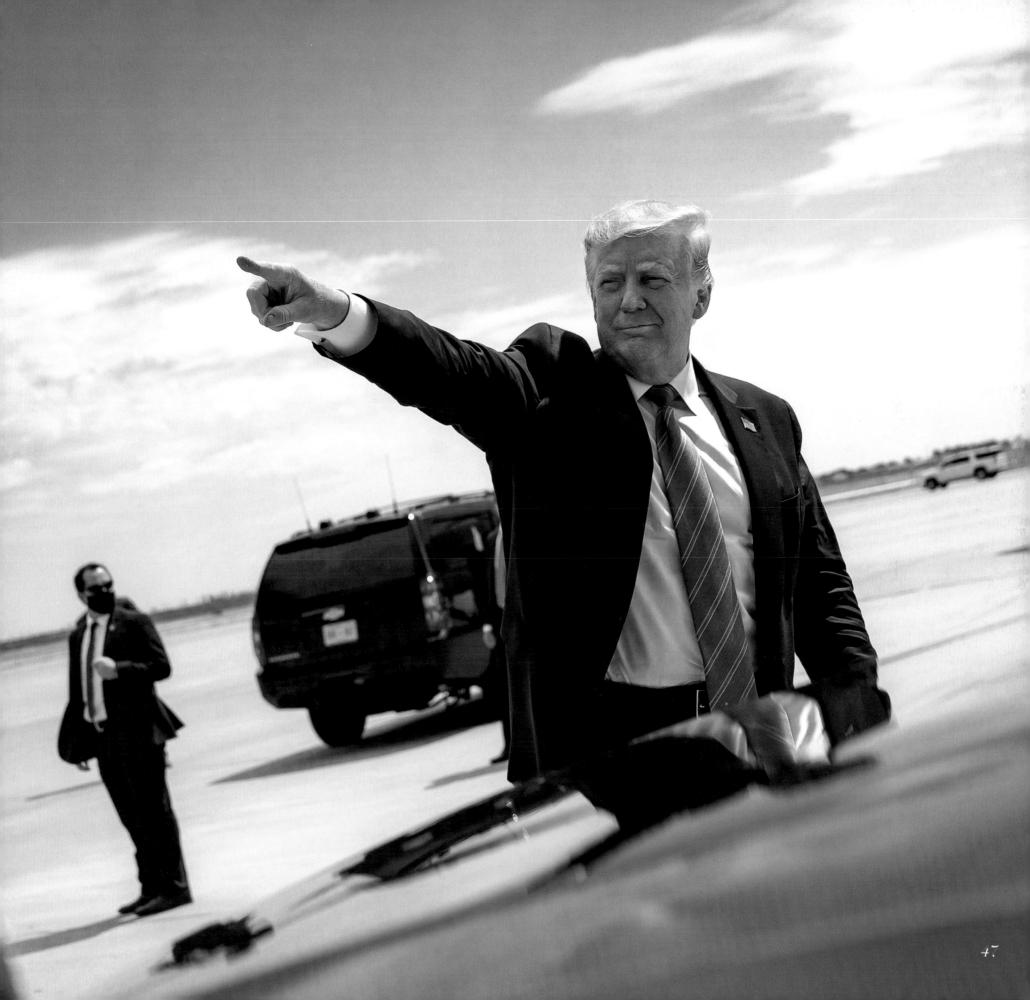

47

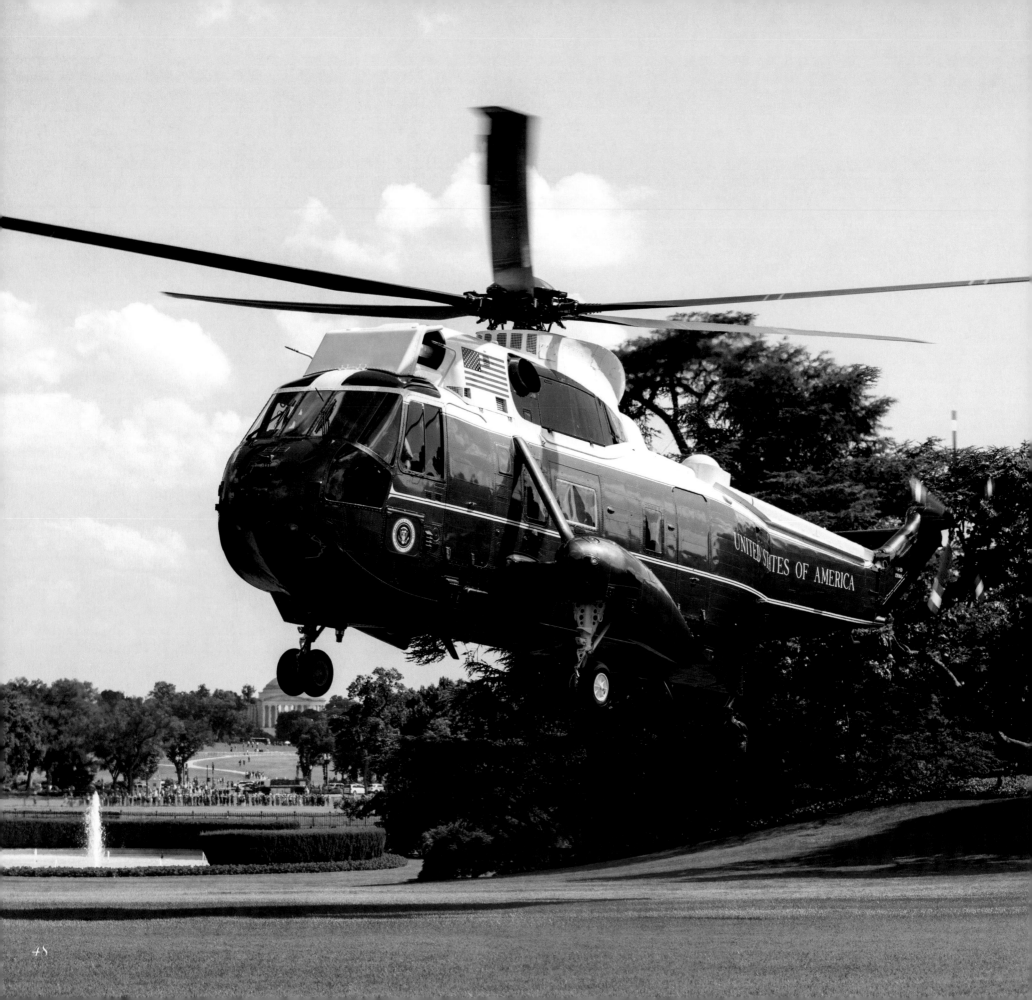

I like Marine One better.

One of the first things I did upon taking office was renegotiate the terrible Air Force One deal which the previous administration agreed to. I saved America over a billion dollars!

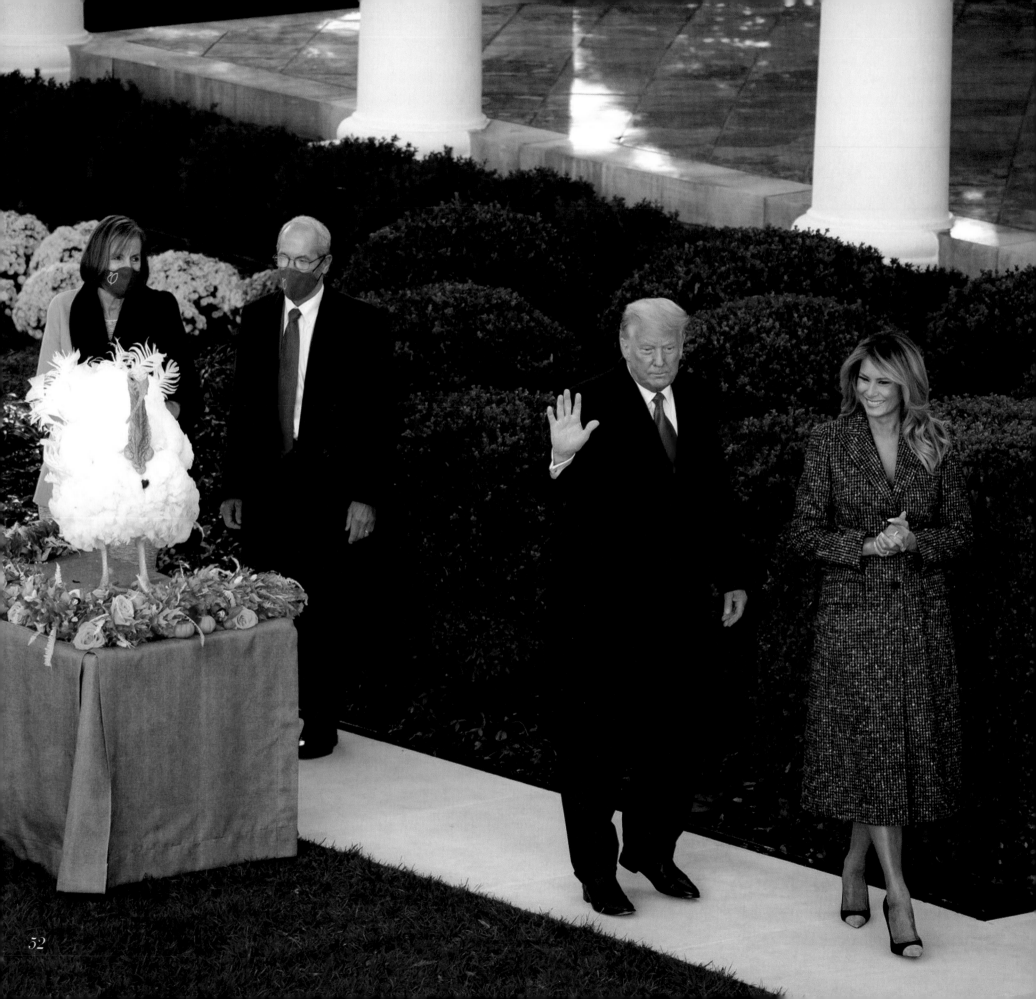

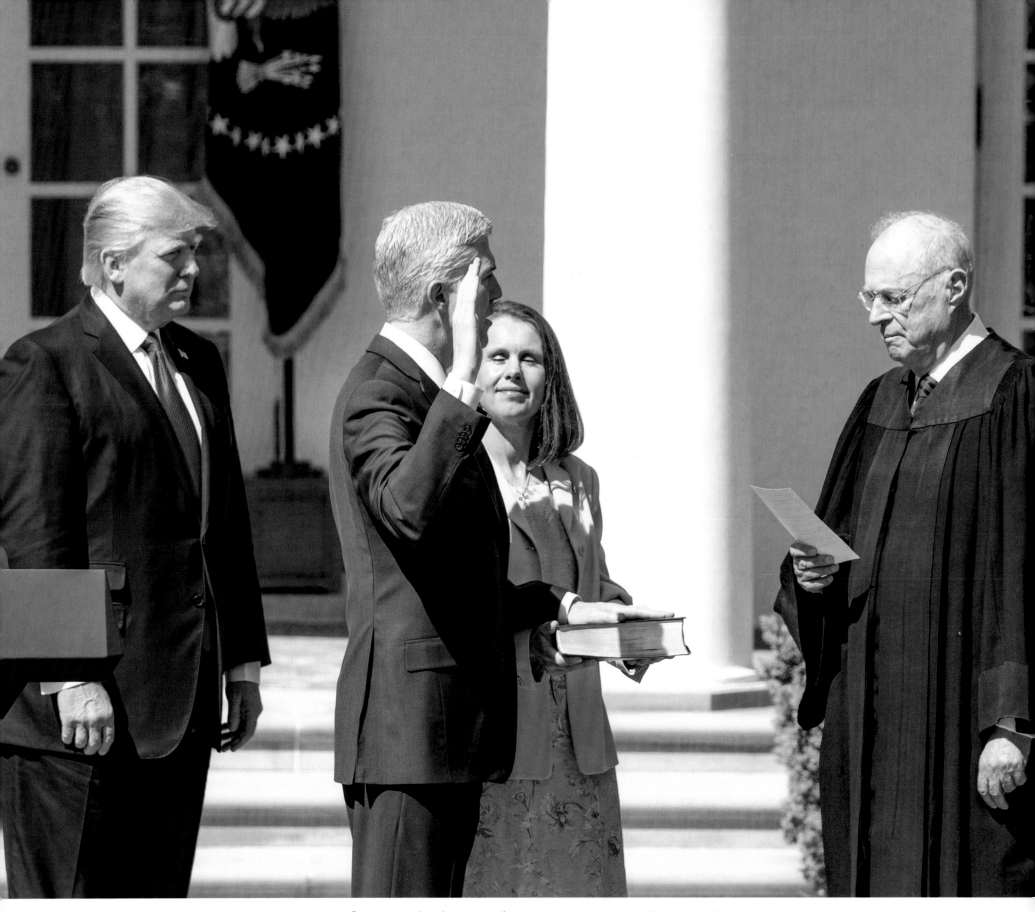

My first pick to the Supreme Court!
Neil Gorsuch, one of the sharpest legal minds in our nation.

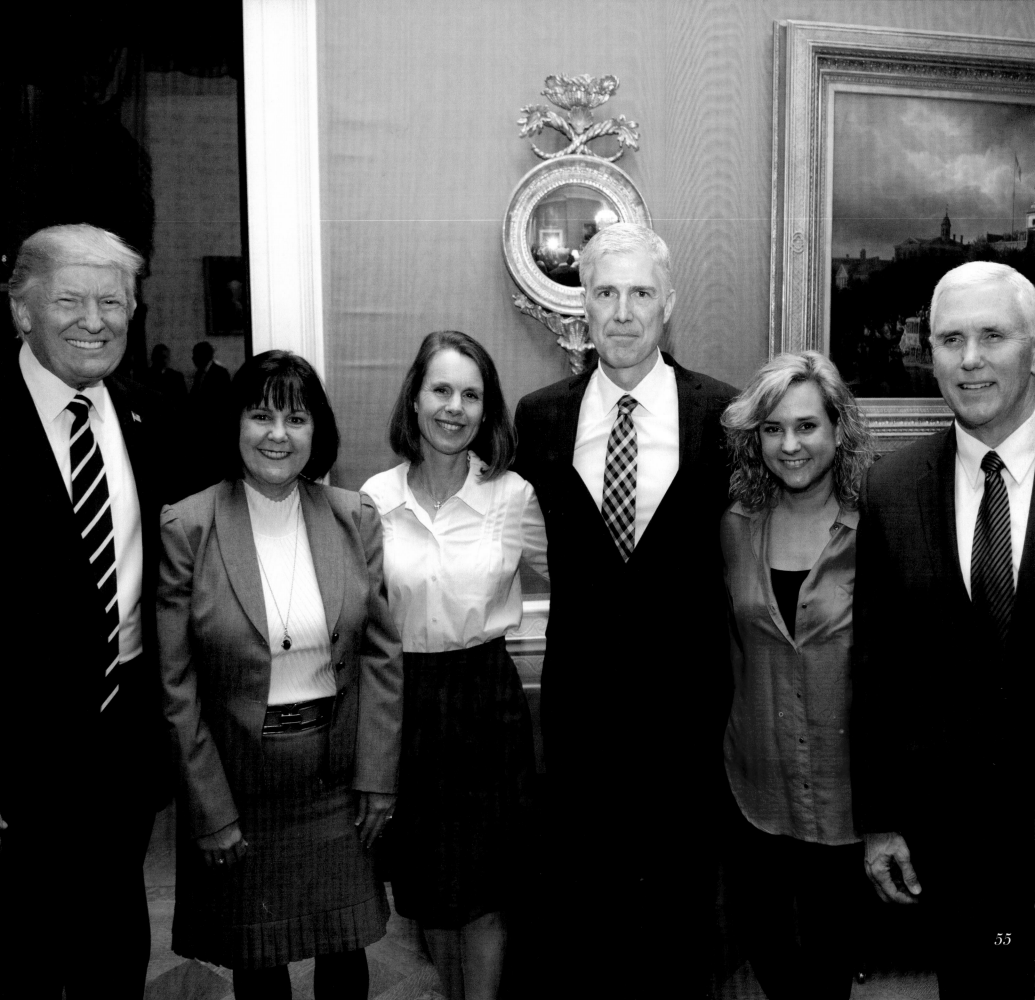

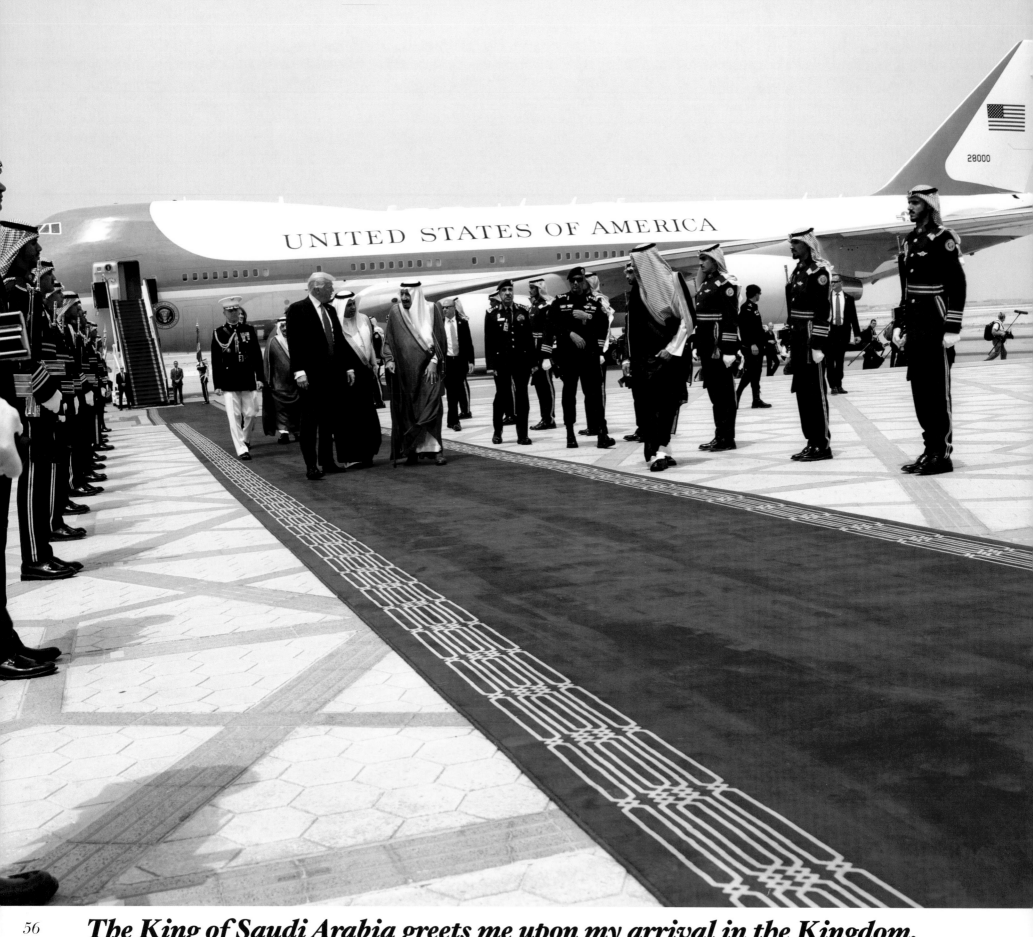

The King of Saudi Arabia greets me upon my arrival in the Kingdom.

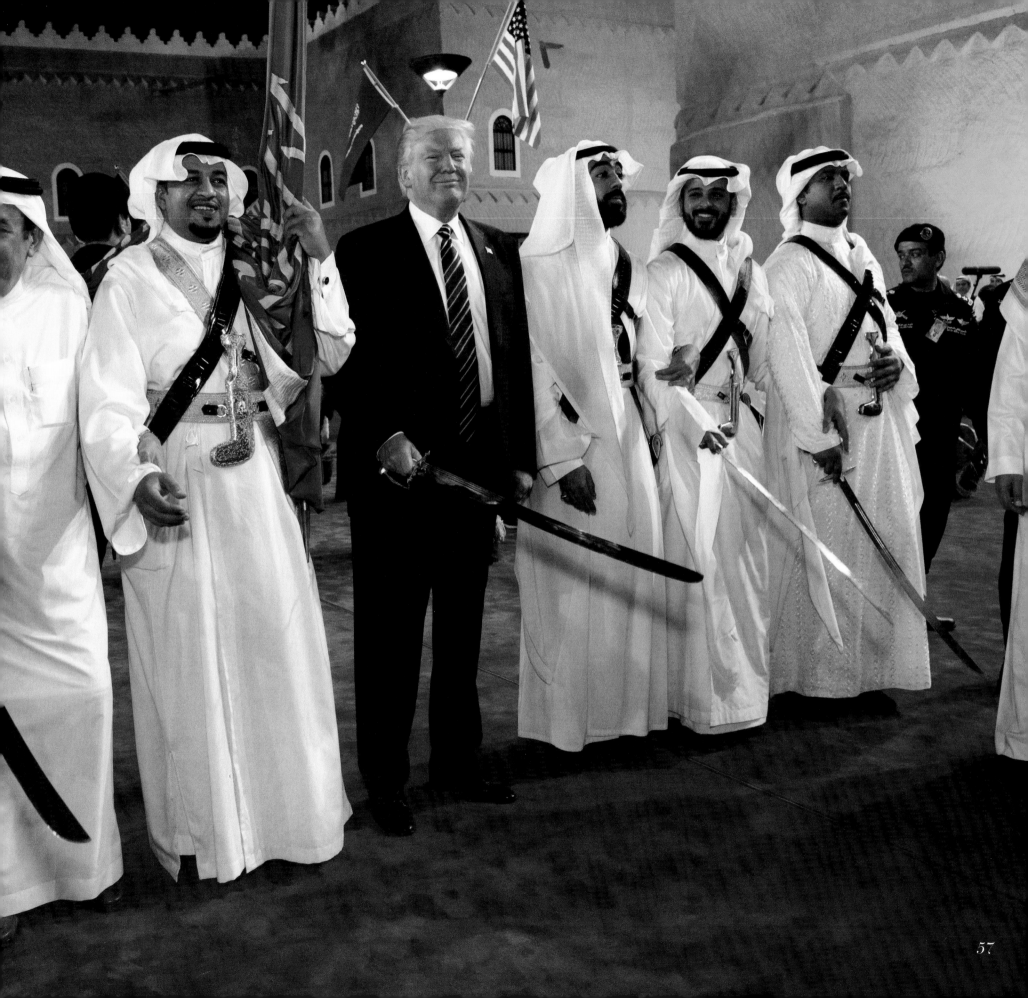

57

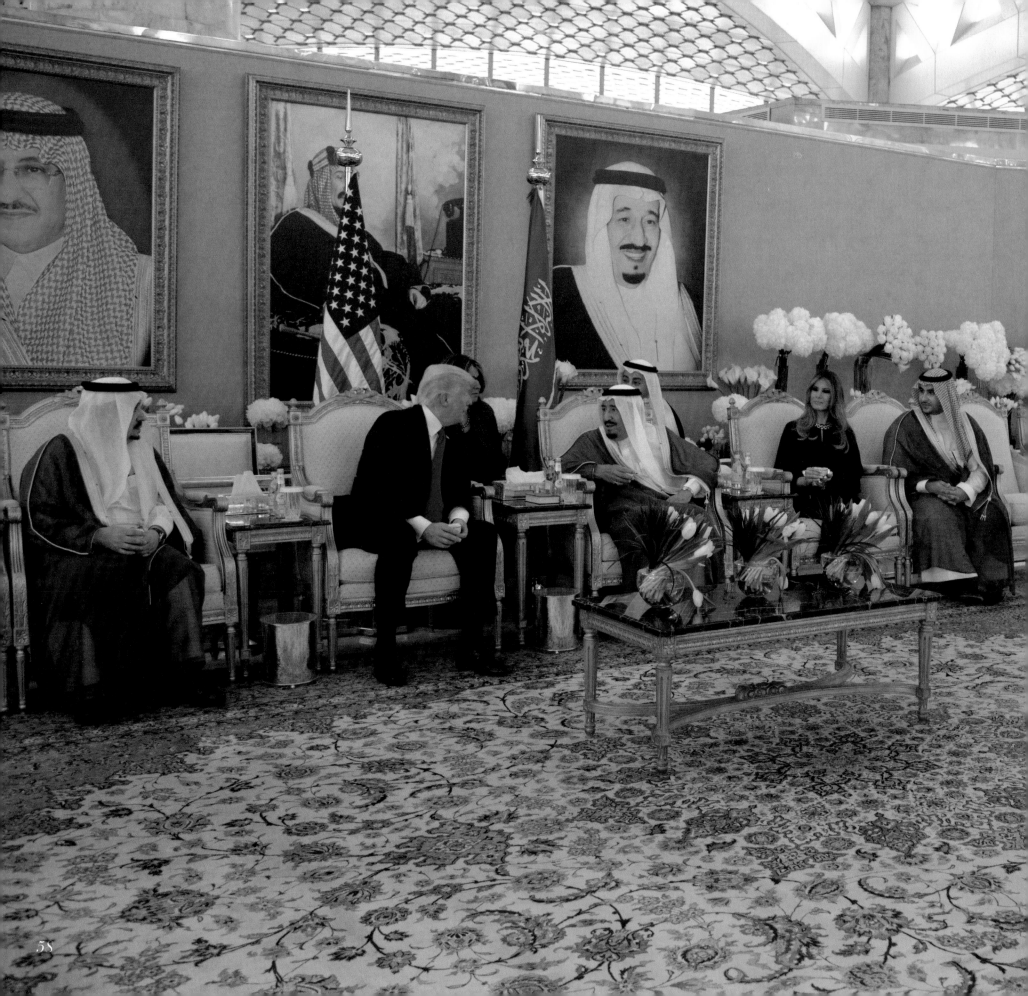

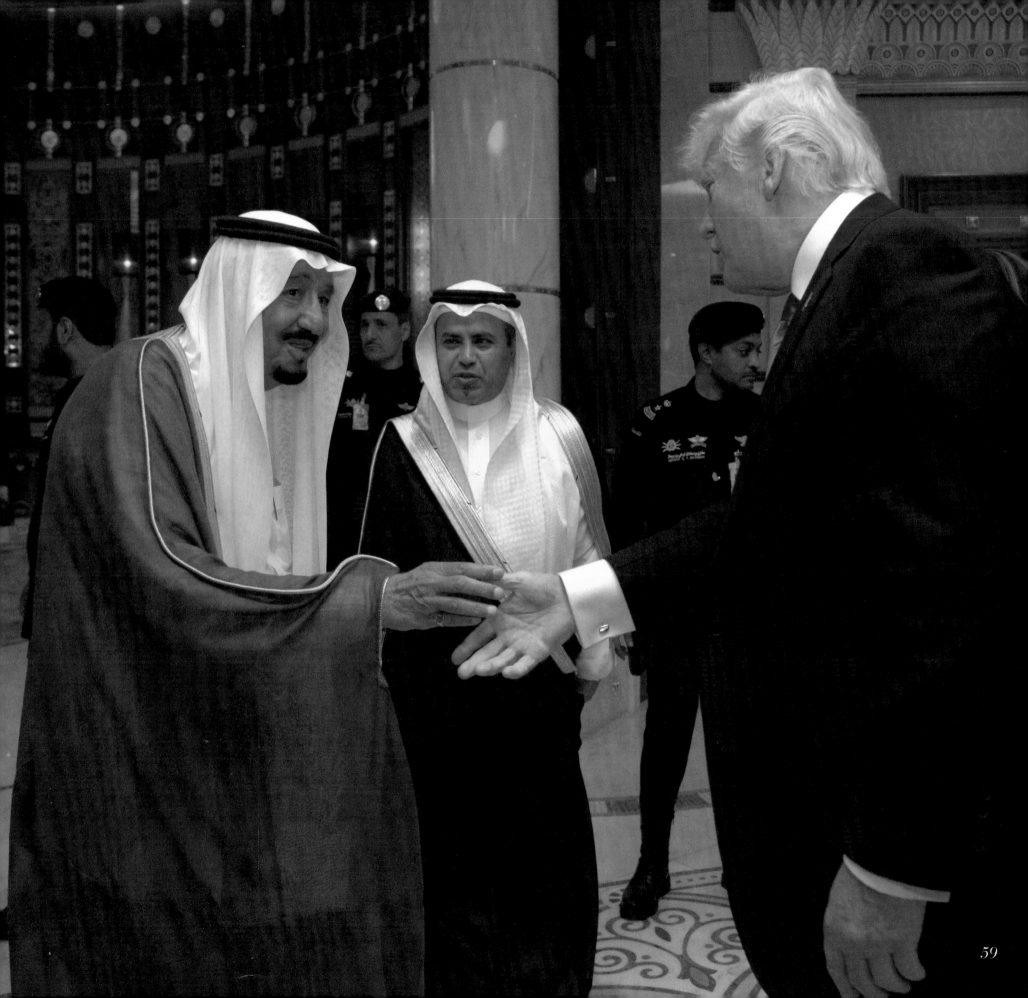

THE CROWN PRINCE WILL SOMEDAY BE, I PREDICT, A GREAT KING OF SAUDI ARABIA.

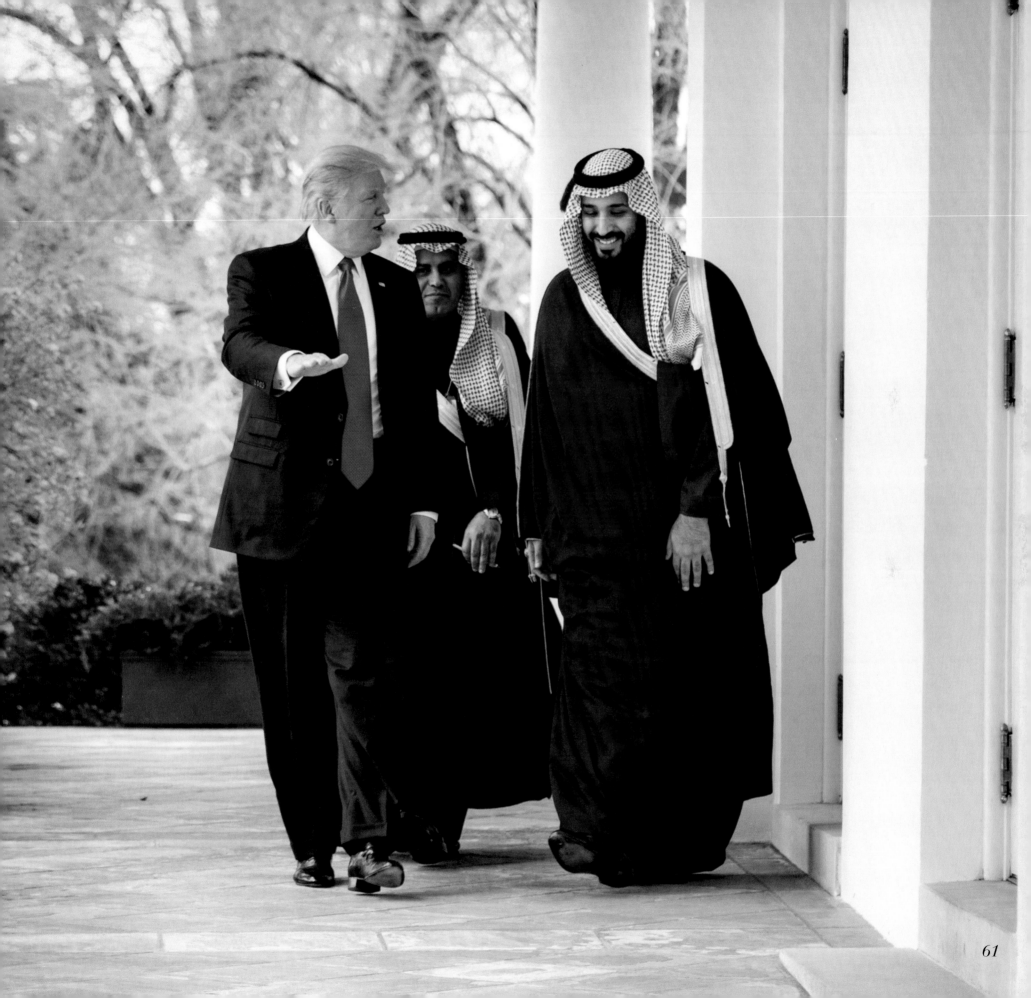

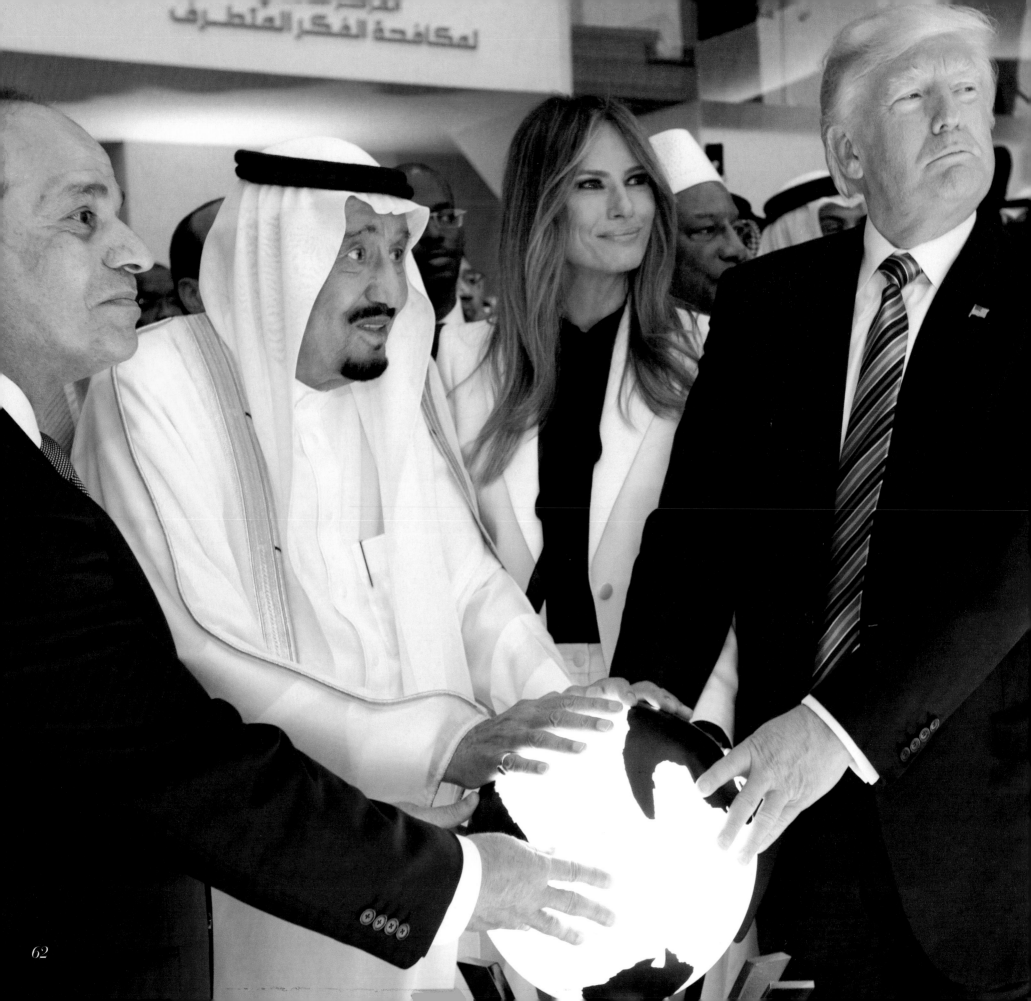

THE GREAT KING OF SAUDI ARABIA AND THE PRESIDENT OF EGYPT – TWO FRIENDS WHO LOVE THEIR COUNTRIES DEARLY!

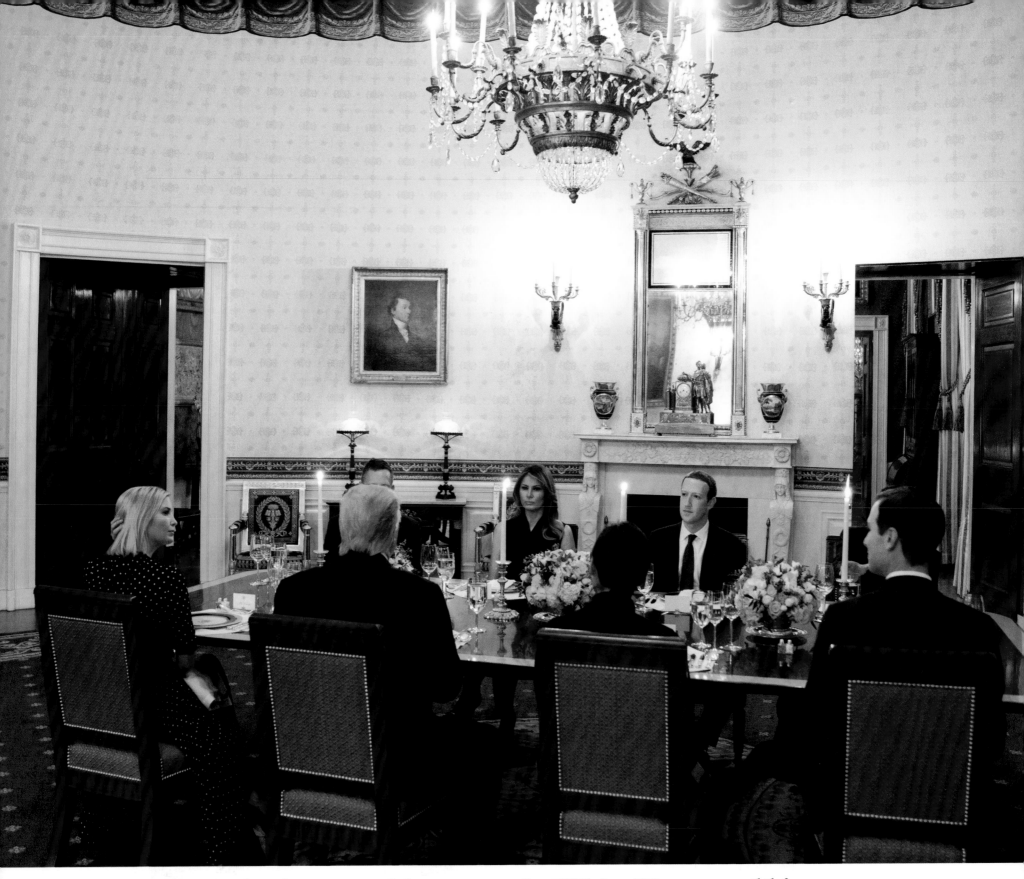

Mark Zuckerberg would come to the White House and kiss my ass.
His censorship is terrible for America.
His "campaign contributions" even worse!

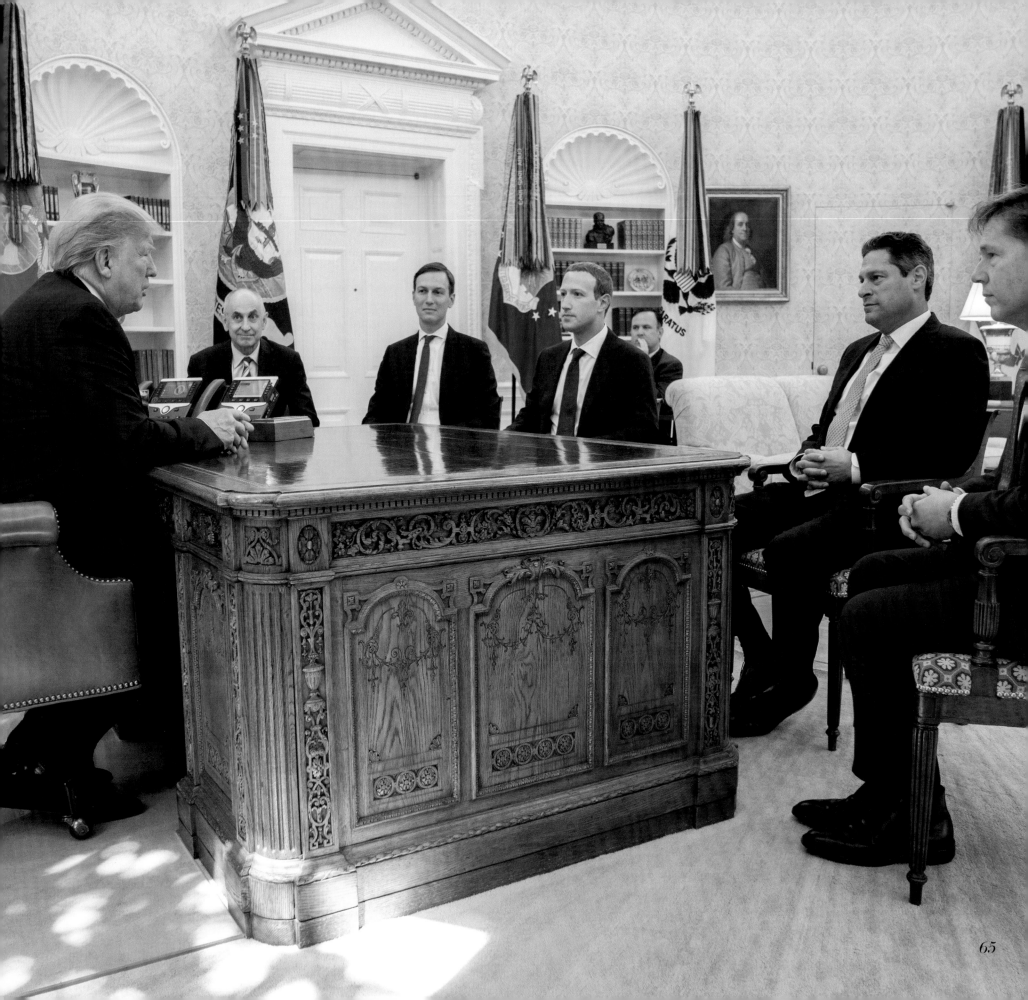

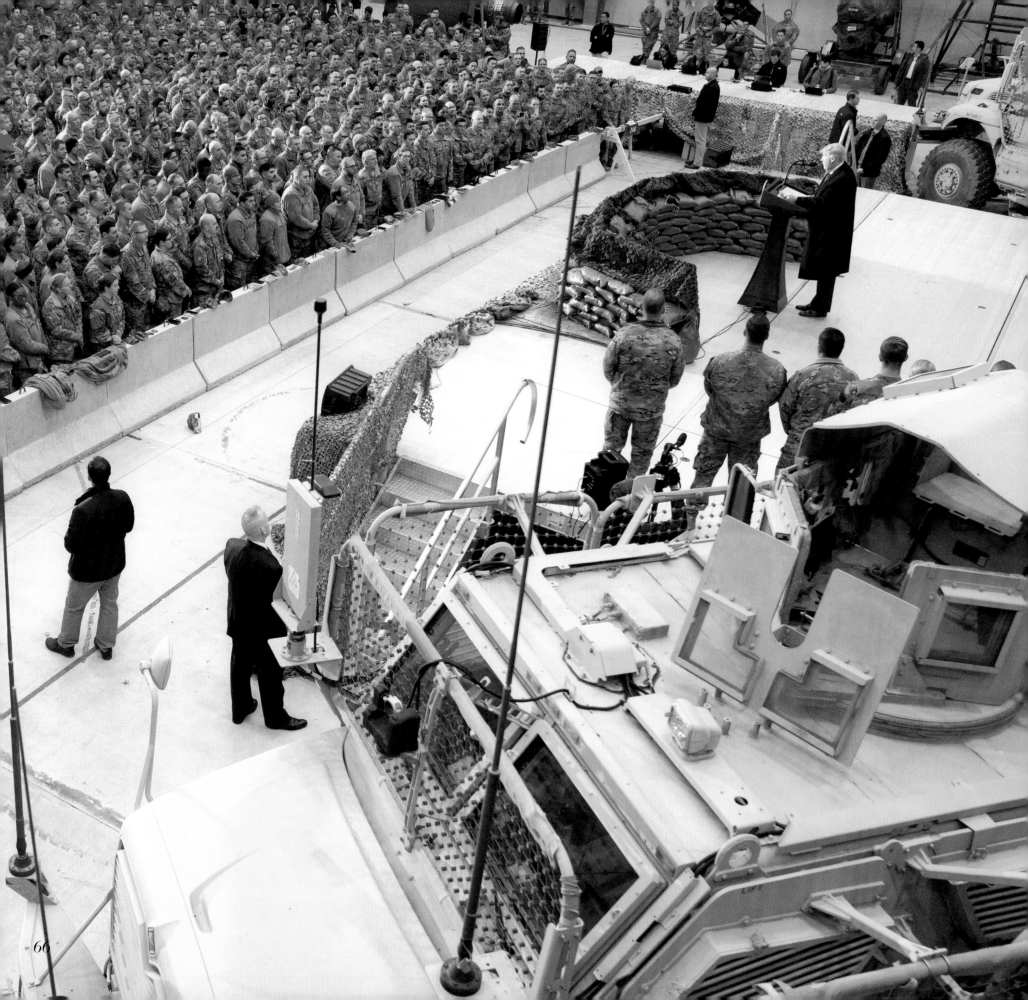

I ALWAYS STOOD FOR OUR
TROOPS AND THEIR FAMILIES.
NO PRESIDENT DID MORE FOR
THE MILITARY THAN ME.

I LOVE THEM!

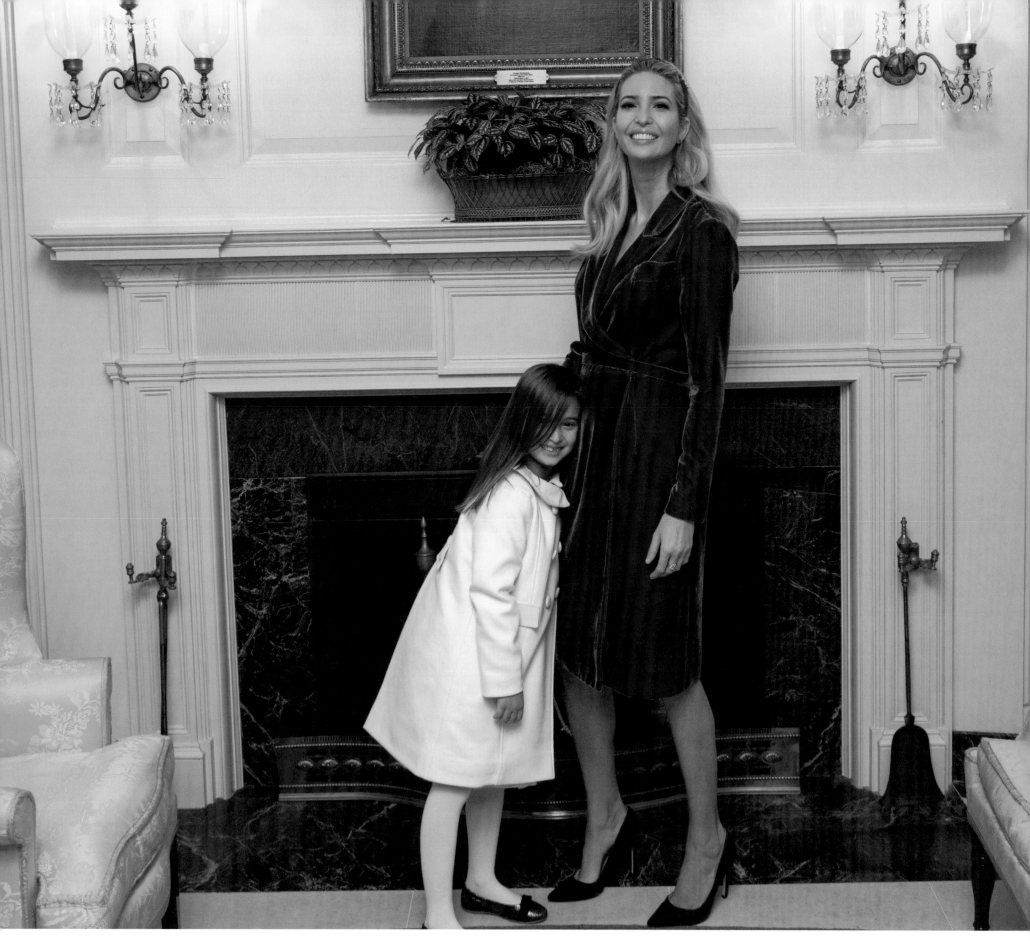

Ivanka with my brilliant granddaughter Arabella.

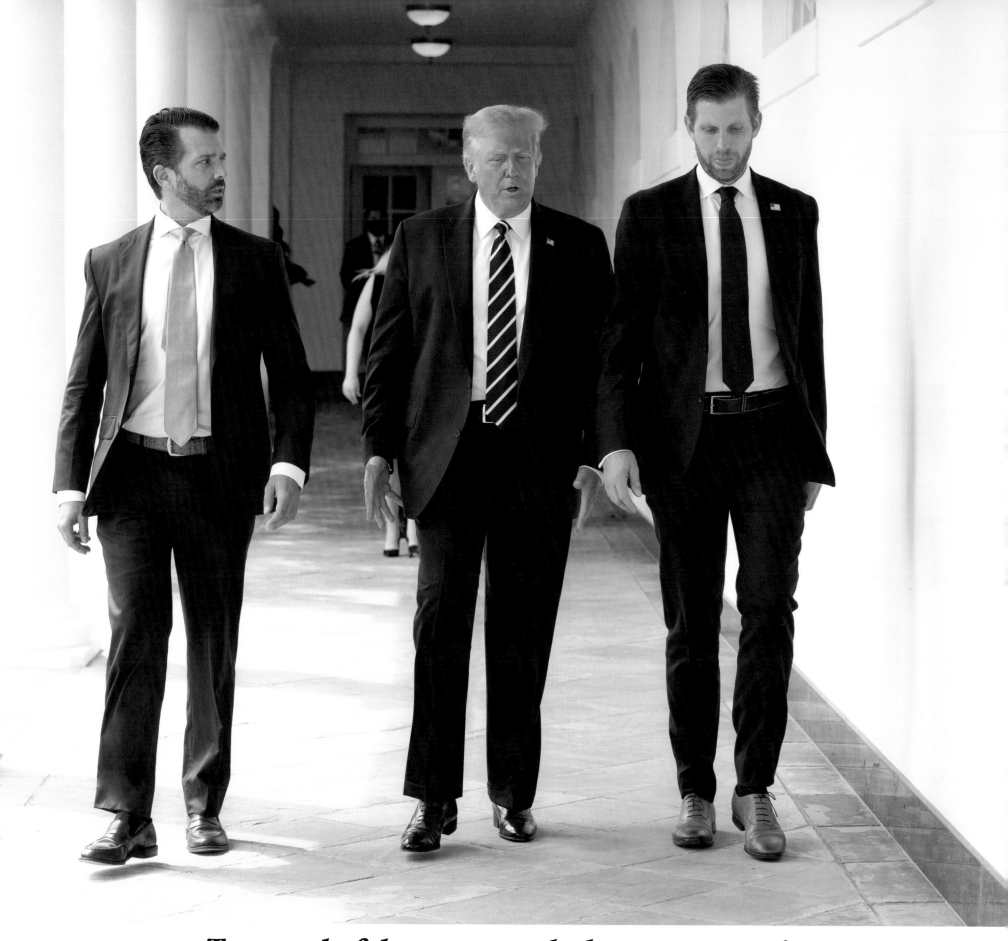

Two wonderful young men who love our country!

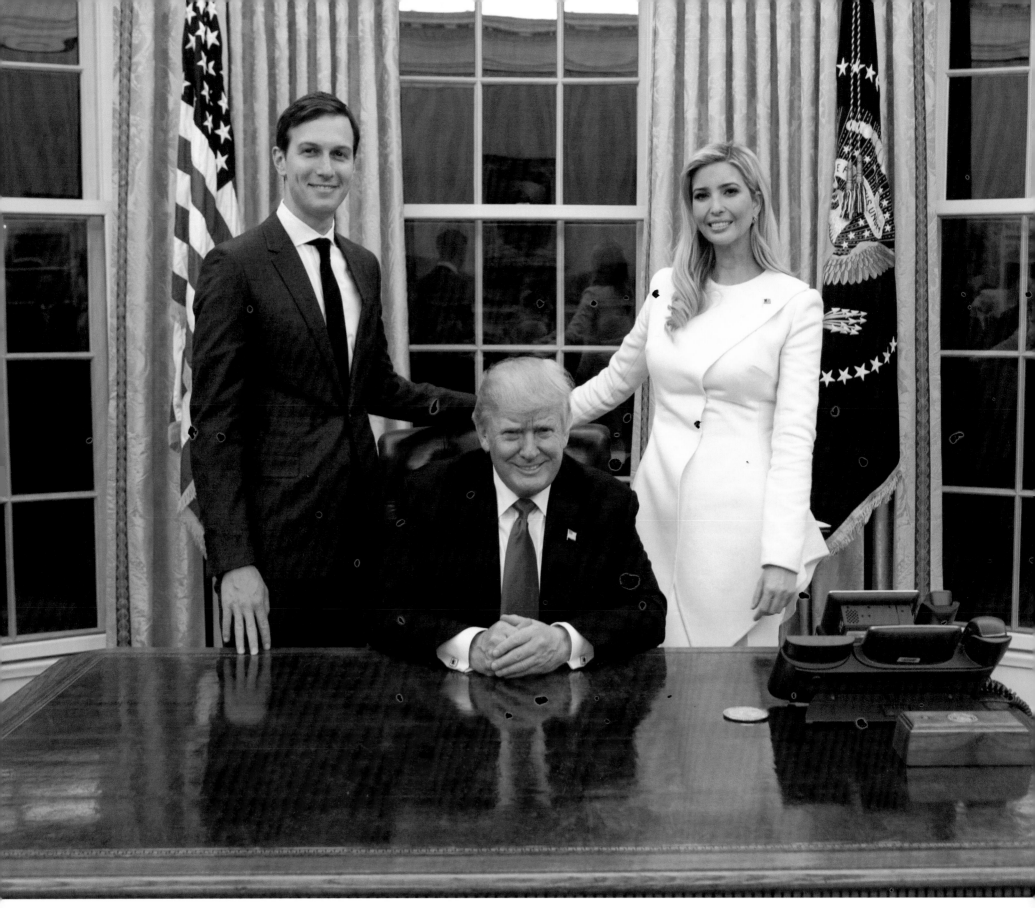

I was glad to have Jared and Ivanka with me in the White House!
Smart, loving, and loyal!

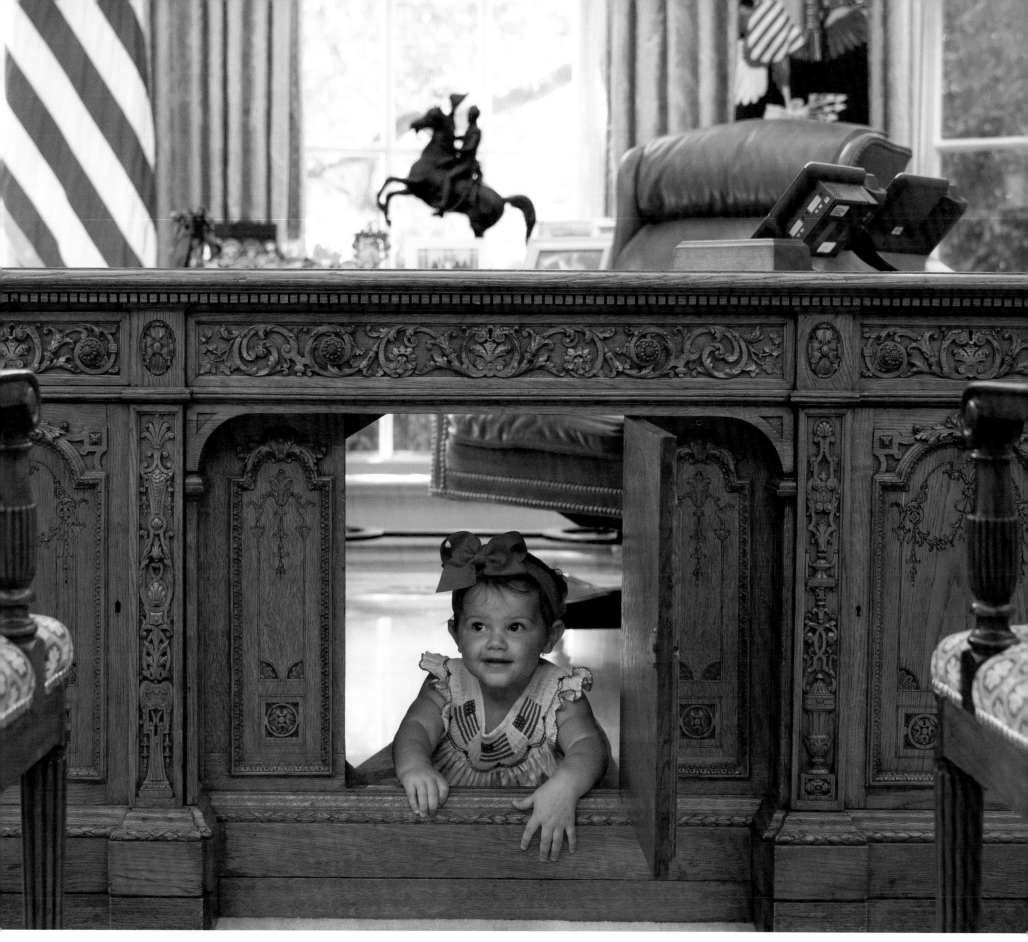

A little patriot visits me in the Oval Office.

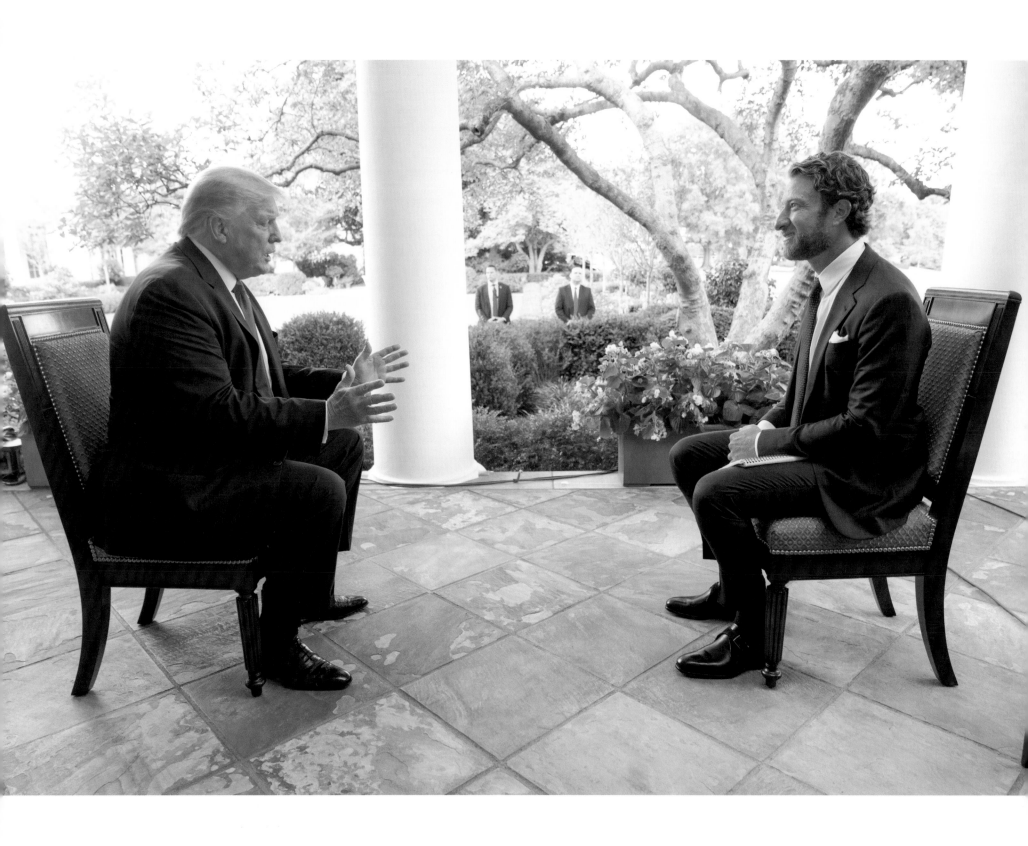

Dave Portnoy interviews me in the White House. A good guy.

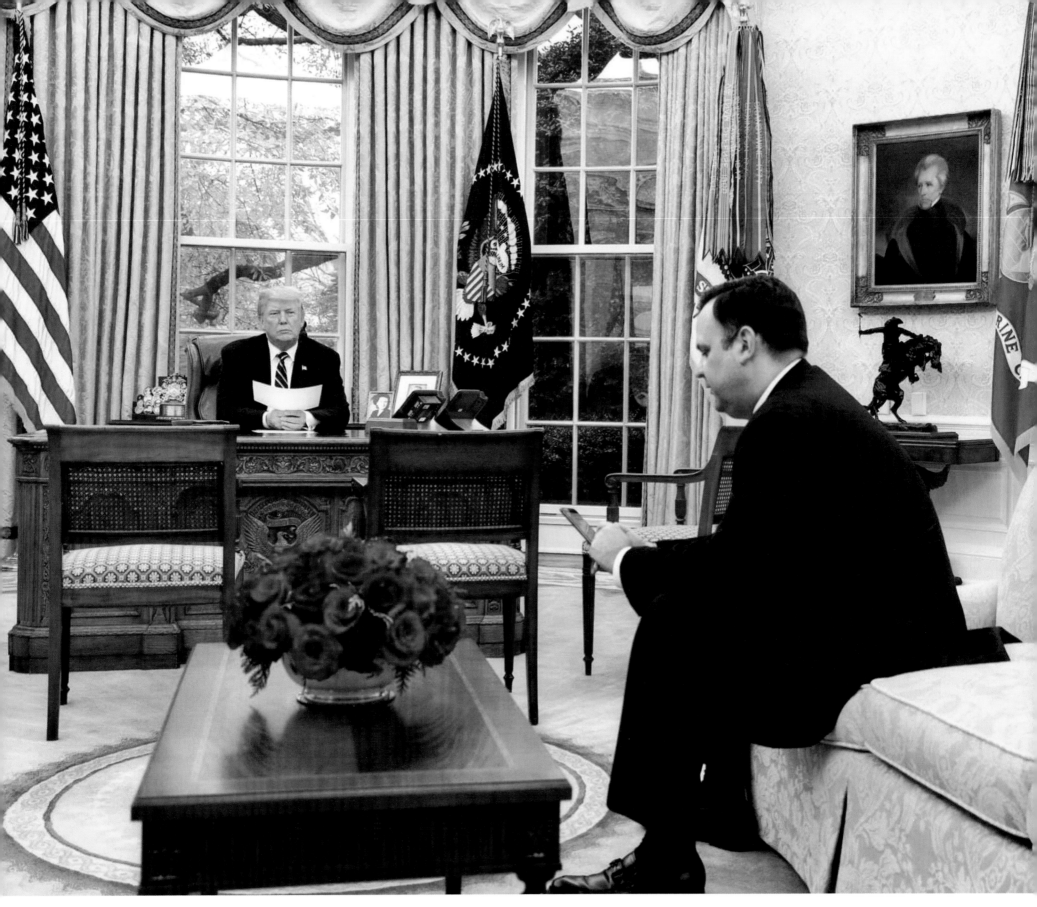

**Dan Scavino has been with me for many years.
A tough and loyal part of the team.**

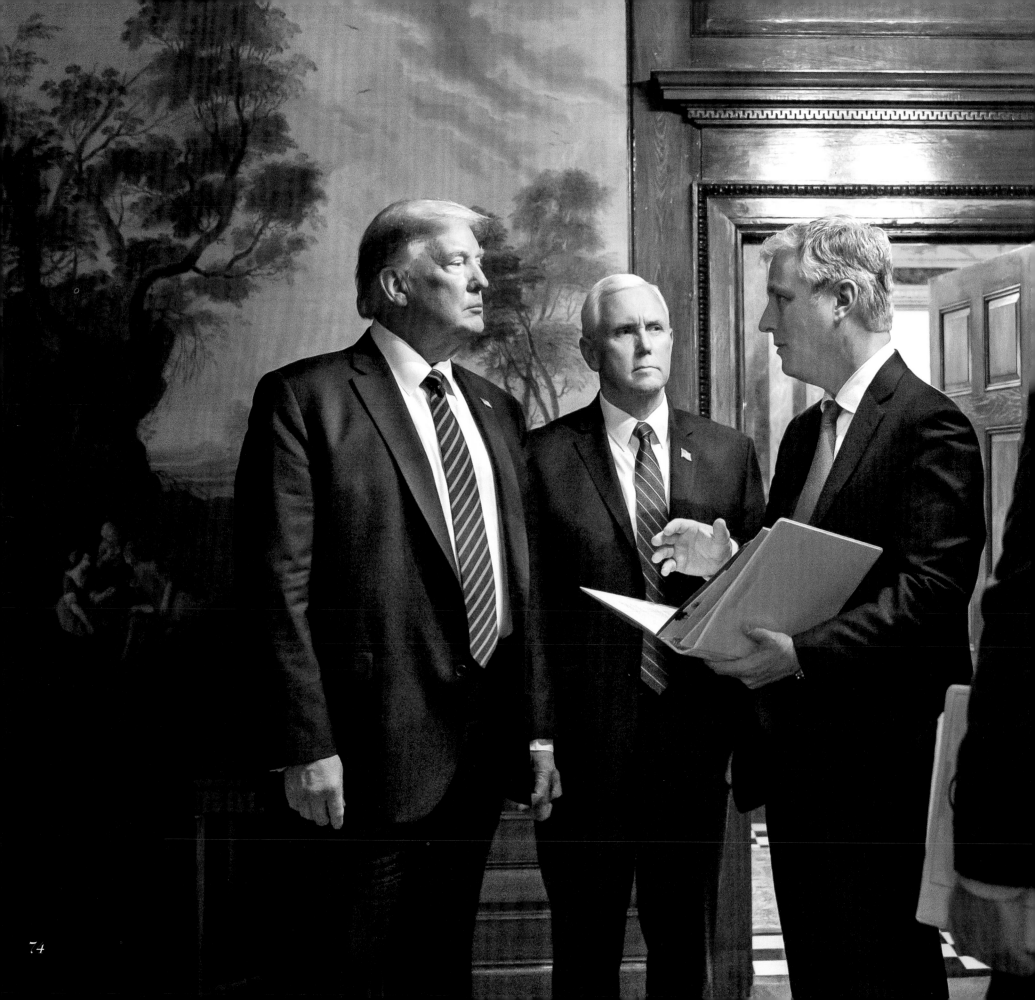

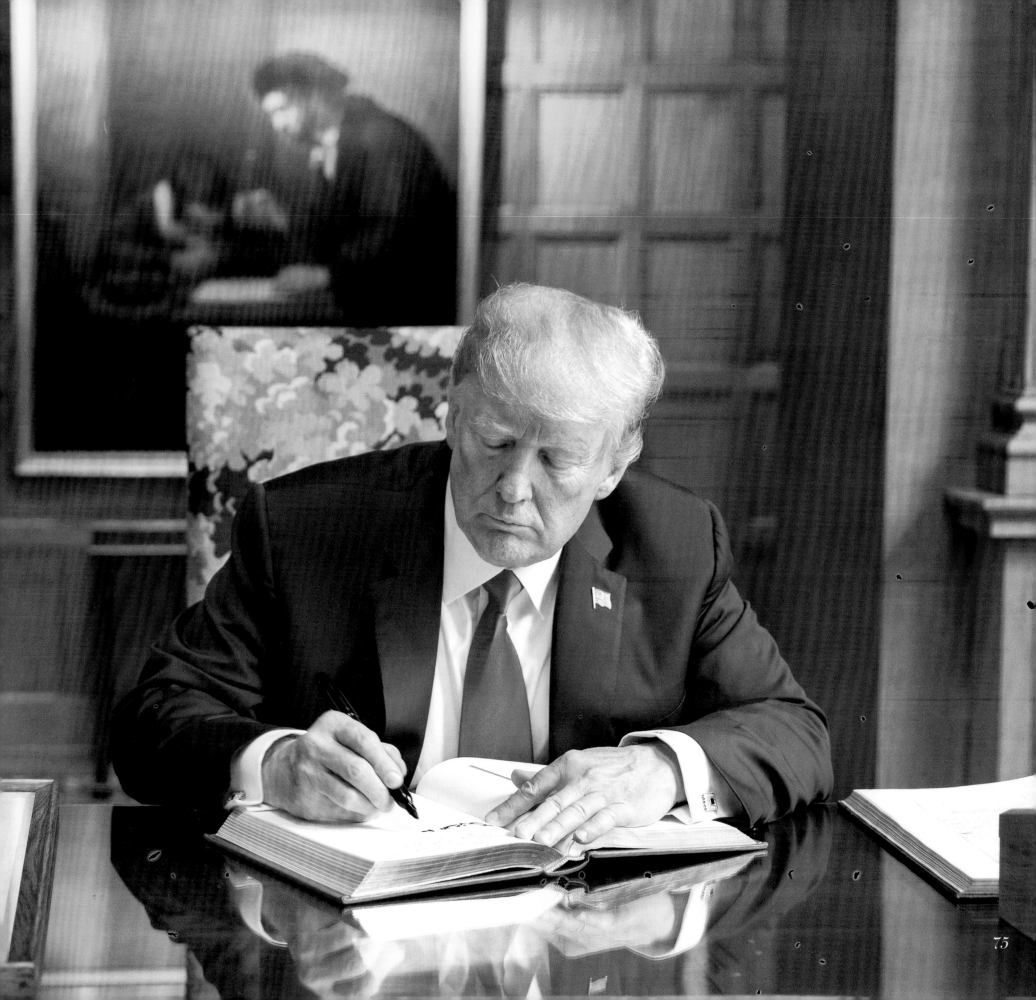

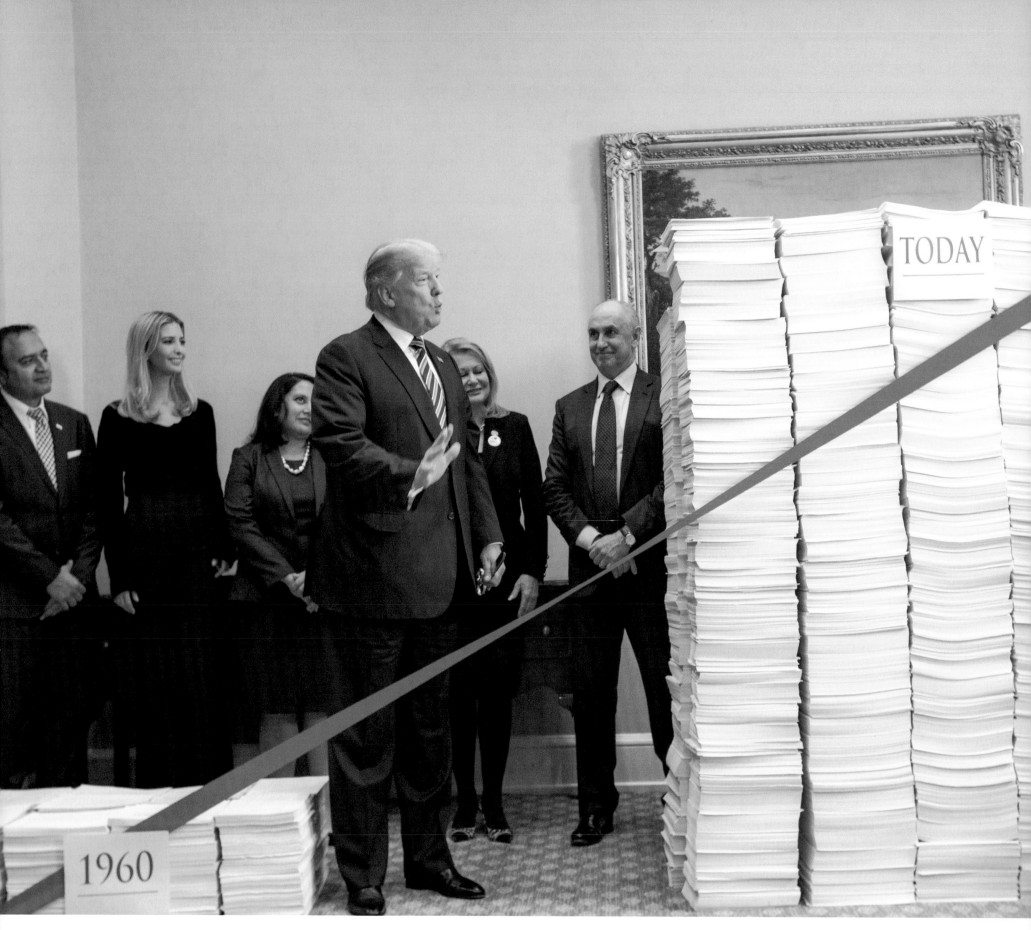

No one cut red tape in the federal government like I did!

1960

TODAY

MASSIVE DEREGULATION

Ended the regulatory assault on American Businesses and Workers.

Instead of 2-for-1, we eliminated 8 old regulations for every 1 new regulation adopted.

Provided the average American household an extra $3,100 every year.

Reduced the direct cost of regulatory compliance by $50 billion, and will reduce costs by an additional $50 billion in FY 2020 alone.

Removed nearly 25,000 pages from the Federal Register – more than any other president. The previous administration added over 16,000 pages.

Established the Governors' Initiative on Regulatory Innovation to reduce outdated regulations at the state, local, and tribal levels.

Signed an executive order to make it easier for businesses to offer retirement plans.

Signed two executive orders to increase transparency in Federal agencies and protect Americans and their small businesses from administrative abuse.

Reduced approval times for major infrastructure projects from 10 or more years down to 2 years or less.

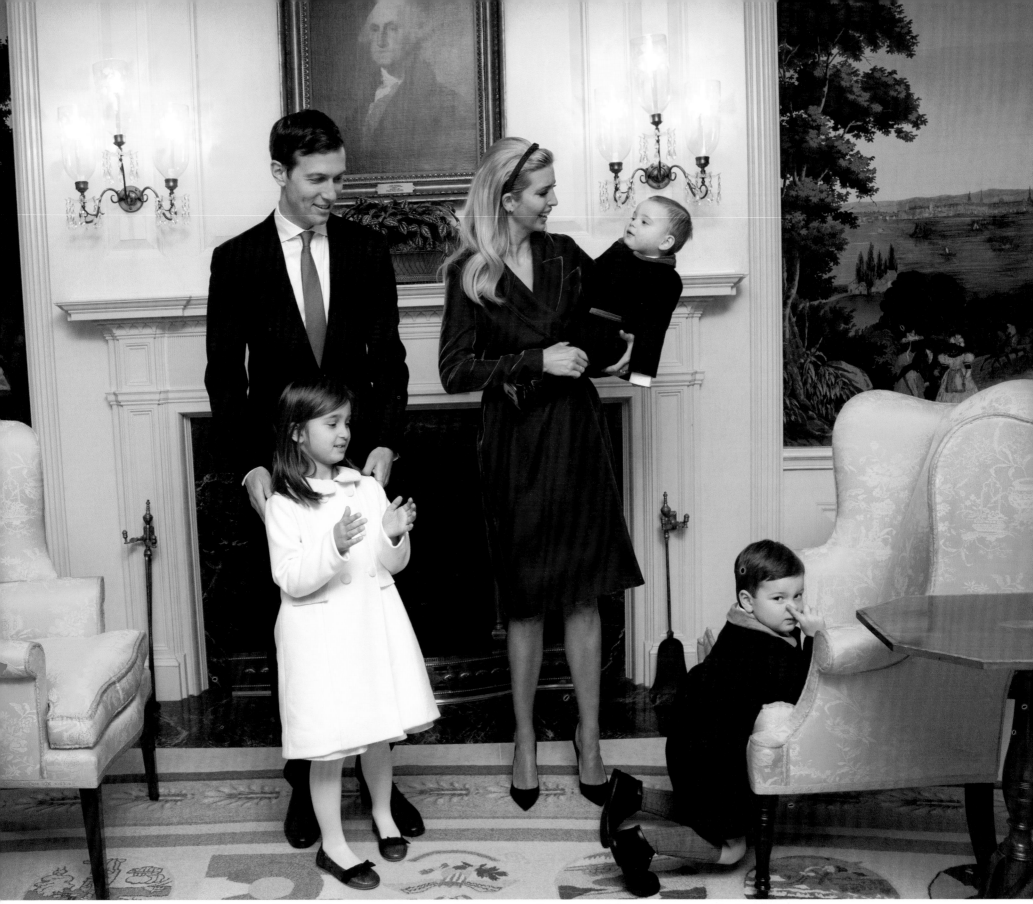

***Jared and Ivanka with my beautiful grandchildren—
Arabella, Joseph, and Theodore.***

79

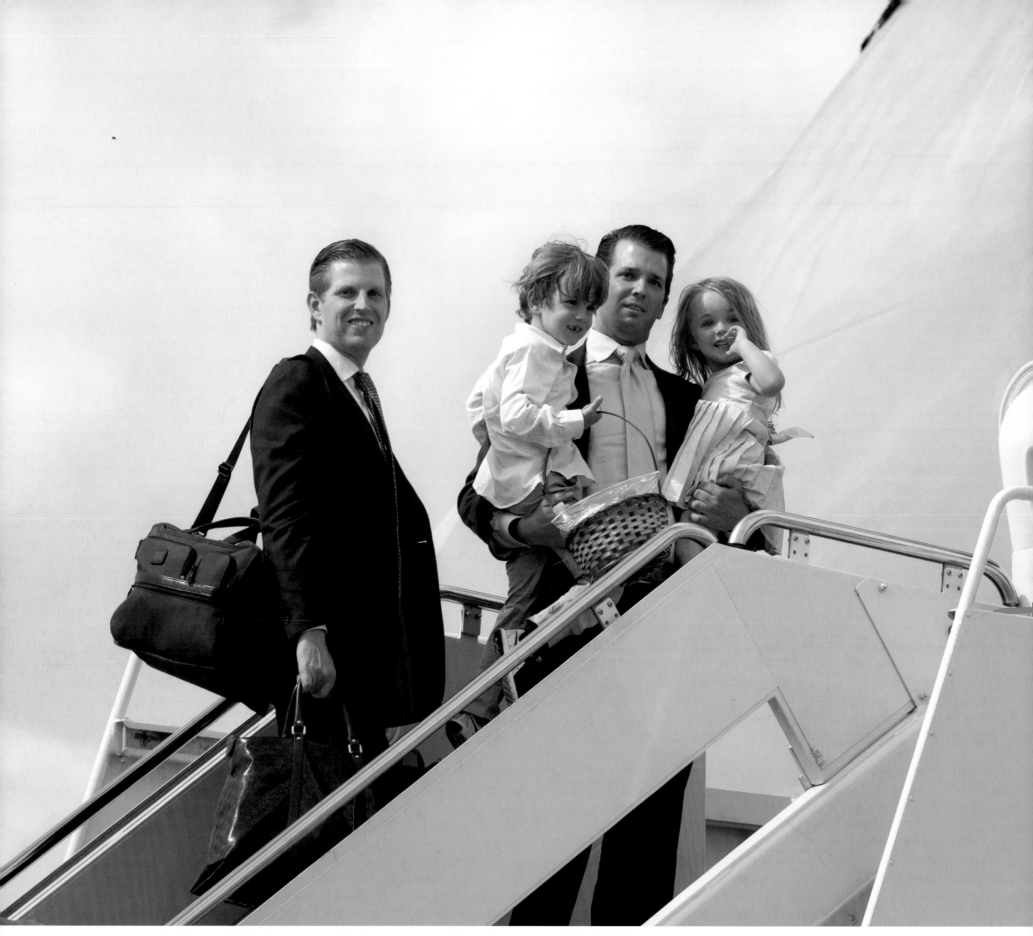

Eric and Don with two of my grandkids, Spencer and Chloe.

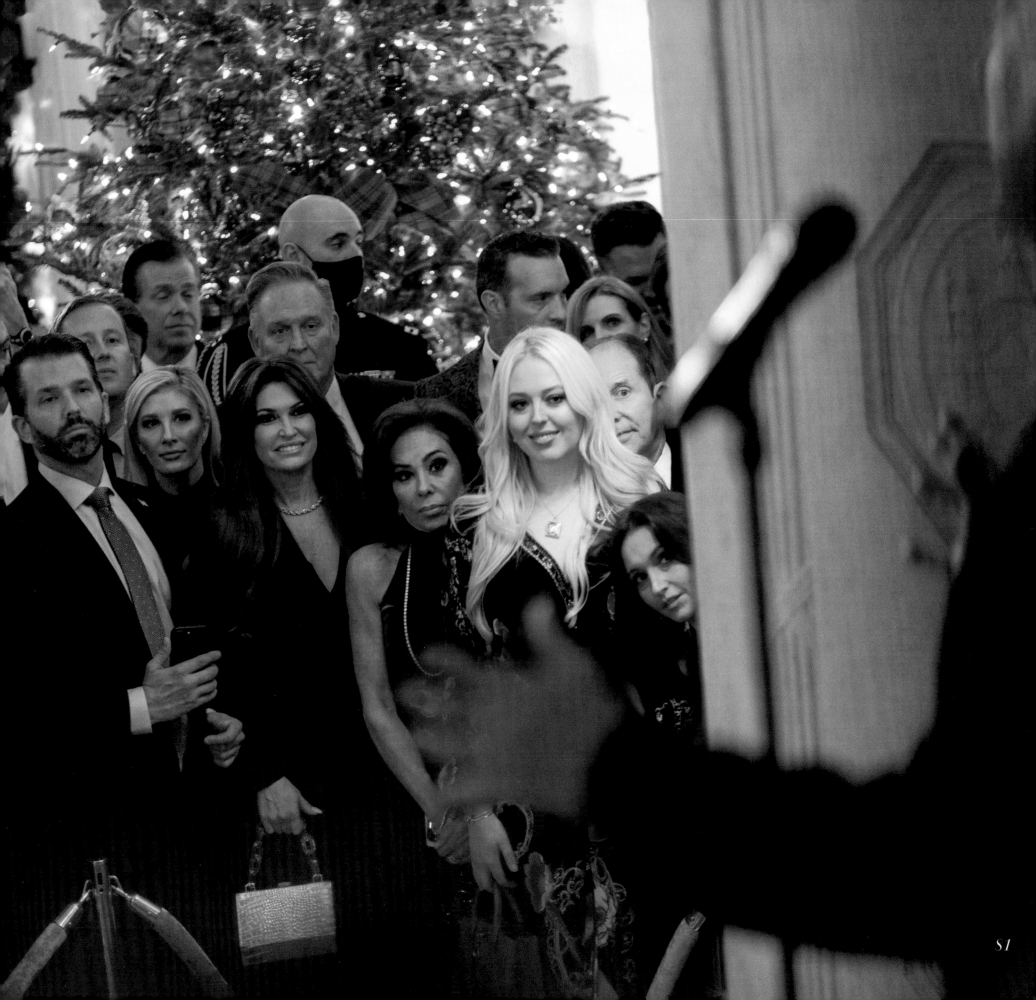

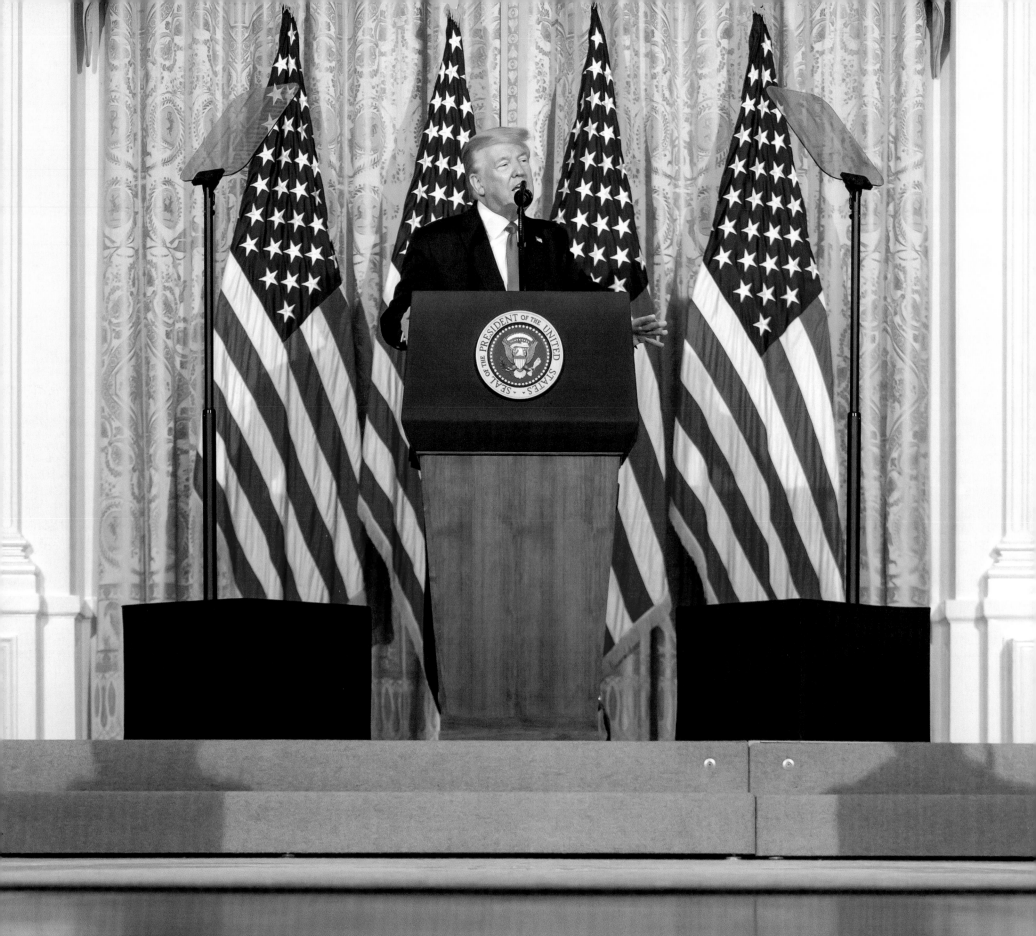

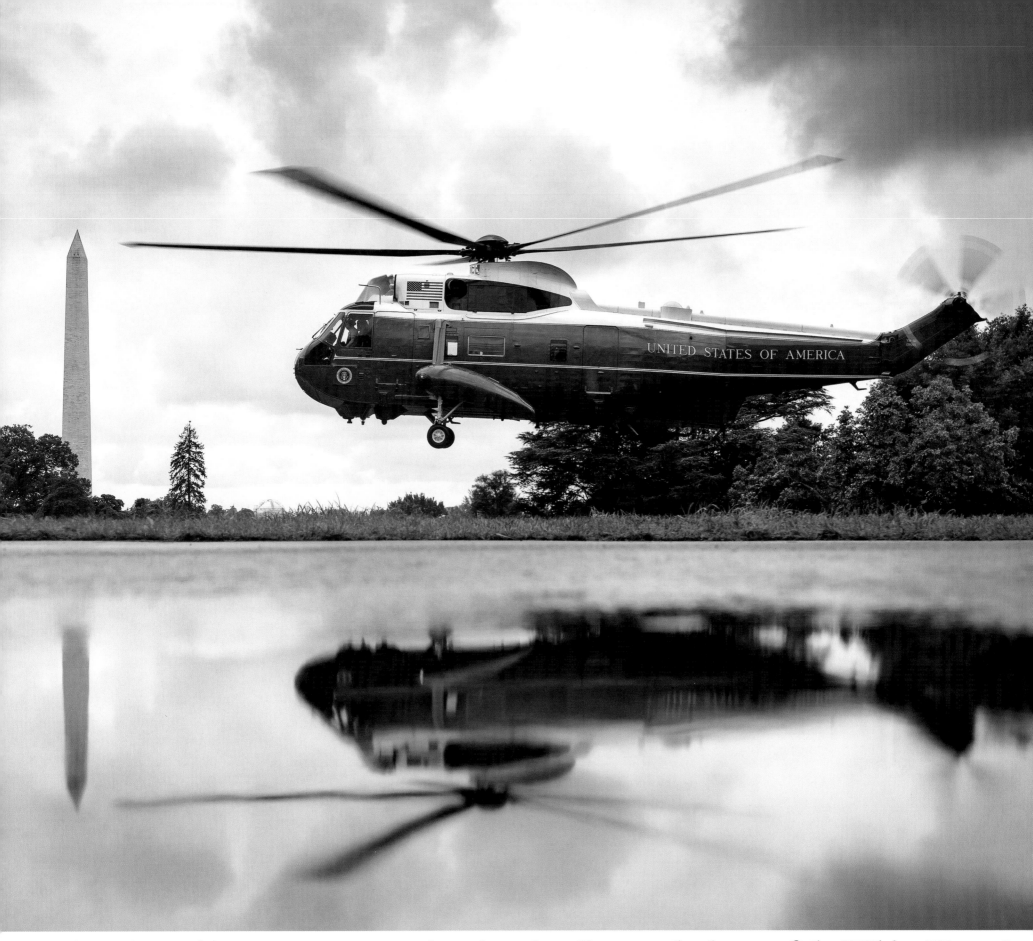

There is nothing more spectacular than landing on the lawn of the White House!

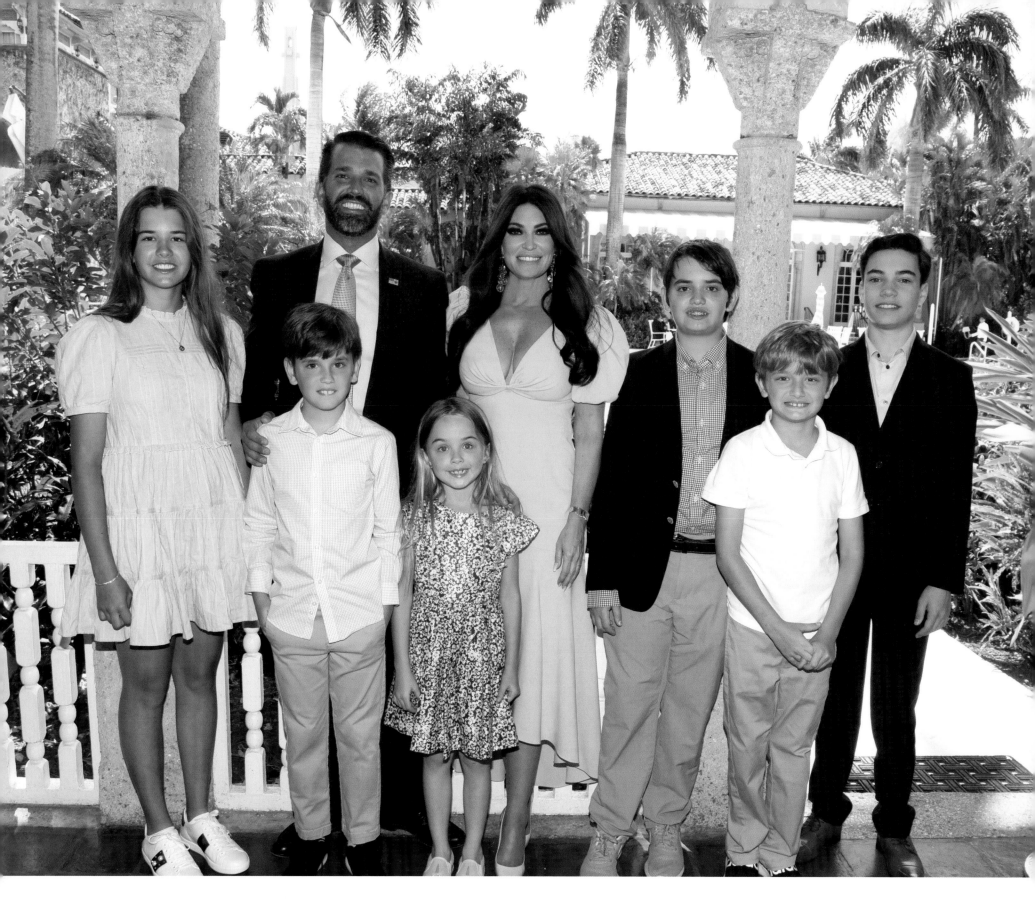

Don Jr. and Kimberly Guilfoyle with the kids Kai, Spencer, Chloe, Donnie III, Tristan, and Ronan.

Lara Trump is a great television analyst, politician, and mother!

Eric's oldest son, and my grandson, Luke in the Oval Office.

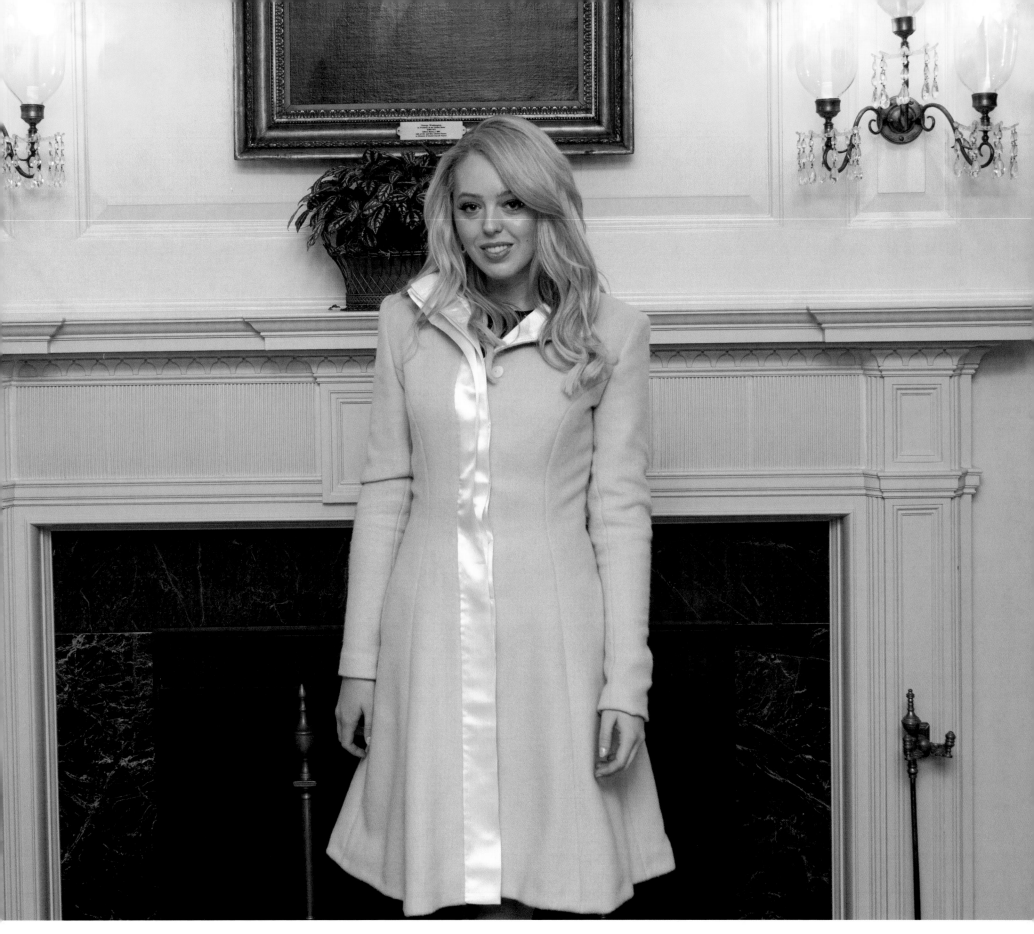

My Tiffany!

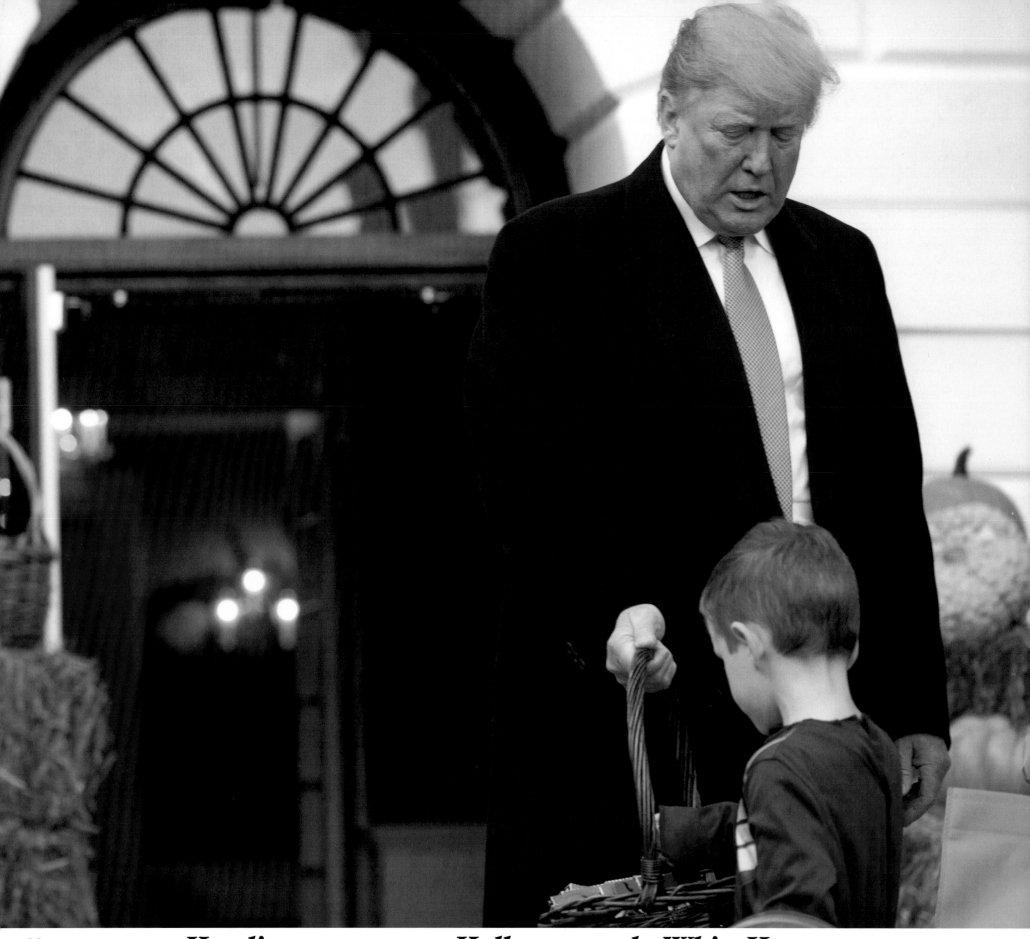

Handing out treats on Halloween at the White House.

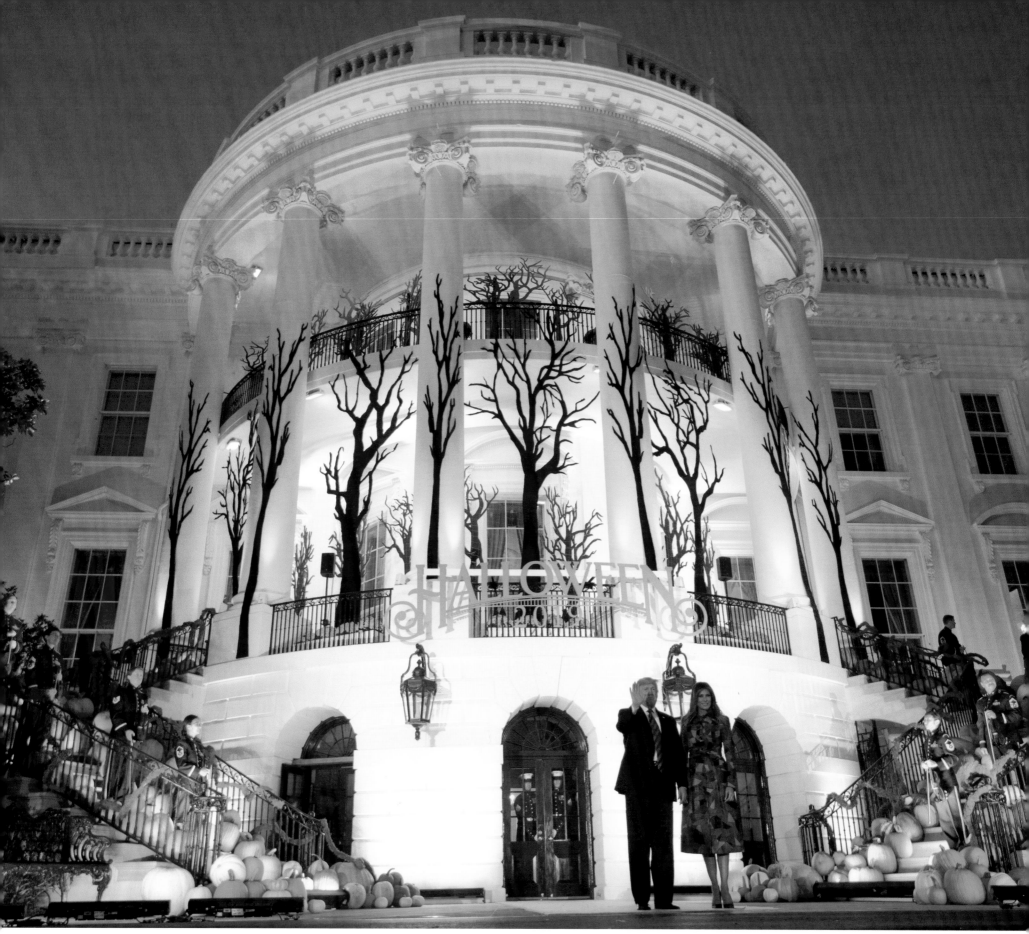

Halloween at the White House.

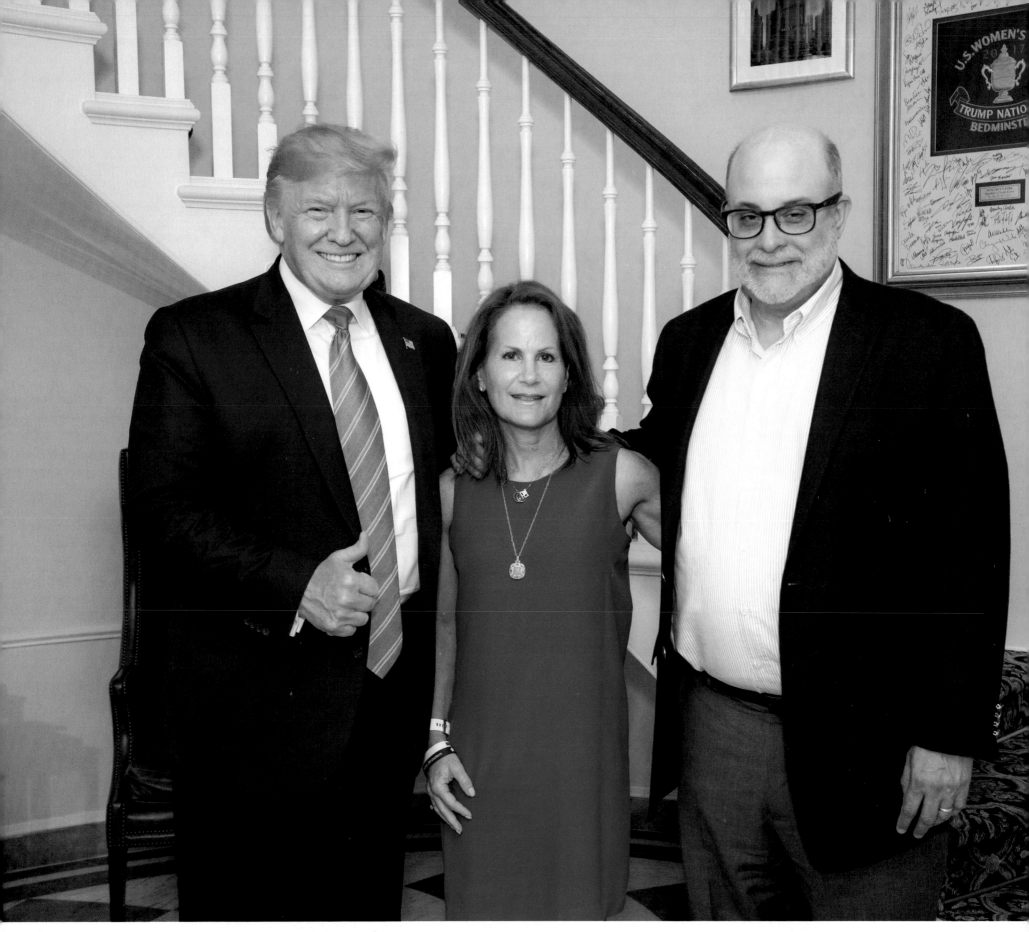

The "Great One" — Mark Levin — and his wife, Julie.

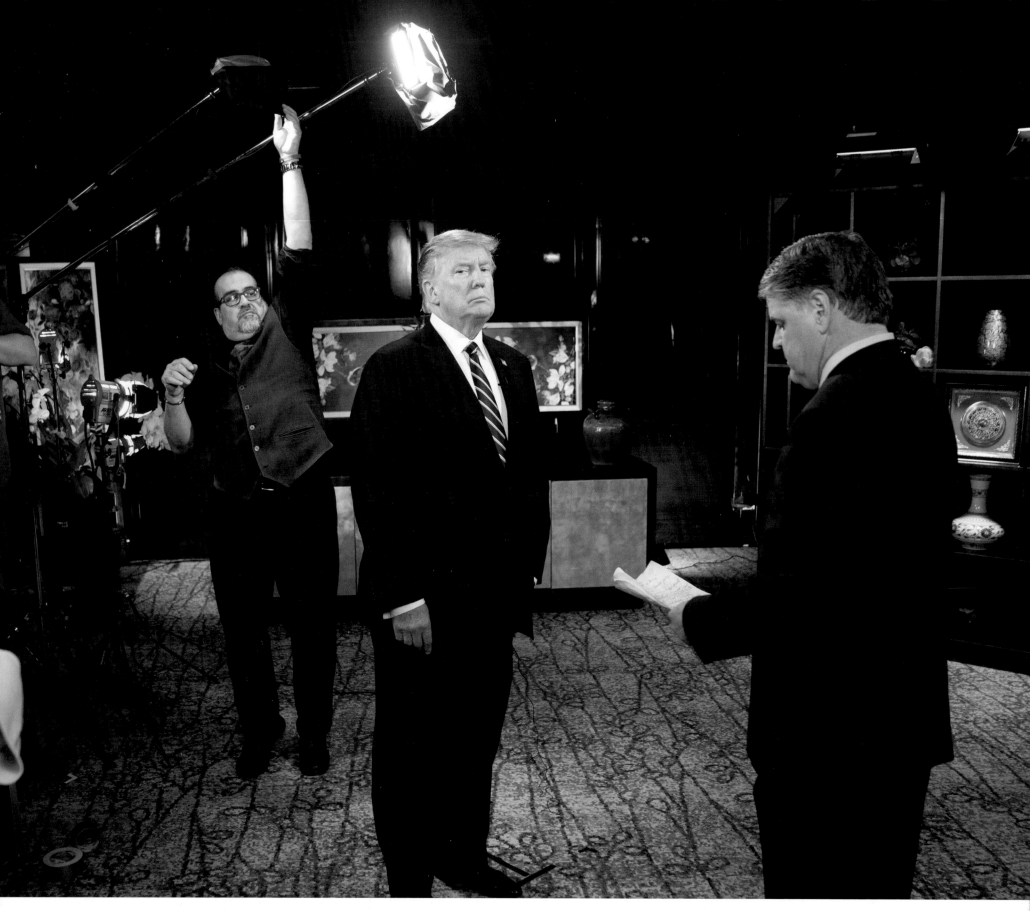

***Getting ready to be interviewed by Sean Hannity
for another #1-rated newscast across all cable.***

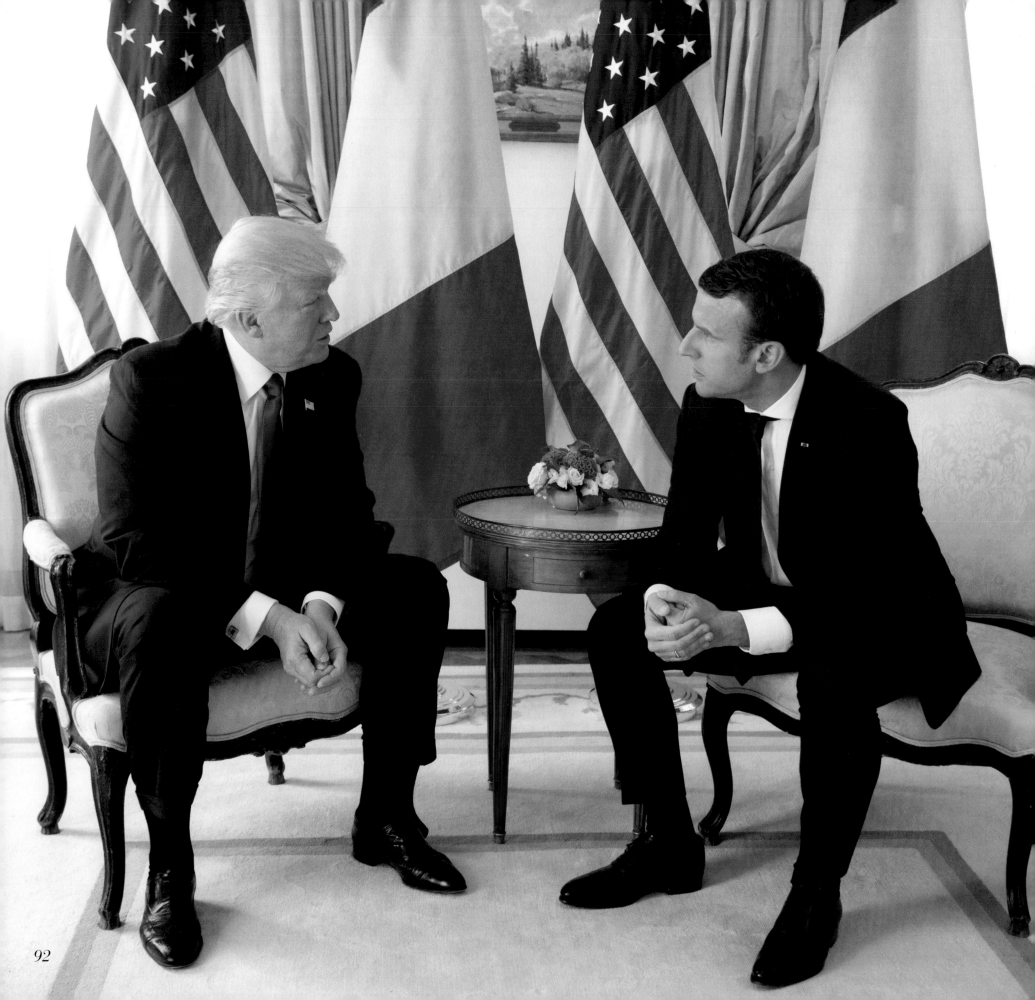

An intense and powerful fighter for France. Emmanuel Macron was always at the top of his game.

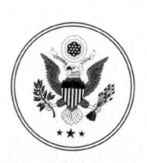

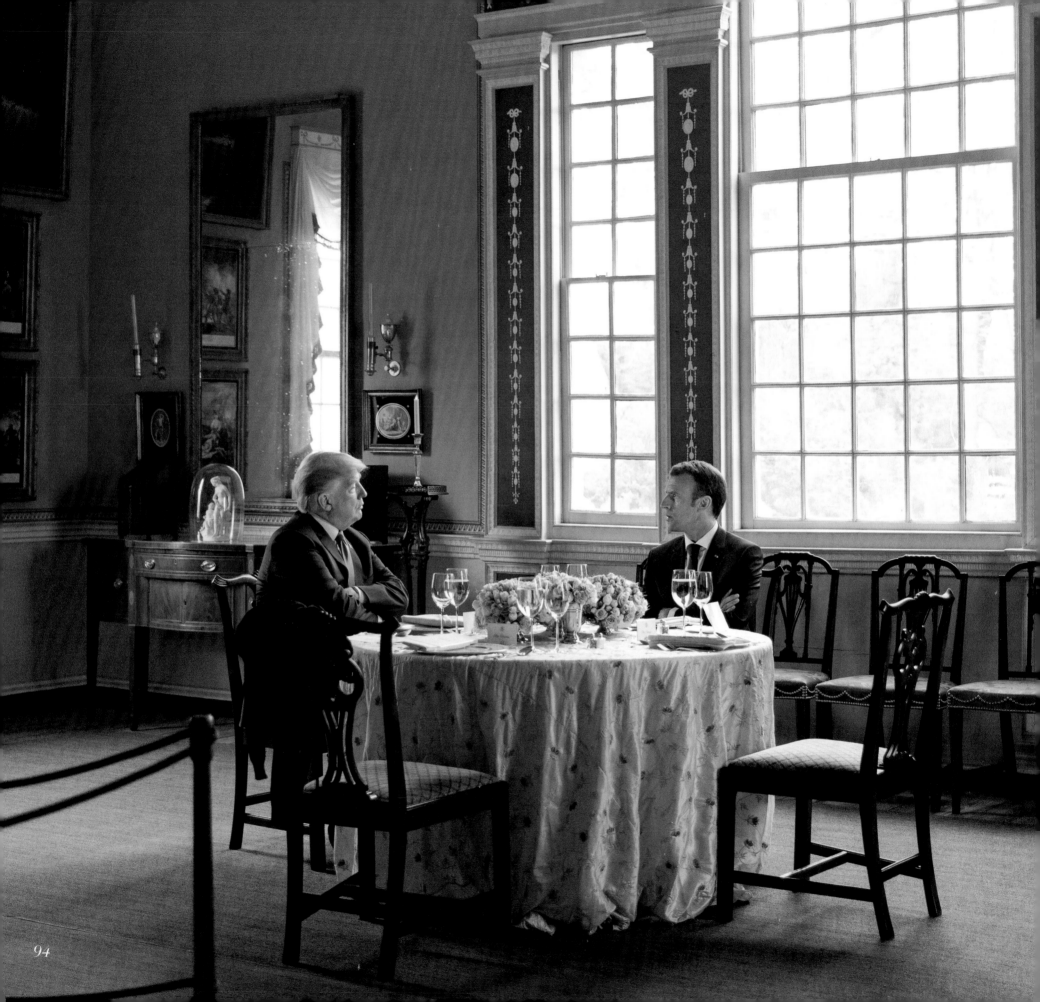

Visiting the Suresnes American Cemetery near Paris, France, to pay my respects to the many American heroes who gave so much for the cause of liberty. Here on these revered grounds lie more than 1,500 U.S. service members who made the ultimate sacrifice in the First World War.

95

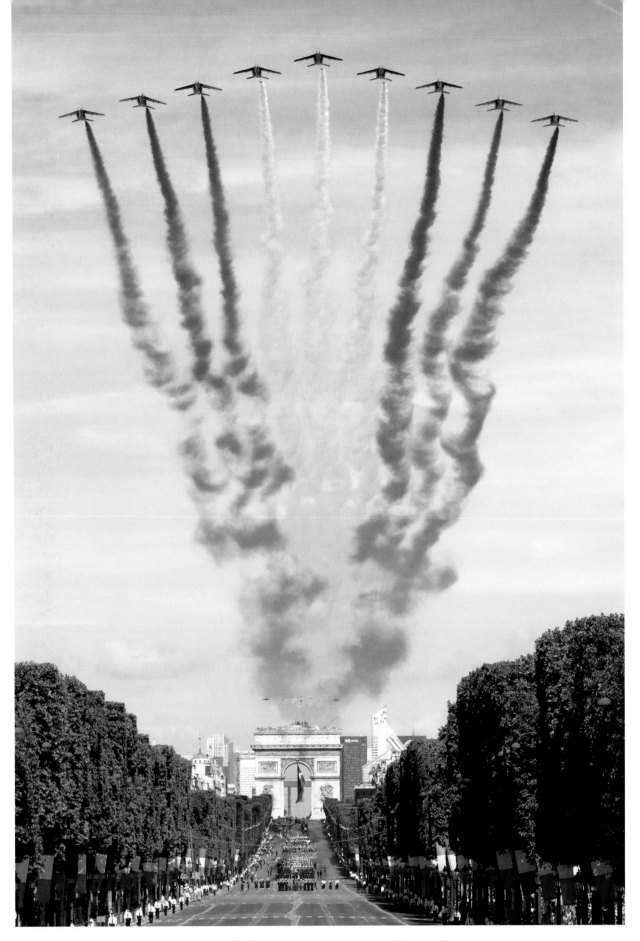

Bastille Day over Paris.

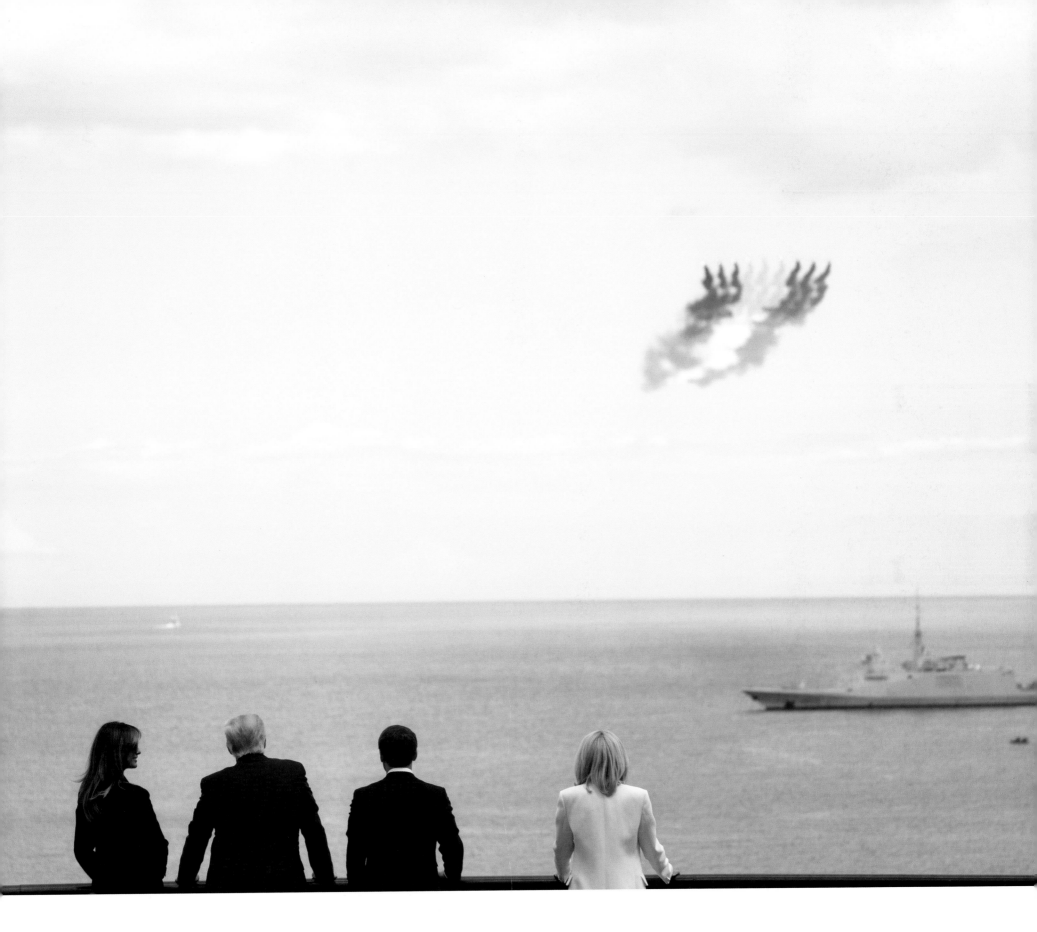

A flyover during the 75th Commemoration of D-Day in Normandy, France. 97

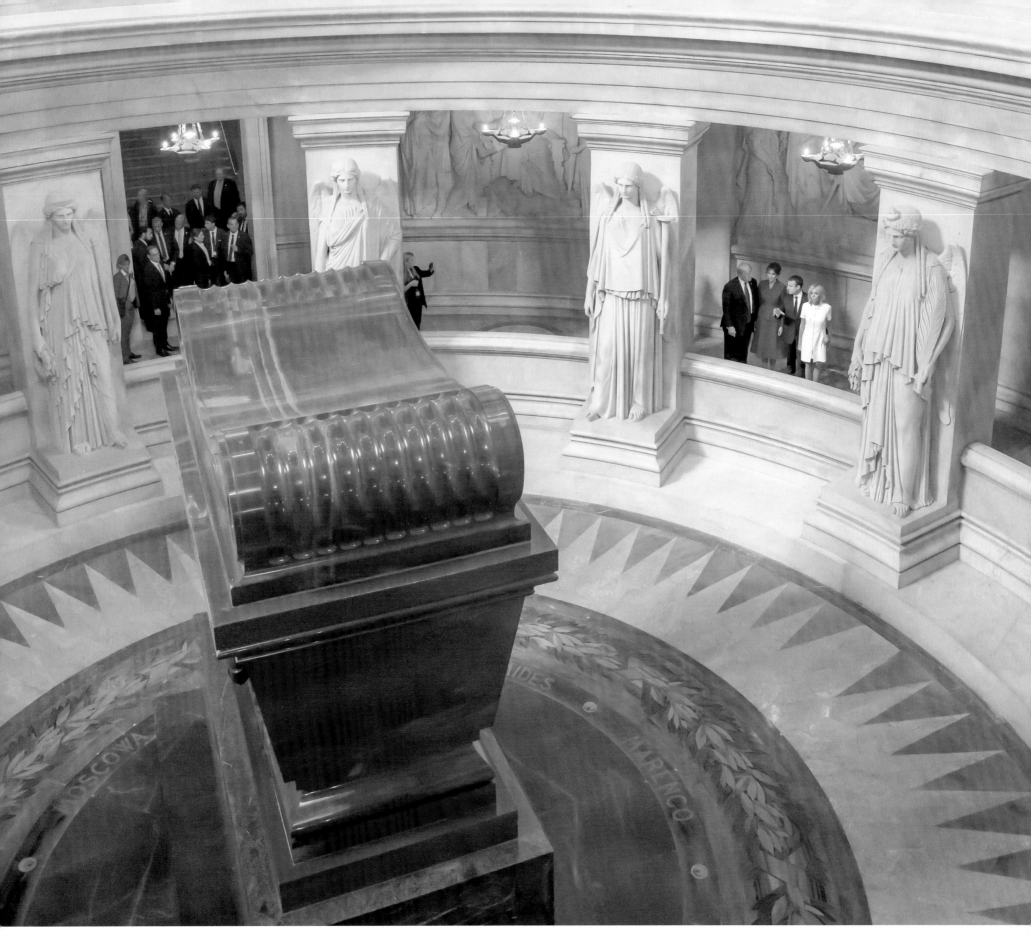

Visiting the grave of Napoleon in Paris, France.

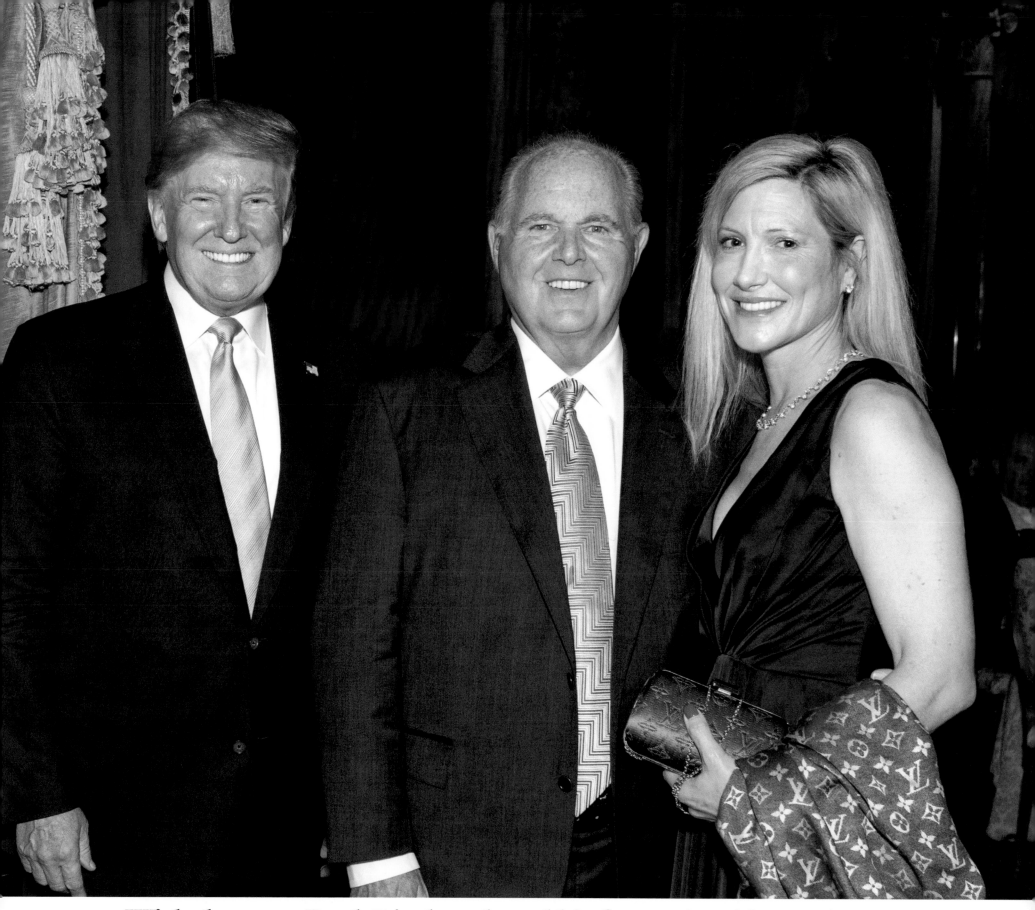

With the great Rush Limbaugh and his fantastic wife, Kathryn. Rush was a national treasure, and our nation lost a good one with his passing.

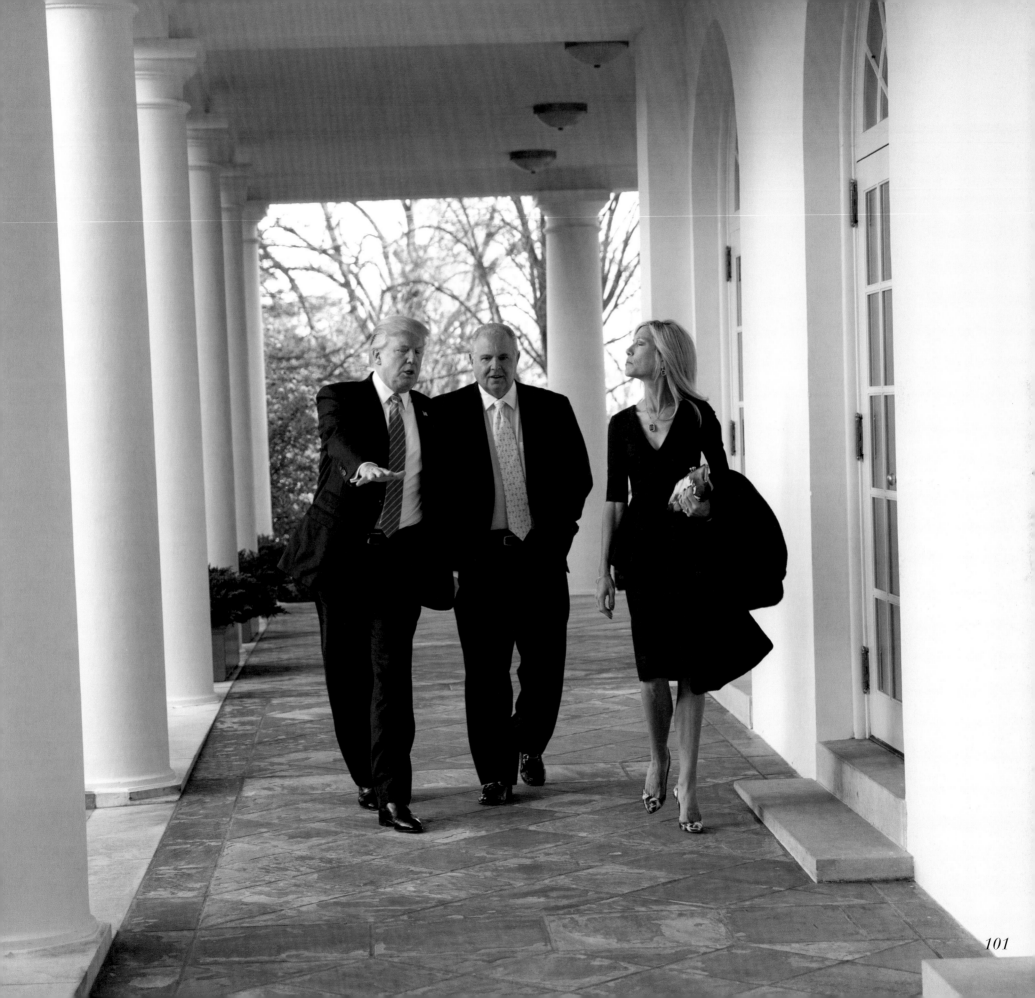

Charlie Kirk, a great young conservative dynamo who loves our country!

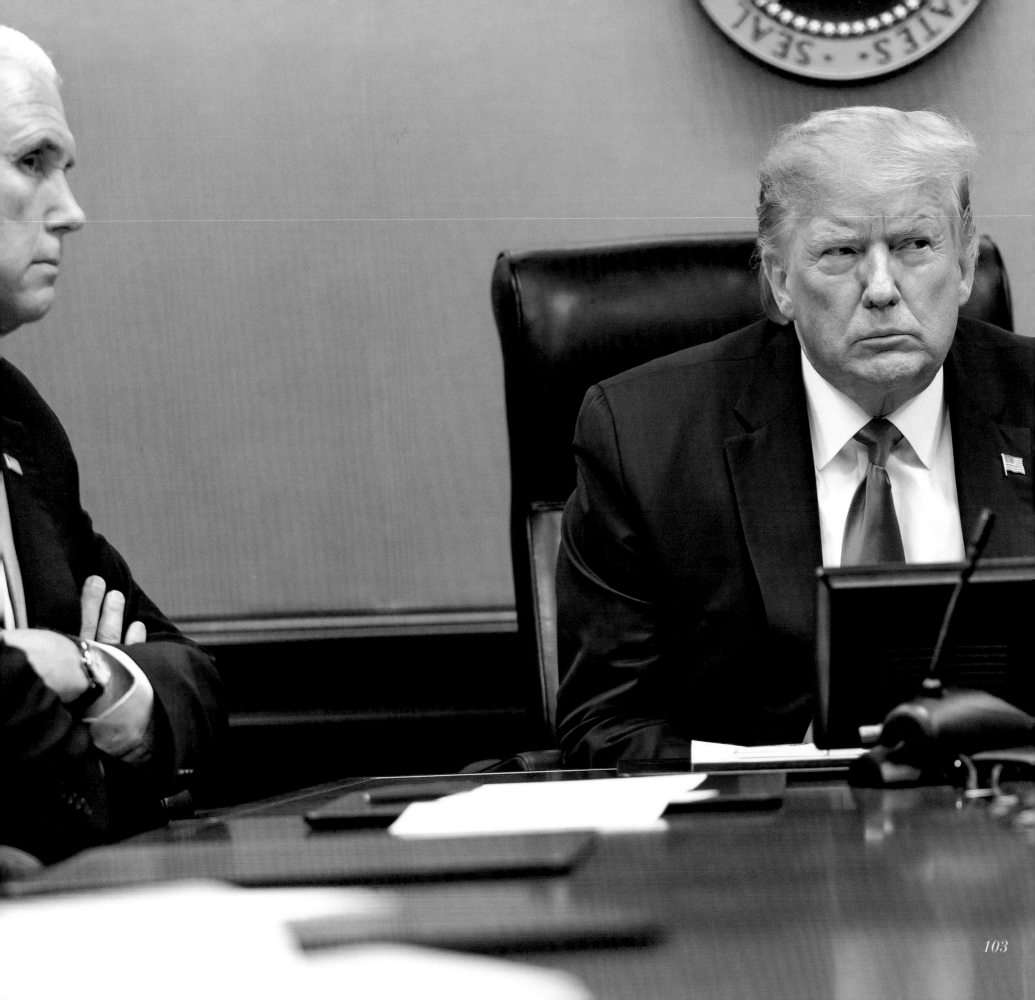

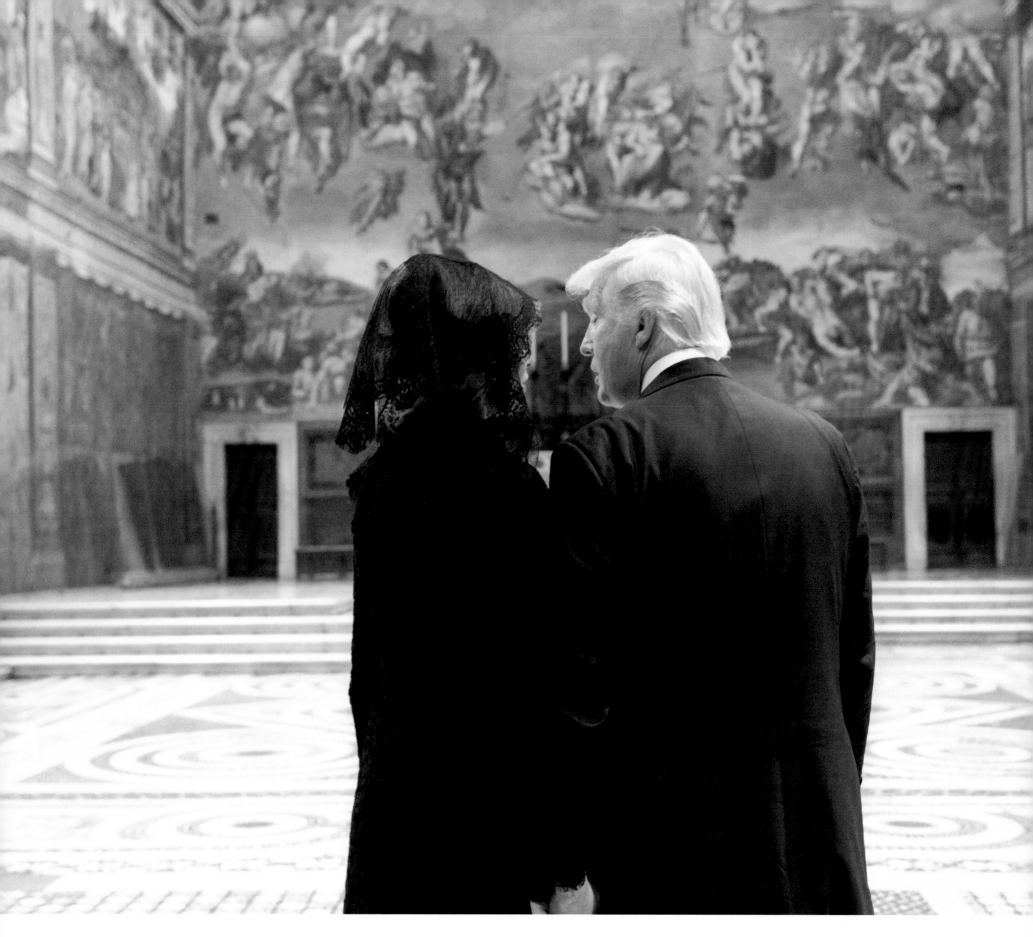

A very special day visiting the magnificent Sistine Chapel inside the Vatican.

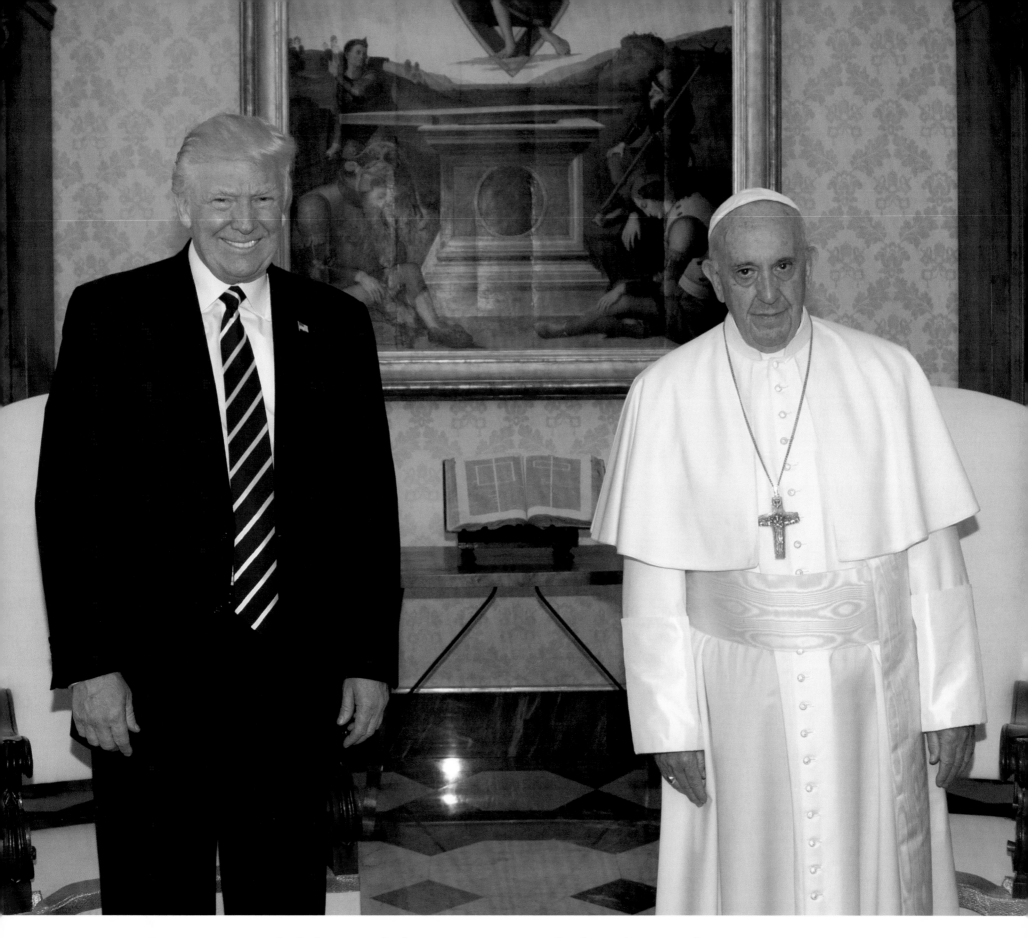

Visiting with Pope Francis in the Vatican.

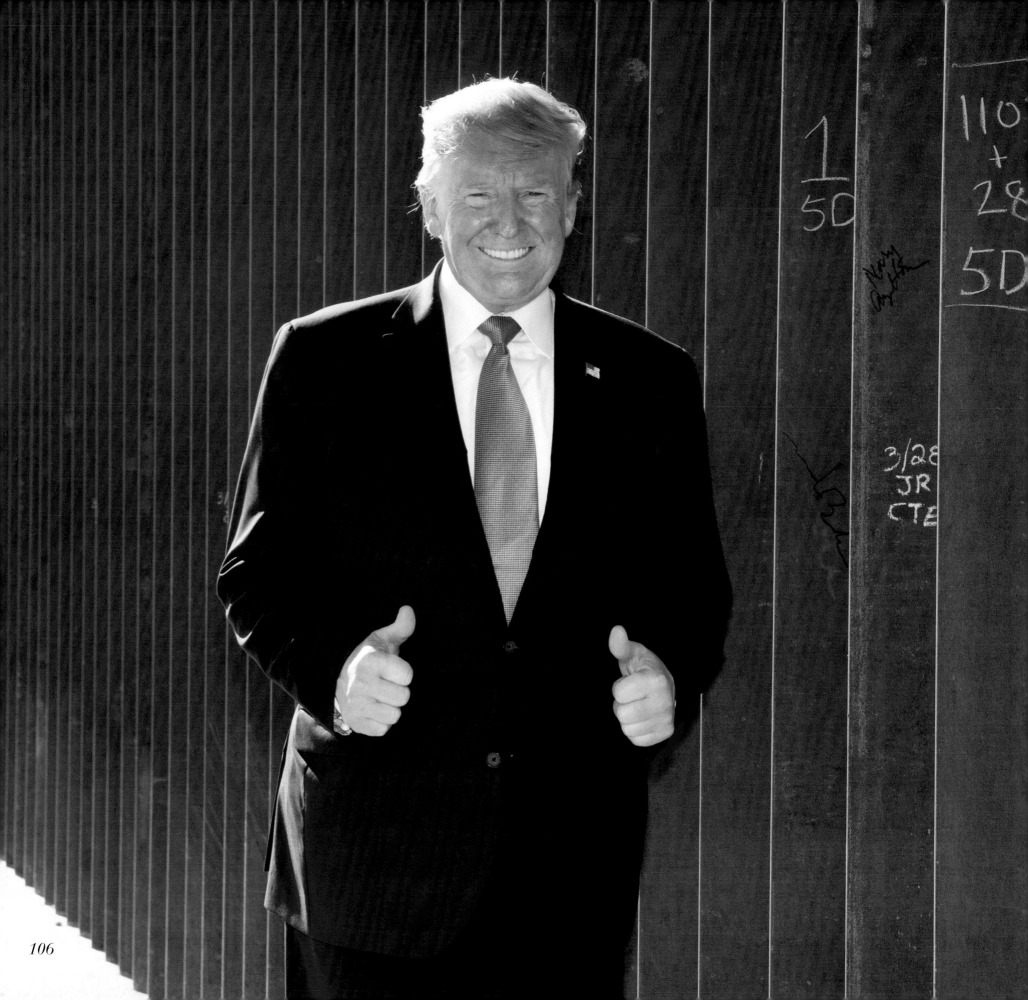

THE WALL KEPT US SAFE!

Despite tremendous opposition and many lawsuits, all of which I won over two and a half years, the wall was built at a record clip and helped create the most secure southern border in our history—by far. The Democrat-inspired lawsuits delayed the opening. All it needs now is a coat of paint and a few sections to be built—a matter of weeks.

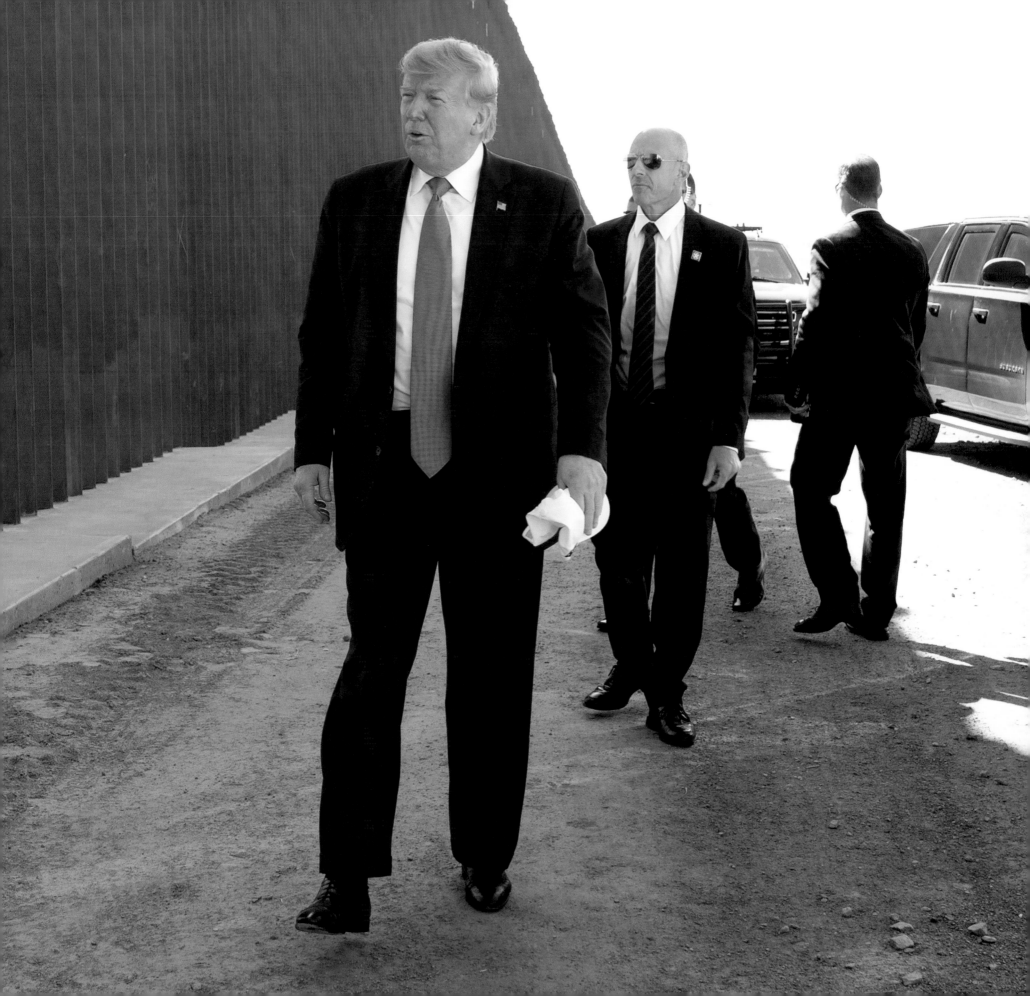

ACHIEVING A SECURE BORDER INFO SHEET

Secured the Southern Border of the United States.

Built over 400 miles of the world's most robust and advanced border wall.

Illegal crossings have plummeted over 87 percent where the wall has been constructed.

Deployed nearly 5,000 troops to the Southern border. In addition, Mexico deployed tens of thousands of their own soldiers and national guardsmen to secure their side of the US-Mexico border.

Ended the dangerous practice of Catch-and-Release, which means that instead of aliens getting released into the United States pending future hearings never to be seen again, they are detained pending removal, and then ultimately returned to their home countries.

Entered into three historic asylum cooperation agreements with Honduras, El Salvador, and Guatemala to stop asylum fraud and resettle illegal migrants in third-party nations pending their asylum applications.

Entered into a historic partnership with Mexico, referred to as the "Migrant Protection Protocols," to safely return asylum-seekers to Mexico while awaiting hearings in the United States.

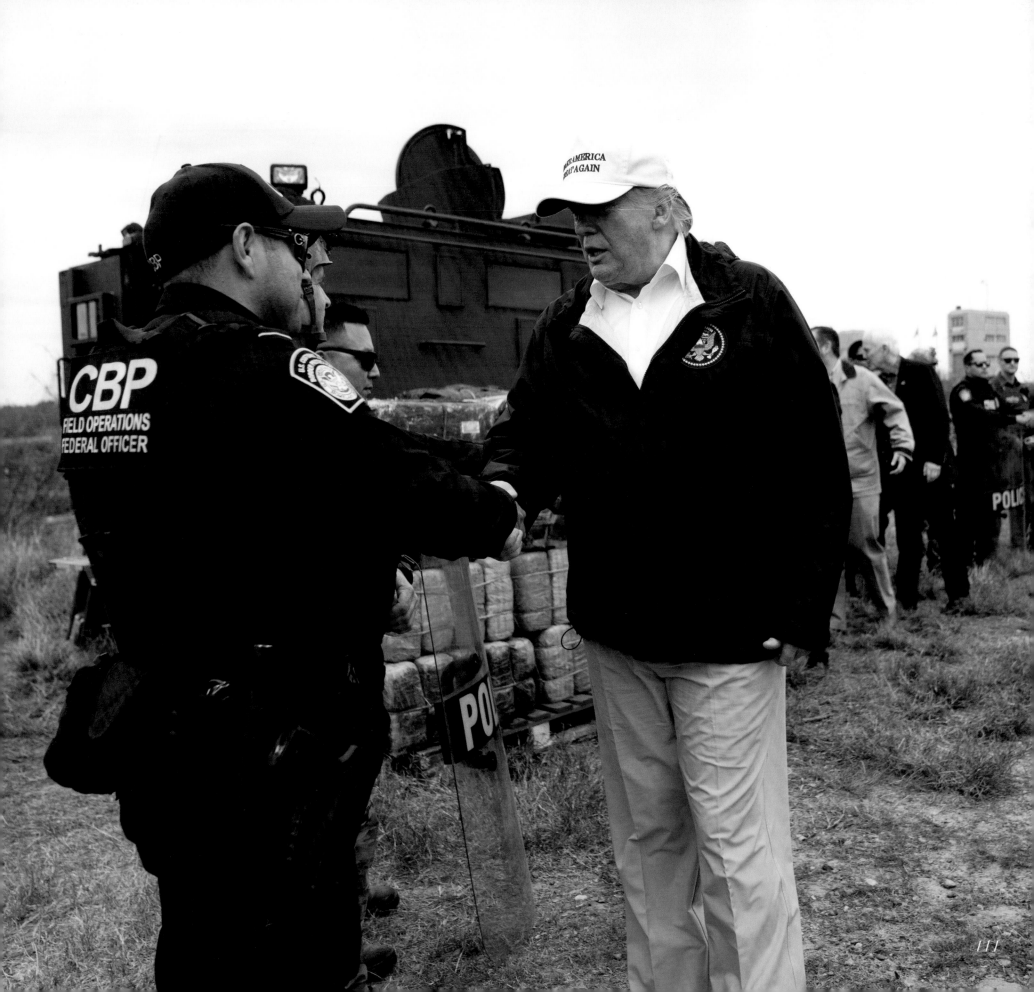

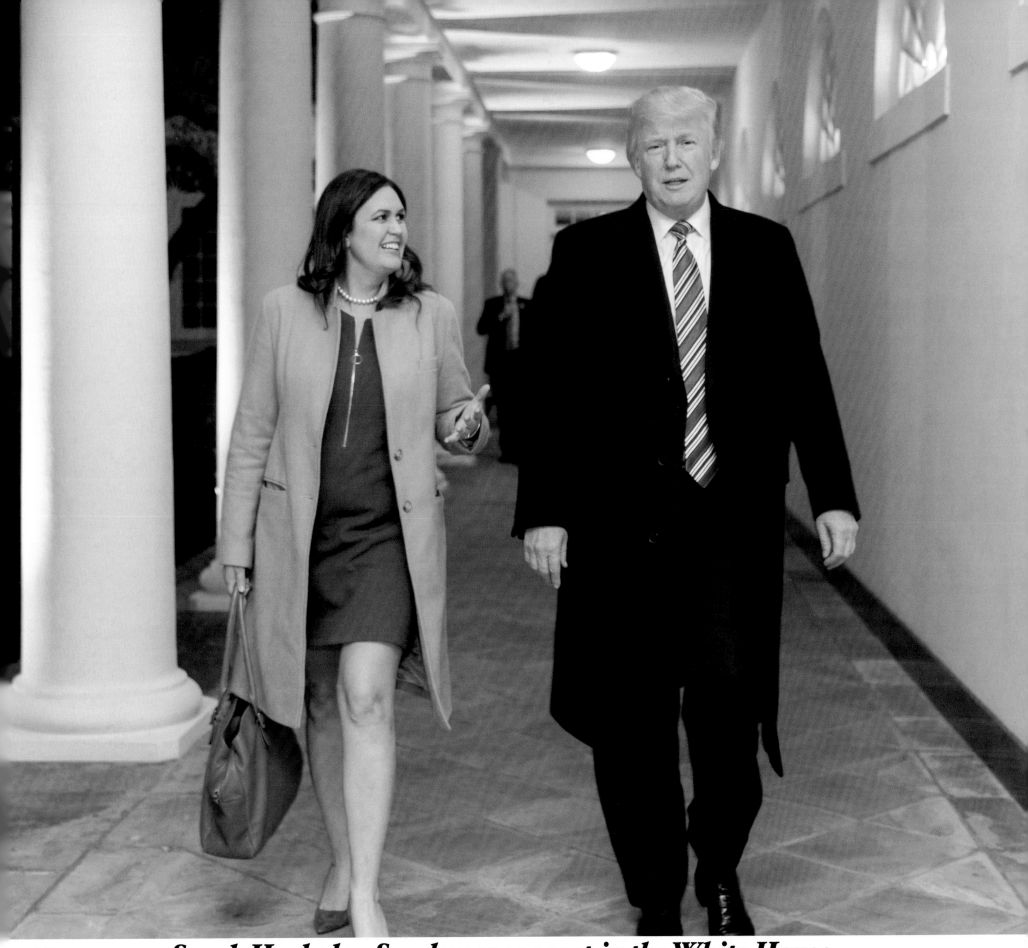

Sarah Huckabee Sanders was great in the White House.

A great future Governor of a wonderful State, Arkansas —

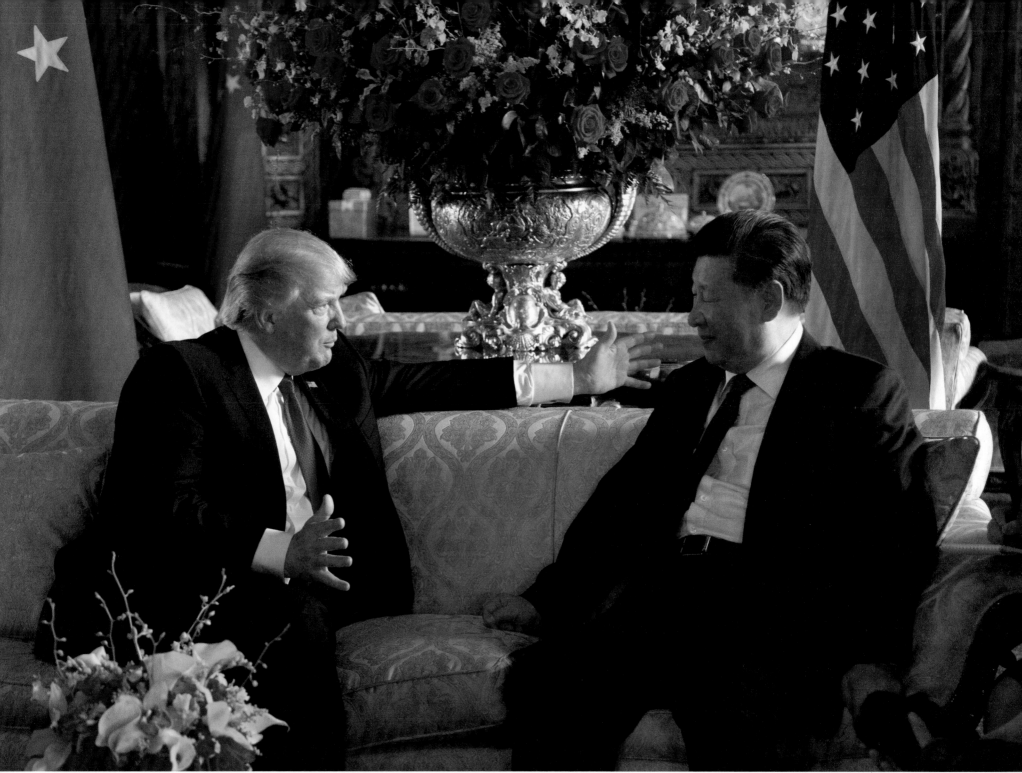

With President Xi Jinping of China at the Mar-a-Lago Club in Palm Beach, Florida—a man whom I totally respect. He loves his country and has brilliantly taken advantage of the U.S. for many years. He is a strong man, and a great leader for China. Who can blame him? He's for China; I'm for the USA. We were turning things around and then came COVID. And unfortunately our great friendship and understanding of each other came to an end—but I predict we will be back together again.

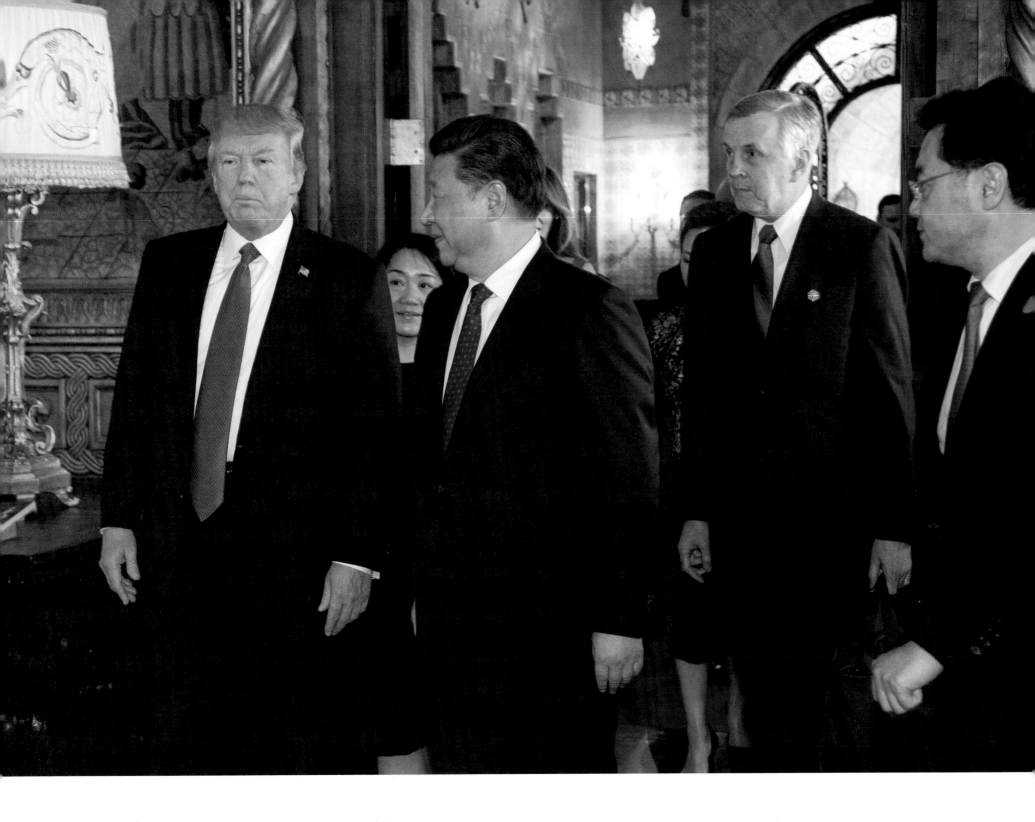

We negotiated with the Chinese often, looking for common ground without compromising. The days of China taking advantage of the American worker were over under my watch.

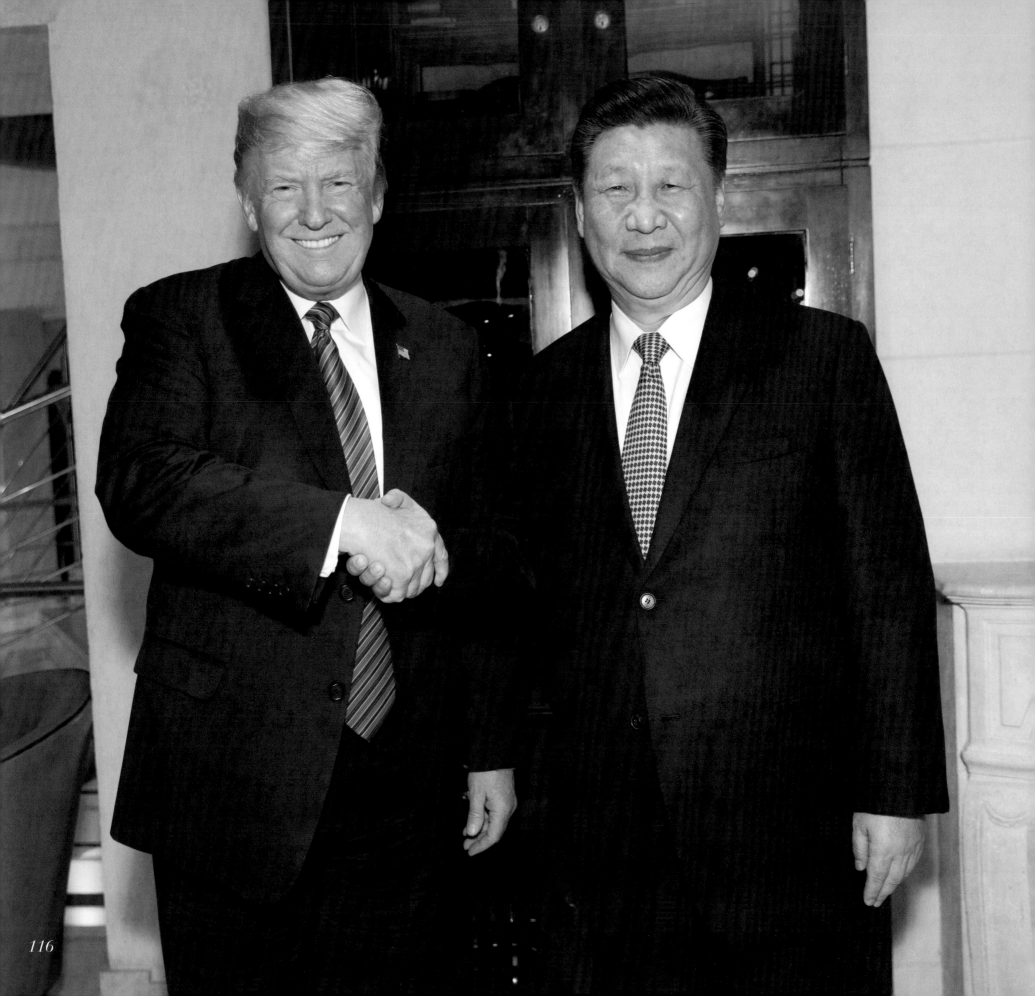

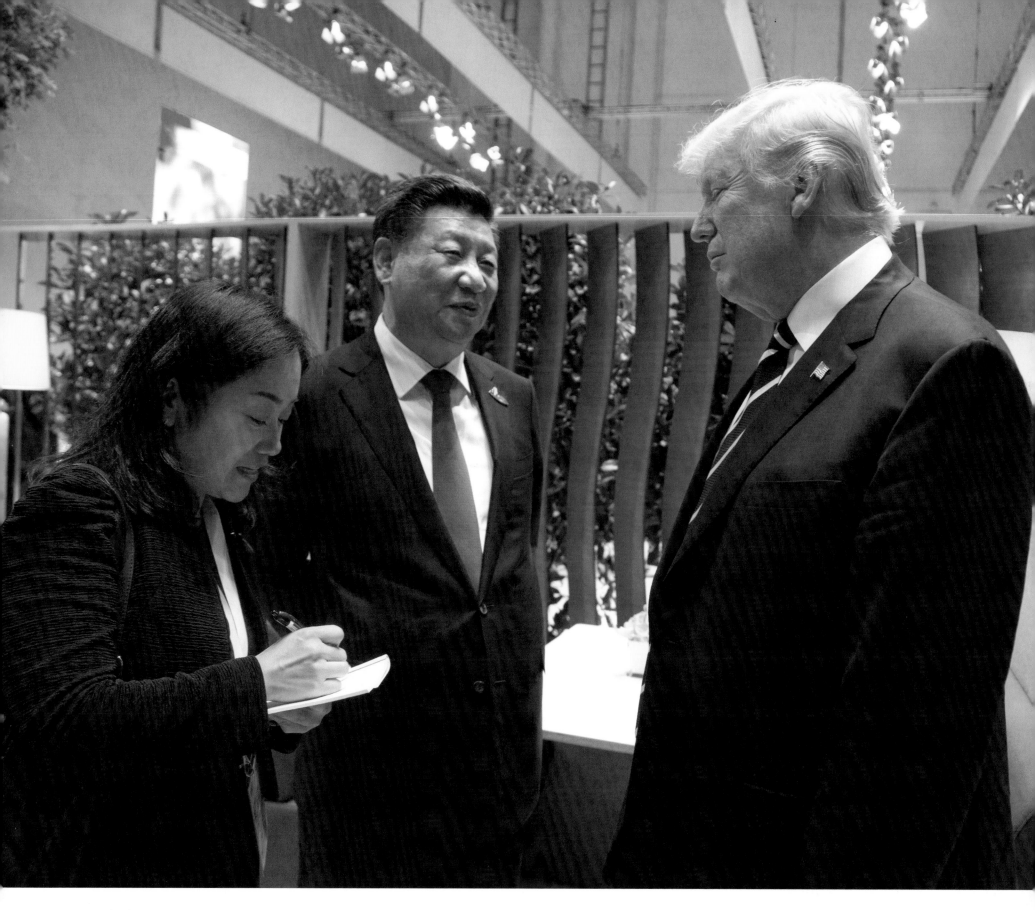

President Xi understood we had to get tough, but we were making true progress. If COVID didn't happen, our nations would both have prospered.

TOOK STRONG ACTIONS TO CONFRONT UNFAIR TRADE PRACTICES AND PUT AMERICA FIRST INFO SHEET

Imposed tariffs on hundreds of billions worth of Chinese goods to protect American jobs and stop China's abuses under Section 232 of the Trade Expansion Act of 1962 and Section 301 of the Trade Act of 1974.

Directed an all-of-government effort to halt and punish efforts by the Communist Party of China to steal and profit from American innovations and intellectual property.

China lifted its ban on poultry, opened its market to beef, and agreed to purchase at least $80 billion of American agricultural products in the next two years.

Reached a written, fully-enforceable Phase One trade agreement with China on confronting pirated and counterfeit goods, and the protection of American ideas, trade secrets, patents, and trademarks.

China agreed to purchase an additional $200 billion worth of United States exports and opened market access for over 4,000 American facilities to exports while all tariffs remained in effect.

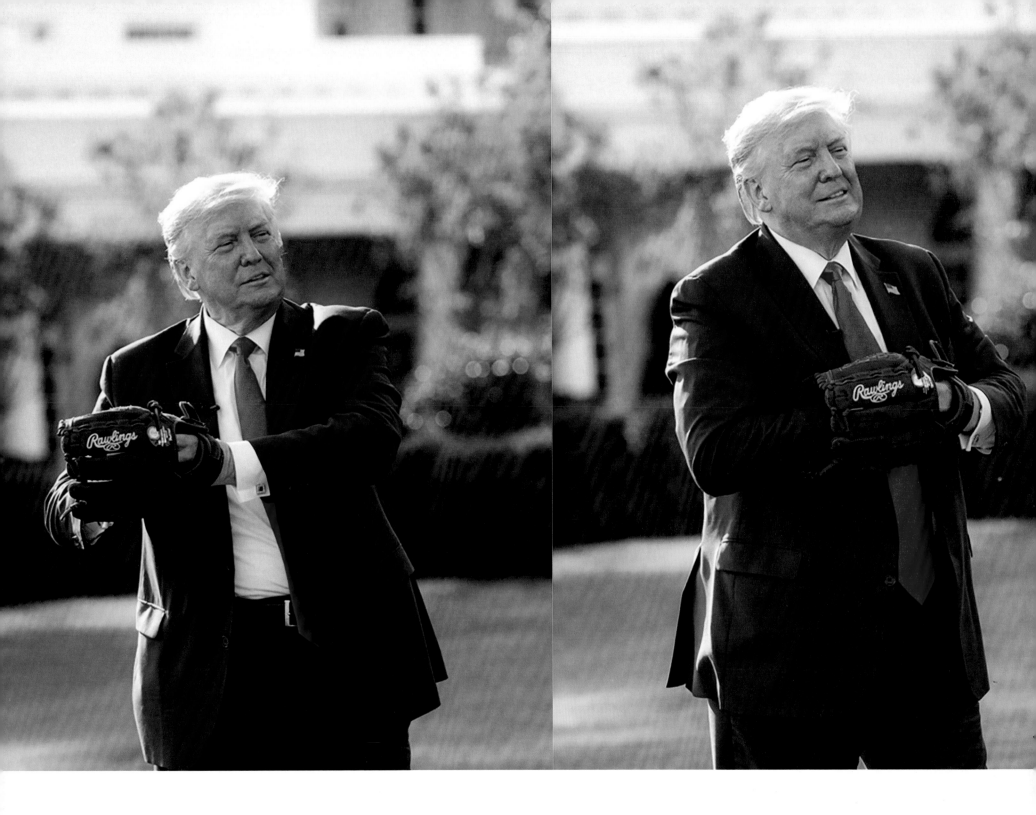

122

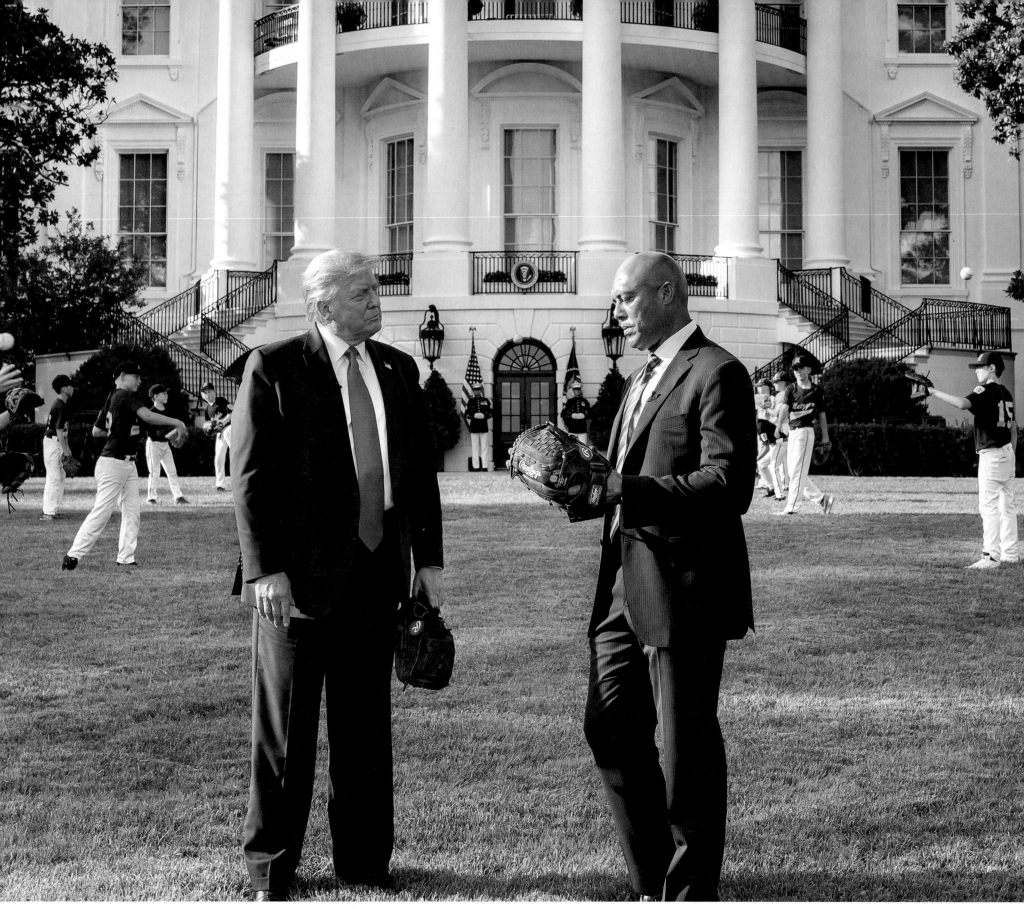

The great Mariano Rivera, one of the best pitchers in baseball history. A total winner!

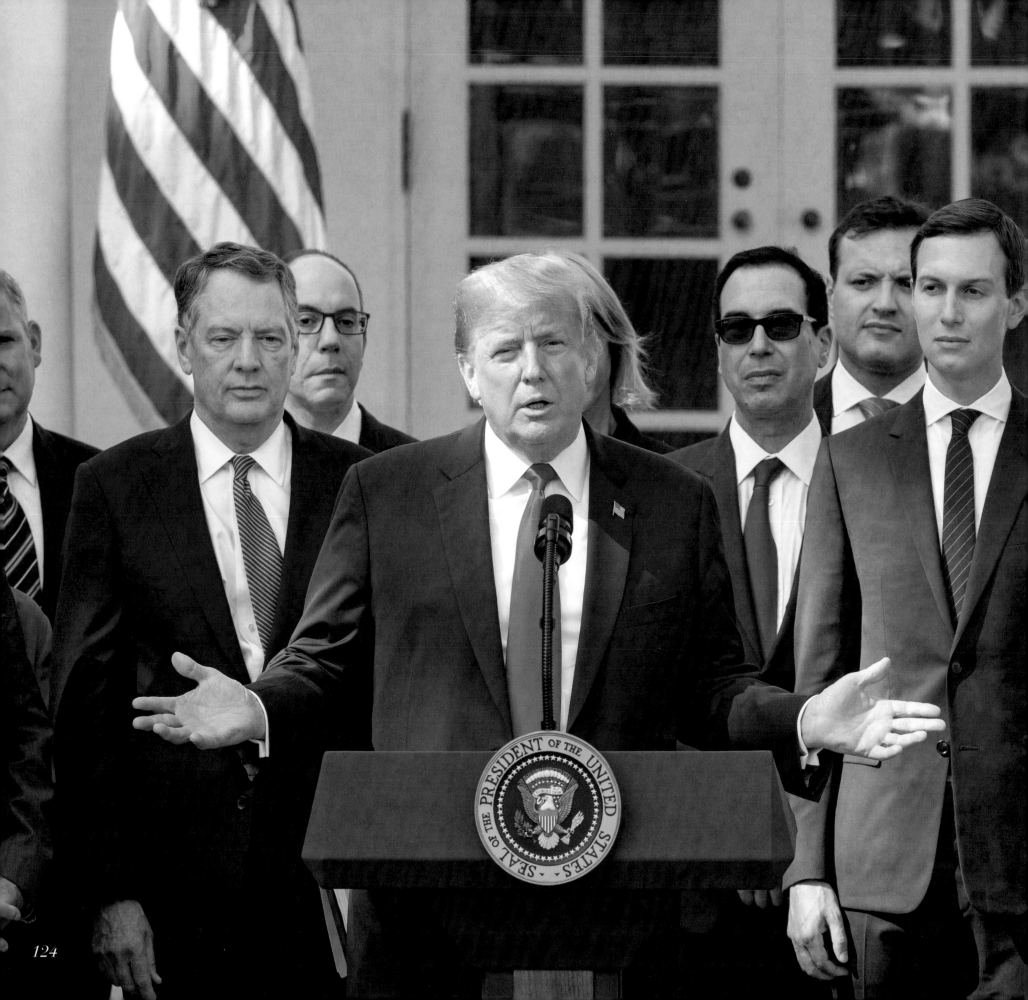

UNPRECEDENTED ECONOMIC BOOM INFO SHEET

Before the China Virus invaded our shores, we built the world's most prosperous economy.

America gained 7 million new jobs – more than three times government experts' projections.

Middle-Class family income increased nearly $6,000 – more than five times the gains during the entire previous administration.

The unemployment rate reached 3.5 percent, the lowest in a half-century.

Achieved 40 months in a row with more job openings than job-hirings.

More Americans reported being employed than ever before – nearly 160 million. Jobless claims hit a nearly 50-year low.

The number of people claiming unemployment insurance as a share of the population hit its lowest on record.

Incomes rose in every single metro area in the United States for the first time in nearly 3 decades.

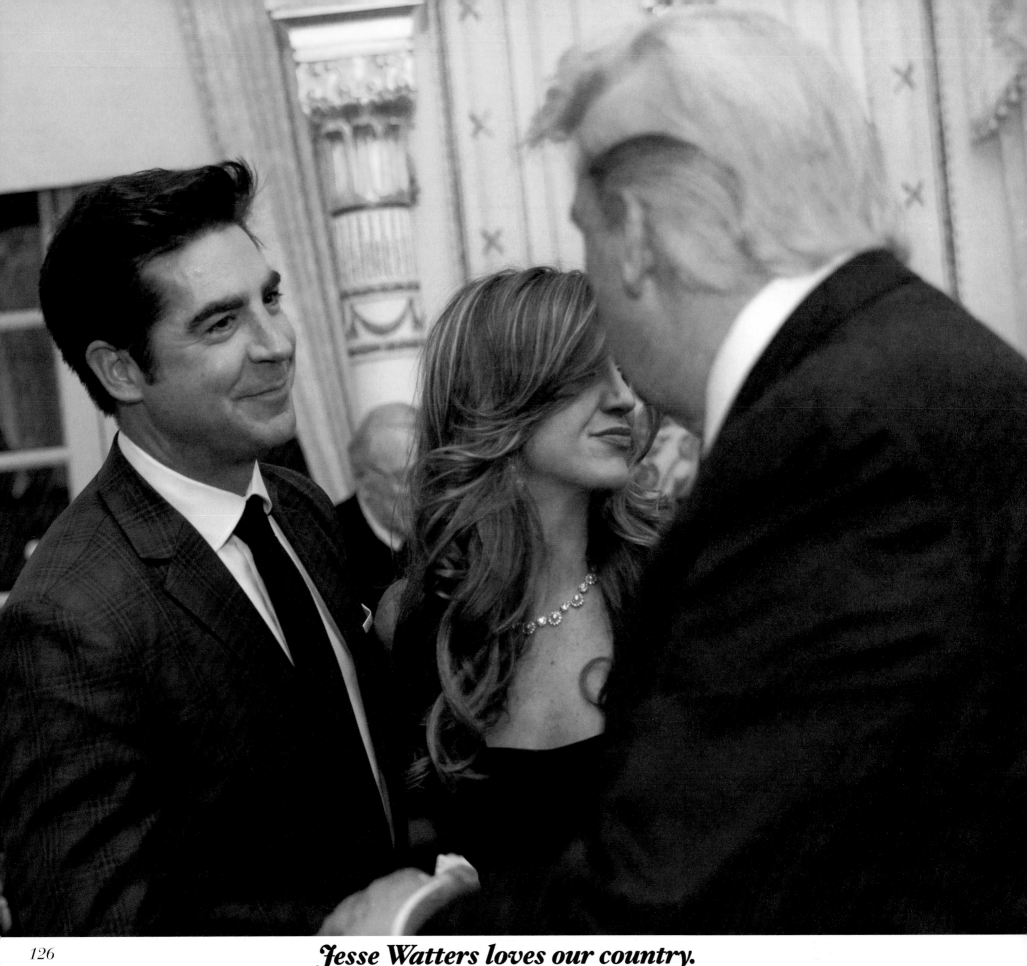

Jesse Watters loves our country.

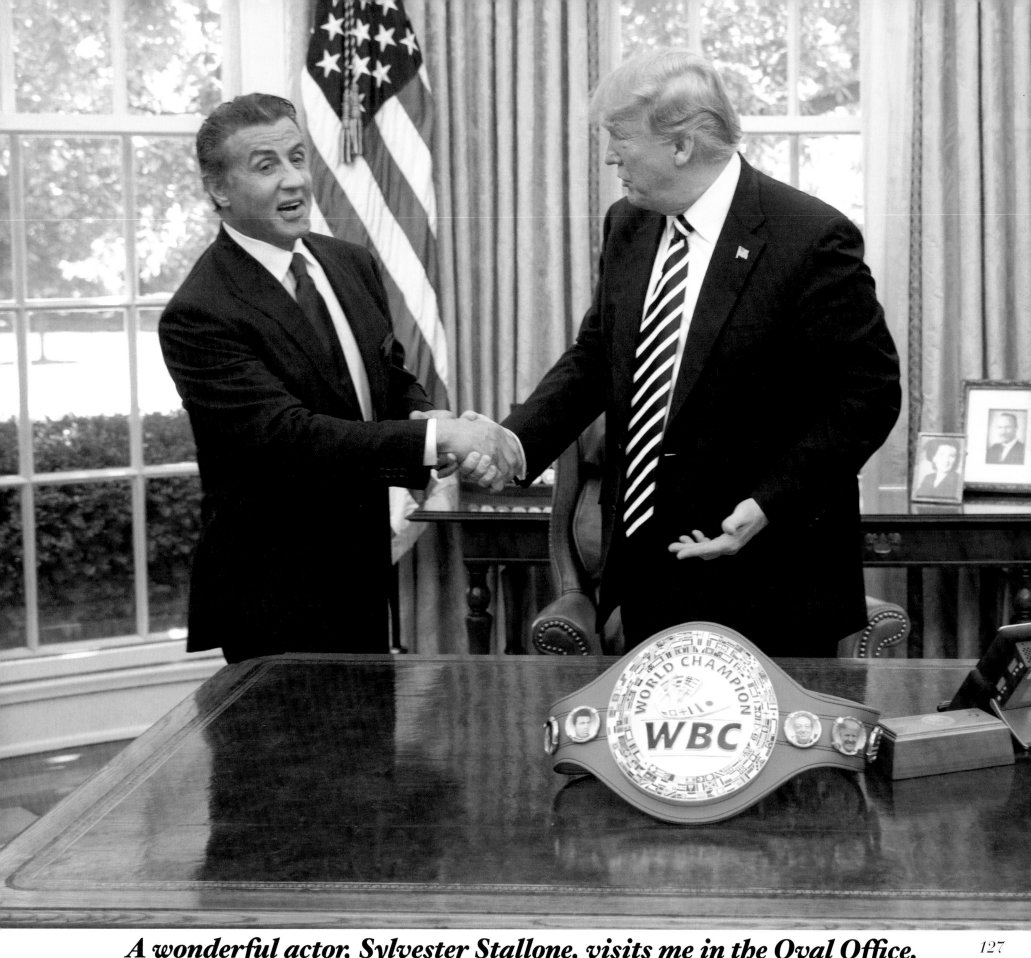

A wonderful actor, Sylvester Stallone, visits me in the Oval Office.

127

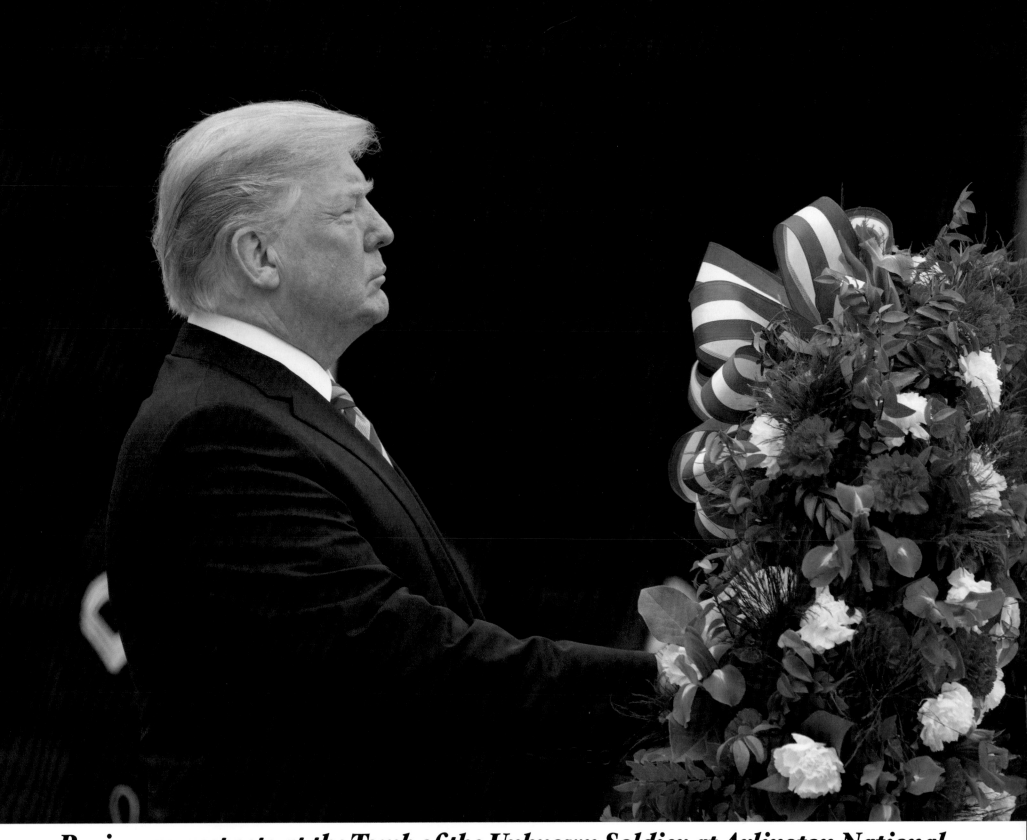

Paying my respects at the Tomb of the Unknown Soldier at Arlington National Cemetery. We will never forget the sacrifices of those who fought for our freedoms.

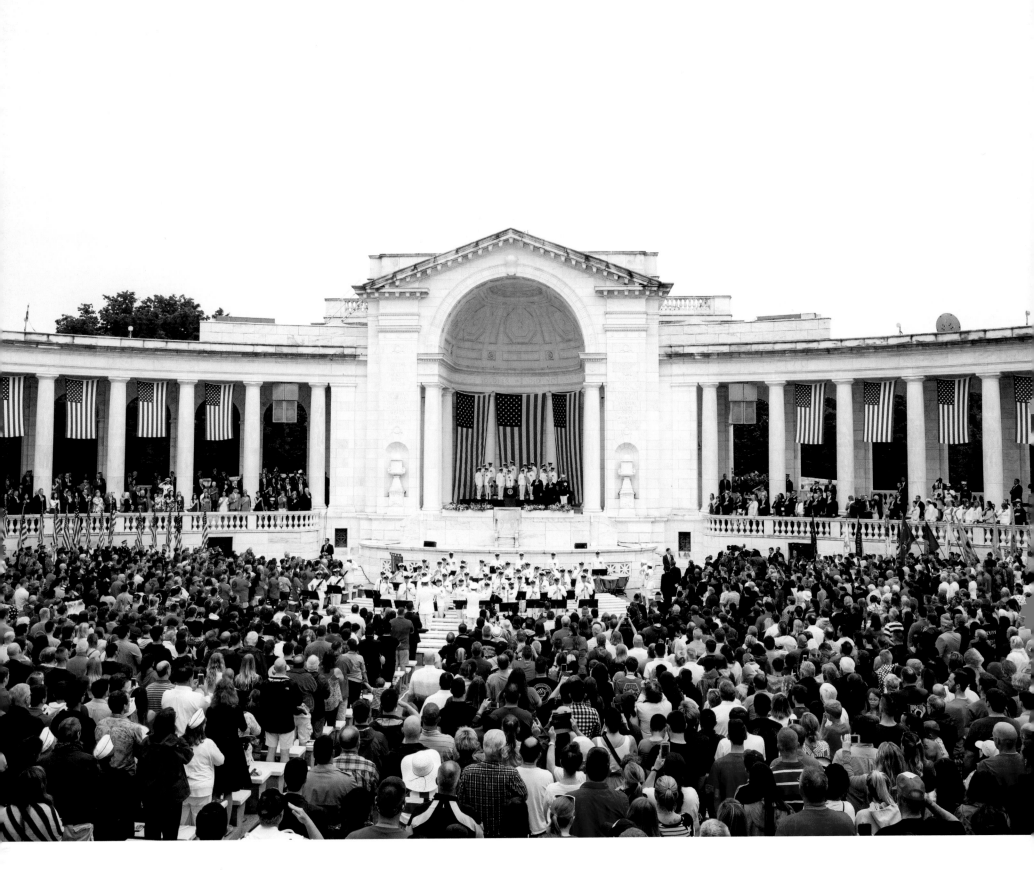

Arlington National Cemetery's Memorial Amphitheater.

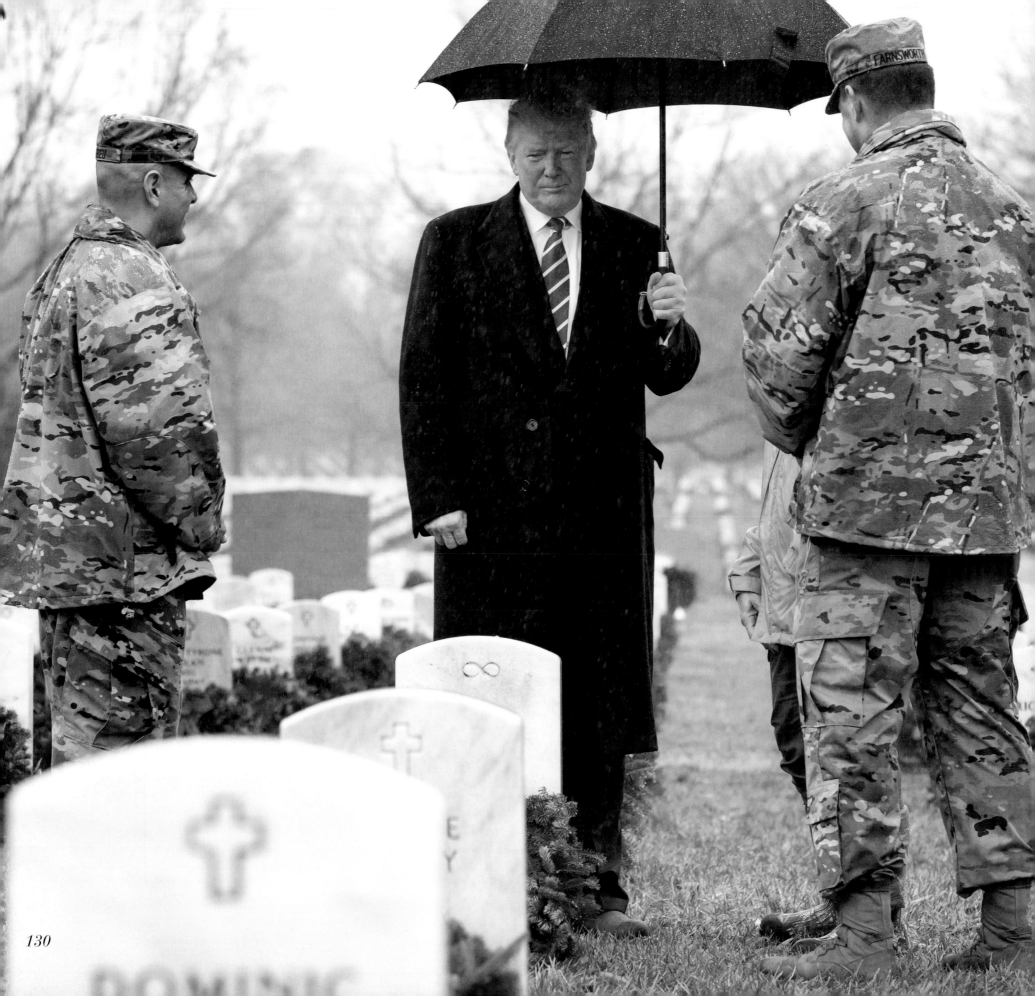

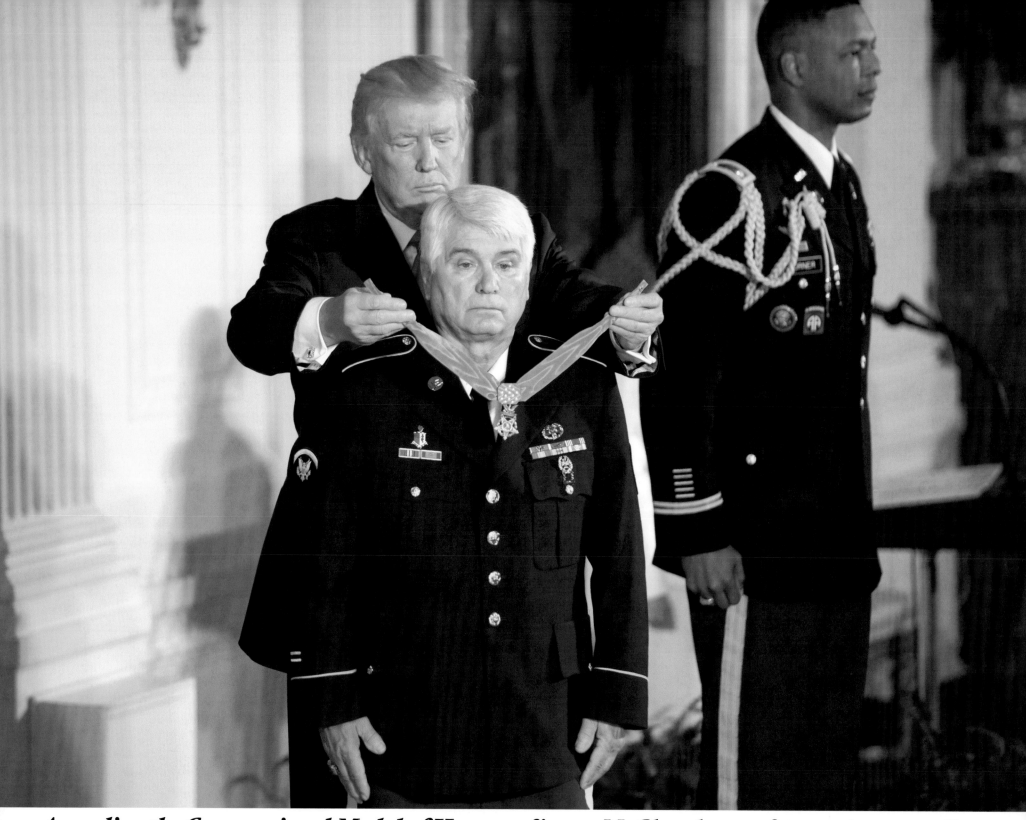

Awarding the Congressional Medal of Honor to James McCloughan, a former Army medic during the Vietnam War. Over a 48-hour bloody battle in 1969, Private First Class McCloughan entered the "kill zone" to rescue ten badly wounded men. He stated: "I would have rather died on the battlefield than know that men died because they did not have a medic." A true American HERO!

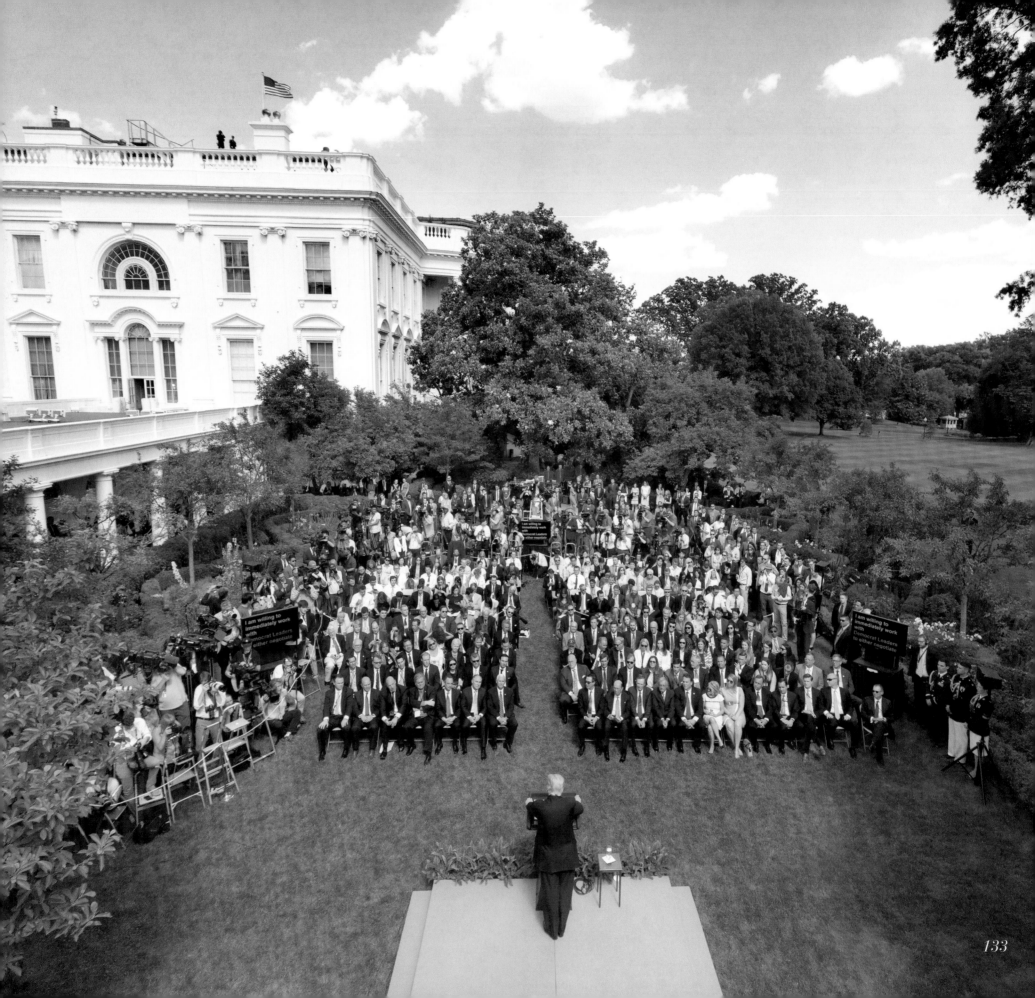

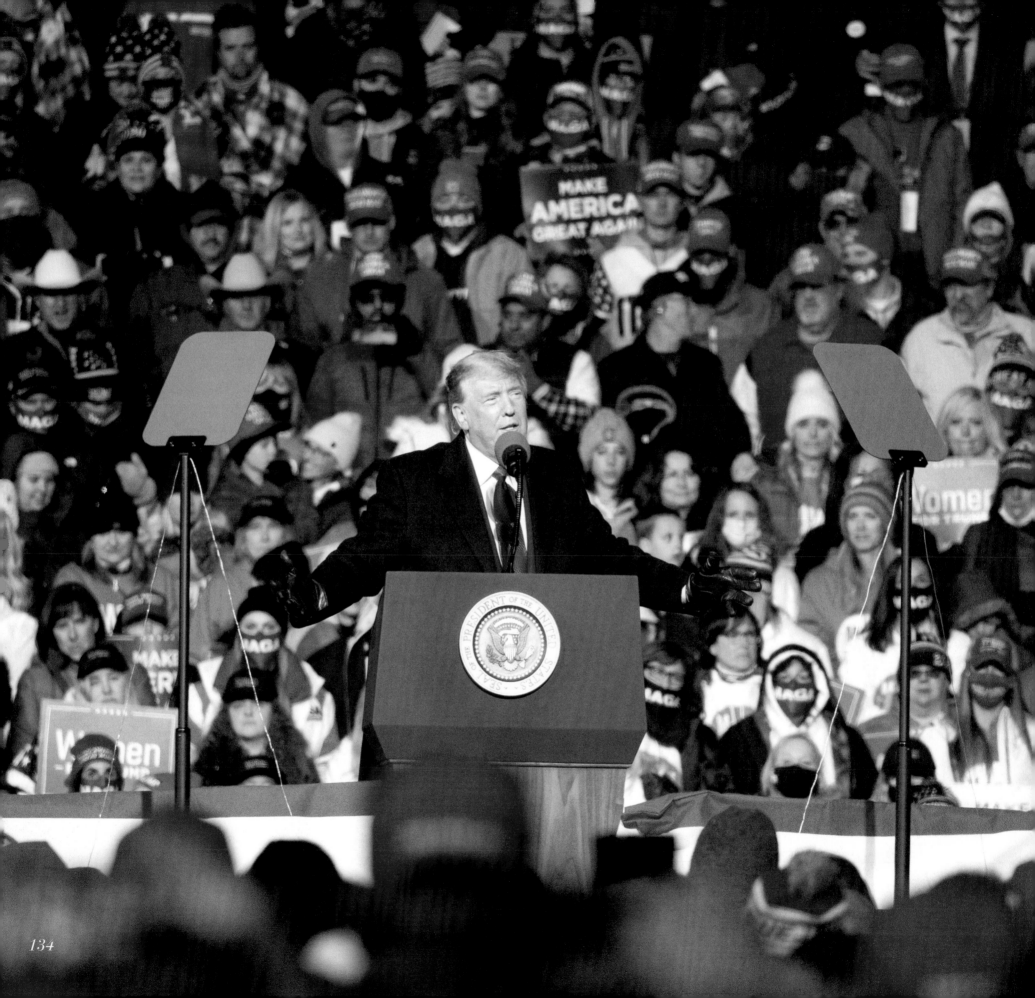

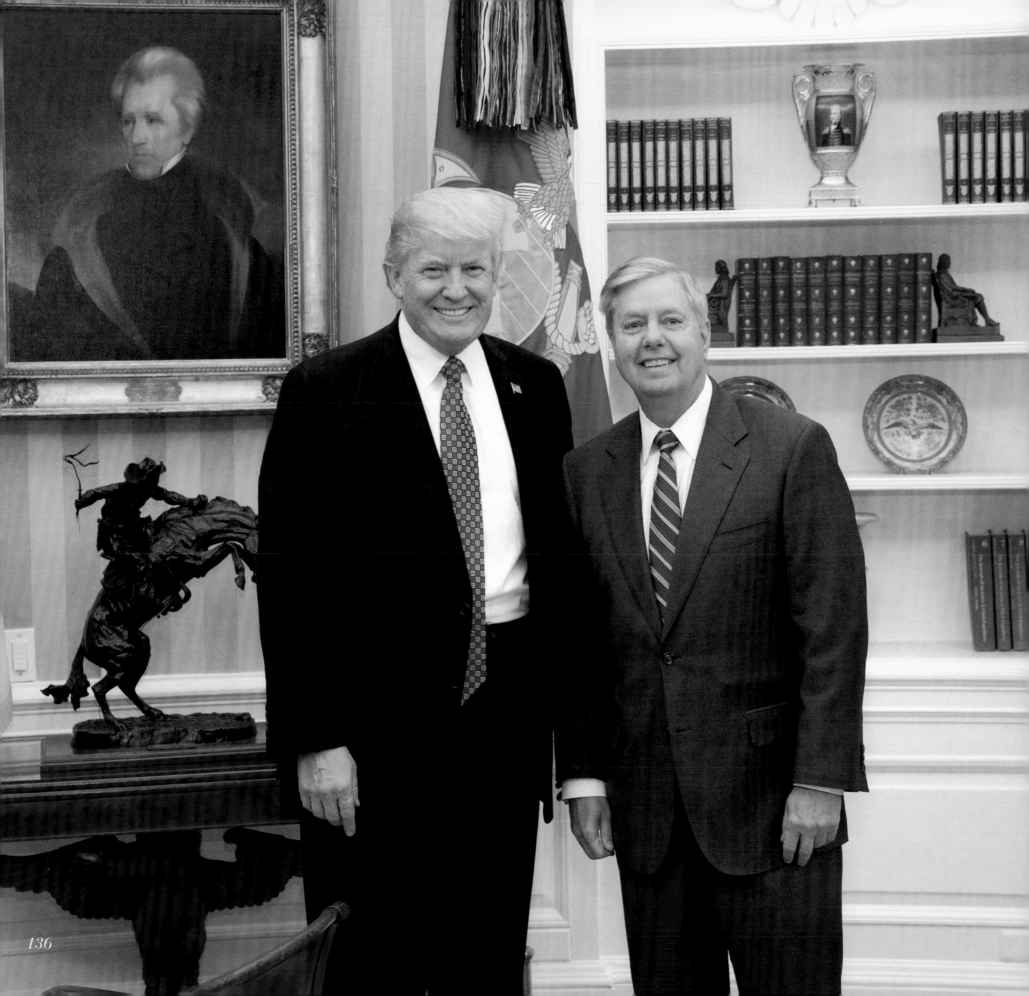

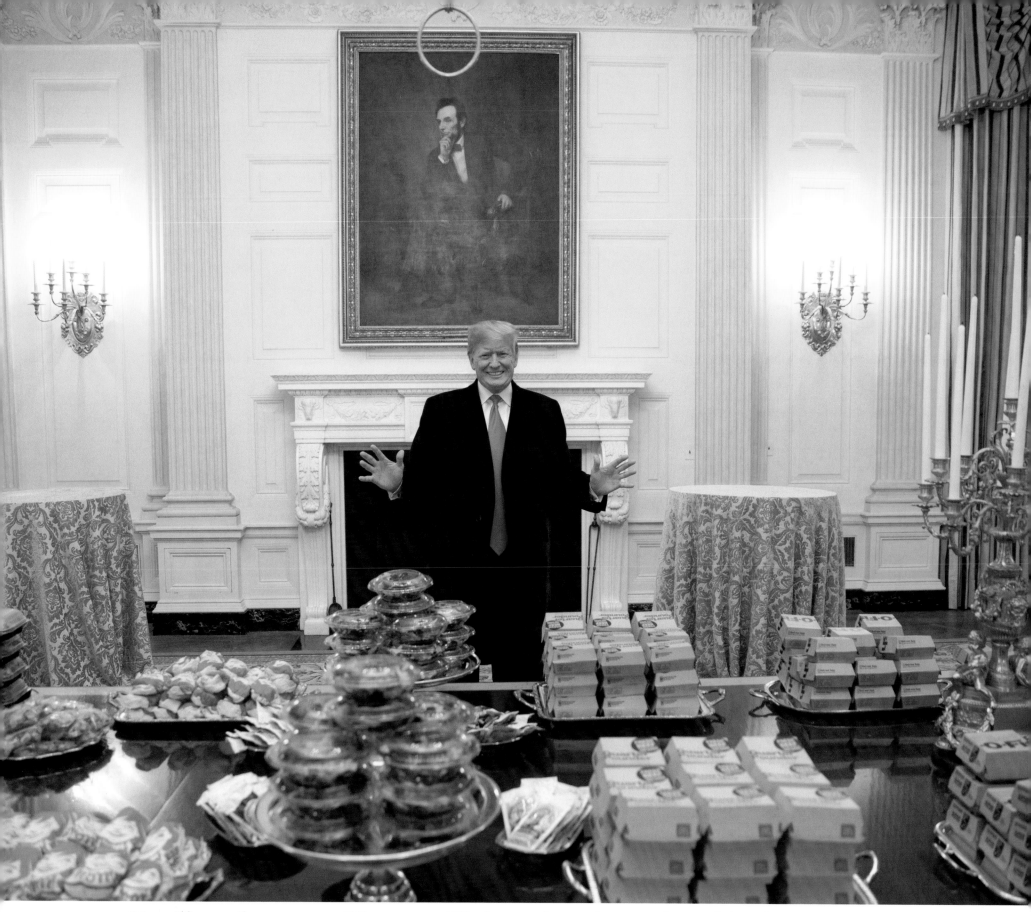

Feeding the great Clemson University championship football team during a government shutdown.

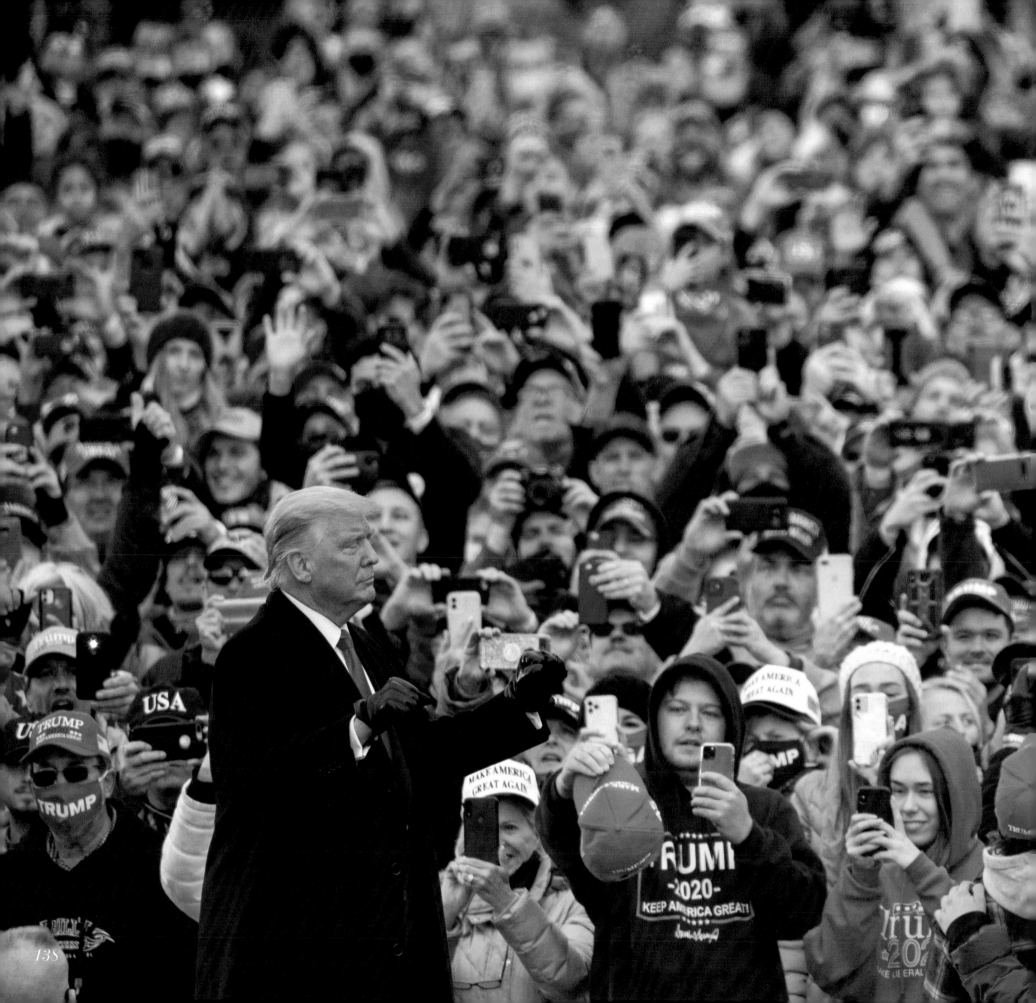

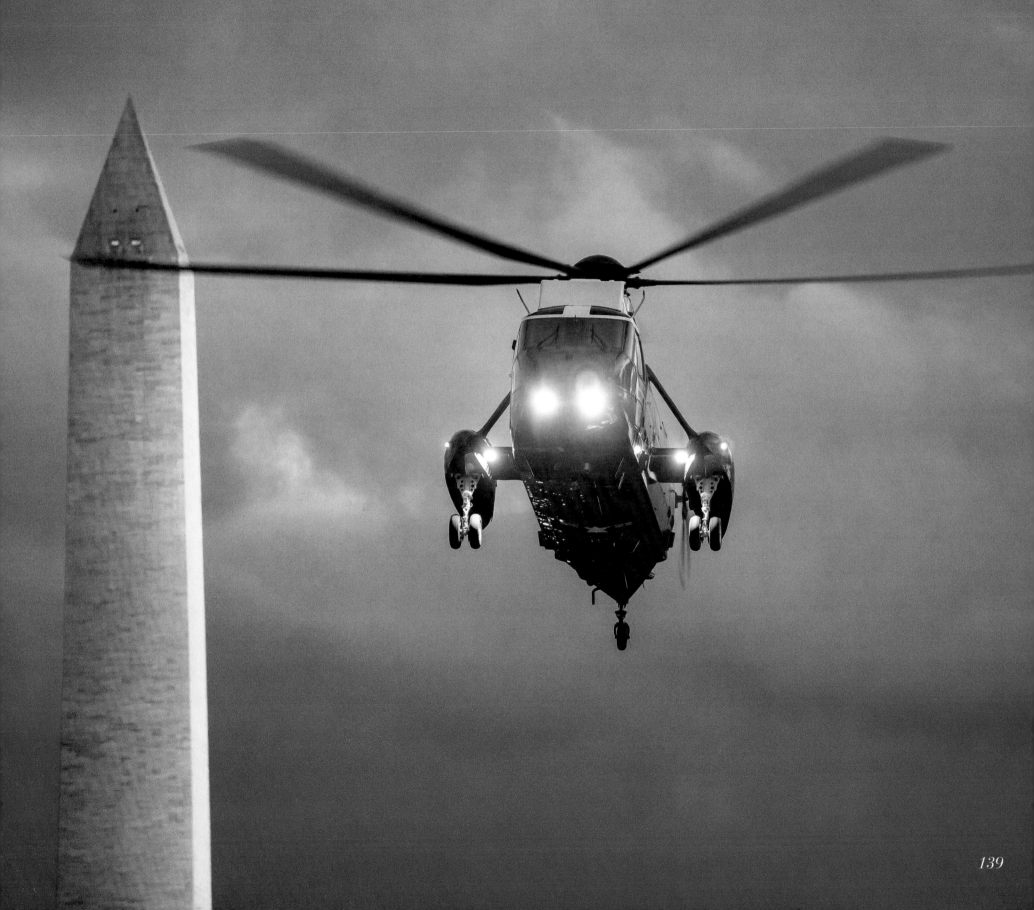

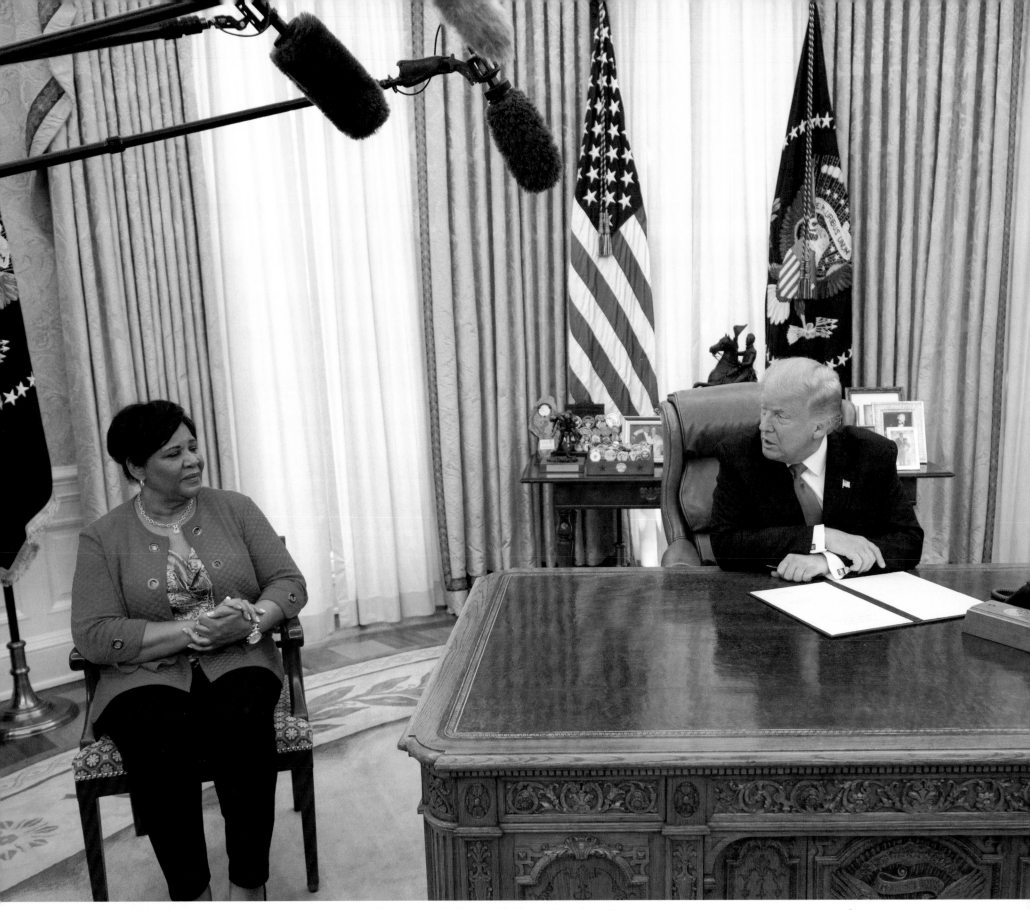

It was my honor to allow Alice Marie Johnson to reenter society.
She is thriving!

SIGNED INTO LAW LANDMARK CRIMINAL JUSTICE REFORM

Signed the bipartisan First Step Act into law, the first landmark criminal justice reform legislation ever passed to reduce recidivism and help former inmates successfully rejoin society.

Promoted second chance hiring to give former inmates the opportunity to live crime-free lives and find meaningful employment.

Launched a new "Ready to Work" initiative to help connect employers directly with former prisoners.

Awarded $2.2 million to states to expand the use of fidelity bonds, which underwrite companies that hire former prisoners.

Reversed decades-old ban on Second Chance Pell programs to provide postsecondary education to individuals who are incarcerated expand their skills and better succeed in the workforce upon re-entry.

Awarded over $333 million in Department of Labor grants to nonprofits and local and state governments for reentry projects focused on career development services for justice-involved youth and adults who were formerly incarcerated.

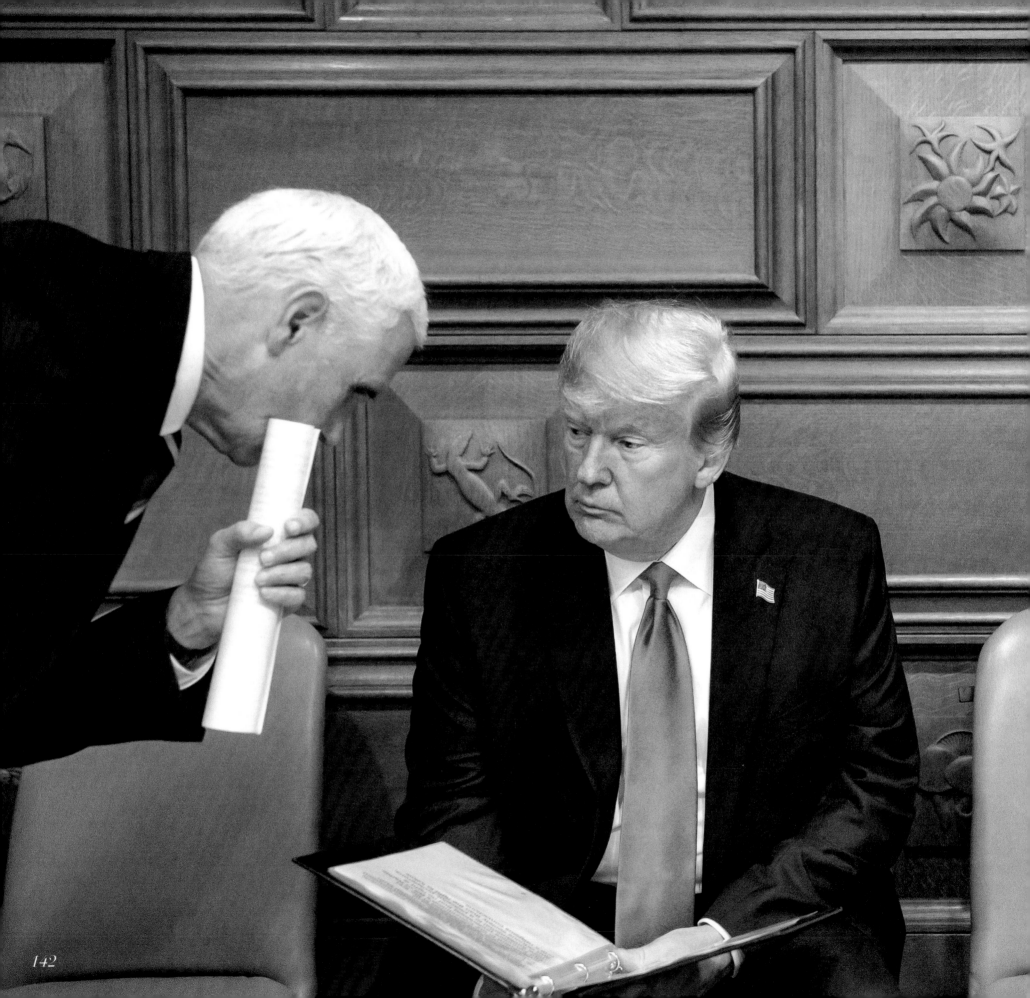

Mike Pence and I had a great relationship. I only disagreed with him on one point - but it was a big one!

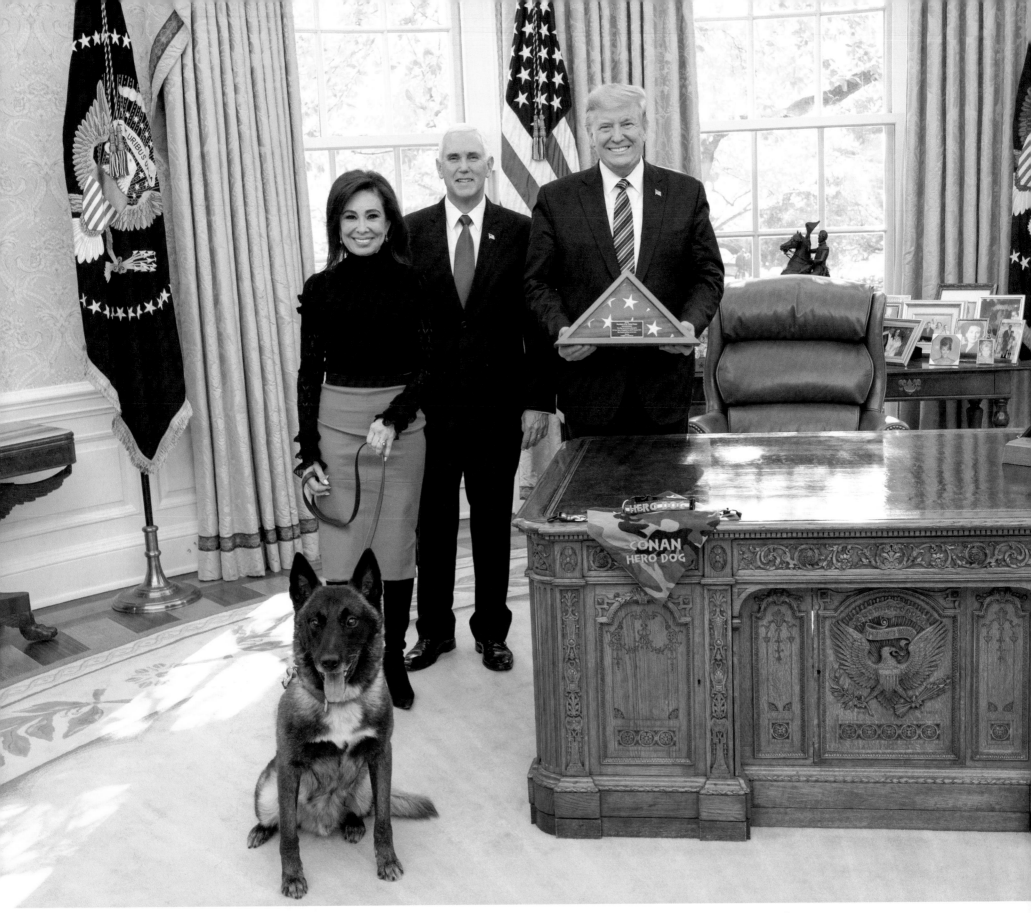

***My friend Jeanine Pirro showed absolutely no fear of Conan,
the hero dog who chased down Abu Bakr al-Baghdadi.***

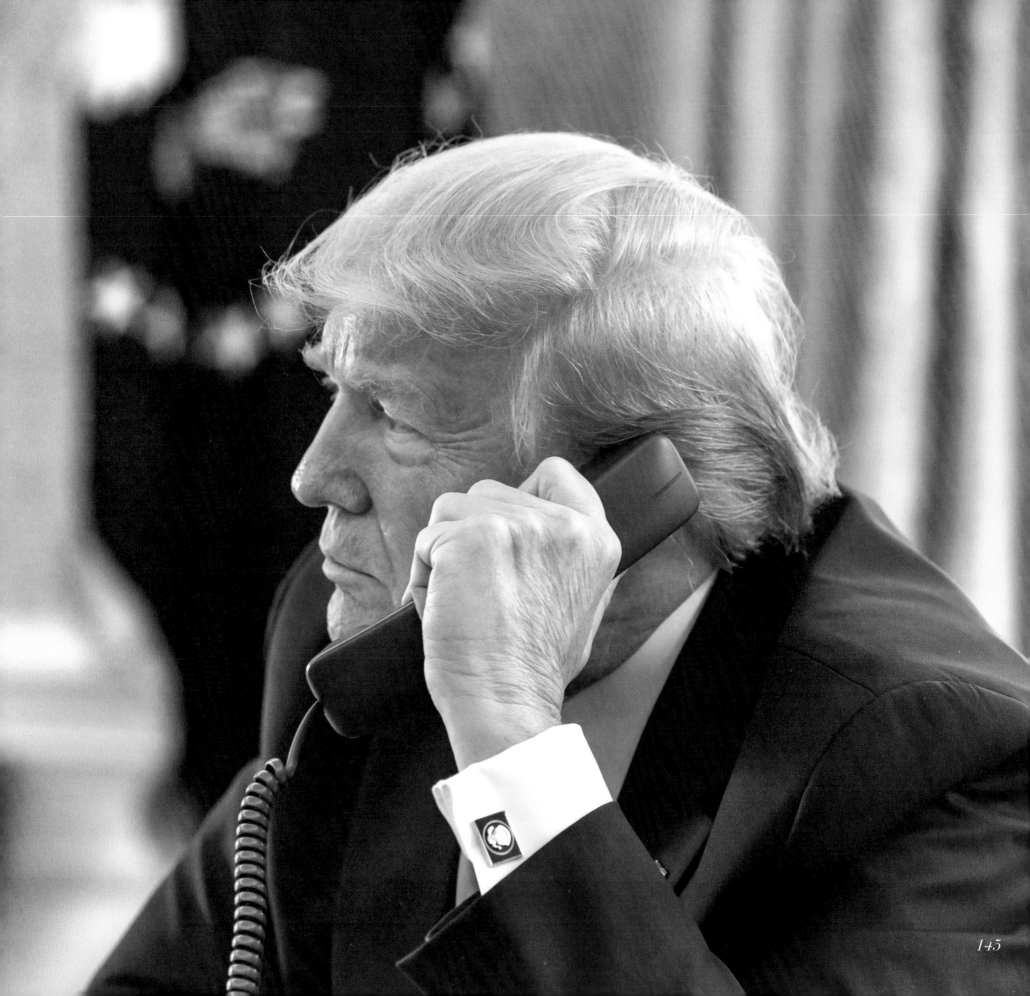

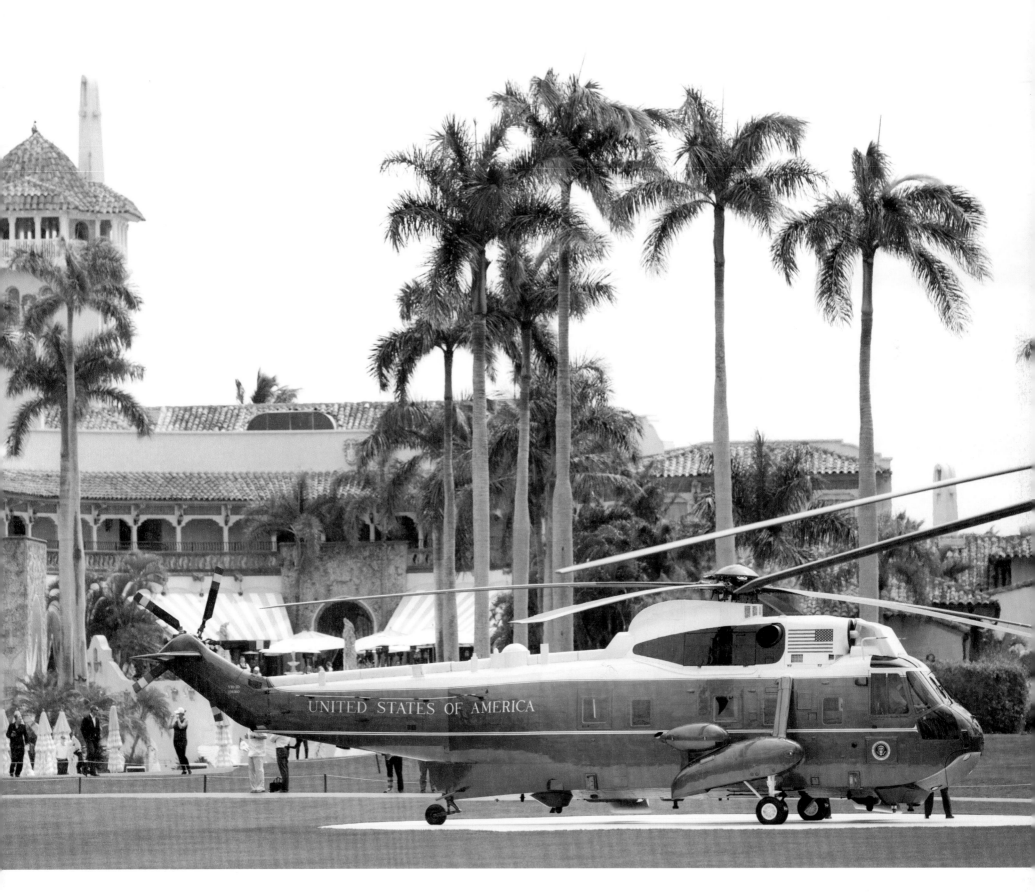

Marine One gets ready to take off from Mar-a-Lago.

RENEWED OUR CHERISHED FRIENDSHIP AND ALLIANCE WITH ISRAEL AND TOOK HISTORIC ACTION TO PROMOTE PEACE IN THE MIDDLE EAST

Recognized Jerusalem as the true capital of Israel and quickly moved the American Embassy in Israel to Jerusalem.

Acknowledged Israel's sovereignty over the Golan Heights and declared that Israeli settlements in the West Bank are not inconsistent with international law.

Removed the United States from the United Nations Human Rights Council due to the group's blatant anti-Israel bias.

Brokered historic peace agreements between Israel and Arab-Muslim countries, including the United Arab Emirates, the Kingdom of Bahrain, and Sudan.

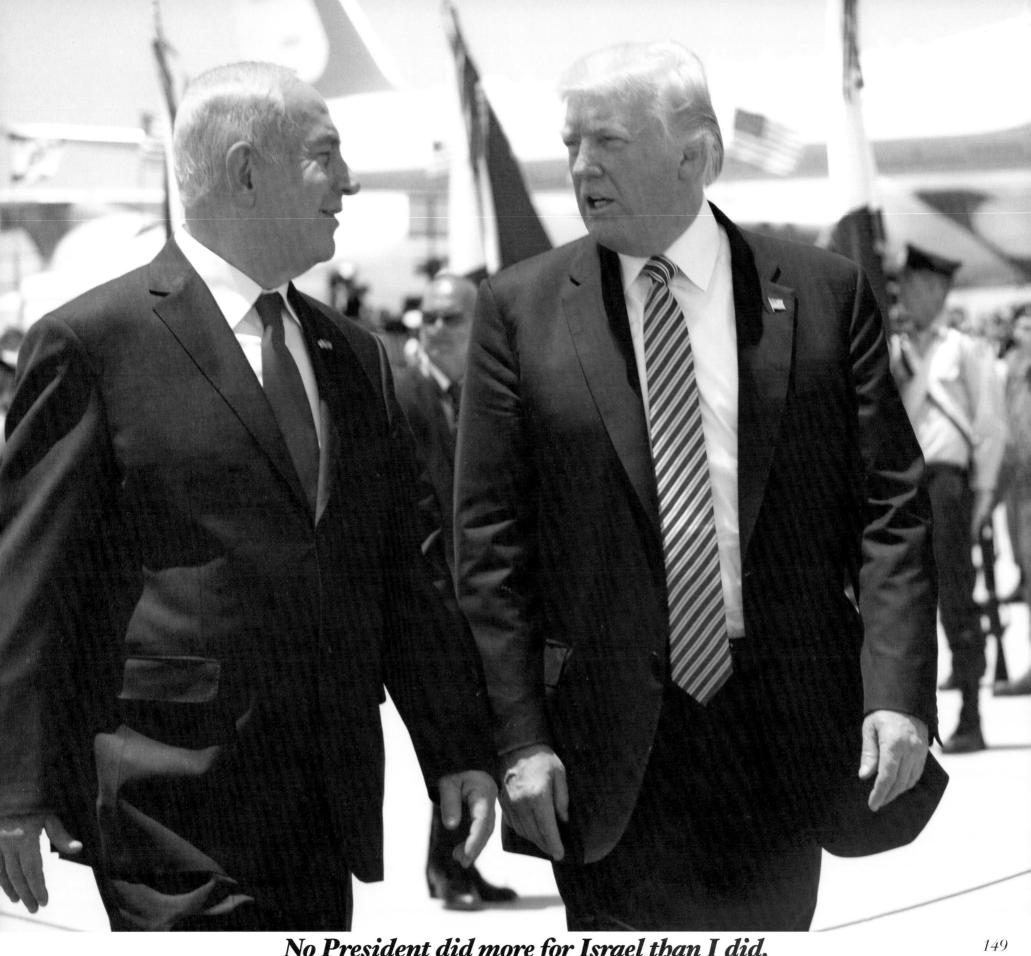

No President did more for Israel than I did.

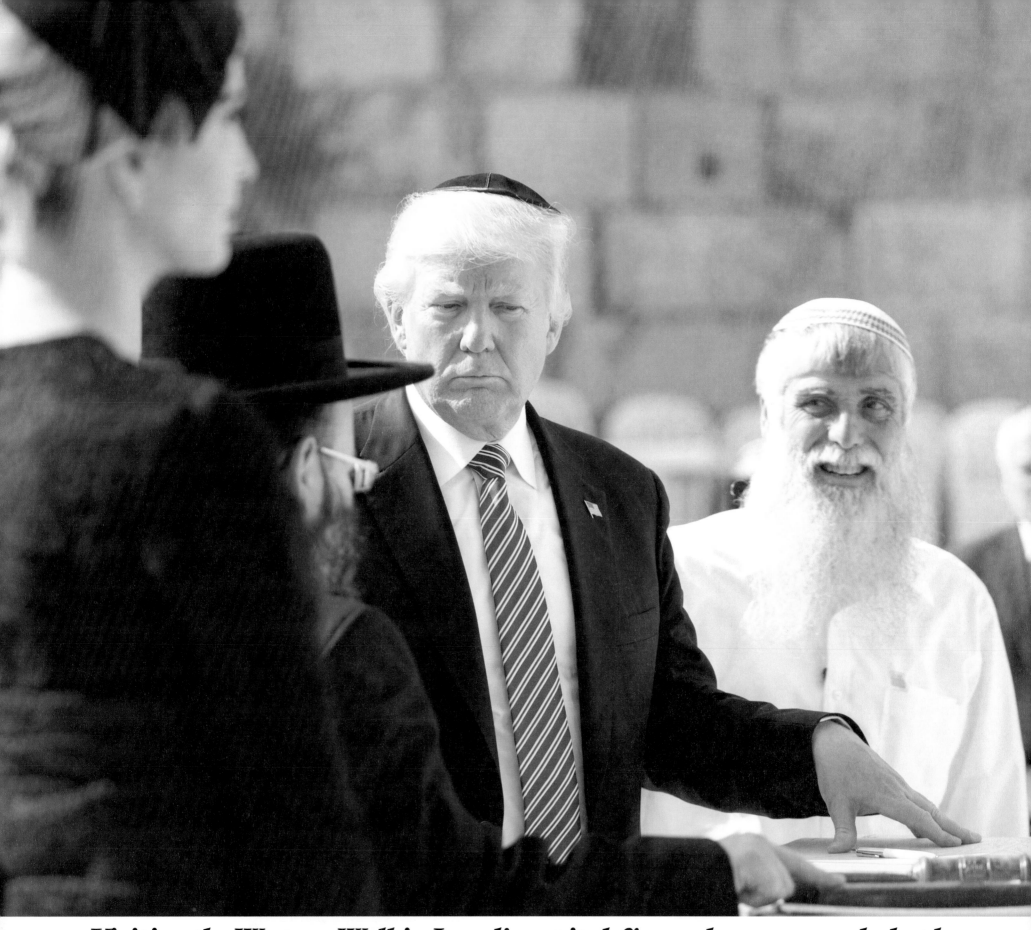

Visiting the Western Wall in Israel's capital, Jerusalem — a very holy place.

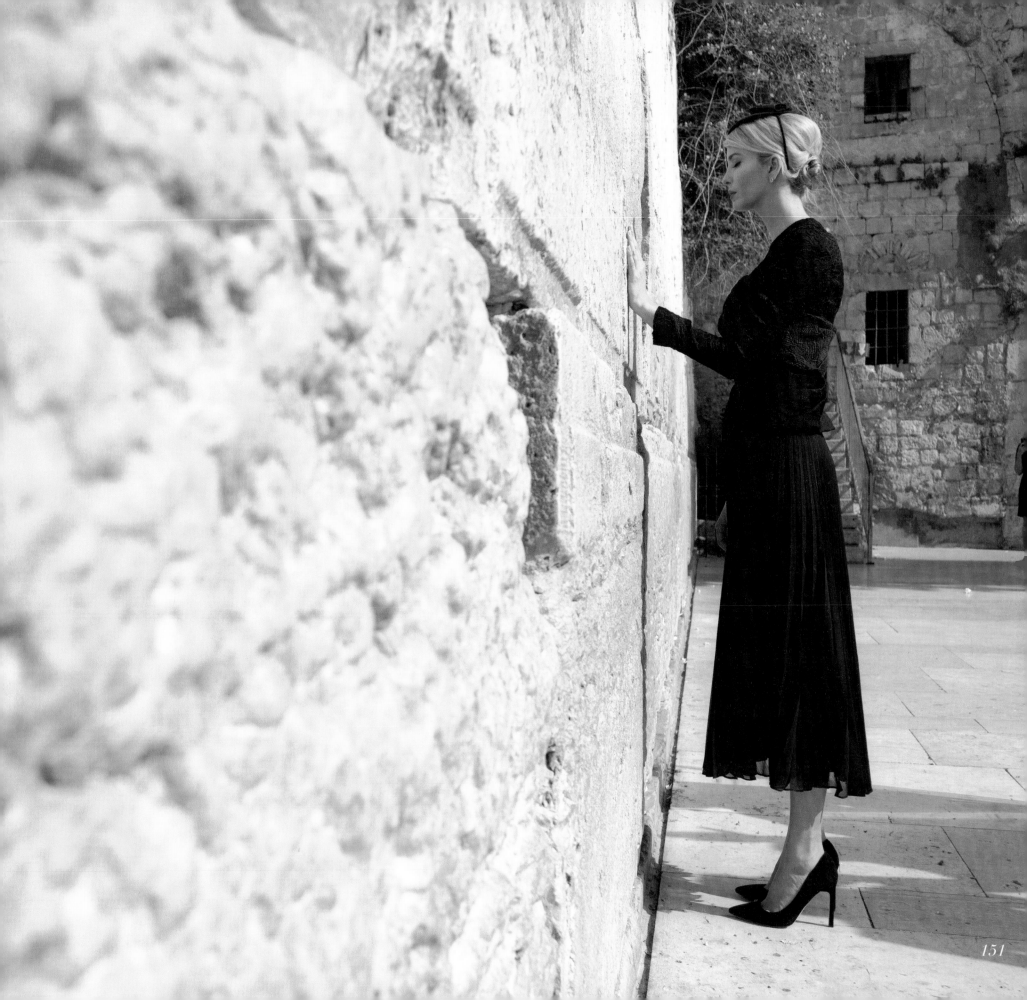

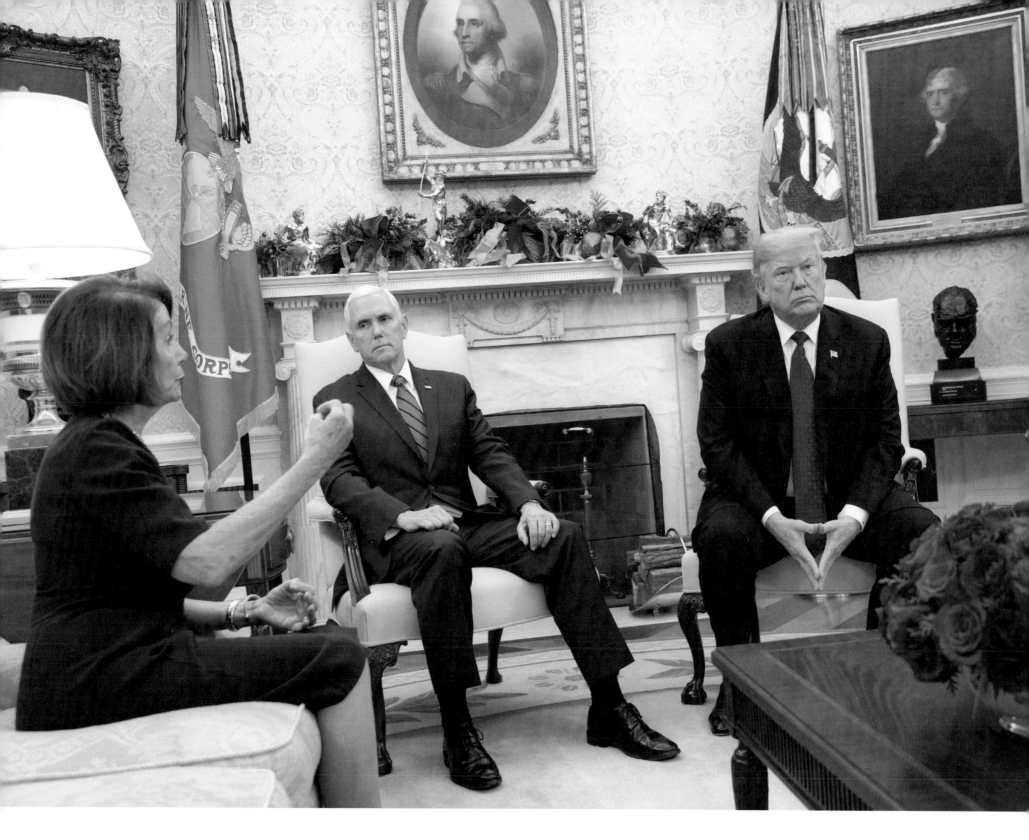

Attempting to listen to Crazy Nancy Pelosi in the Oval Office—
such natural disagreement.

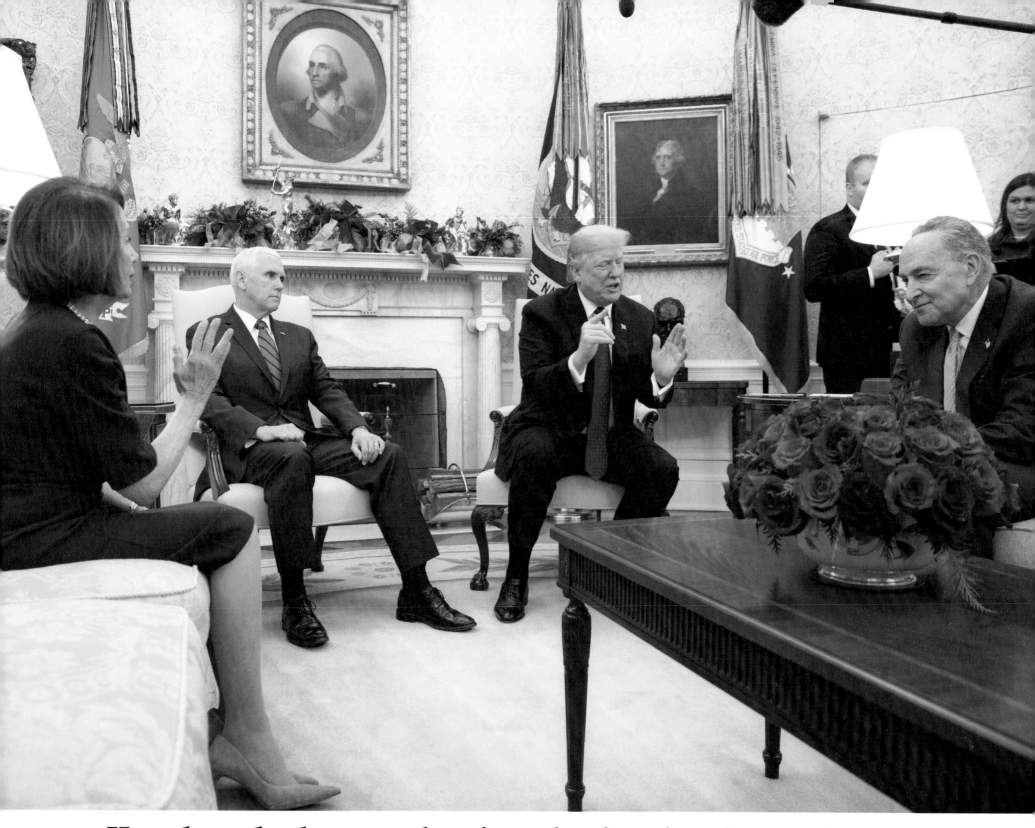

Here she makes her remarks prior to leaving, then she gave the press a totally different summation of what actually happened. Dealing with these people is far more difficult than dealing with the heads of other countries. So bad for America.

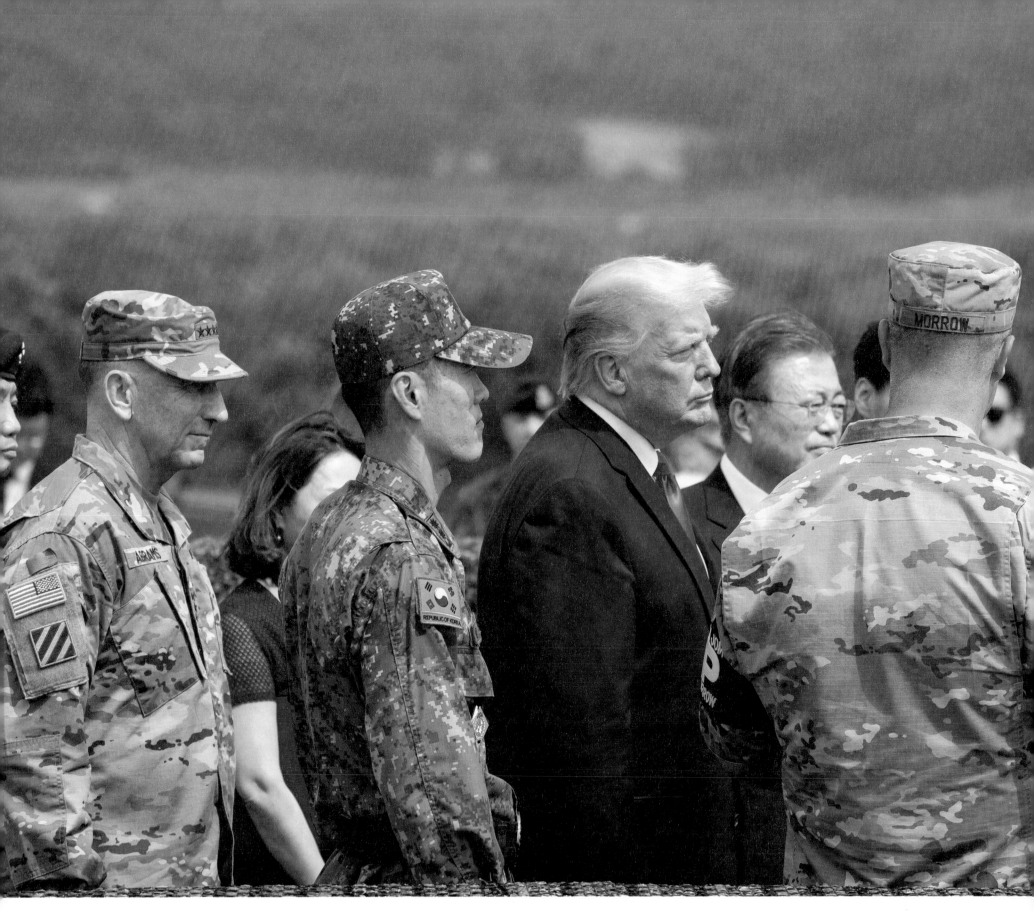

Looking into North Korea—I felt very safe because of my relationship with Kim Jong Un.

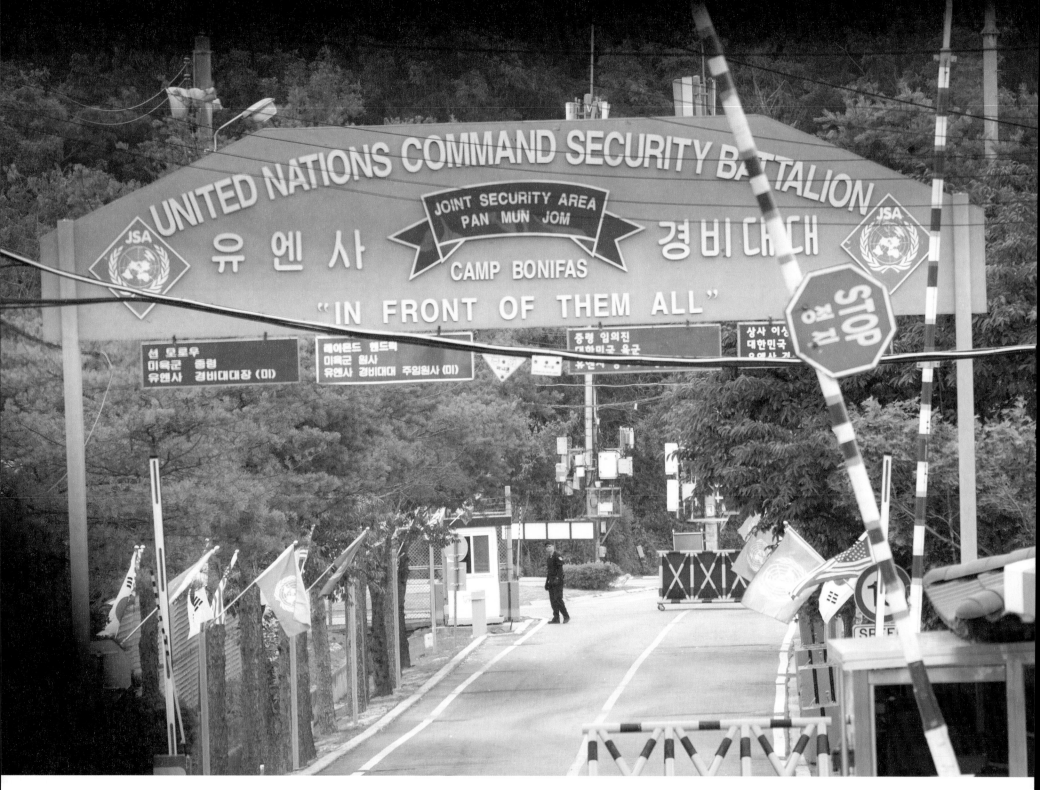

Camp Bonifas is a UN military post in South Korea, located just feet away from the border with North Korea.

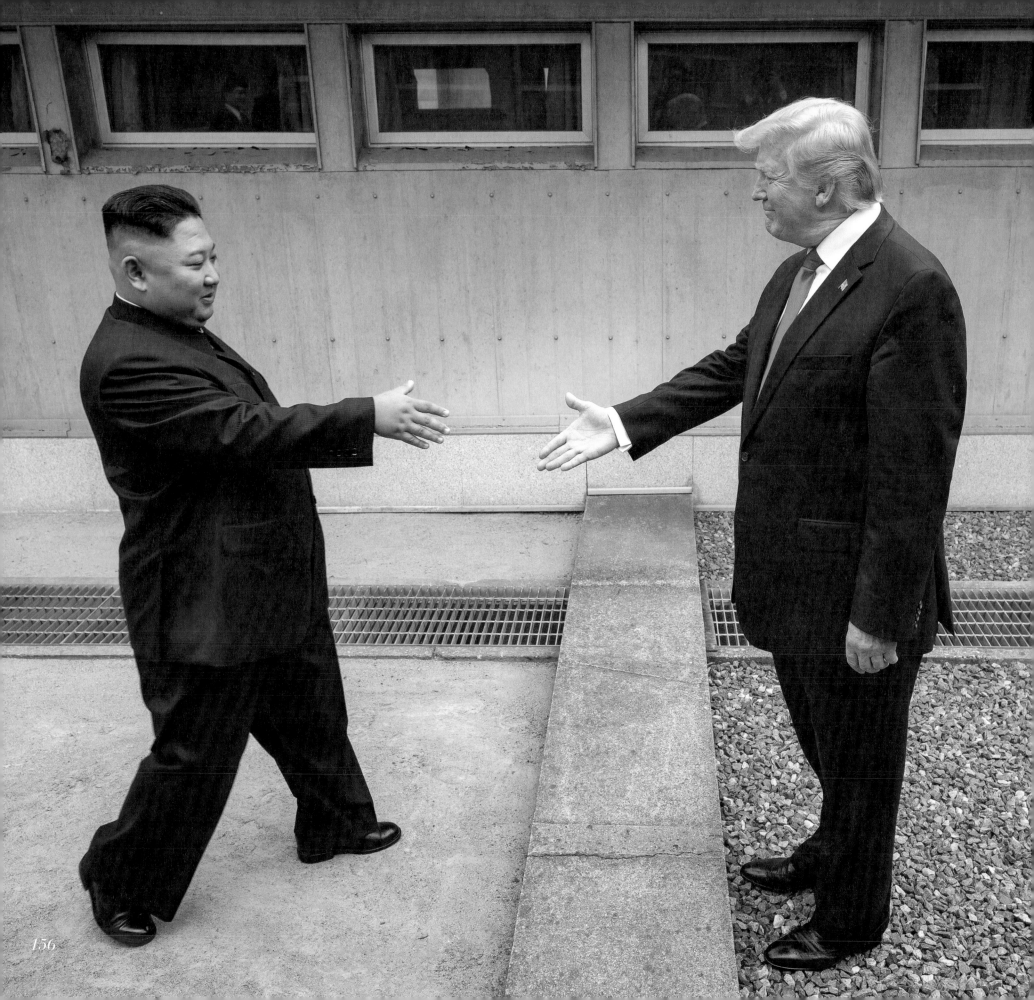

At the Border of North & South Korea, I liked Kim Jong Un - very tough and smart. The world was a safer place because of our relationship. If our election was not rigged, we would by now have a deal with North Korea.

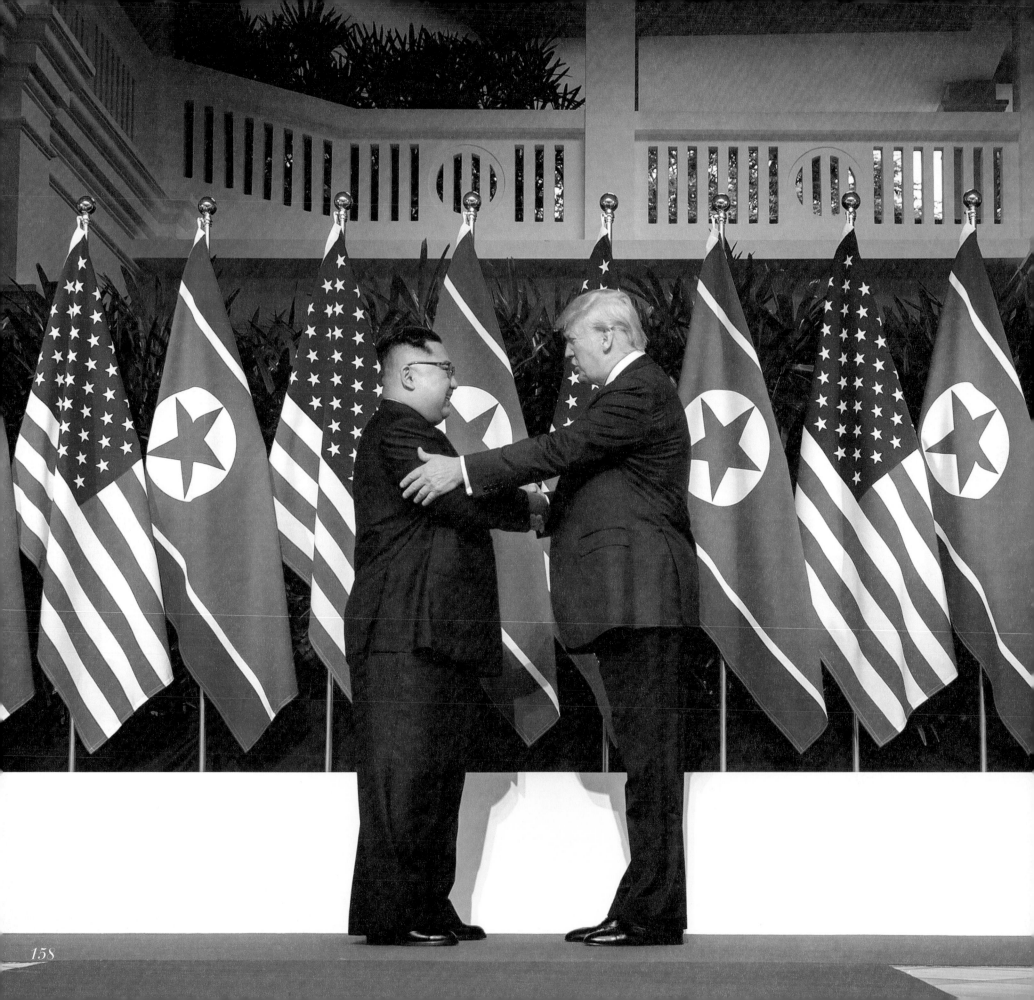

ADVANCED PEACE THROUGH STRENGTH

*First president to meet with a leader of North Korea and the first sitting president
to cross the demilitarized zone into North Korea.*

*Maintained a maximum pressure campaign and enforced tough sanctions on North Korea while negotiating
de-nuclearization, the release of American hostages, and the return of the remains of American heroes.*

TRUMP WHITE HOUSE ONLINE ARCHIVES
TRUMPWHITEHOUSE.ARCHIVES.GOV

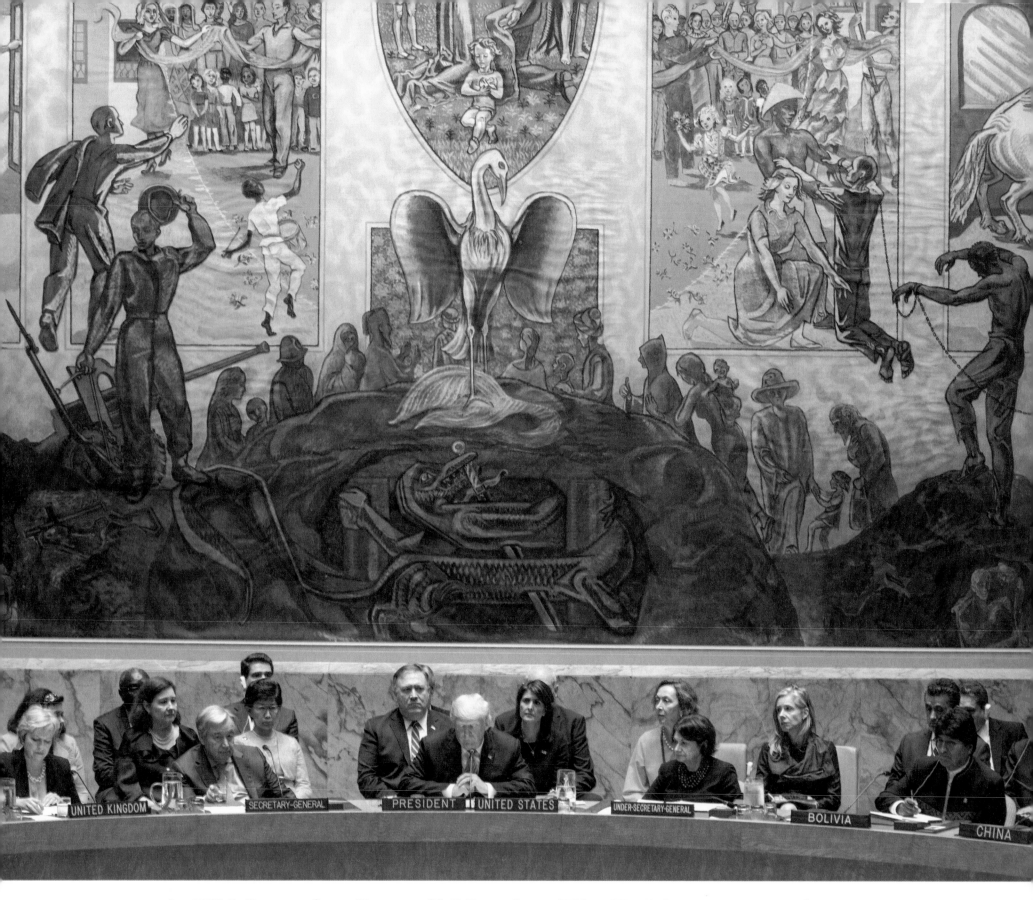

At UN Security Council Meeting. The UN has tremendous untapped potential for peace, and many other things!

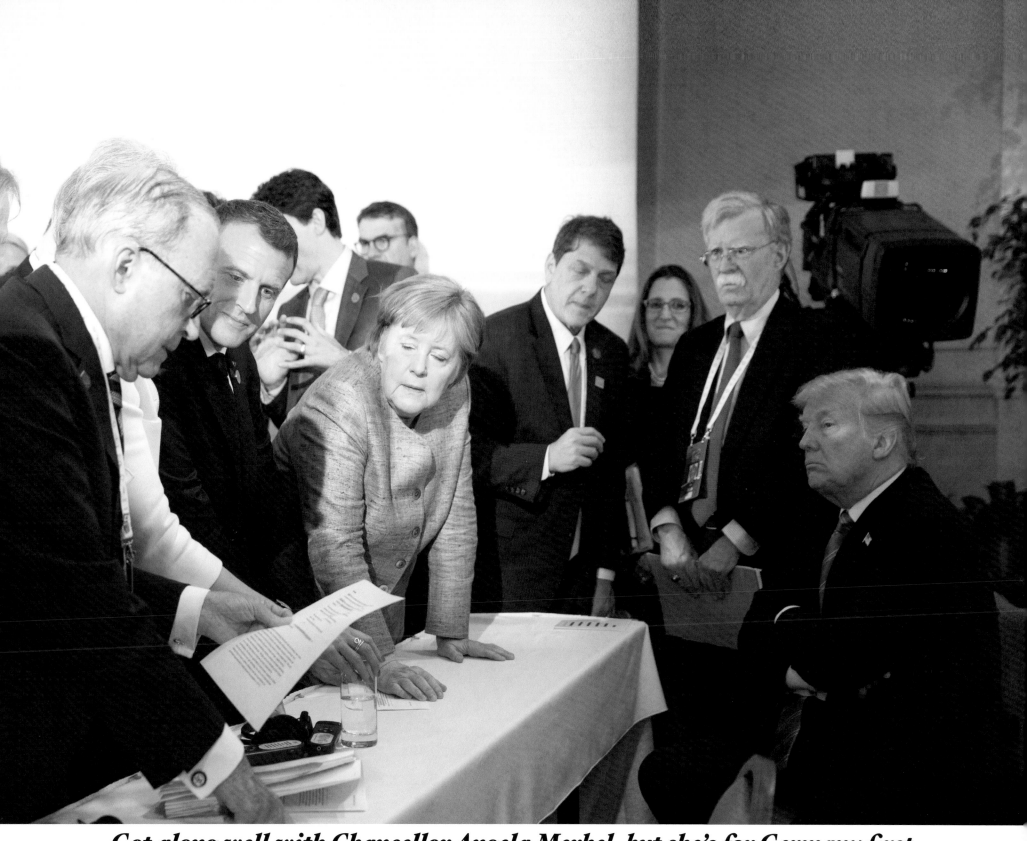

Got along well with Chancellor Angela Merkel, but she's for Germany first, as she should be. I used John Bolton when necessary because all he wanted to do was go to war with other countries. I didn't, but good for negotiating purposes. He was dumb as a rock. Larry Kudlow — great guy, did a fabulous job.

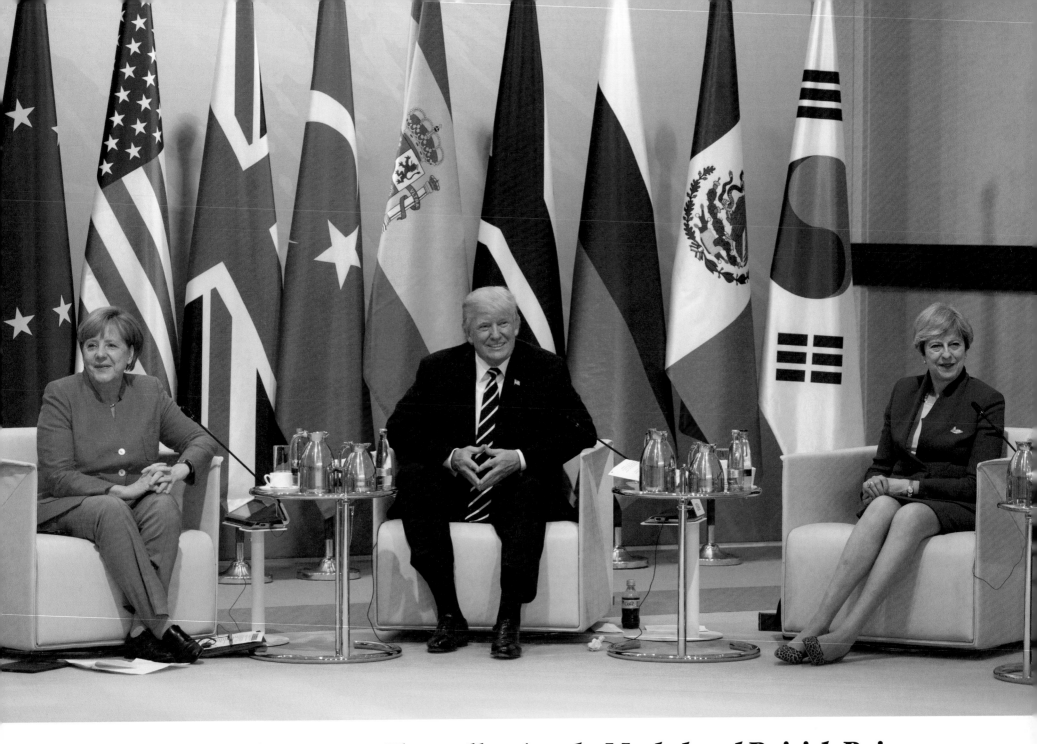

Meeting with German Chancellor Angela Merkel and British Prime Minister Theresa May. Theresa tried hard, but didn't get the job done. Boris Johnson is much better for the United Kingdom.

RESTORING AMERICAN LEADERSHIP ABROAD

***Restored America's leadership in the world and successfully
negotiated to ensure our allies pay their fair share for our military protection.***

*Secured a $400 billion increase in defense spending from NATO (North Atlantic Treaty Organization)
allies by 2024, and the number of members meeting their minimum obligations more than doubled.*

Credited by Secretary General Jens Stoltenberg for strengthening NATO.

Worked to reform and streamline the United Nations (UN) and reduced spending by $1.3 billion.

Allies, including Japan and the Republic of Korea, committed to increase burden-sharing.

*Protected our Second Amendment rights by announcing the United States
will never ratify the UN Arms Trade Treaty.*

Returned 56 hostages and detainees from more than 24 countries.

On my way to deal with the globalists in Davos, Switzerland.

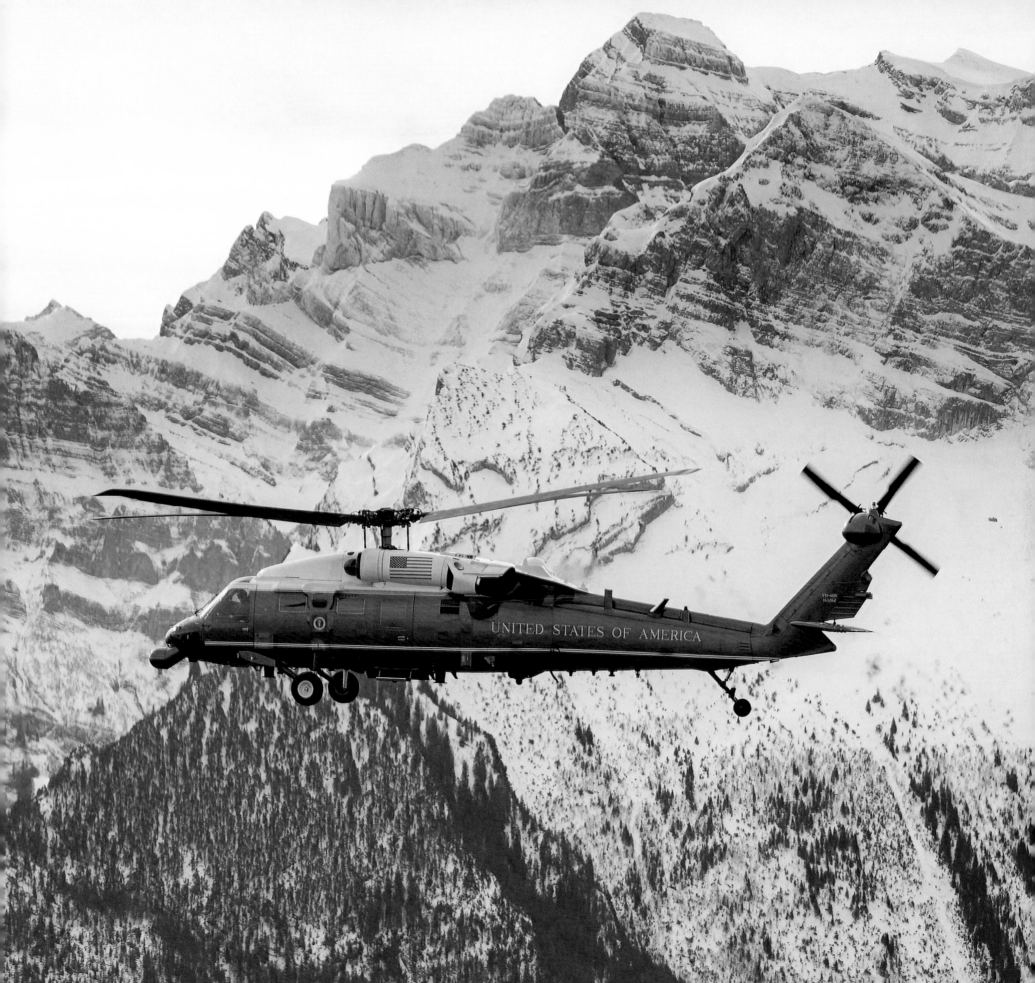

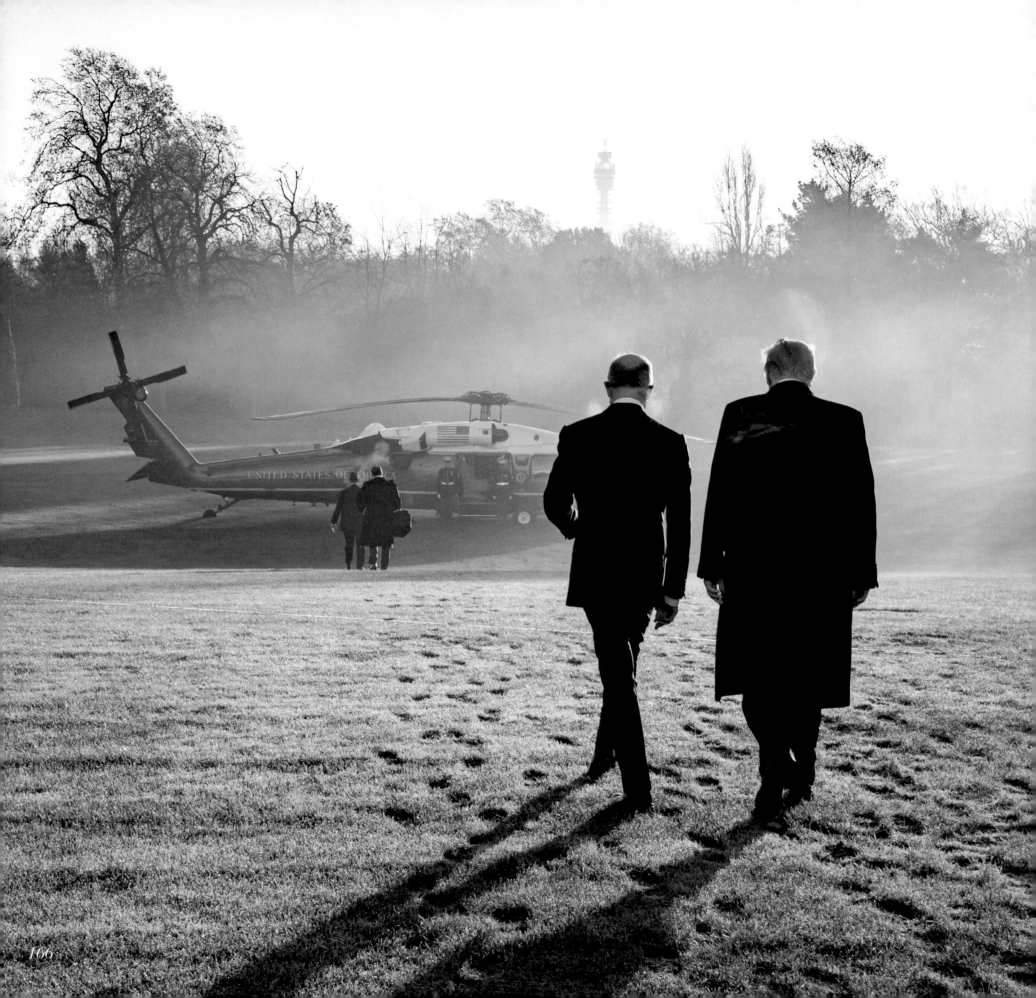

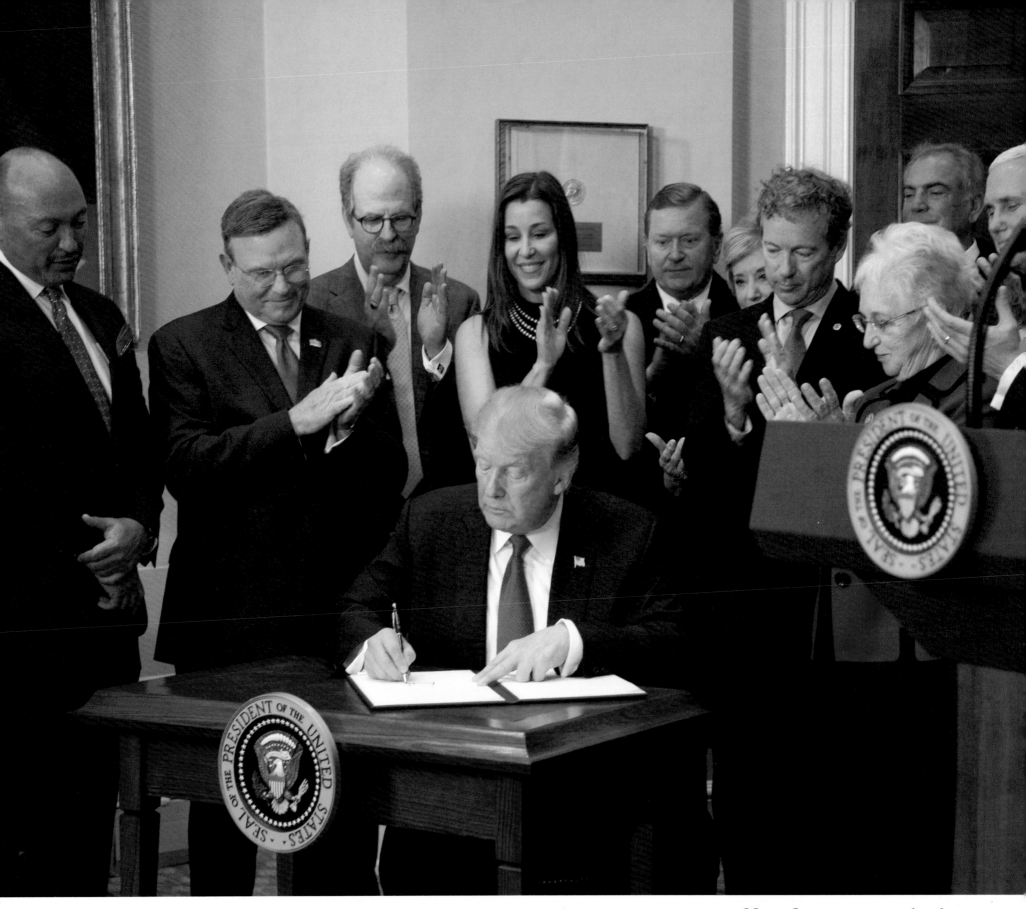

Signing an executive order changing Obama Care to offer far more choice and much better options.

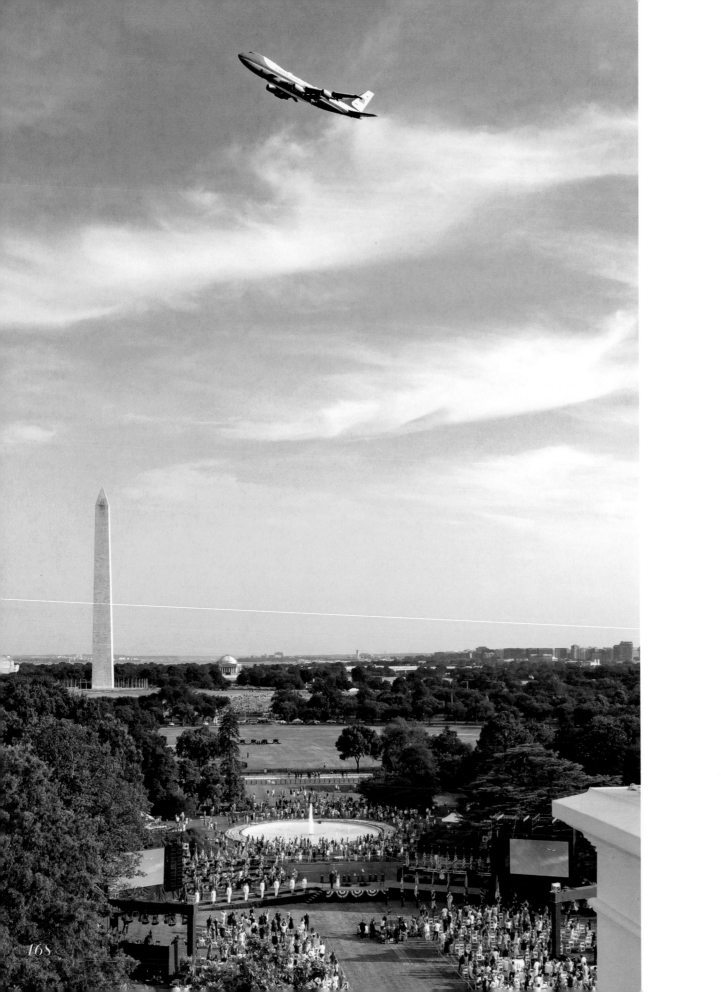

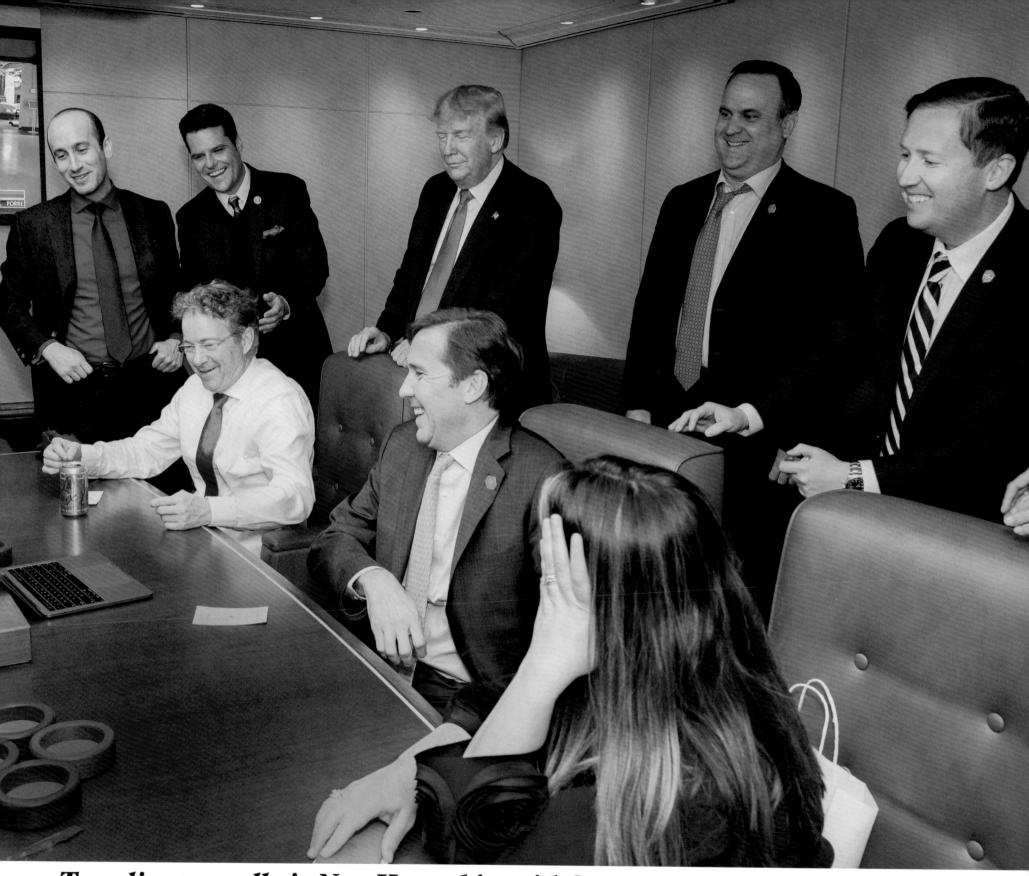

Traveling to a rally in New Hampshire with Senator Rand Paul. Rand was there for me when I truly needed him. With us are Congressman Matt Gaetz, Stephen Miller, Dan Scavino, Sergio Gor, and Ronna McDaniel. A winning team!

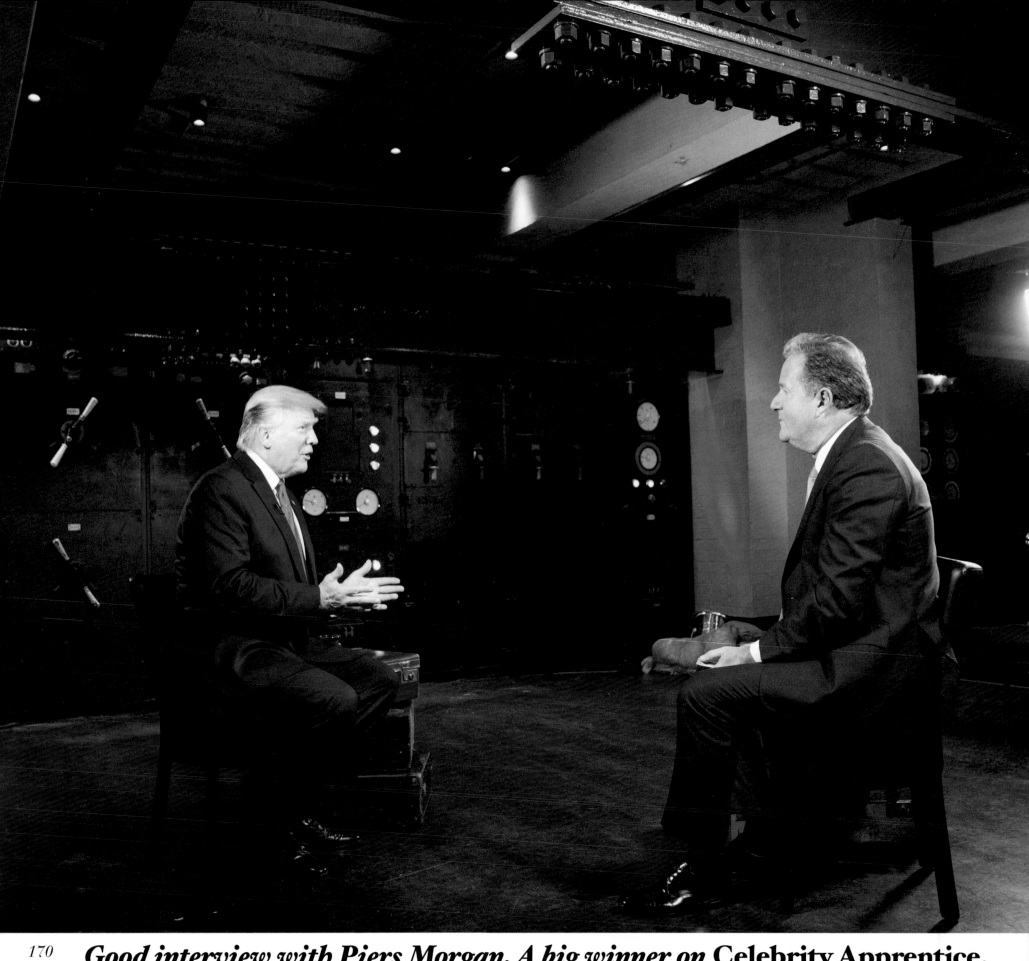

***Good interview with Piers Morgan. A big winner on* Celebrity Apprentice.**

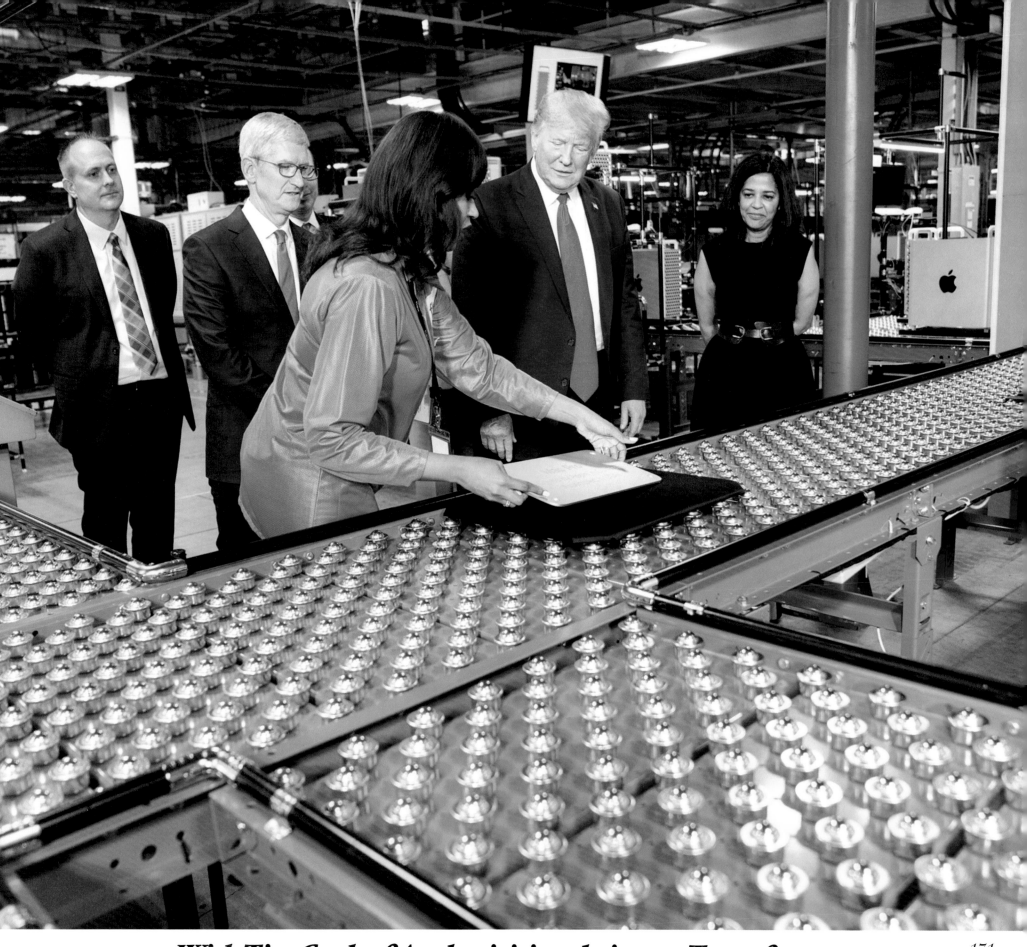

With Tim Cook of Apple visiting their new Texas factory.

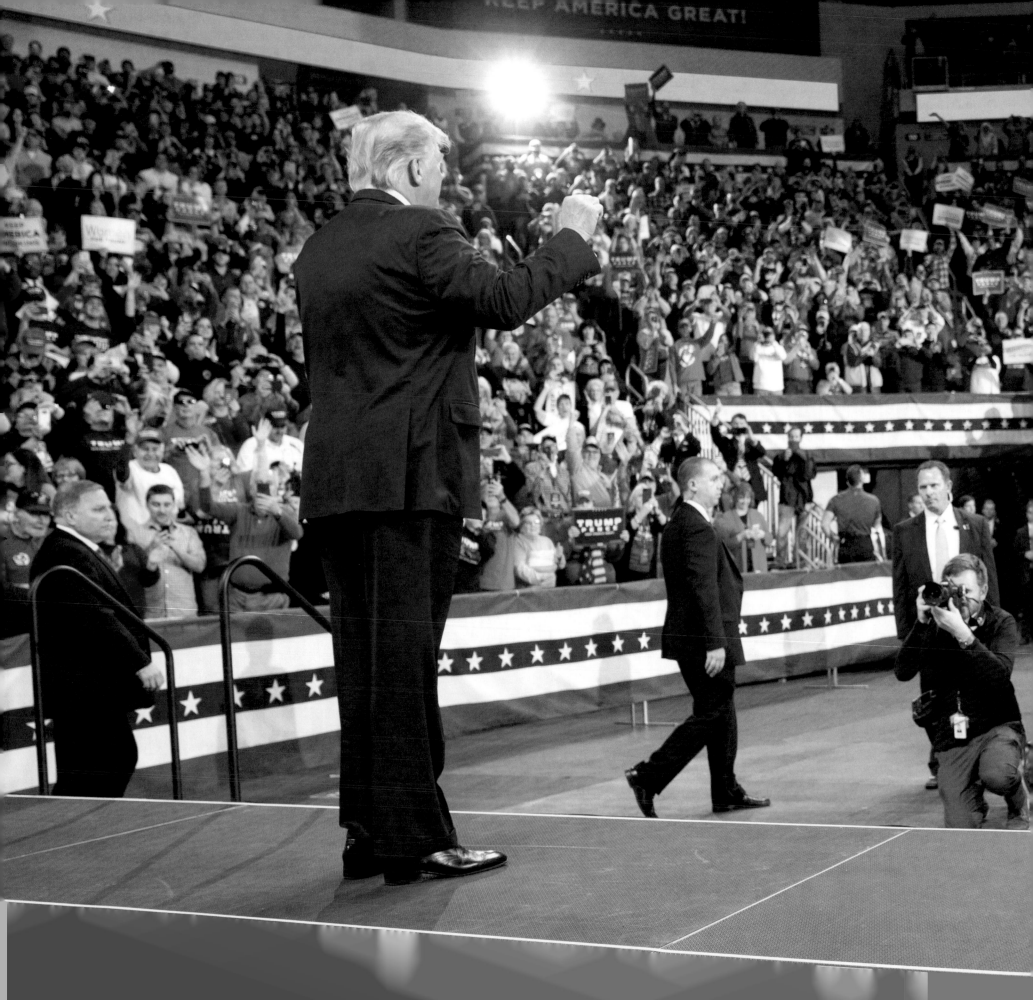

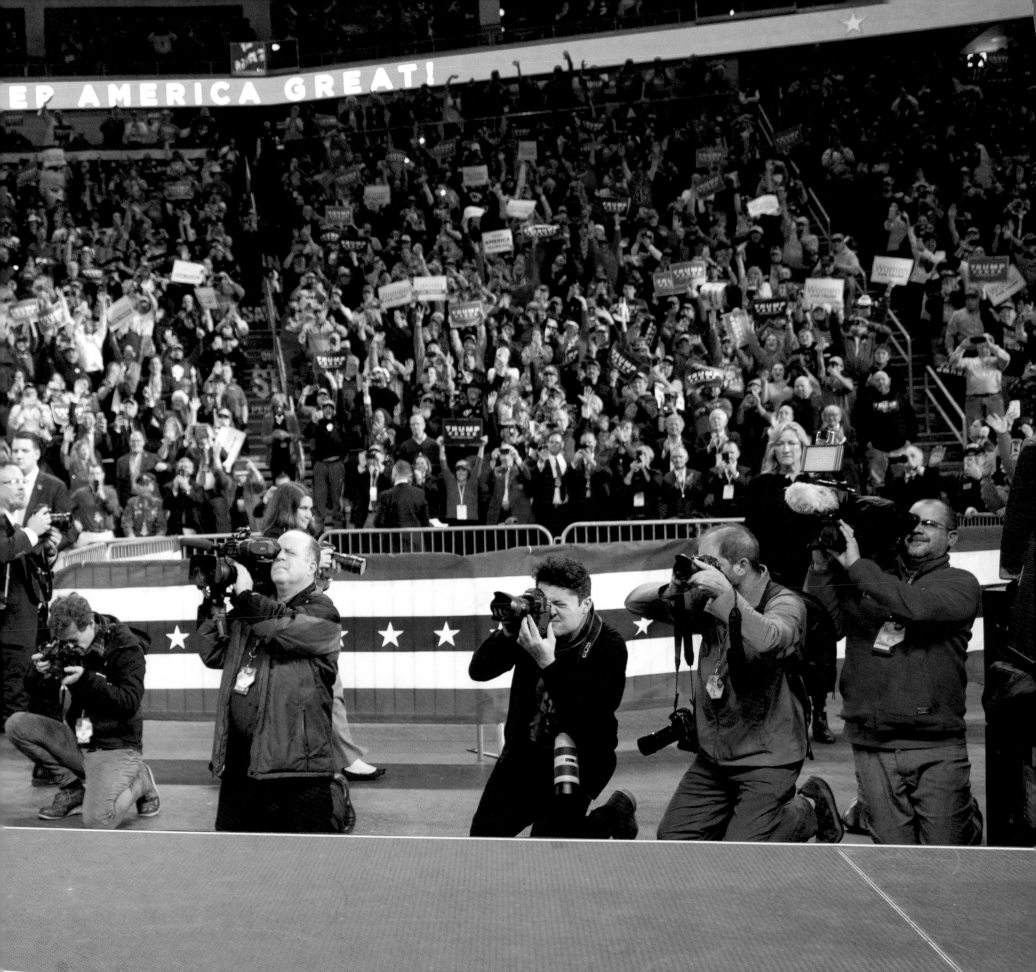

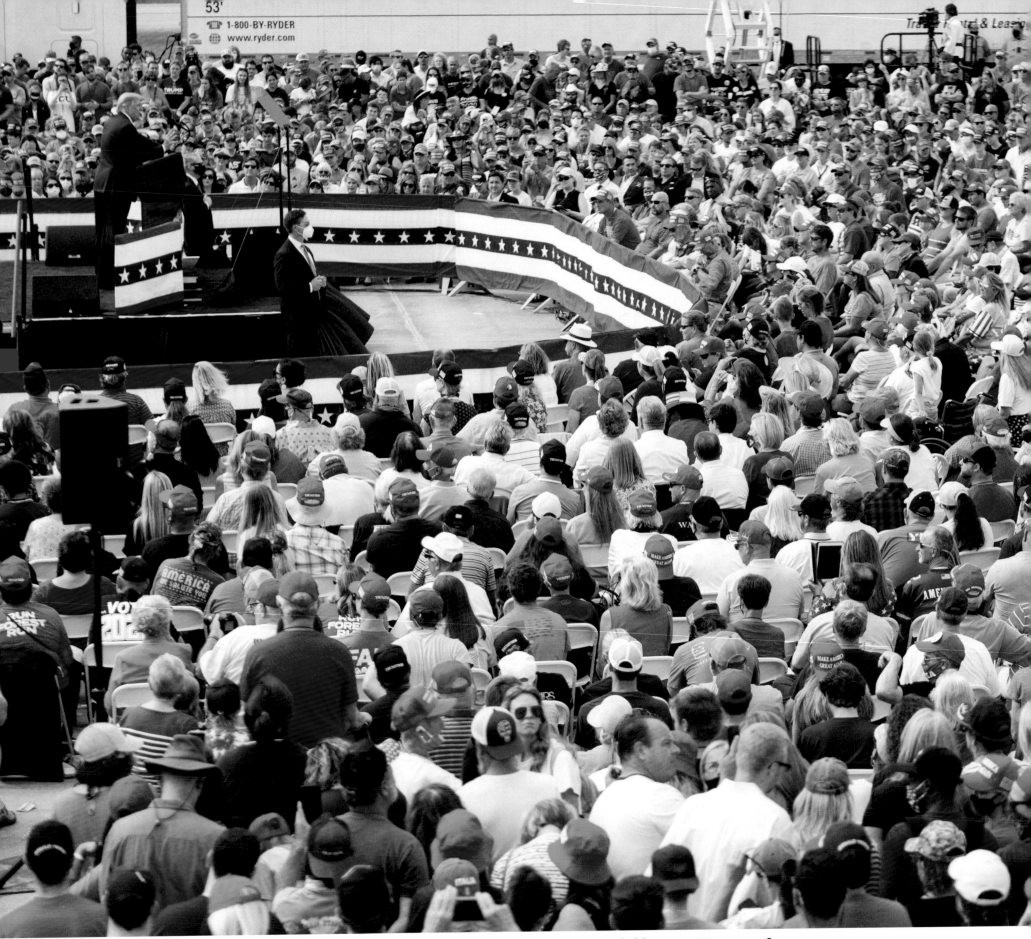

There's a lot of love in the Republican Party!

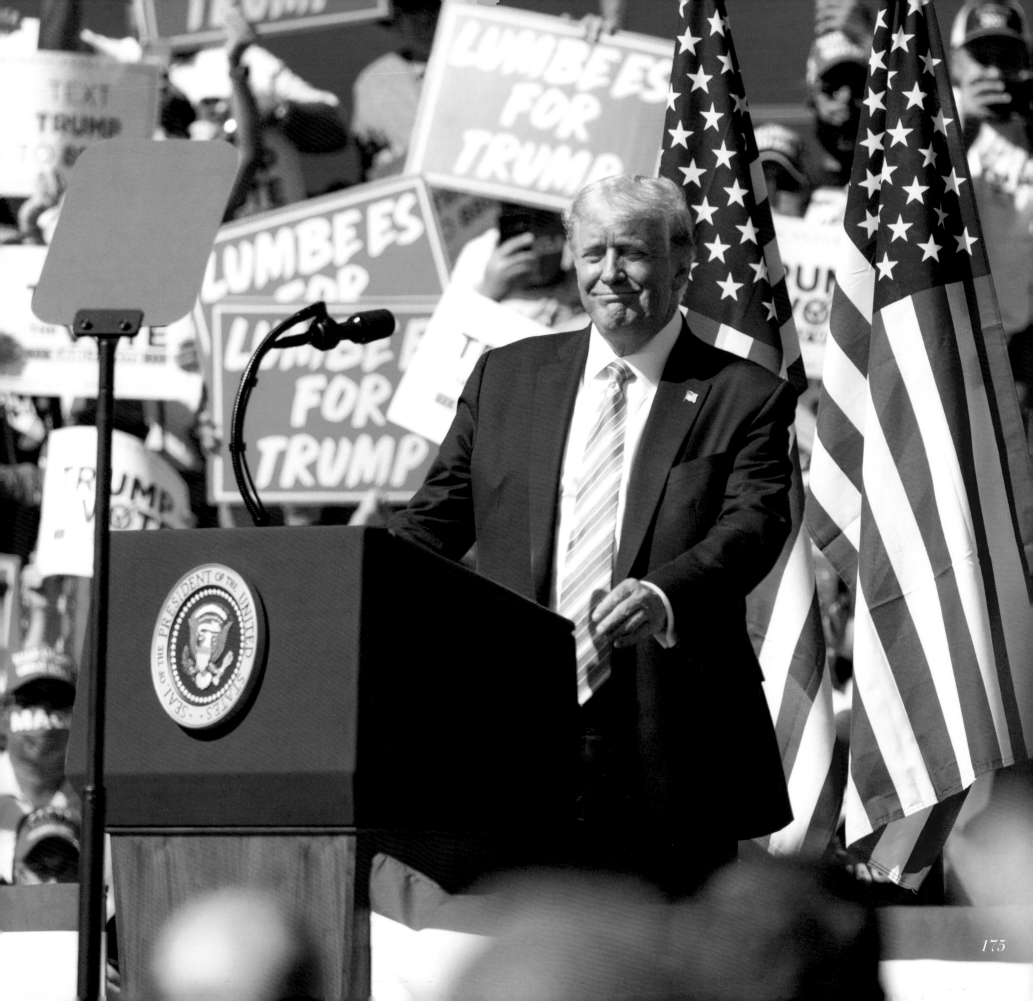

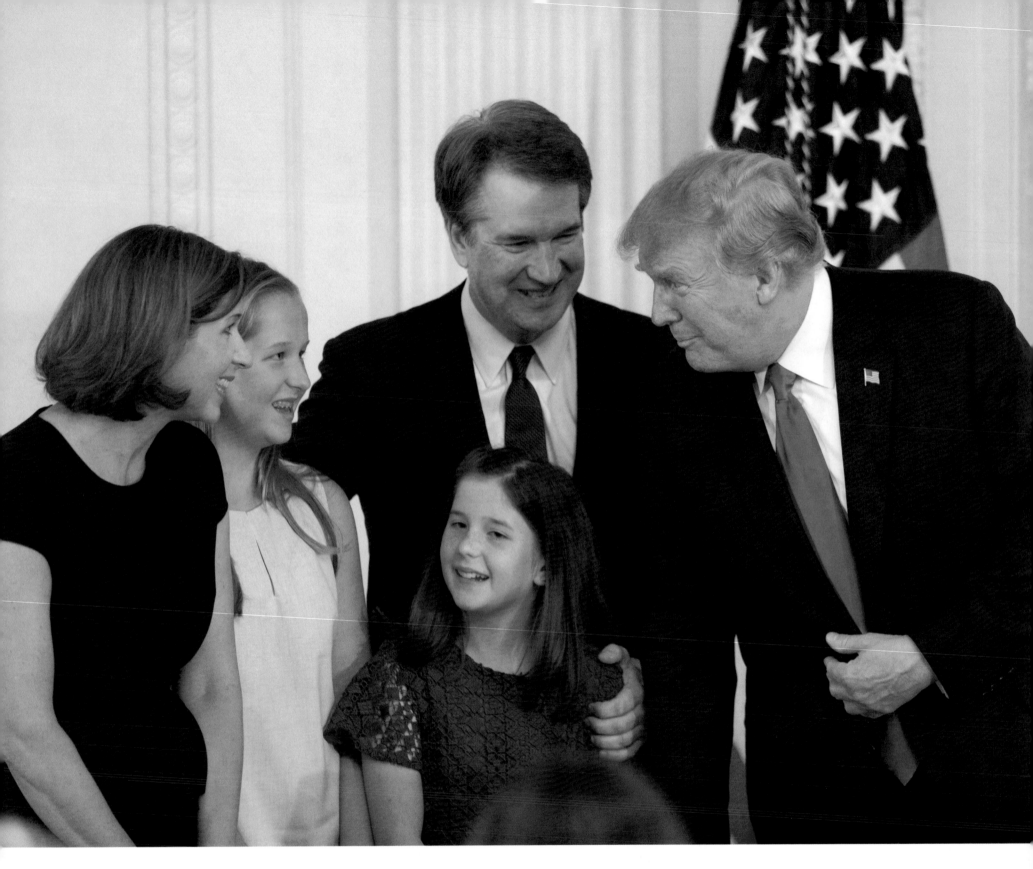

Brett Kavanaugh is joined by his wonderful wife, Ashley, and daughters Liza and Margaret, on the announcement of his nomination to the United States Supreme Court.

REMAKING THE FEDERAL JUDICIARY INFO SHEET

Appointed a historic number of Federal judges who will interpret the Constitution as written.

Nominated and confirmed over 230 Federal judges.

Confirmed 54 judges to the United States Courts of Appeals, making up nearly a third of the entire appellate bench.

Filled all Court of Appeals vacancies for the first time in four decades.

Flipped the Second, Third, and Eleventh Circuits from Democrat-appointed majorities to Republican-appointed majorities. And dramatically reshaped the long-liberal Ninth Circuit.

Appointed three Supreme Court justices, expanding its conservative-appointed majority to 6-3.

Appointed Justice Neil Gorsuch to replace Justice Antonin Scalia.

Appointed Justice Brett Kavanaugh to replace Justice Anthony Kennedy.

Appointed Justice Amy Coney Barrett to replace Justice Ruth Bader Ginsburg.

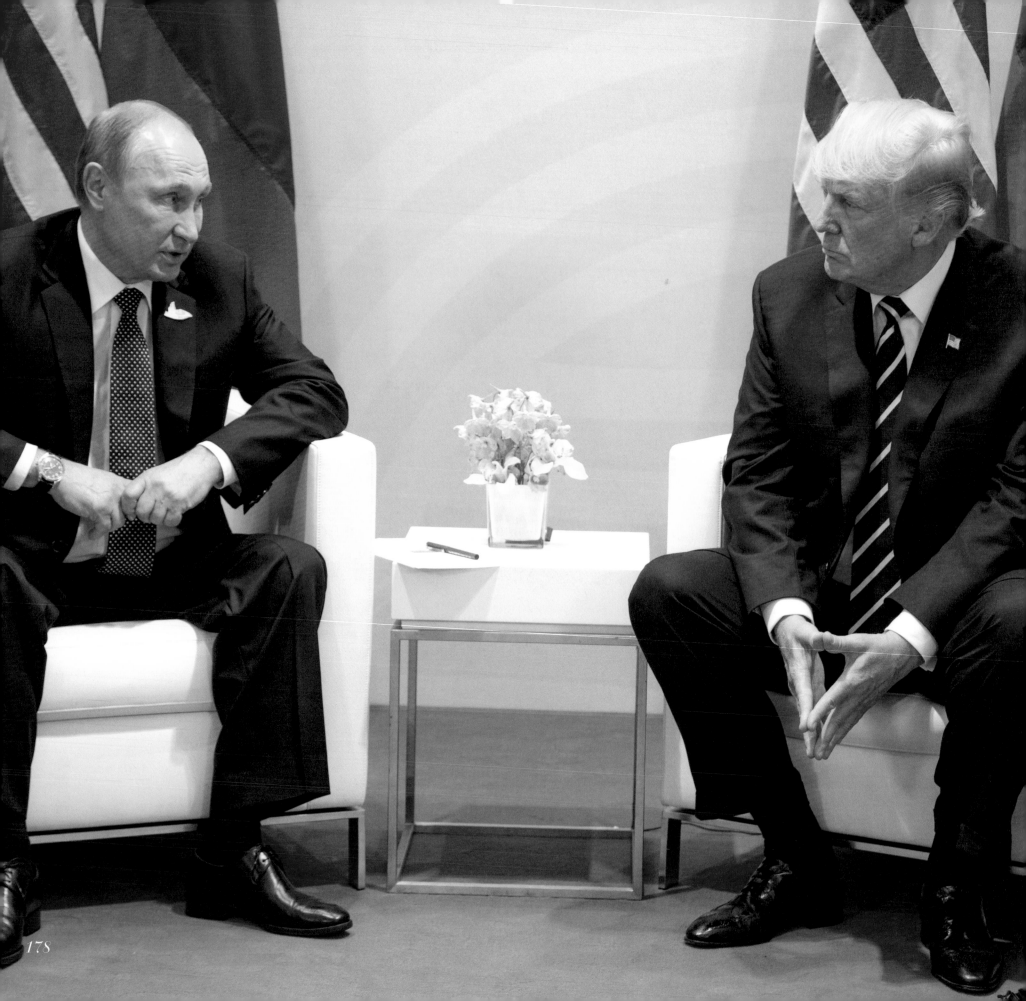

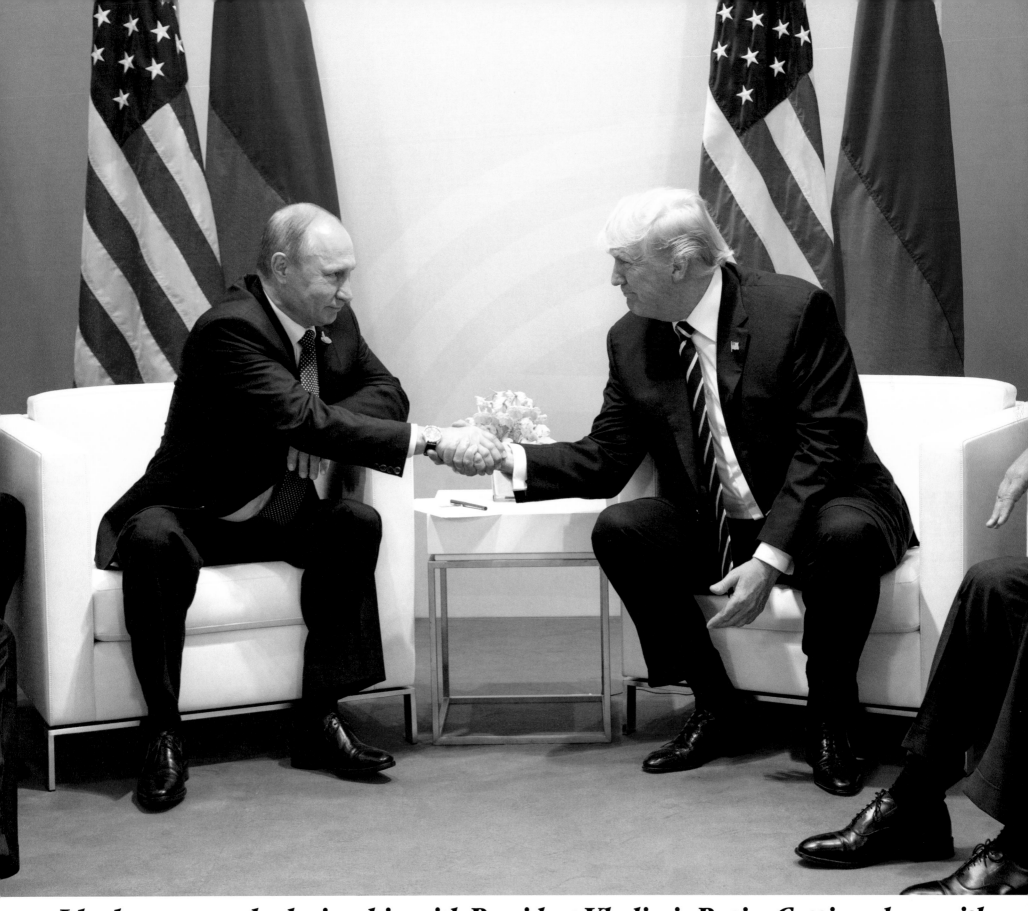

I had a very good relationship with President Vladimir Putin. Getting along with nations like Russia is a good and positive thing for the security of our country.

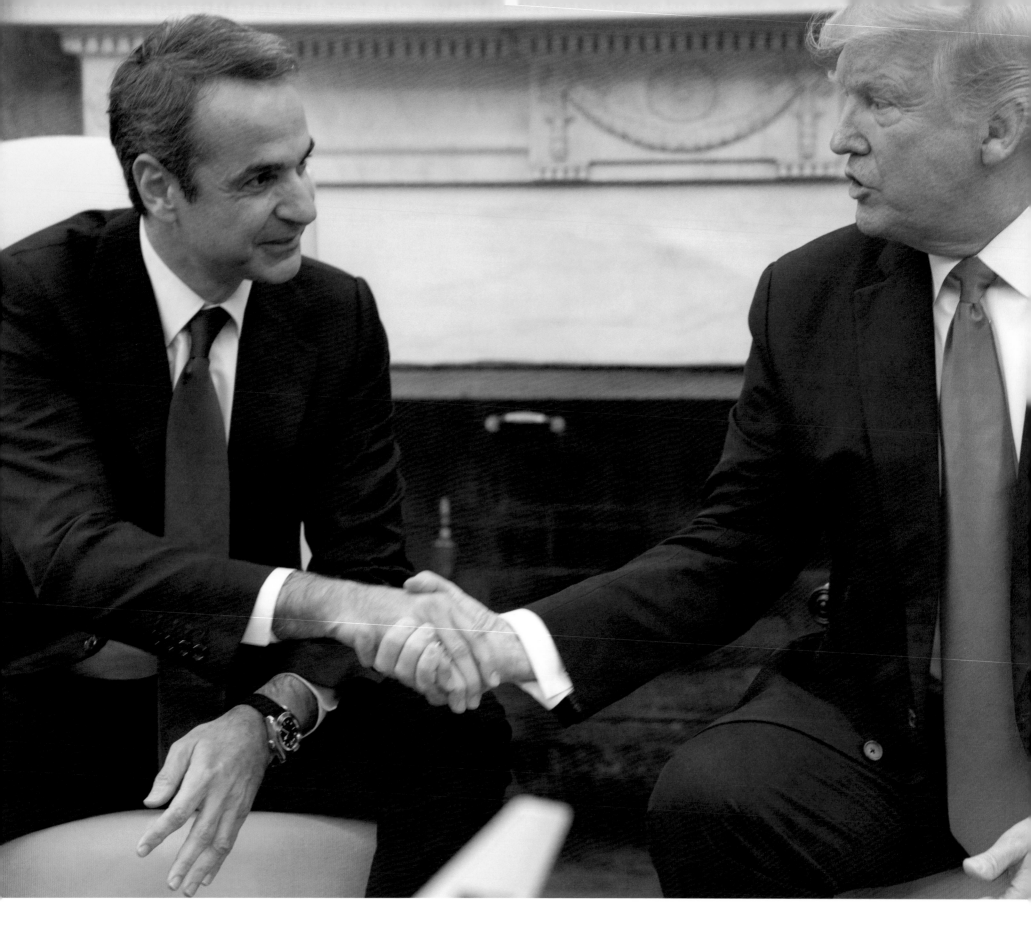

The Greek Prime Minister, Kyriakos Mitsotakis—*a patriot for Greeks.*

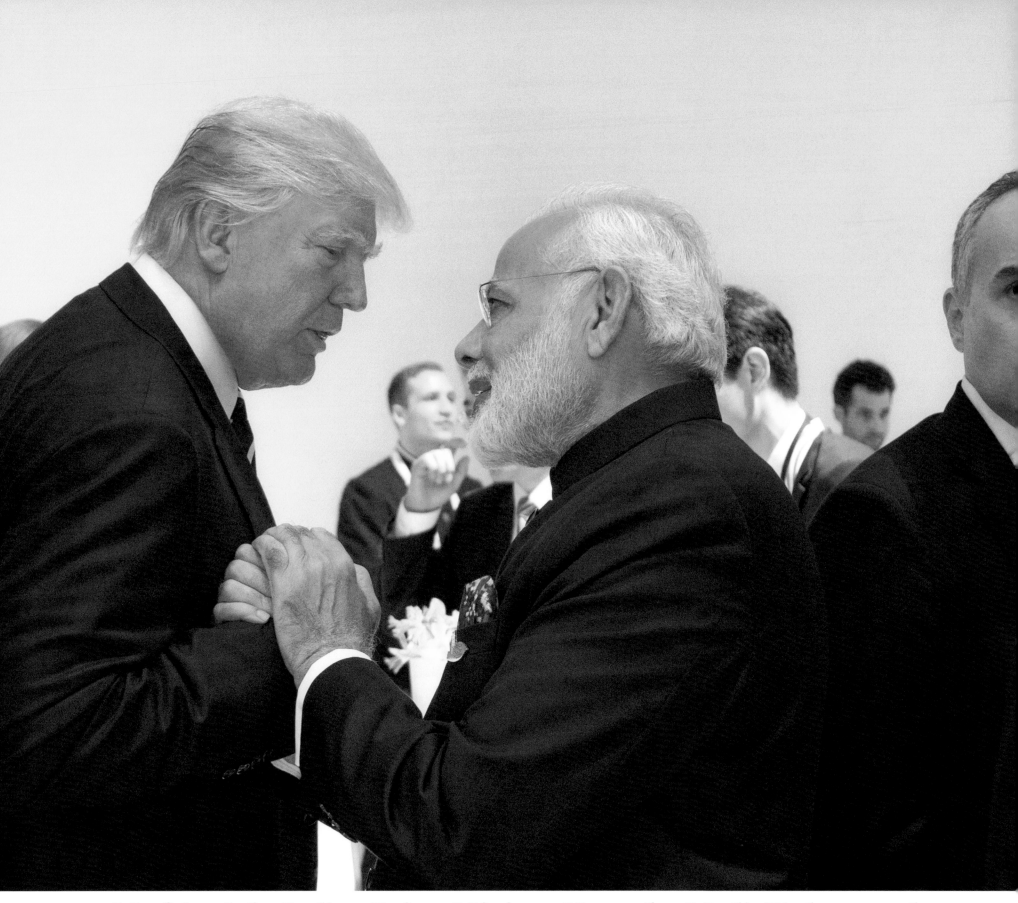

My friend the Indian Prime Minister Narendra Modi. He loves and stands up for his country. We had a great relationship!

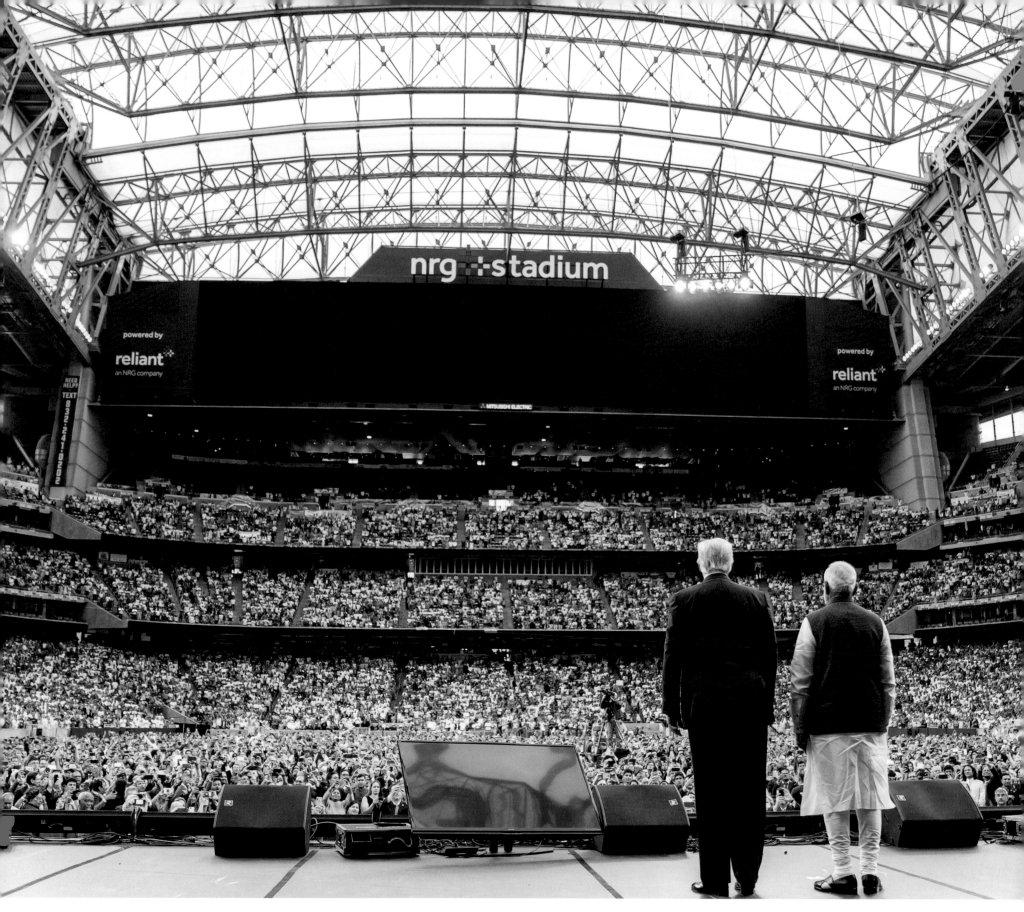

Prime Minister Narendra Modi visits the United States.
Over 60,000 people joined us in Houston!

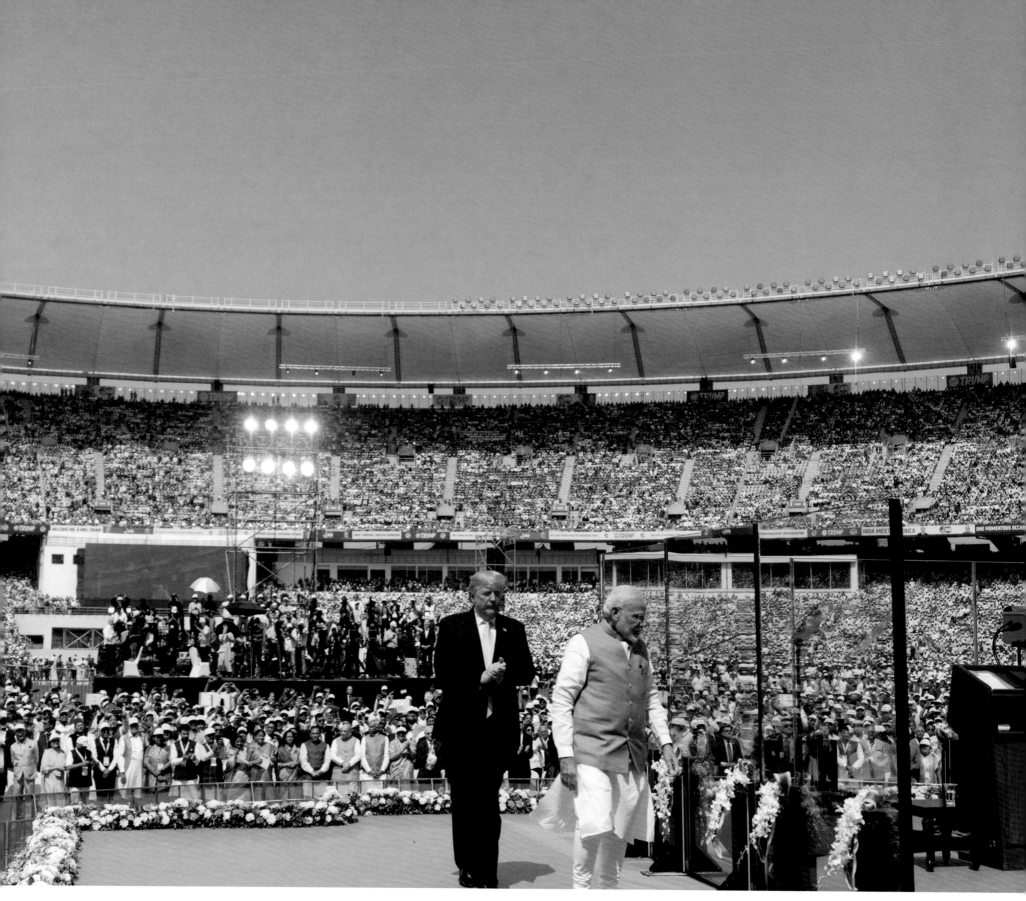

Over 150,000 people showed up to greet me in this great new stadium in Gujarat, India. A completely packed house!

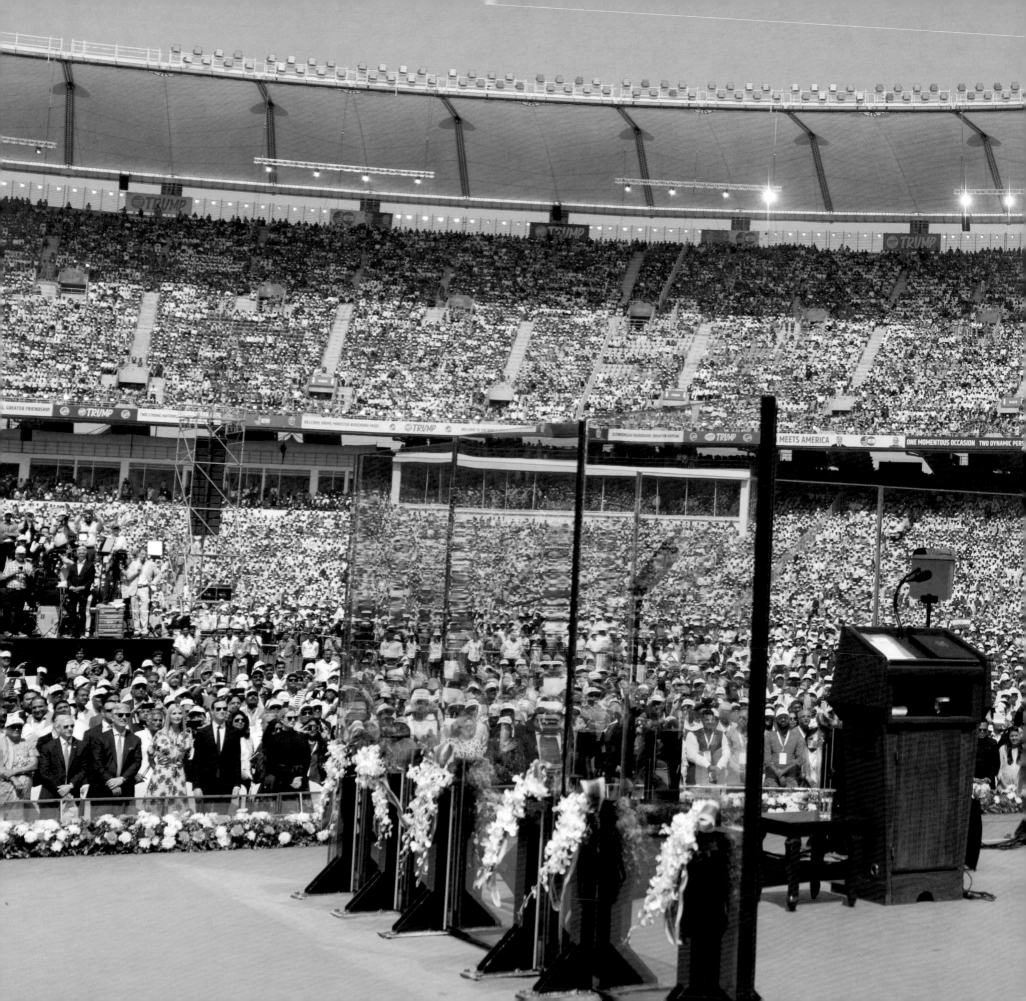

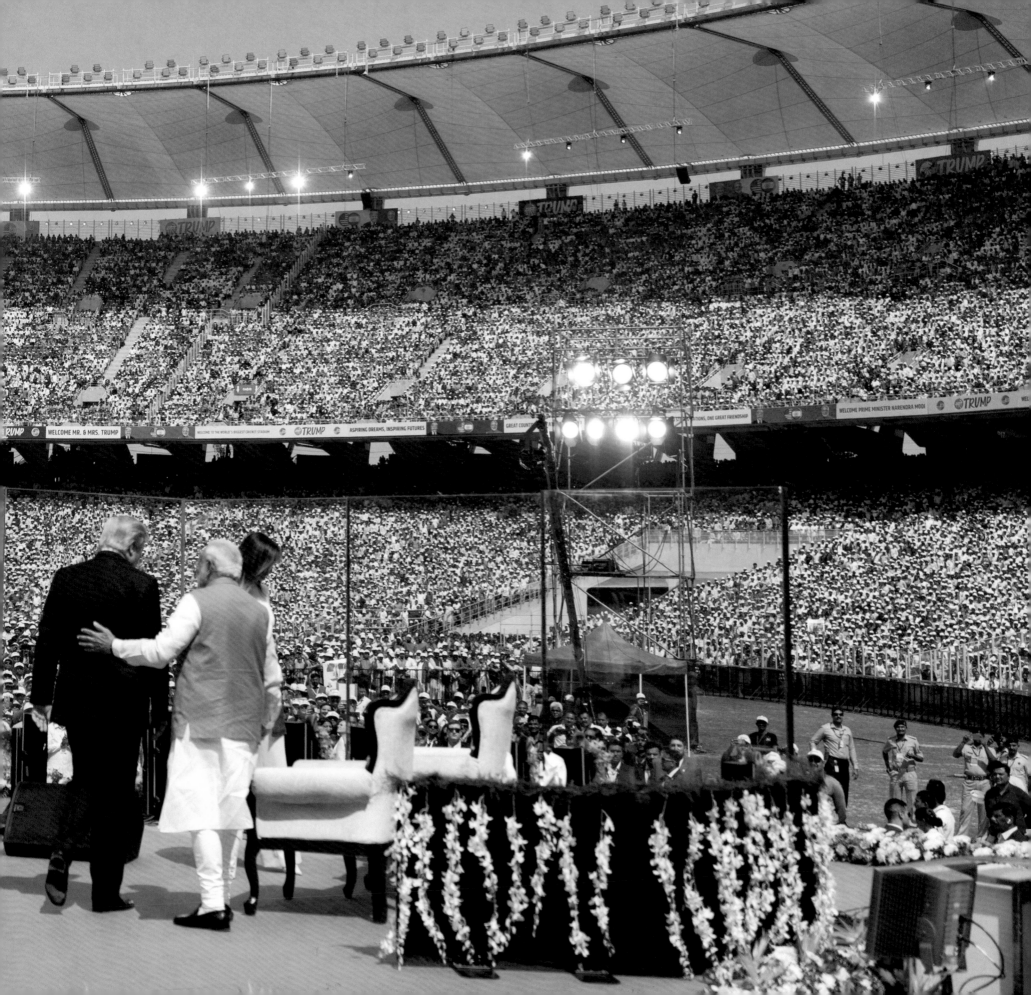

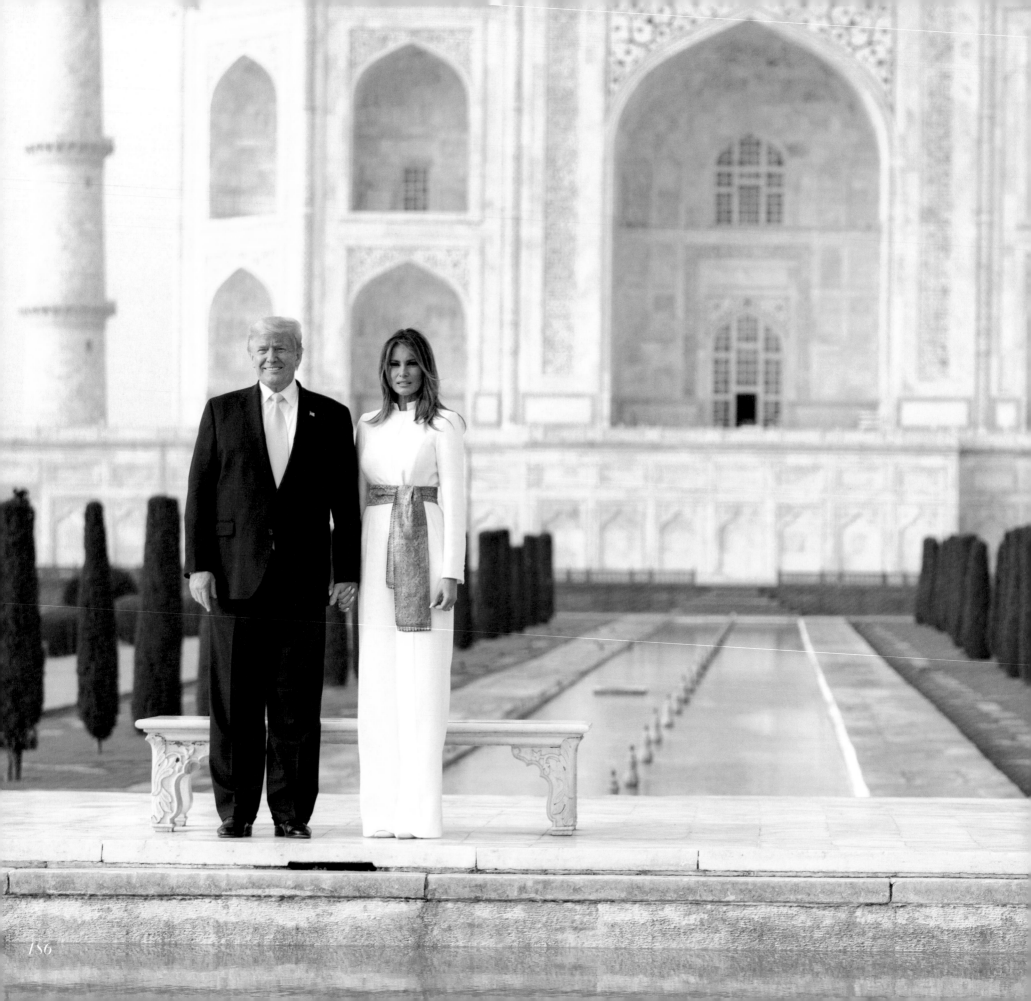

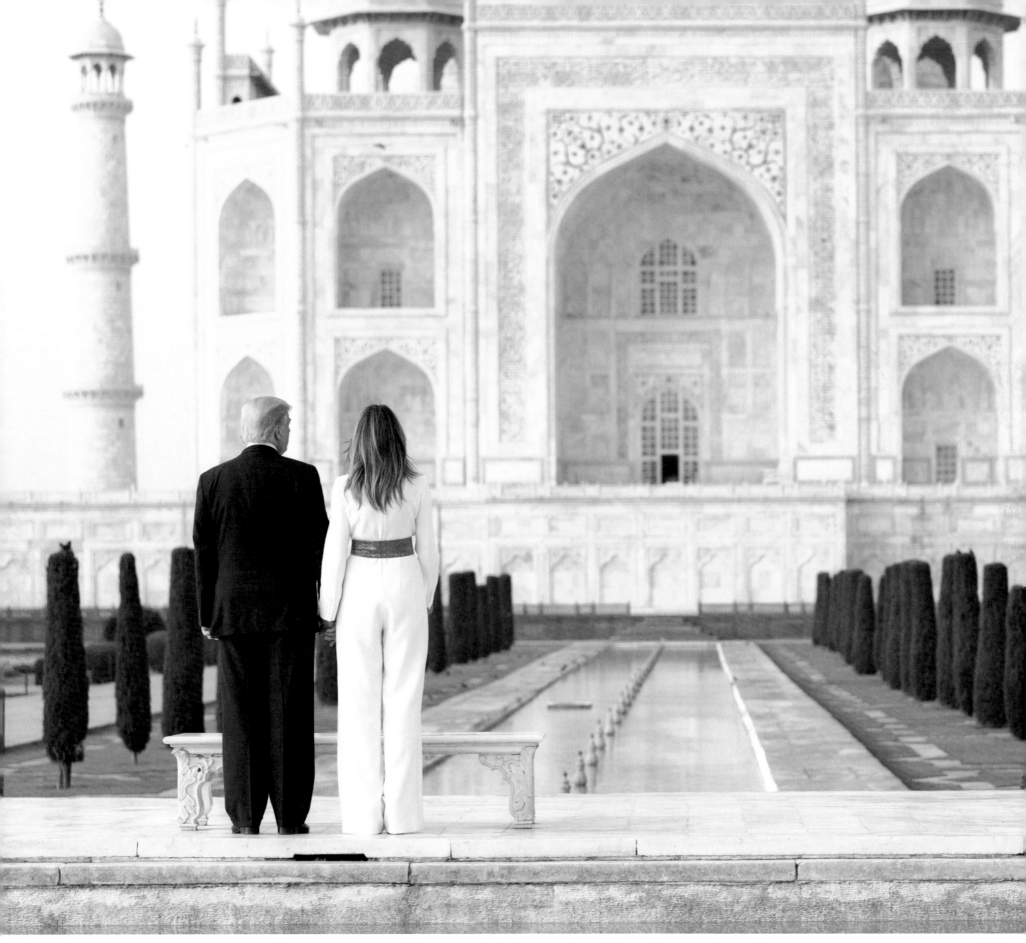

The extraordinary Taj Mahal in Agra, India.

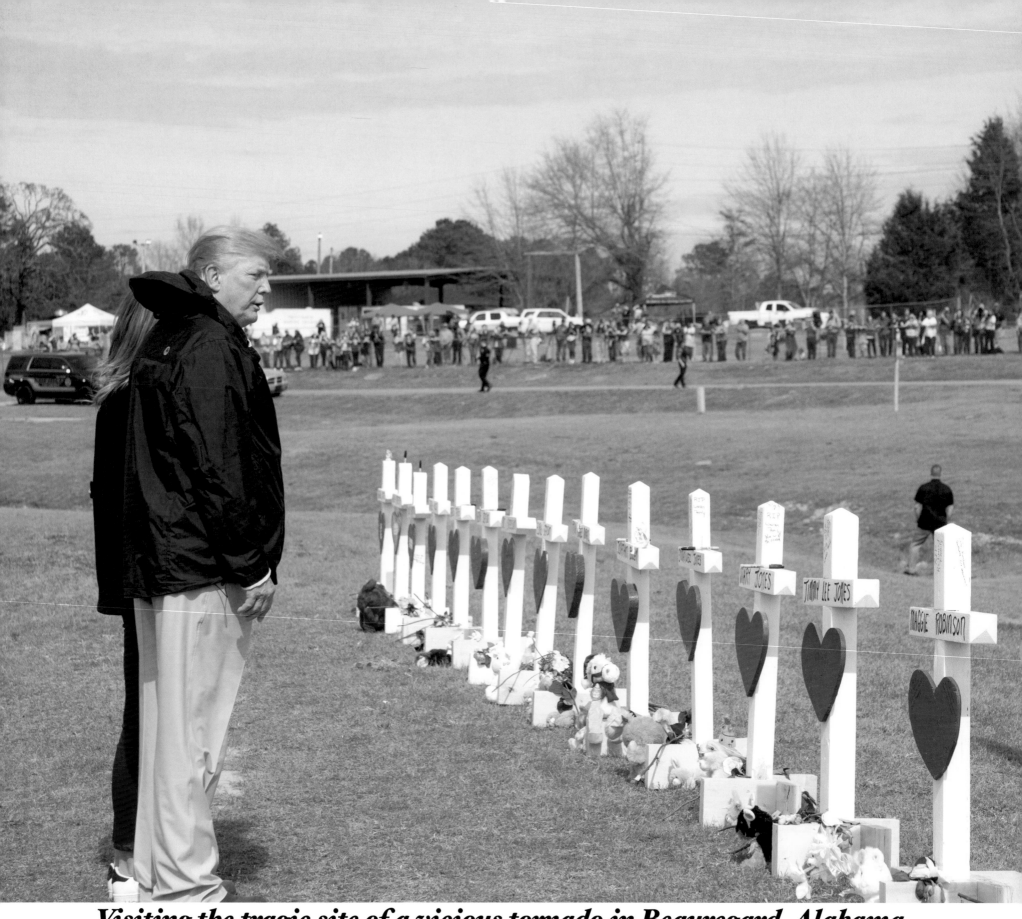

Visiting the tragic site of a vicious tornado in Beauregard, Alabama.
A terrible day for our nation to lose so many innocent lives.

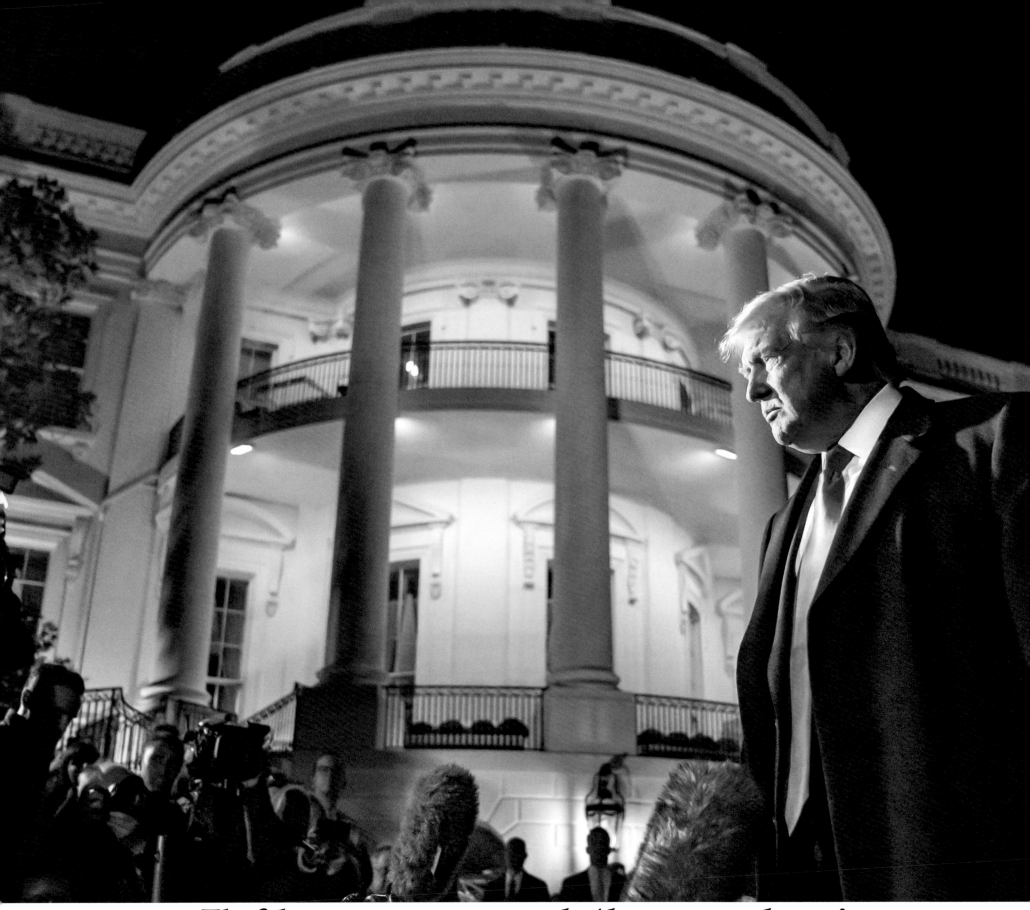

The fake news never got enough. Always wanted more!
Someday they will report the truth, and our country will be united again. 189

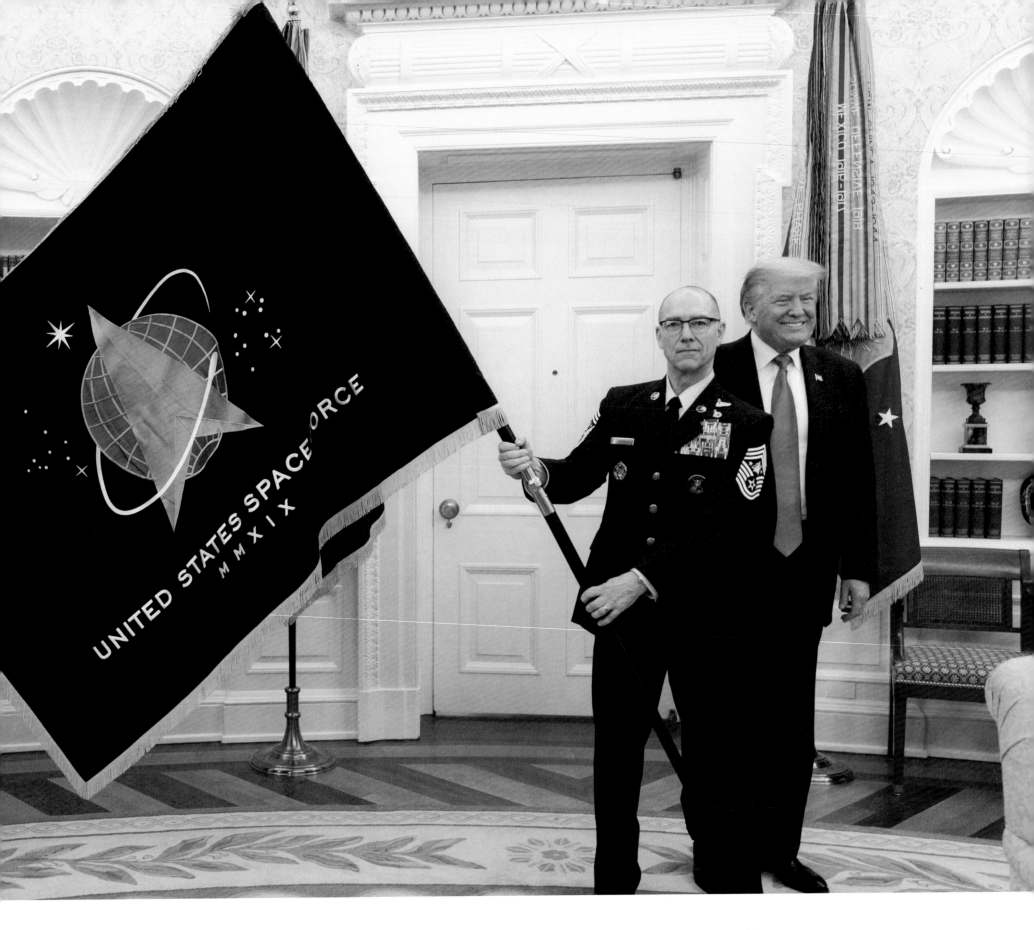

The United States Space Force is now a reality.

A real legend, Conan, a Malinois Special Forces military dog, took part in the operation that brought justice to Abu Bakr al-Baghdadi.

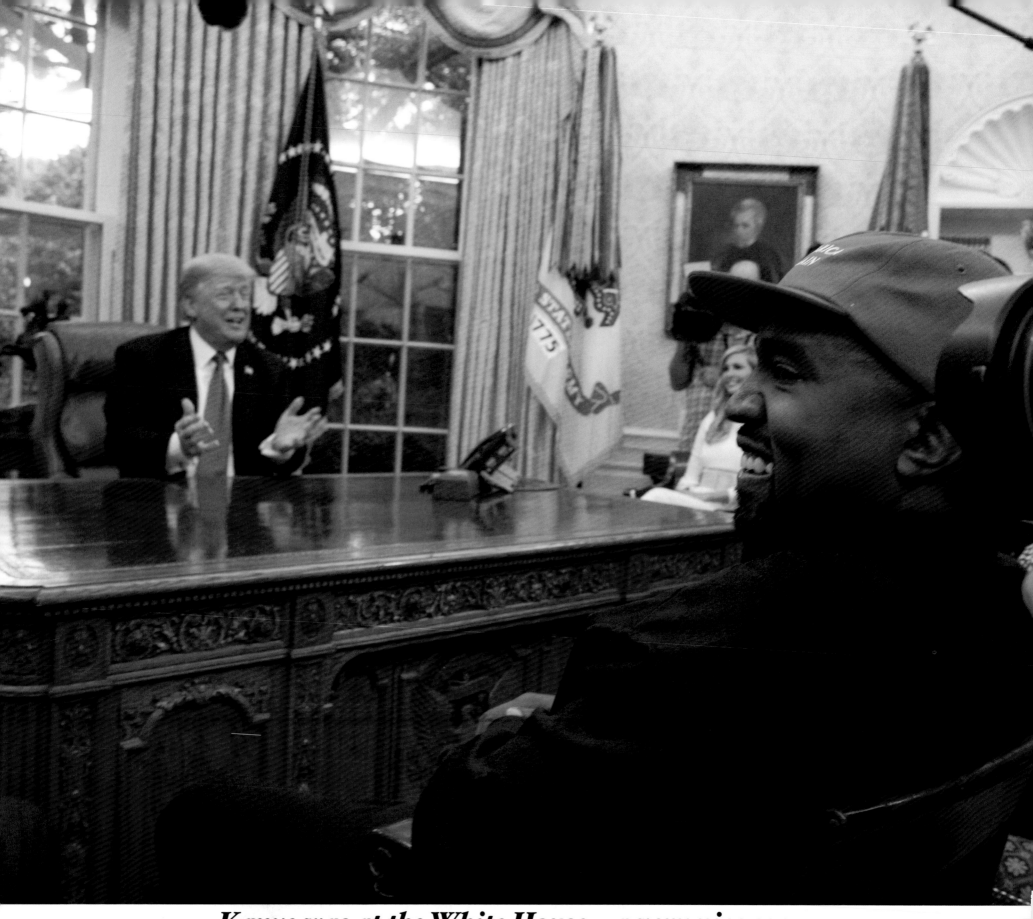

Kanye was at the White House—a very nice guy and supportive of much of what we were doing!

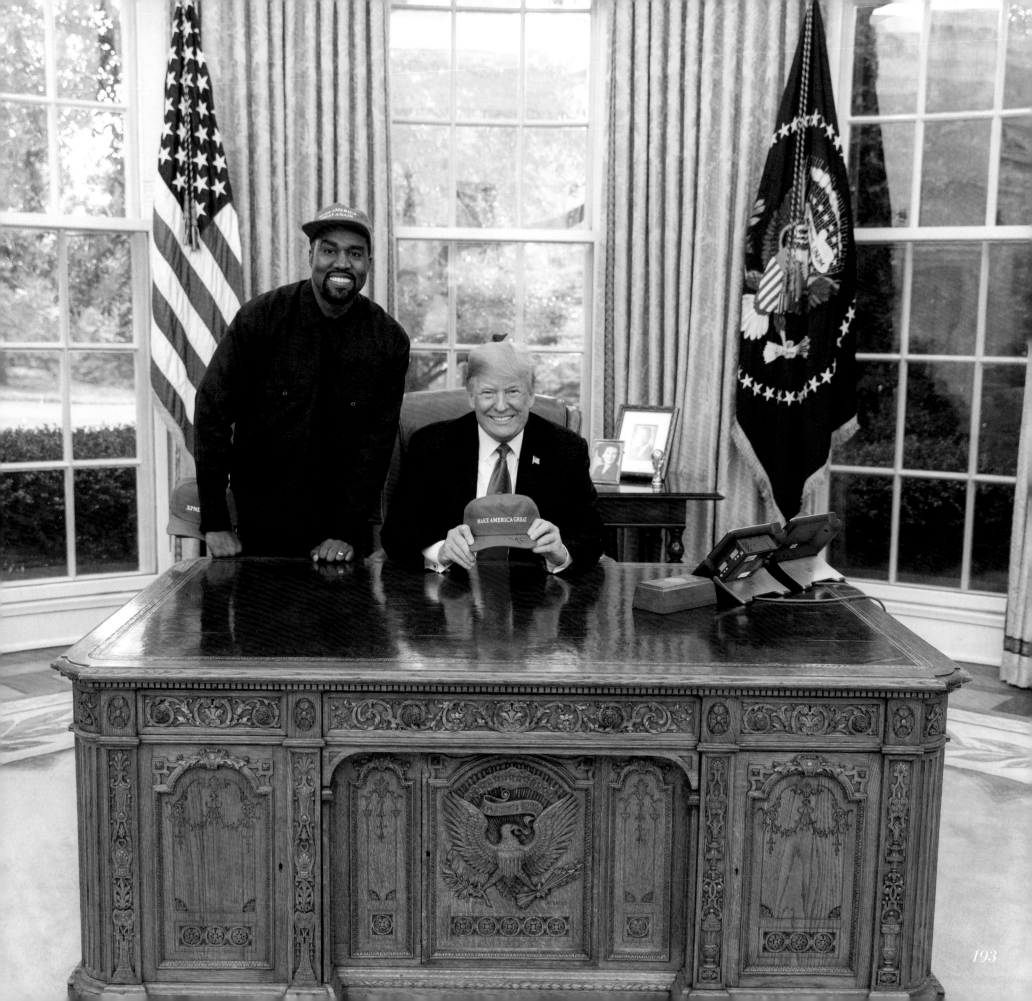

Jeff Van Drew, a highly respected Democrat Congressman who switched his party to Republican. Happens very seldom. We are glad to have him.

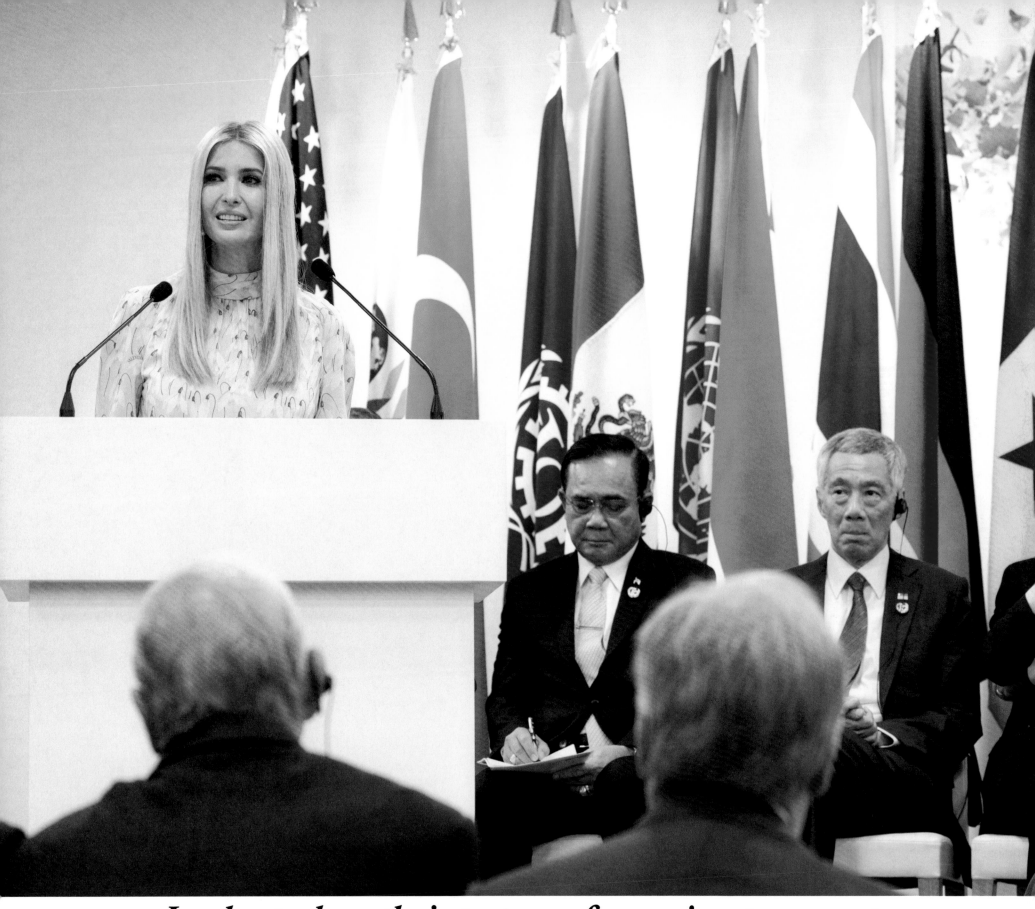

Ivanka speaks on the importance of women's empowerment during the G20 meeting in Japan.

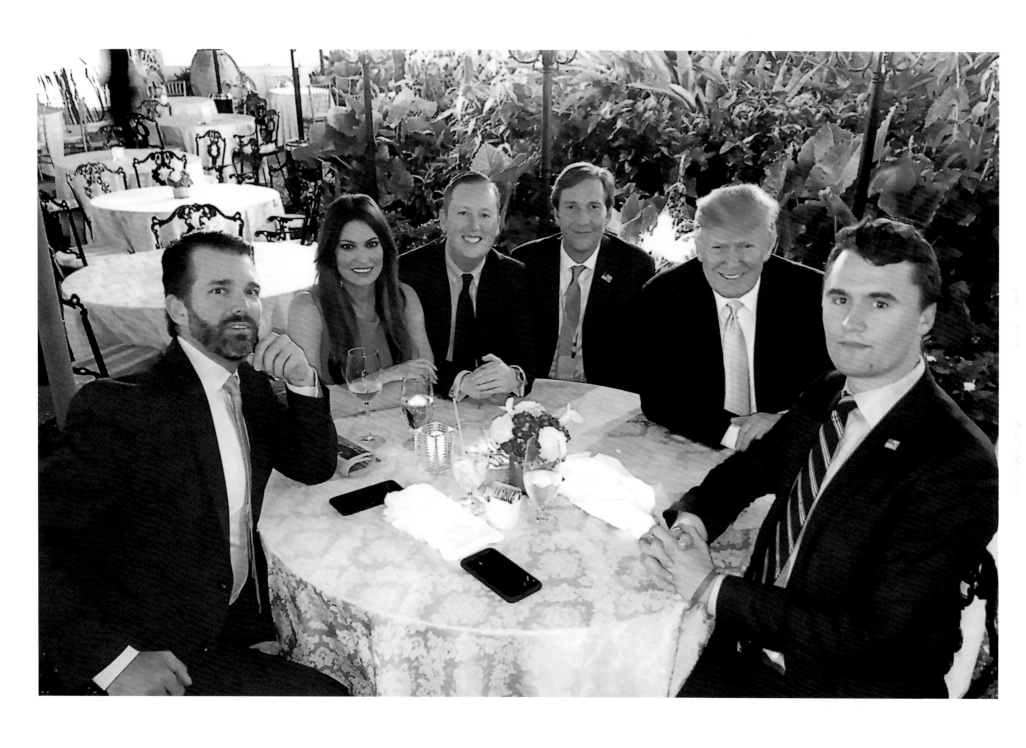

Dinner at the Mar-a-Lago Club with some great patriots, including Don, Kimberly Guilfoyle, Sergio Gor, Tommy Hicks, and Charlie Kirk.

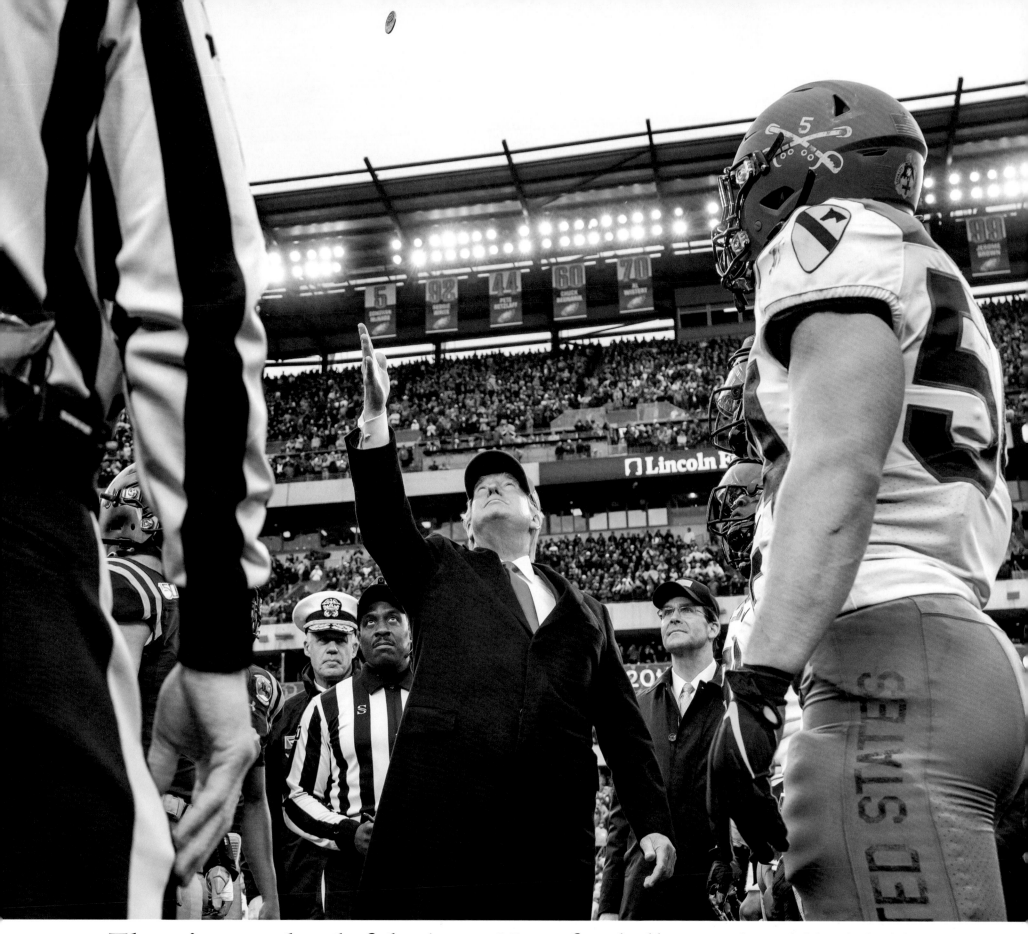

The coin toss ahead of the Army-Navy football game in Philadelphia.

199

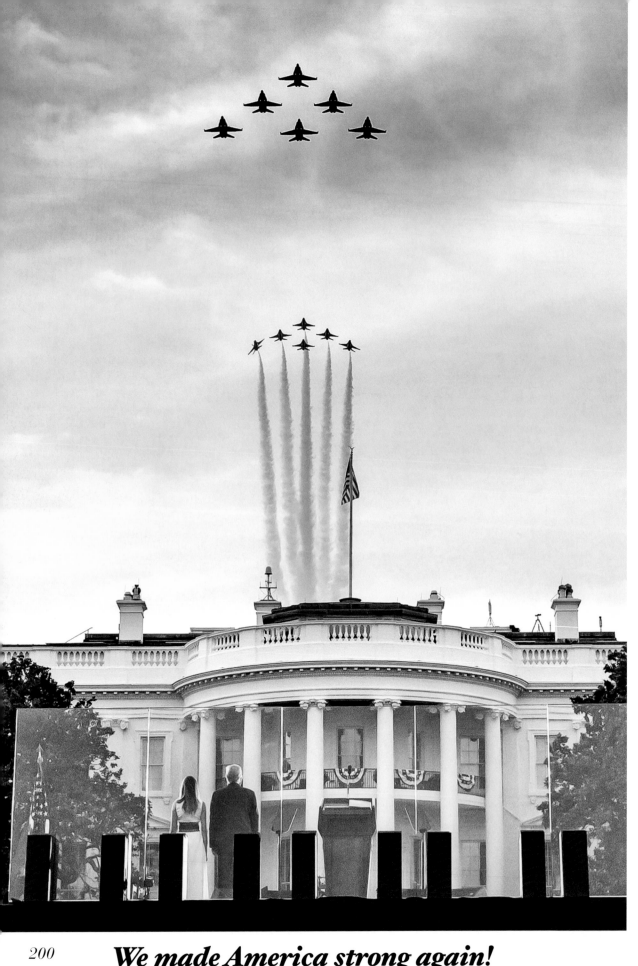

We made America strong again!

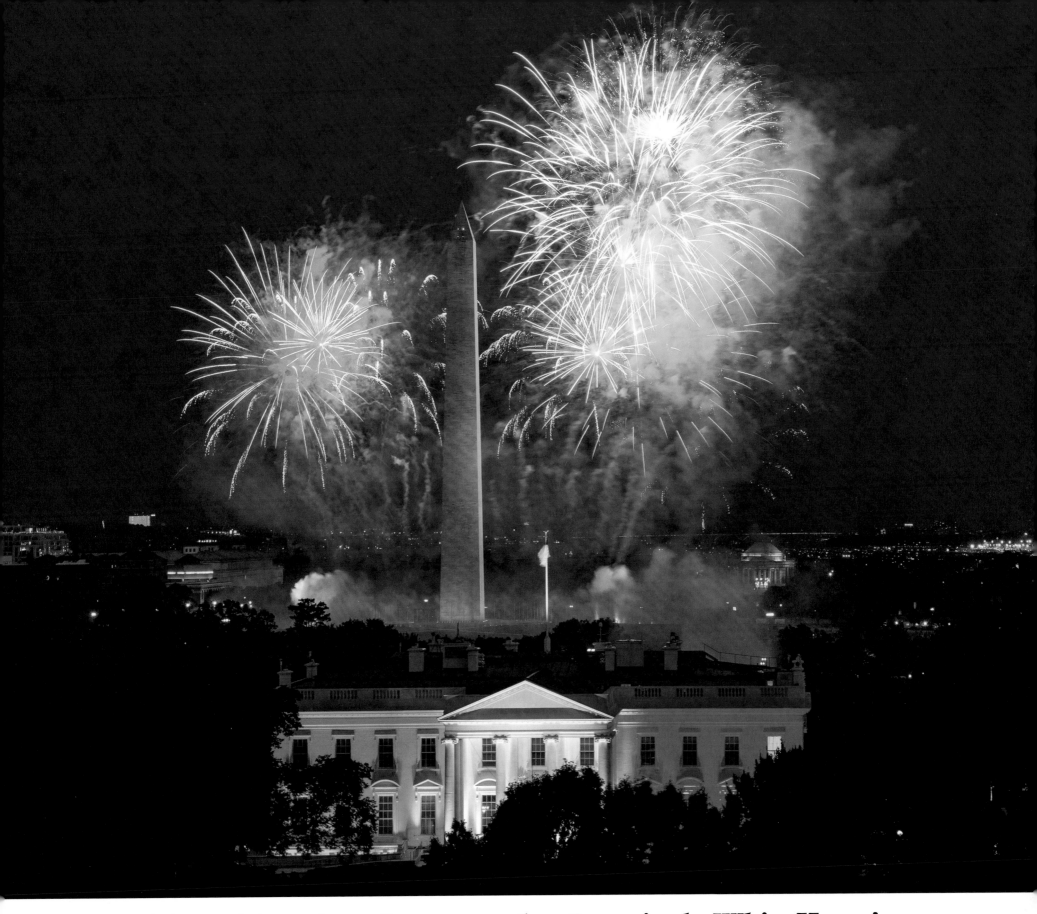

We celebrated American Greatness when I was in the White House!
God Bless America!

201

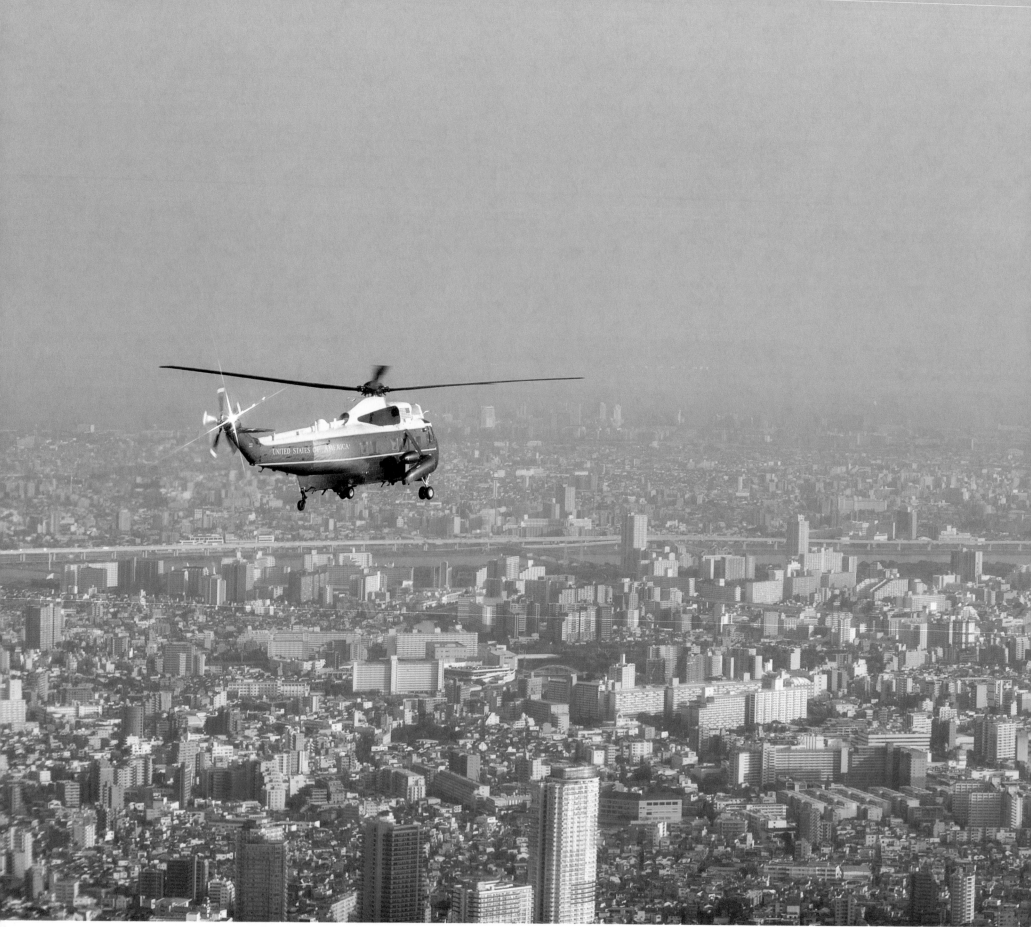

Flying over Tokyo to meet Prime Minister Shinzo Abe.

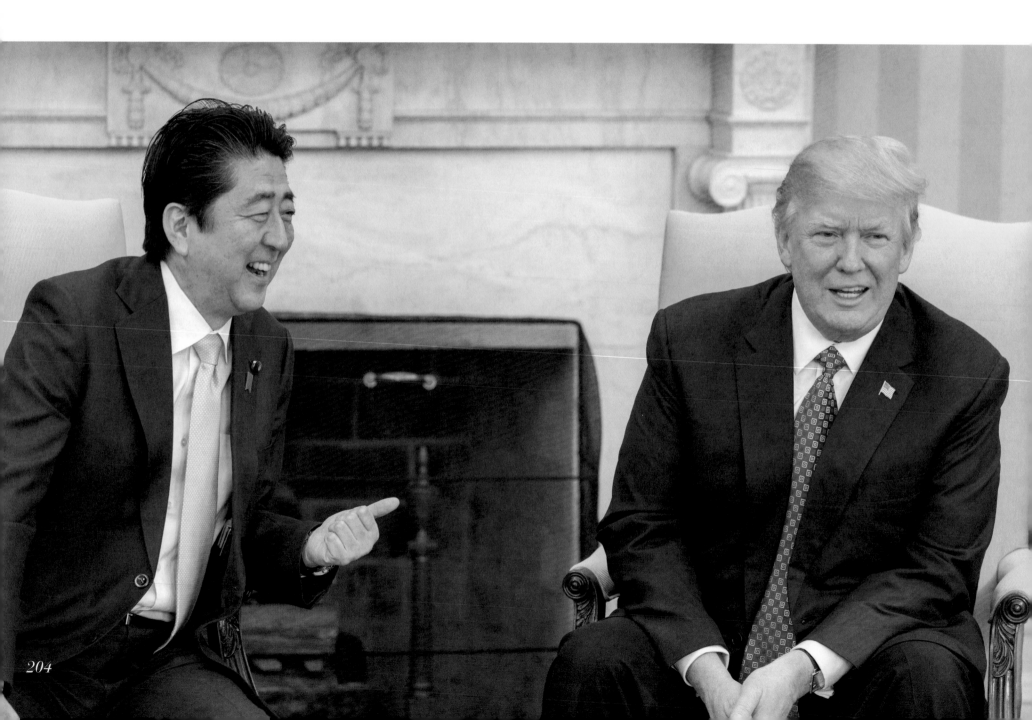

PRime MINISTER ABE OF JAPAN - A great LEADER!

204

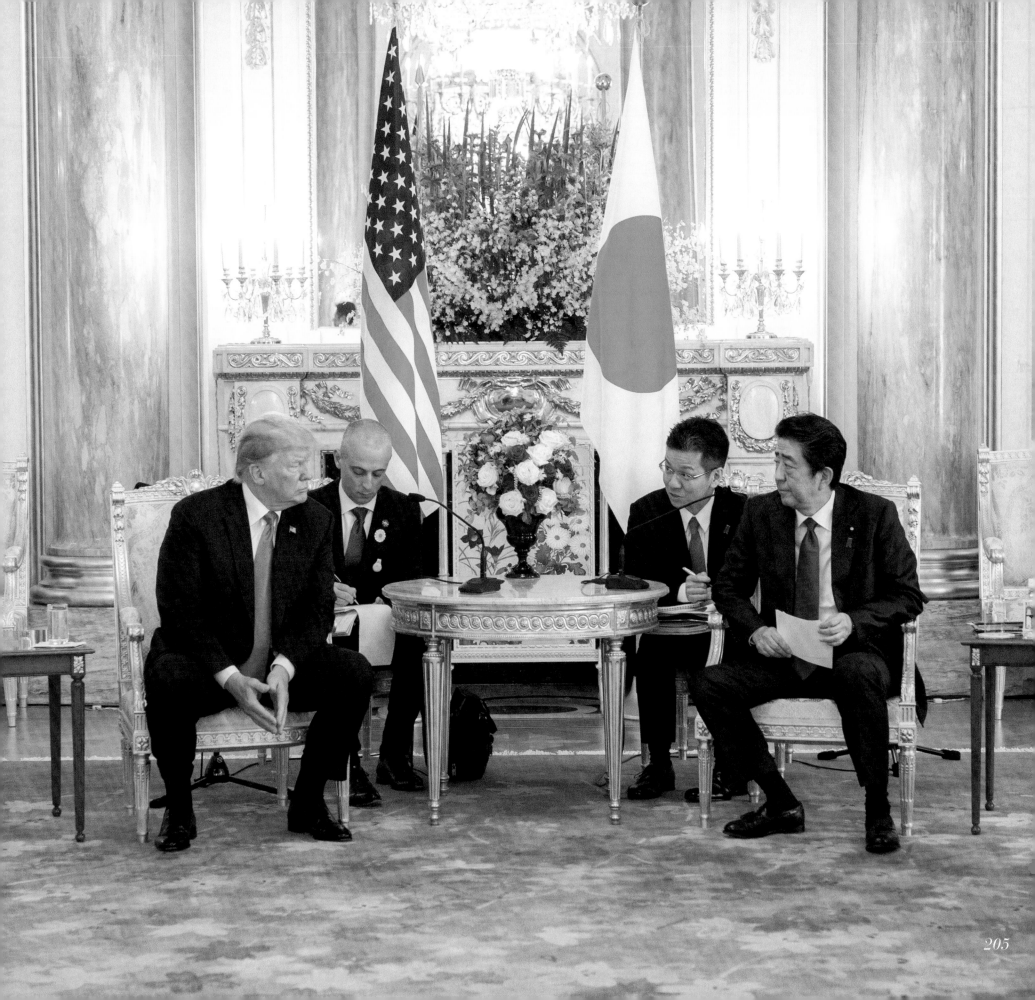

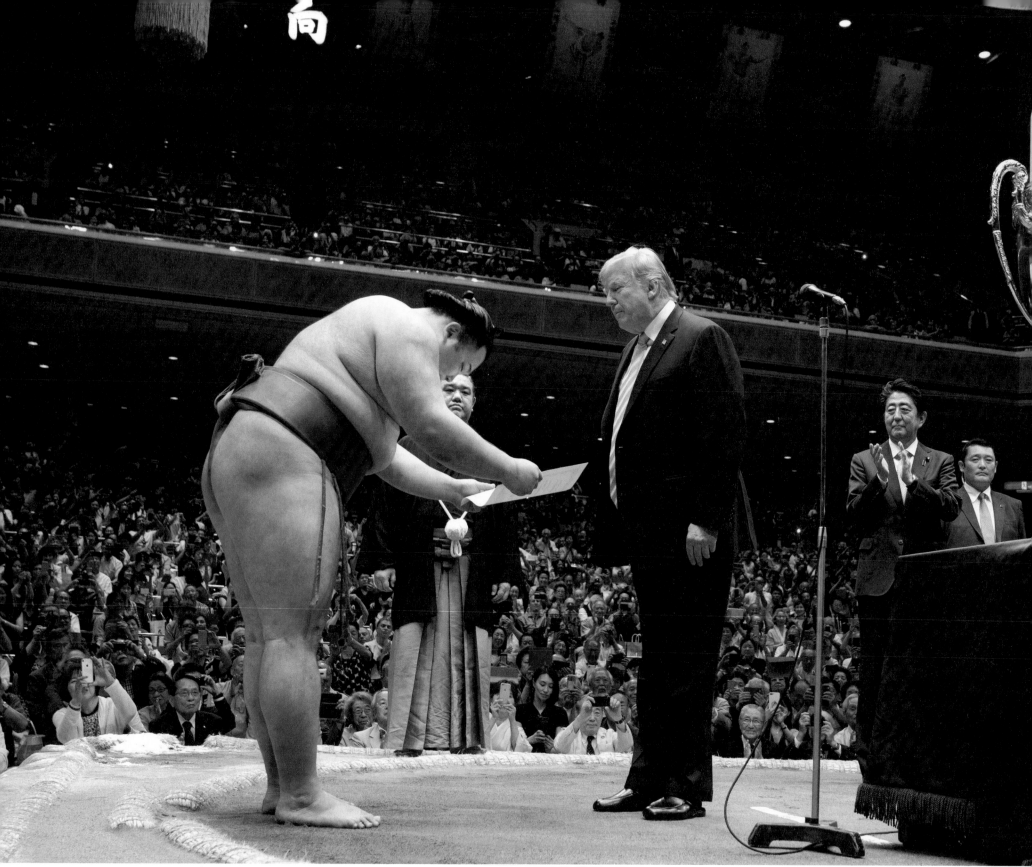

With Prime Minister Abe of Japan giving out the United States President's Cup to the number one sumo wrestler in the world. It was paid for by me personally and will be given out every year by Japan.

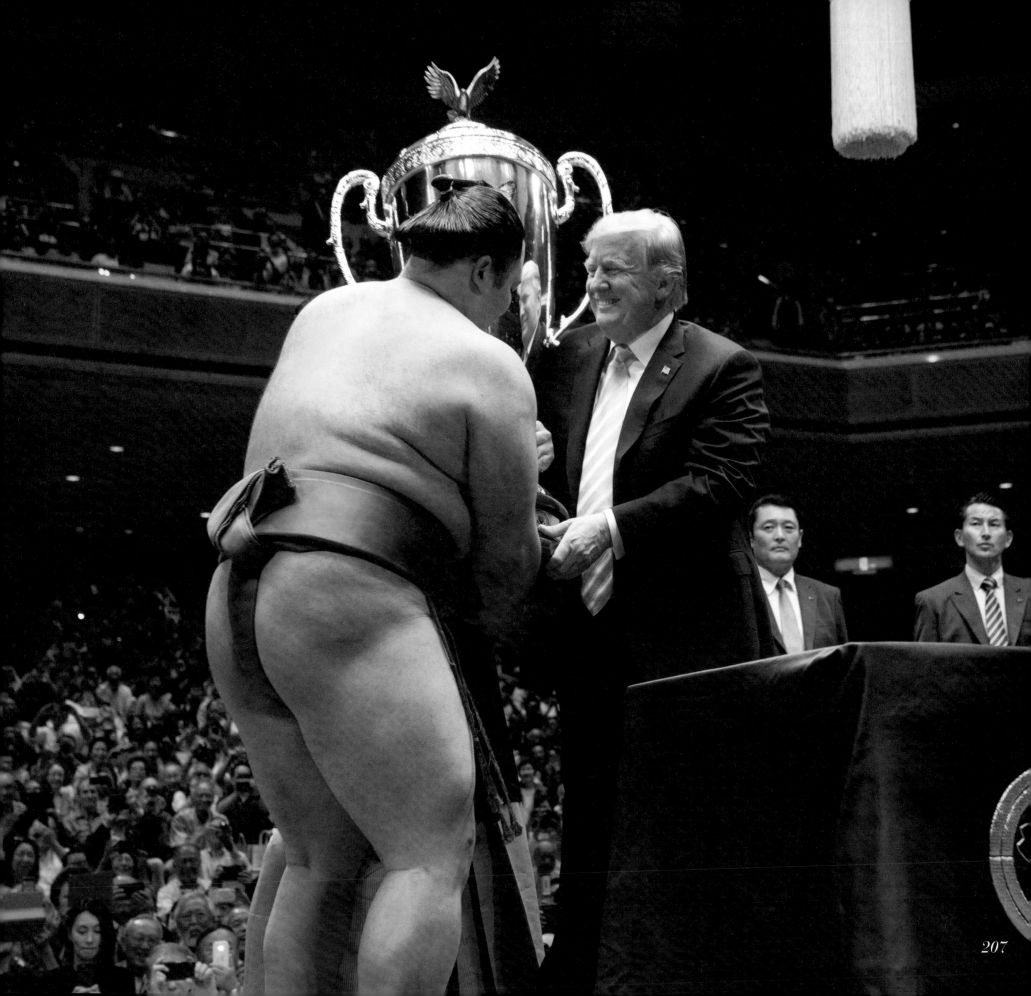

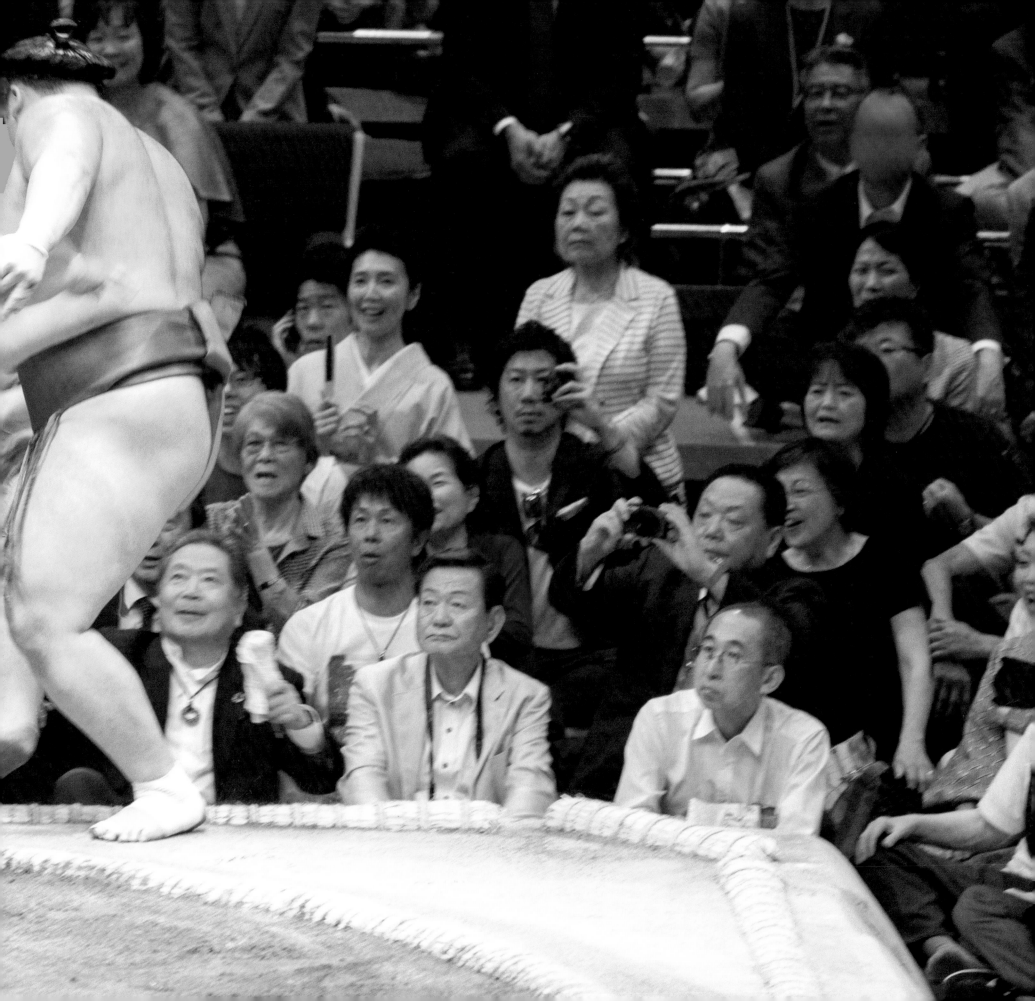

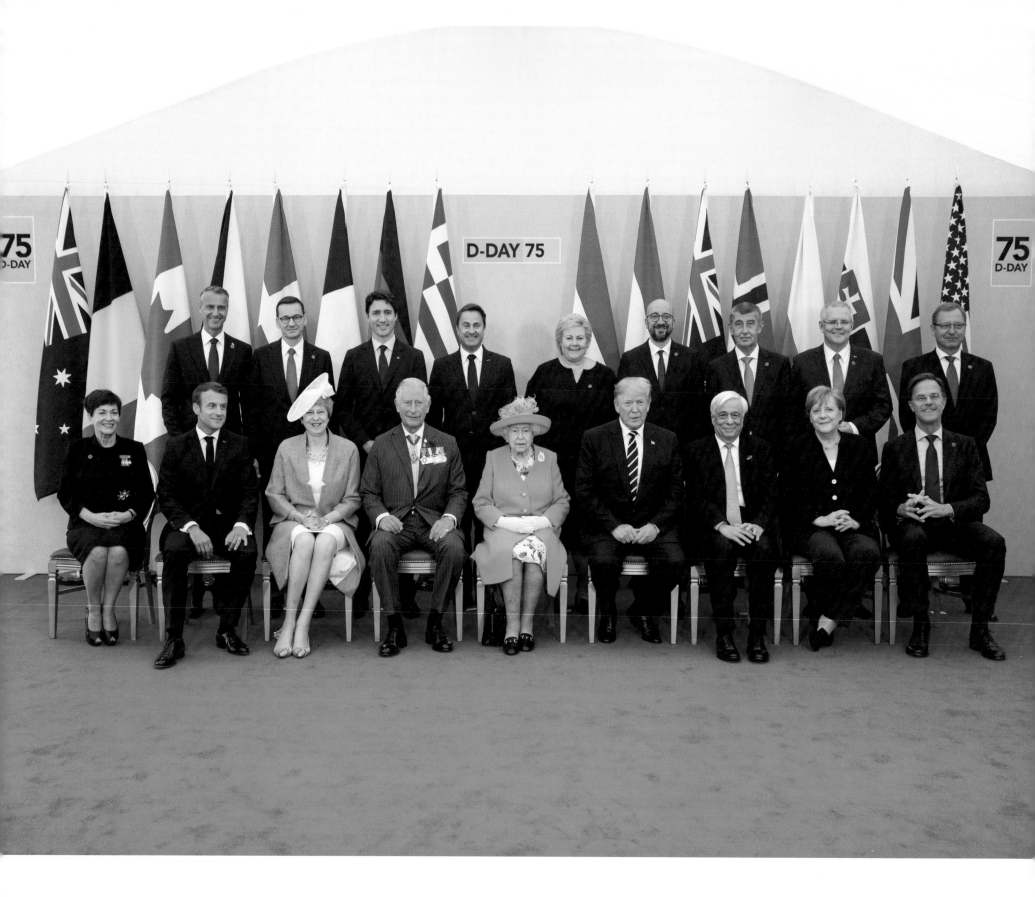

210

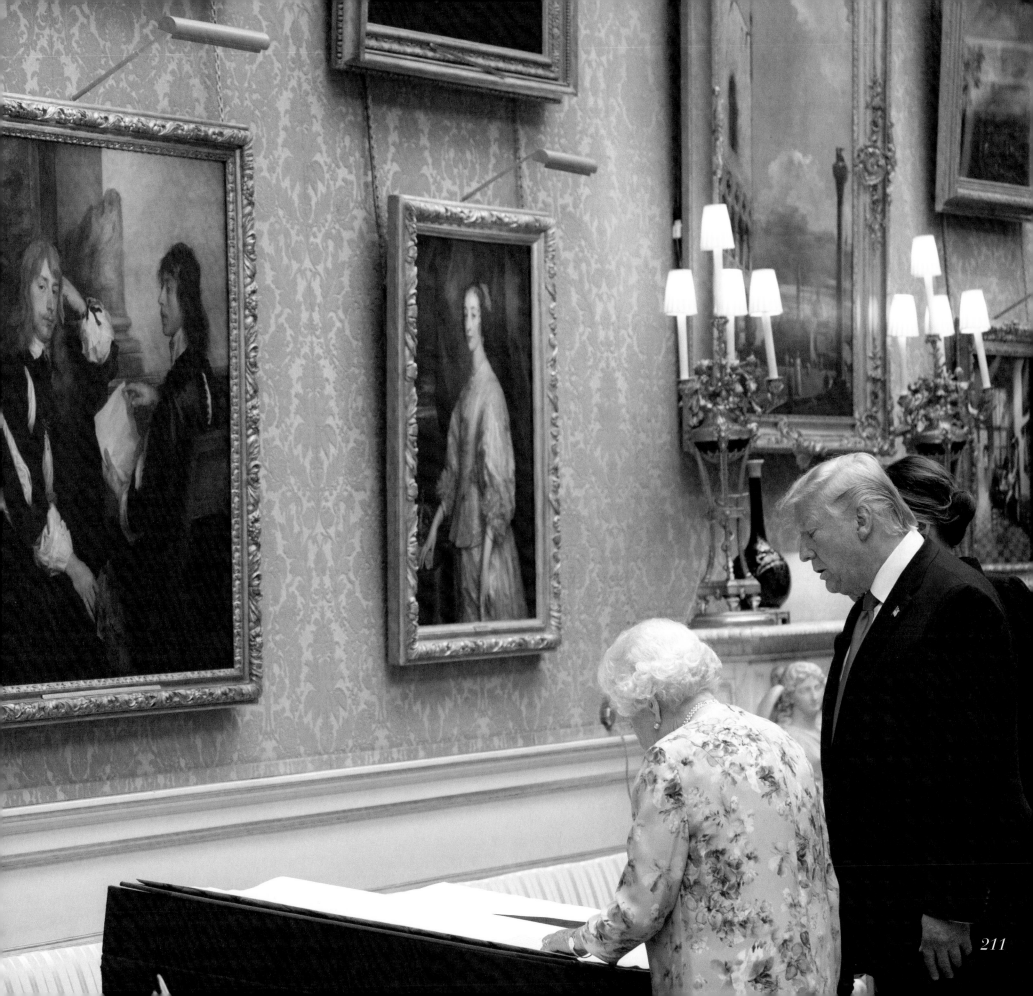

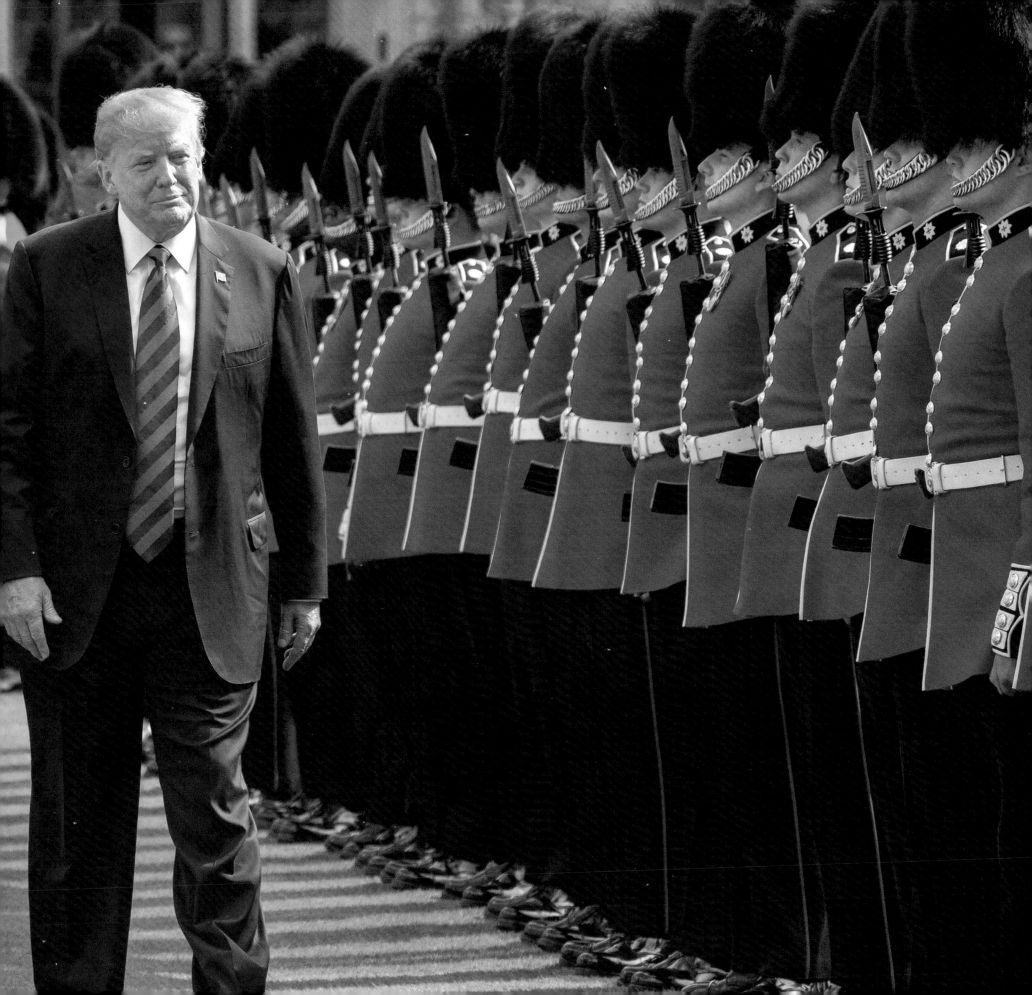

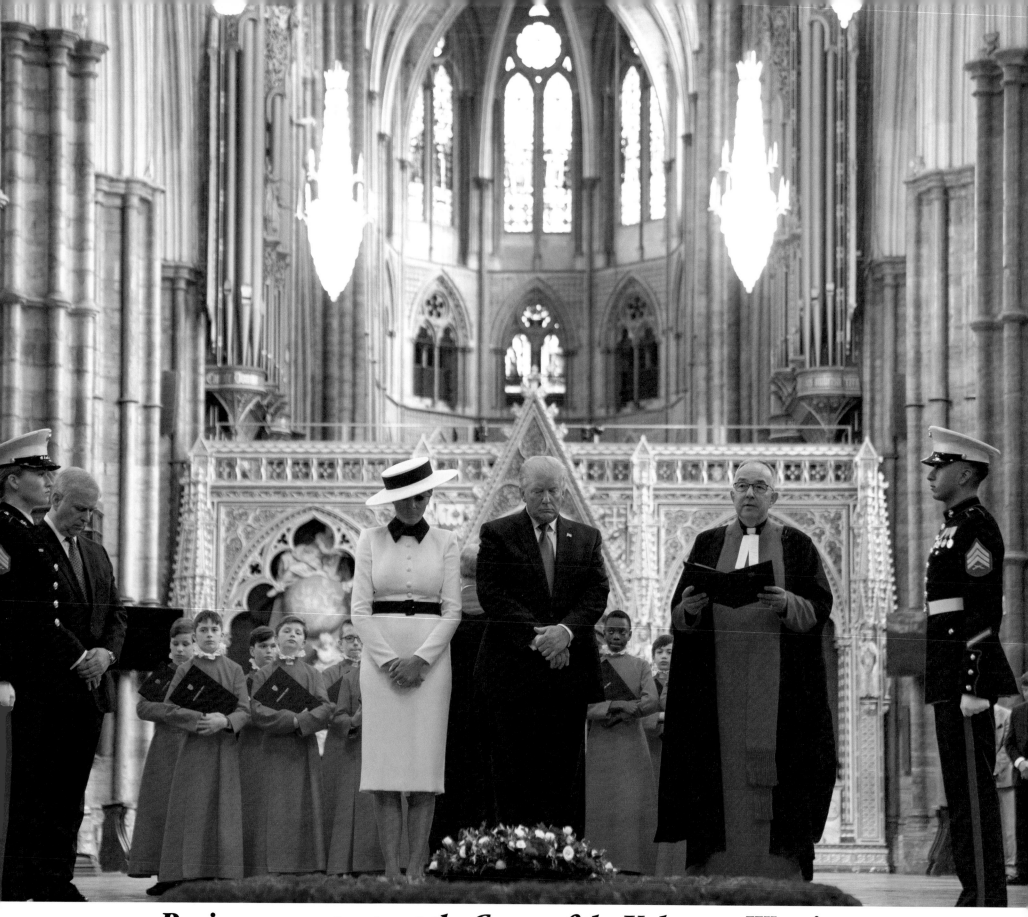

Paying our respects at the Grave of the Unknown Warrior during a visit to Westminster Abbey in London.

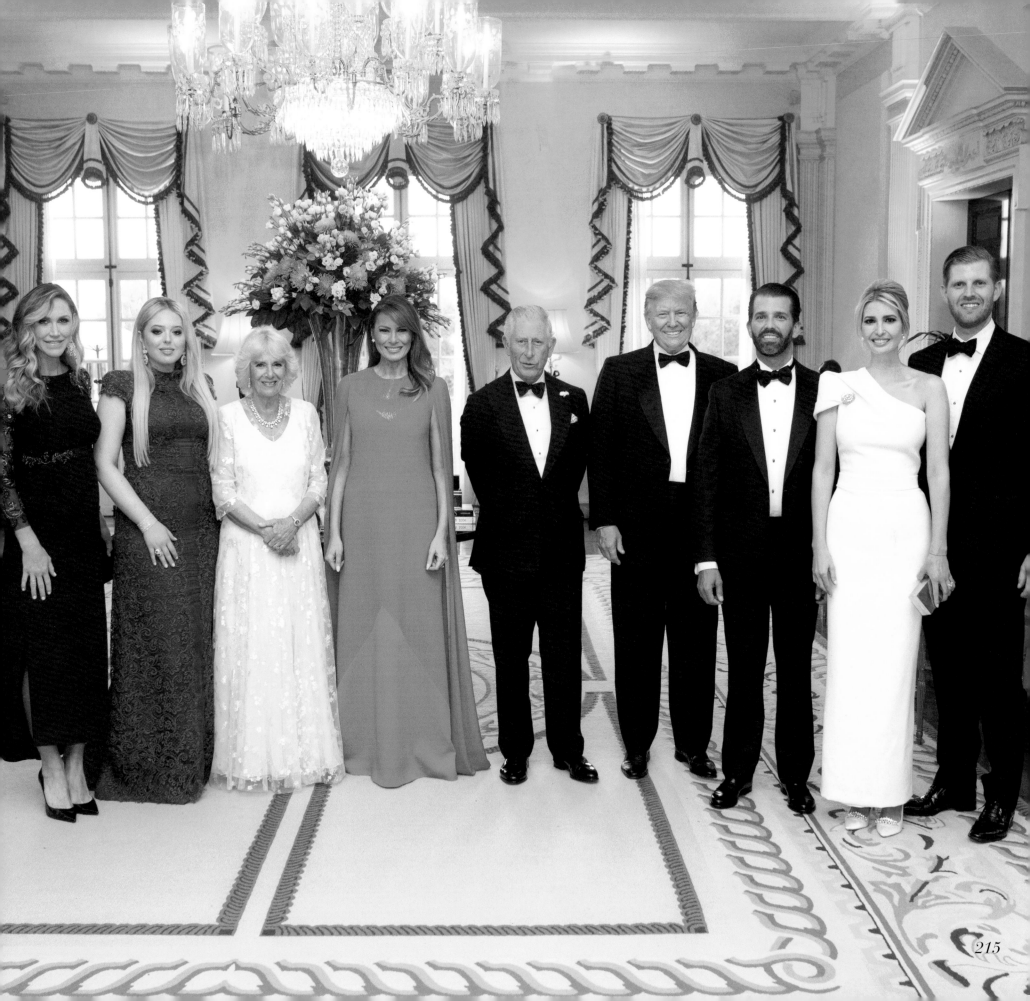

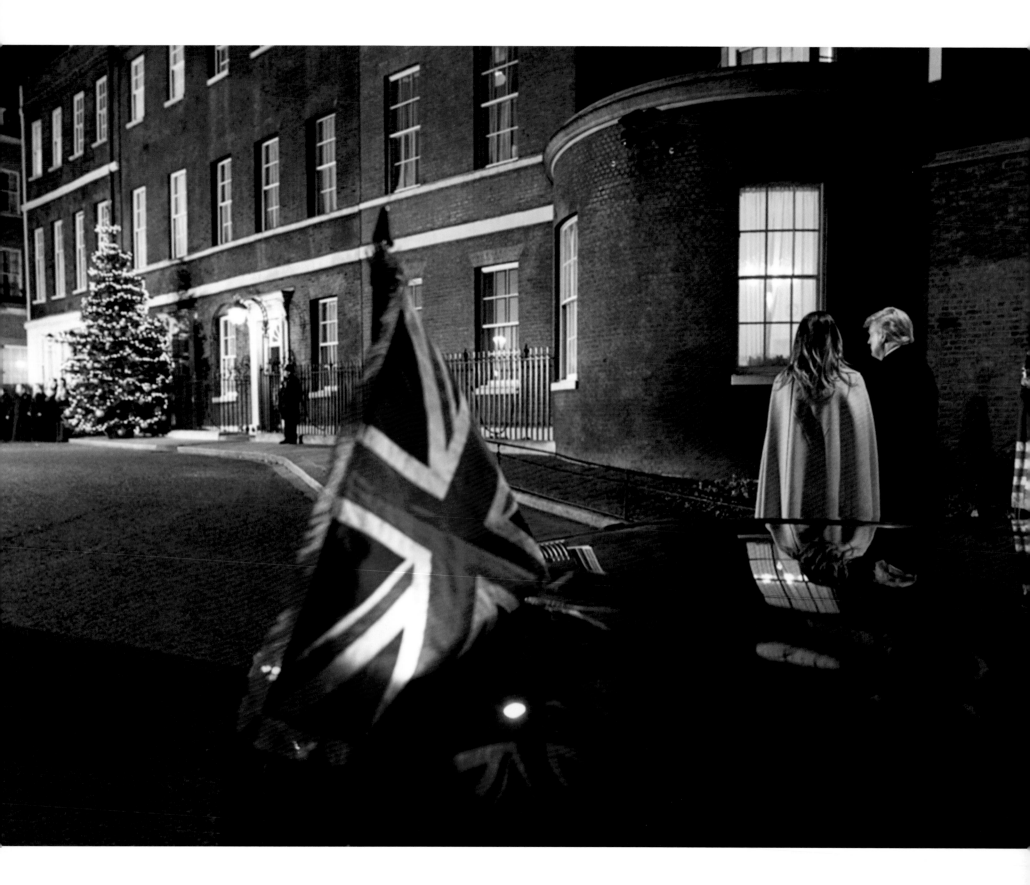

On our way to 10 Downing Street in London.

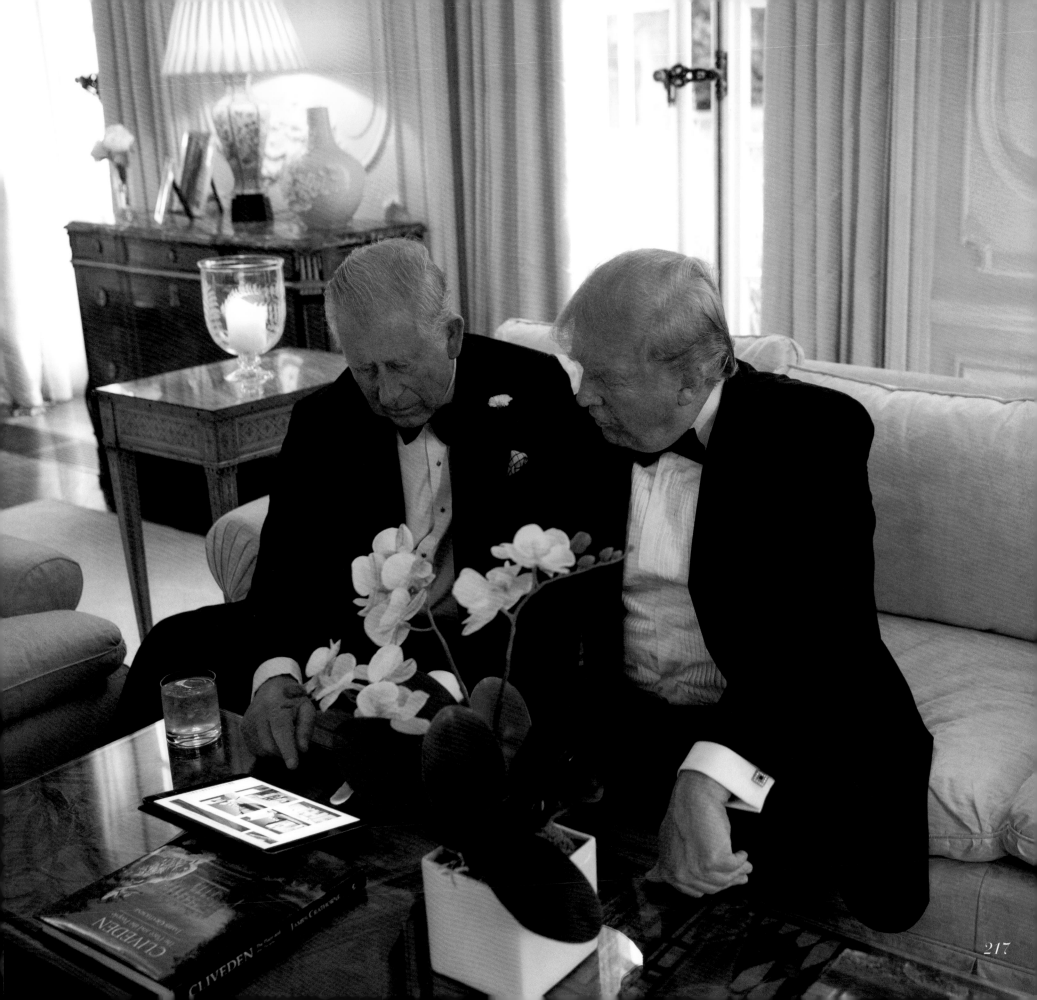

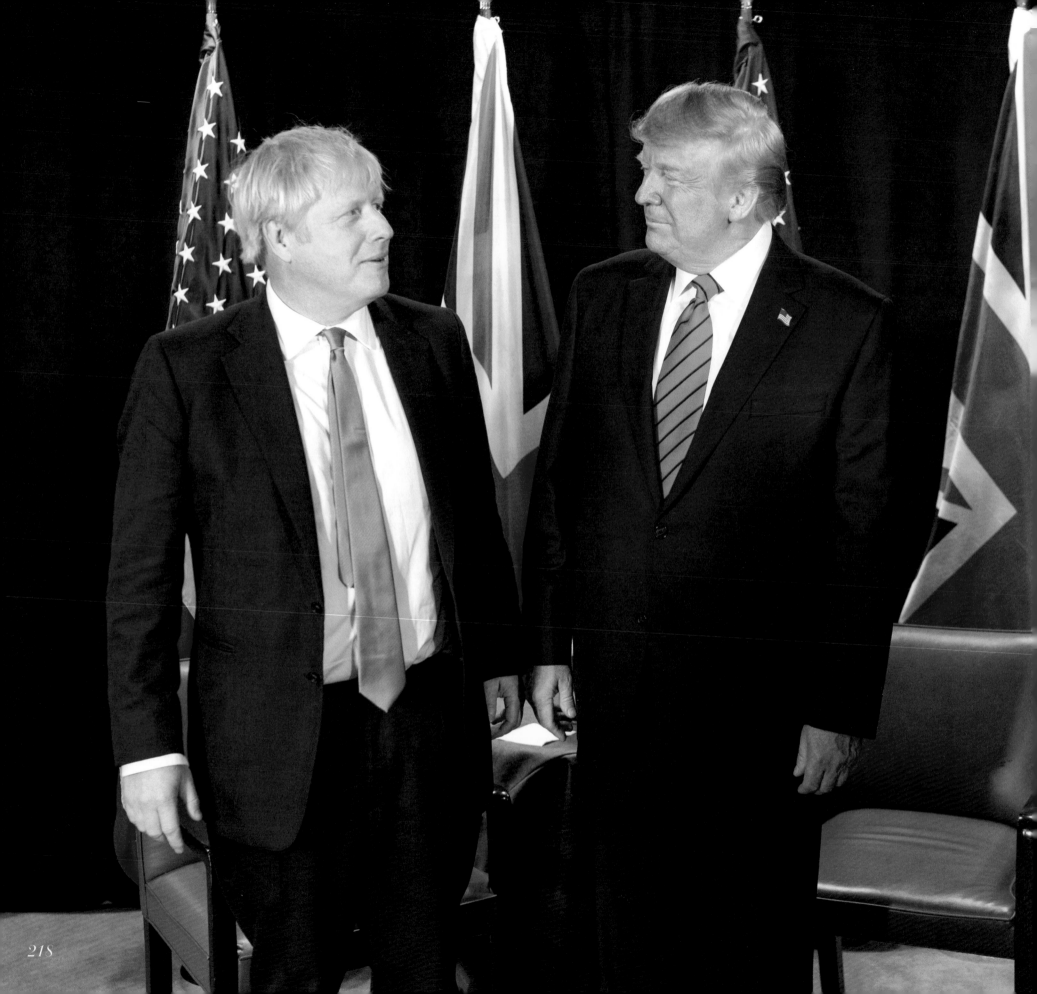

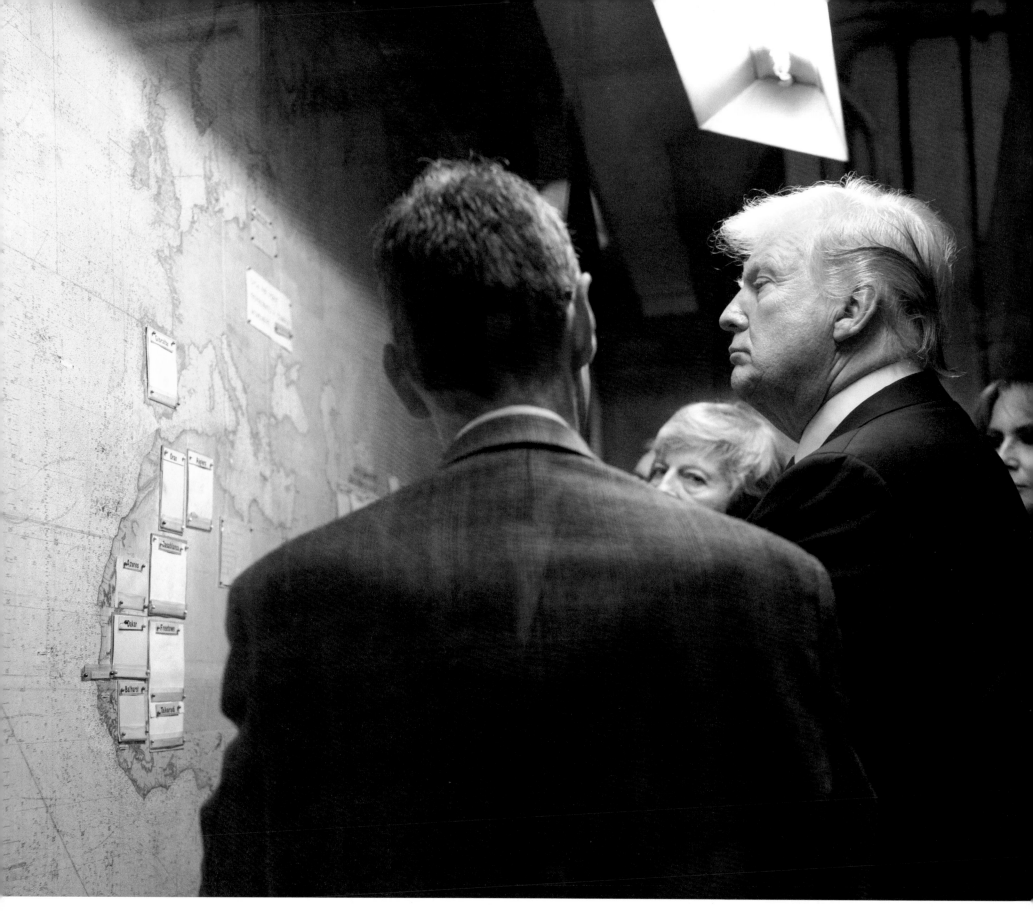

The Churchill War Rooms in London where Winston Churchill lived and worked during World War II. A real HERO.

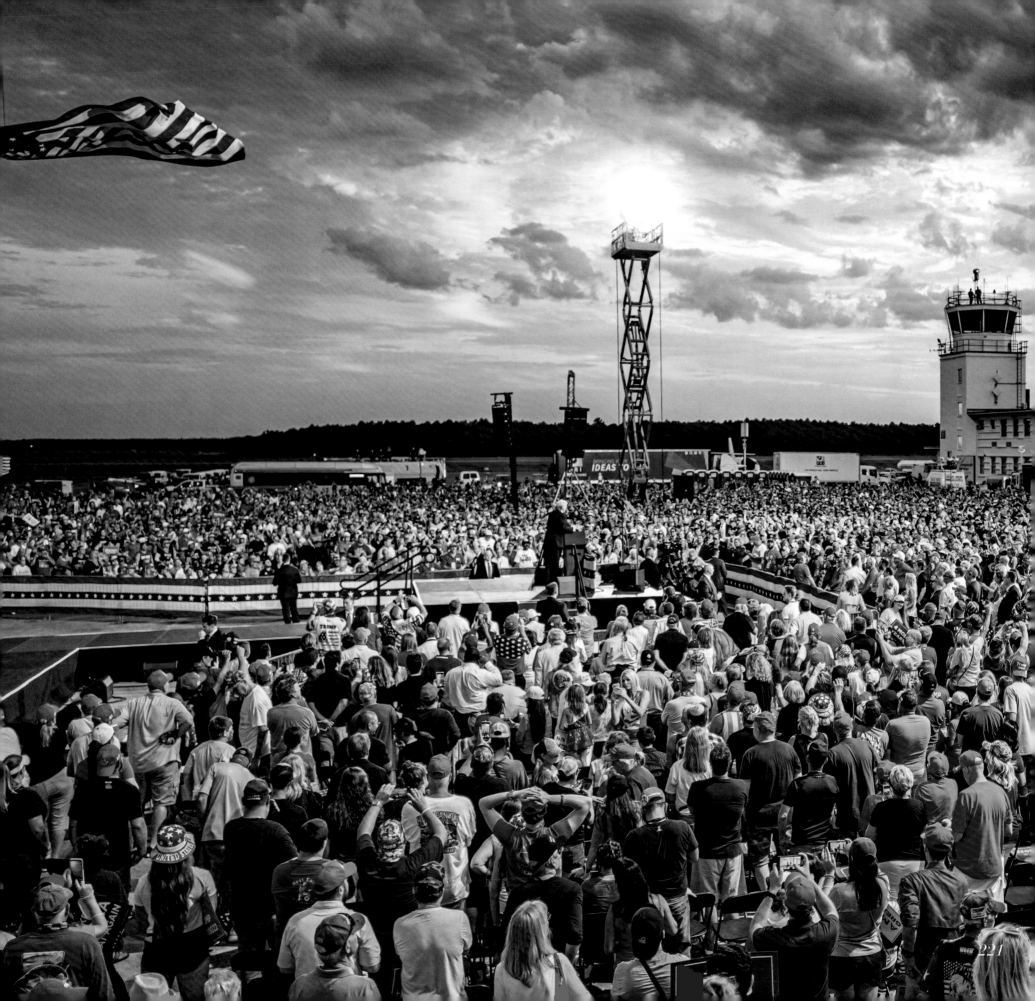

Diamond and Silk, two incredible ladies.

With Italian President Sergio Mattarella.

She was screaming and shaking like a leaf. She's F...ing CRAZY — Hence the name CrazyNancy!

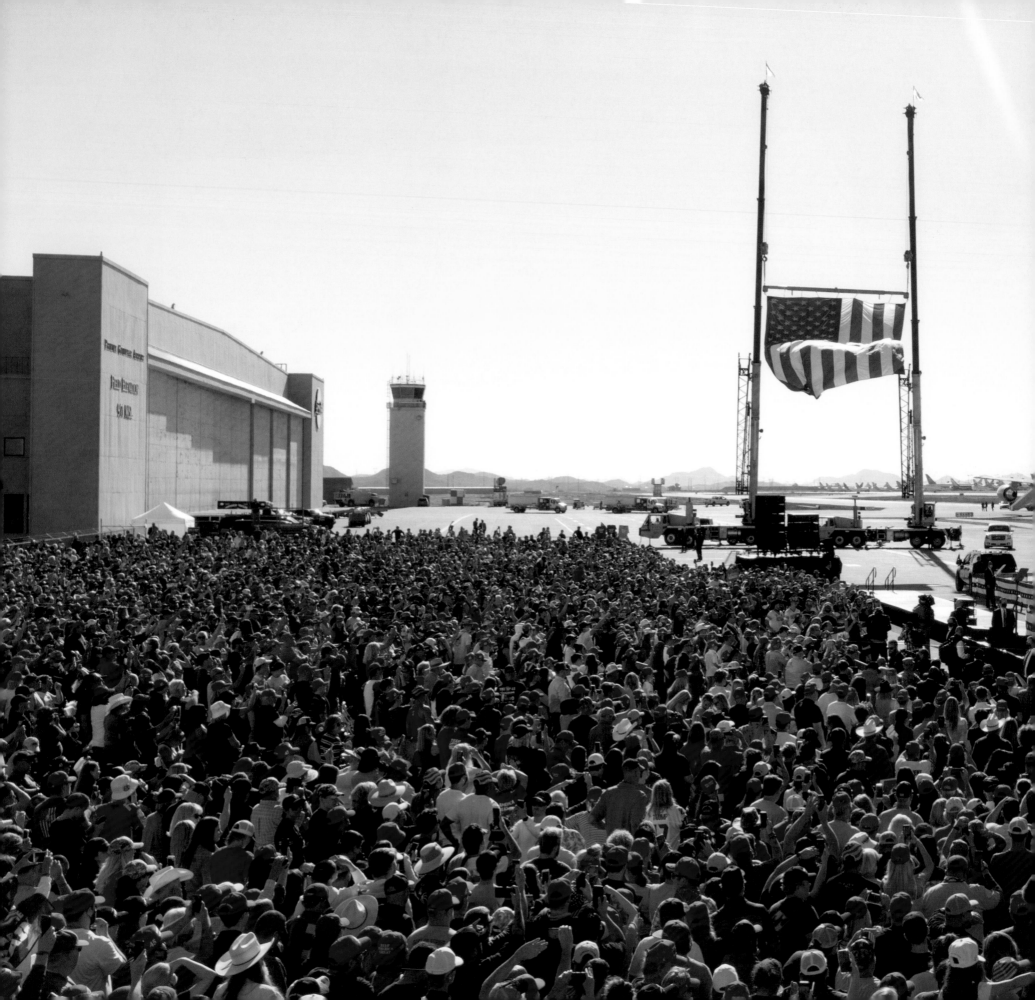

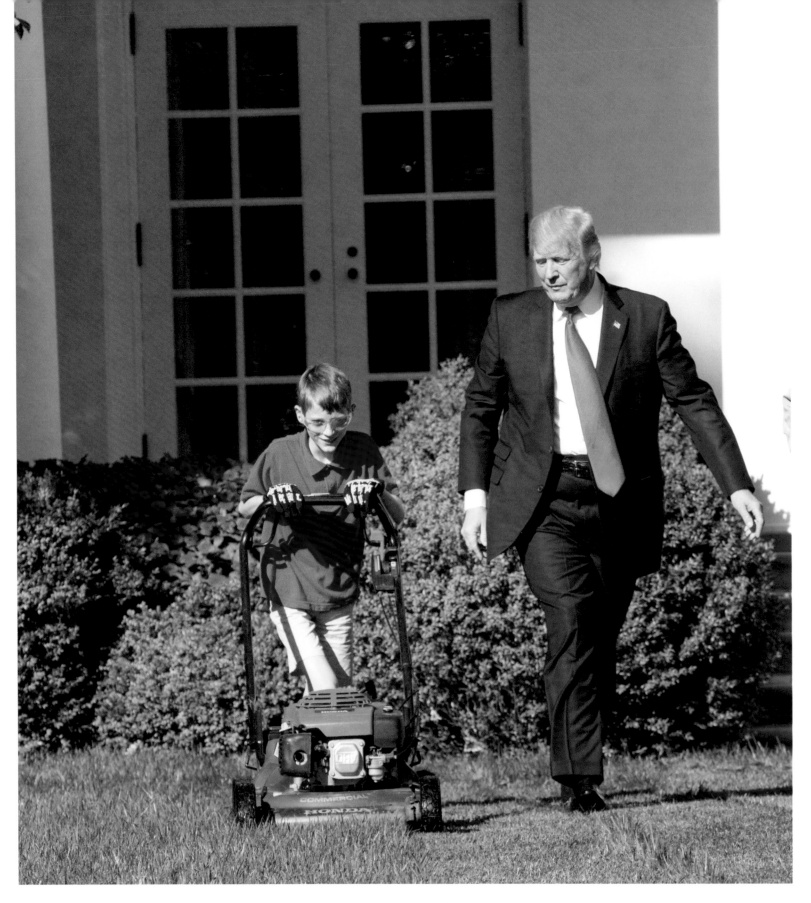

I was always happy to welcome young visitors to the White House, including those who wanted to work and mow the lawn!

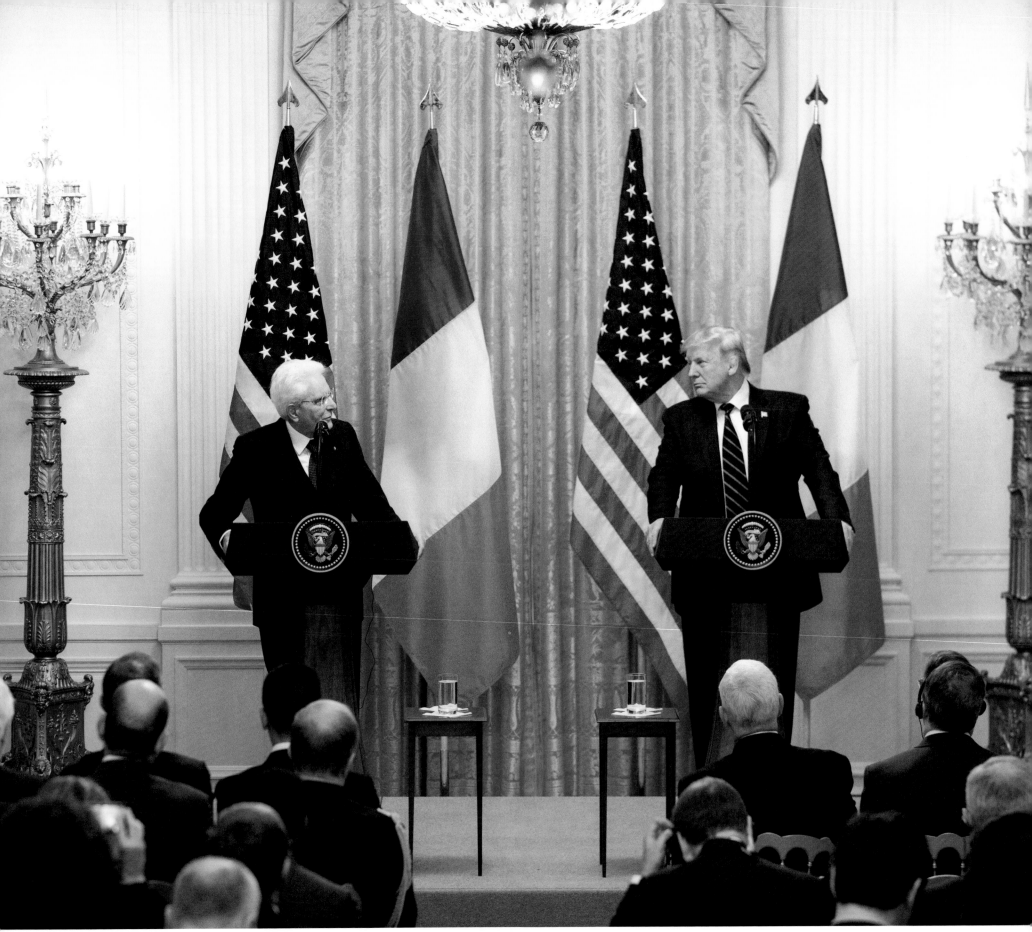

With Italian President Sergio Mattarella.

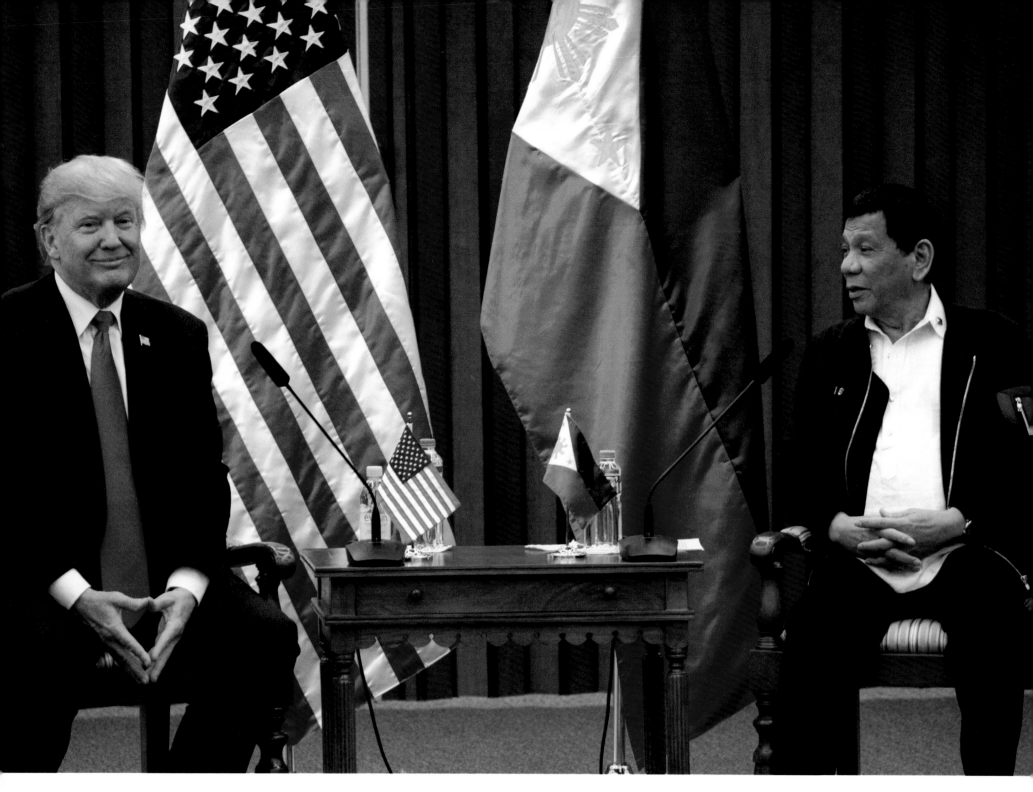

Speaking with the President of the Philippines, Rodrigo Duterte. A guy with a lot of flair and fight. Loves his country and sings just like Frank Sinatra.

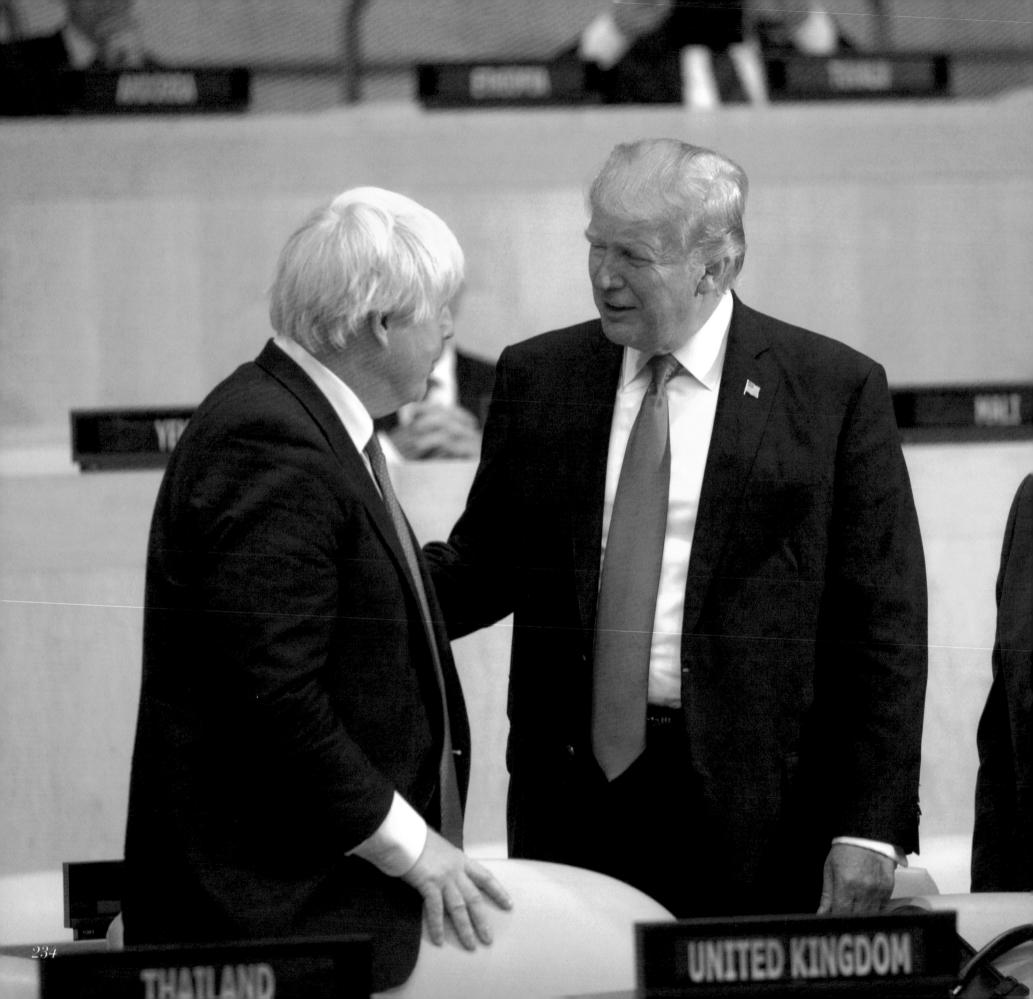

THAILAND

UNITED KINGDOM

Boris is one of a kind - and a fantastic leader of the United Kingdom. He will go down as the best PM since Winston Churchill!

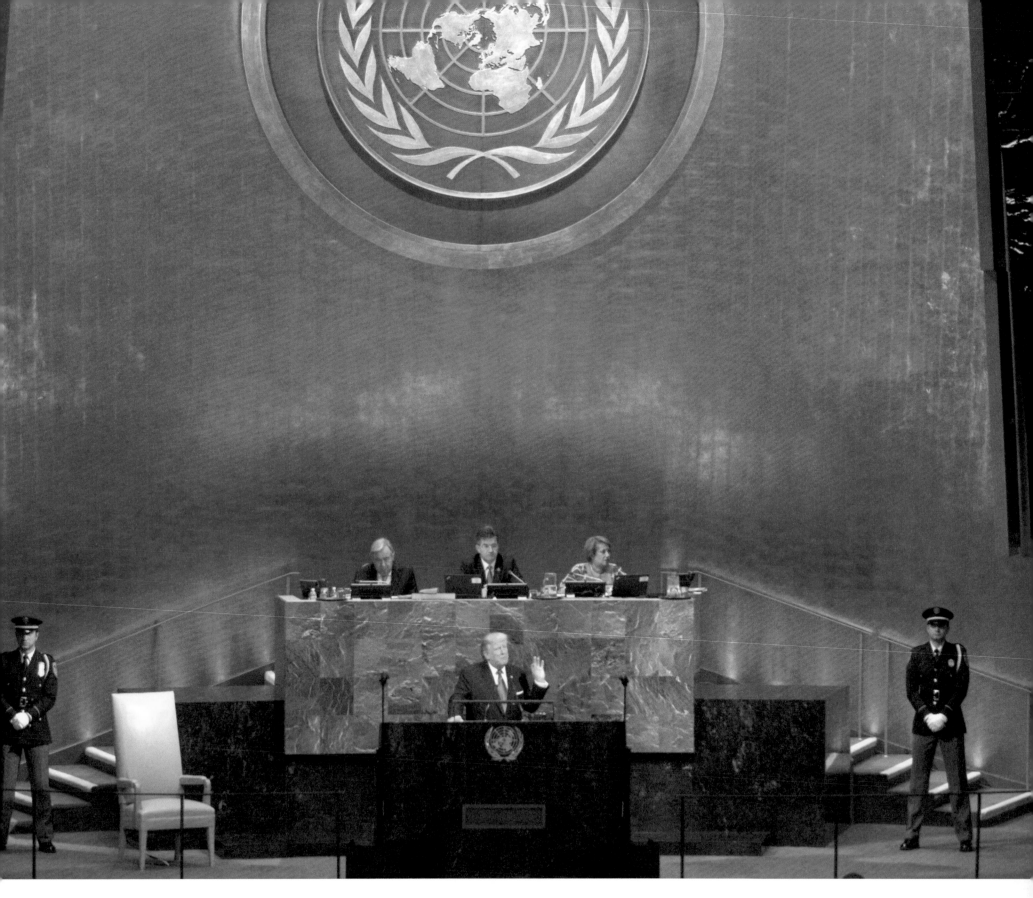

We made it clear to the world, America was not going to be taken for granted.
The "apology tour" of the previous administration was OVER.

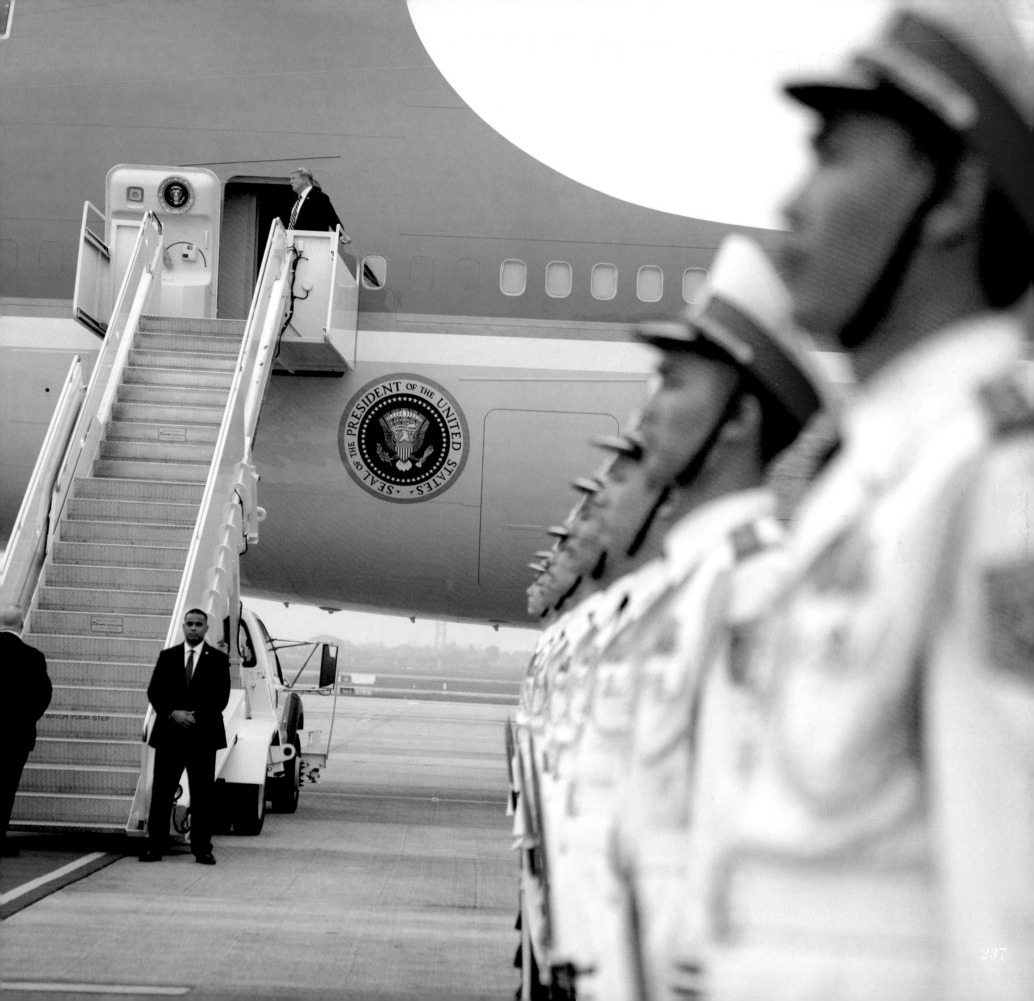

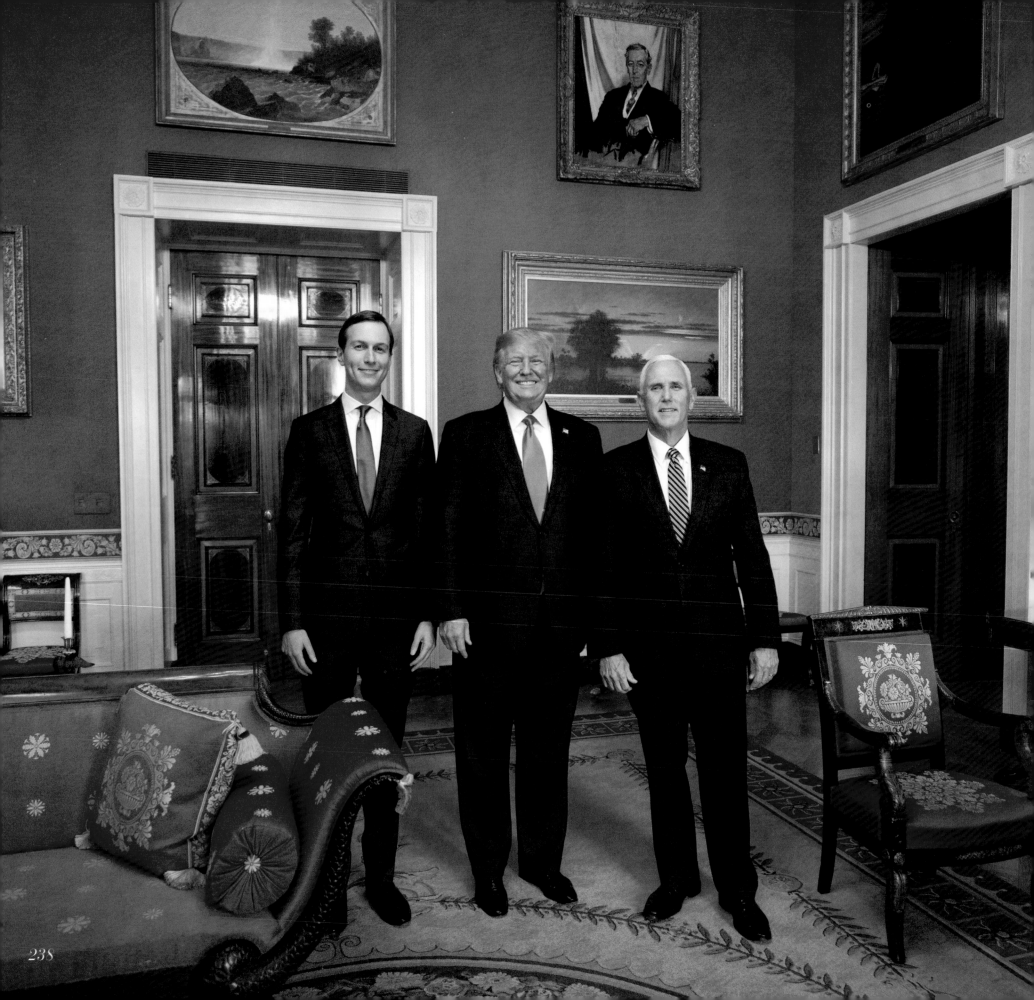

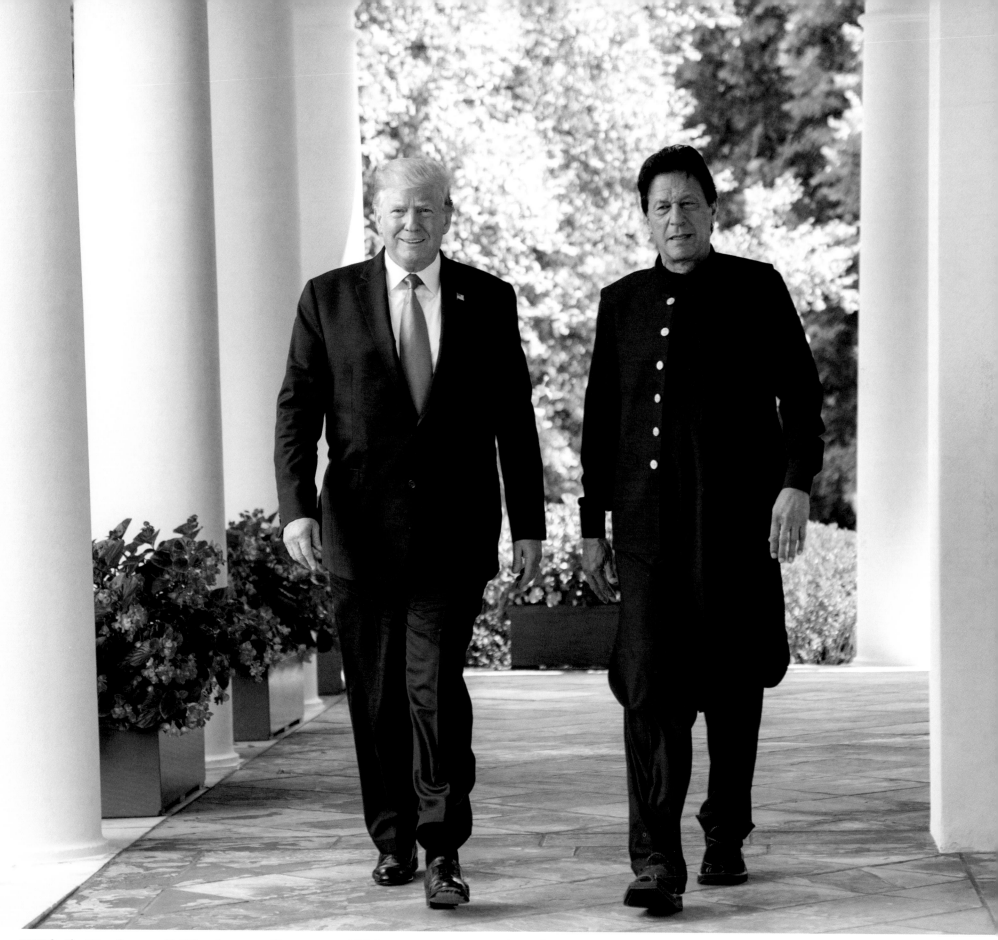

With Prime Minister Imran Khan, a wonderful man and great leader of Pakistan.

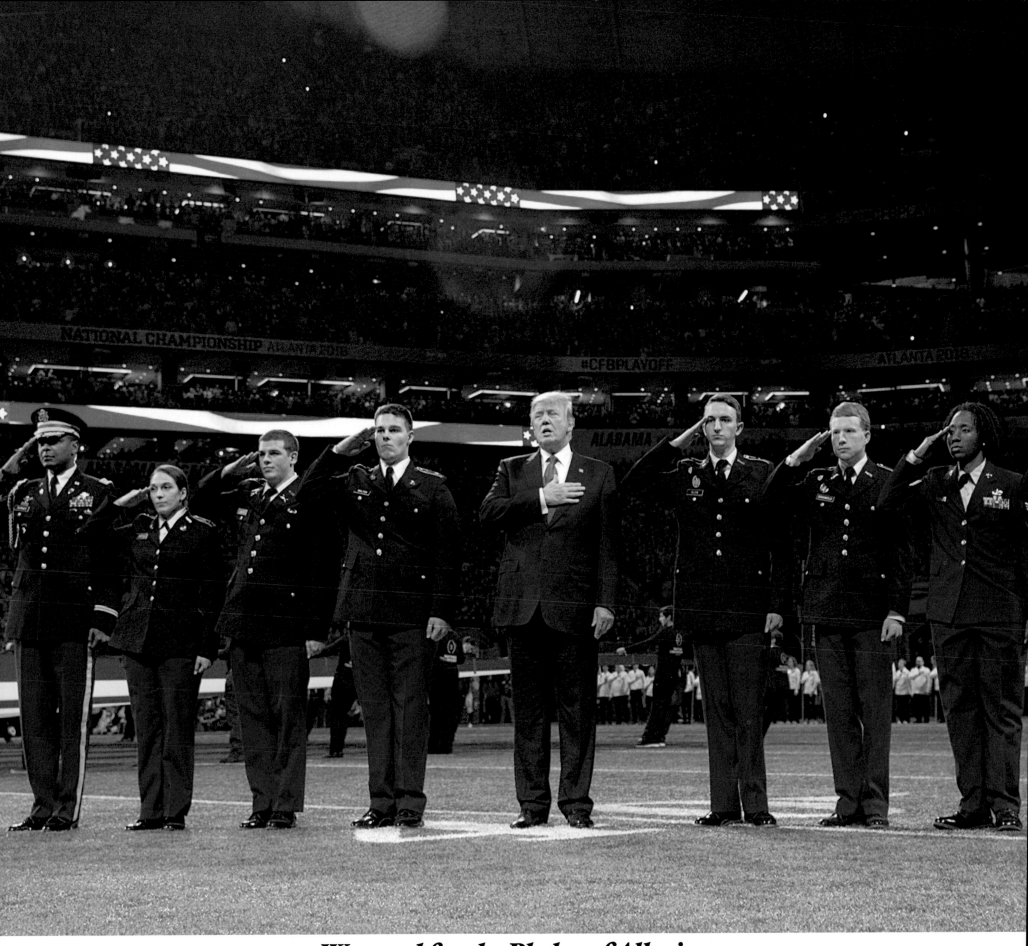

We stood for the Pledge of Allegiance.

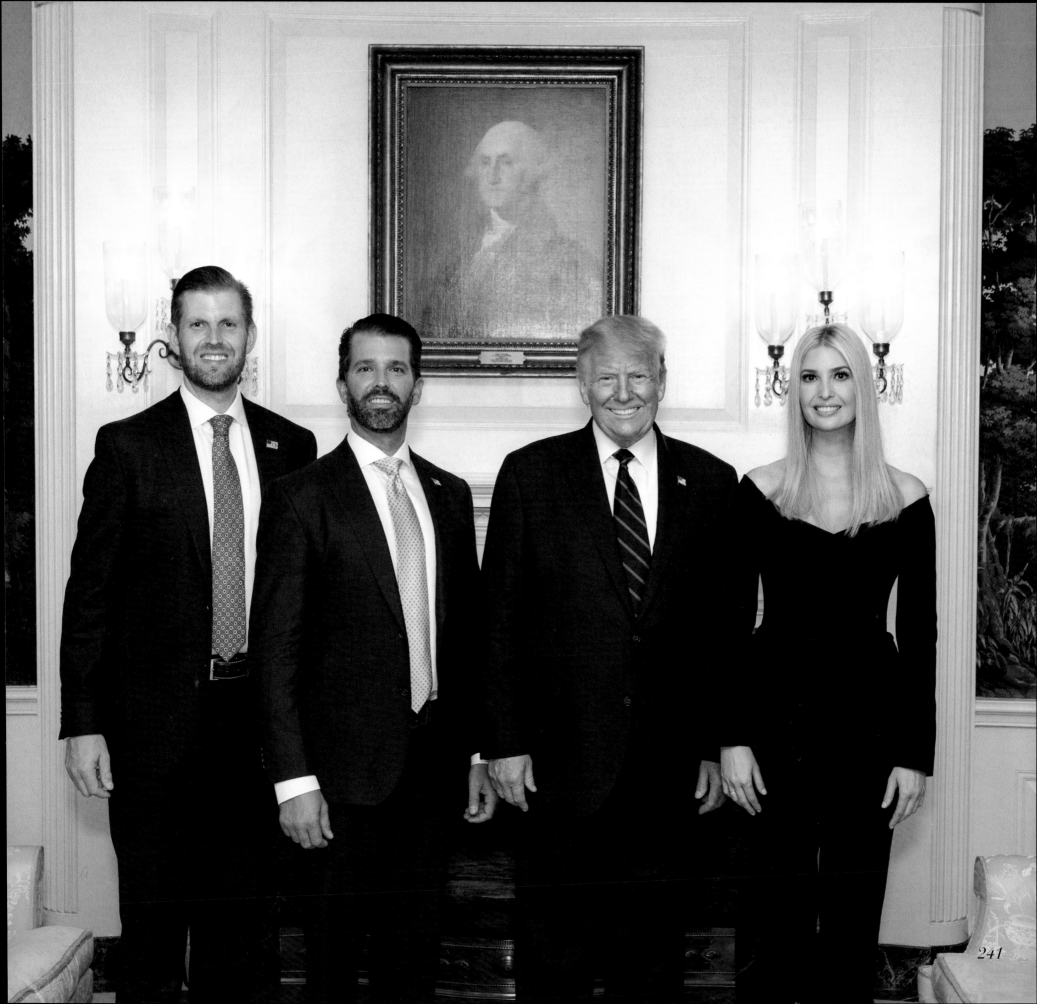

241

INVESTING IN AMERICA'S WORKERS AND FAMILIES

Affordable and high-quality Child Care for American workers and their families.

Doubled the Child Tax Credit from $1,000 to $2,000 per child and expanded the eligibility for receiving the credit.

Nearly 40 million families benefitted from the child tax credit (CTC), receiving an average benefit of $2,200 – totaling credits of approximately $88 billion.

Signed the largest-ever increase in Child Care and Development Block Grants – expanding access to quality, affordable child care for more than 800,000 low-income families.

Secured an additional $3.5 billion in the Coronavirus Aid, Relief, and Economic Security (CARES) Act to help families and first responders with child care needs.

Created the first-ever paid family leave tax credit for employees earning $72,000 or less.

My precious granddaughter Chloe!

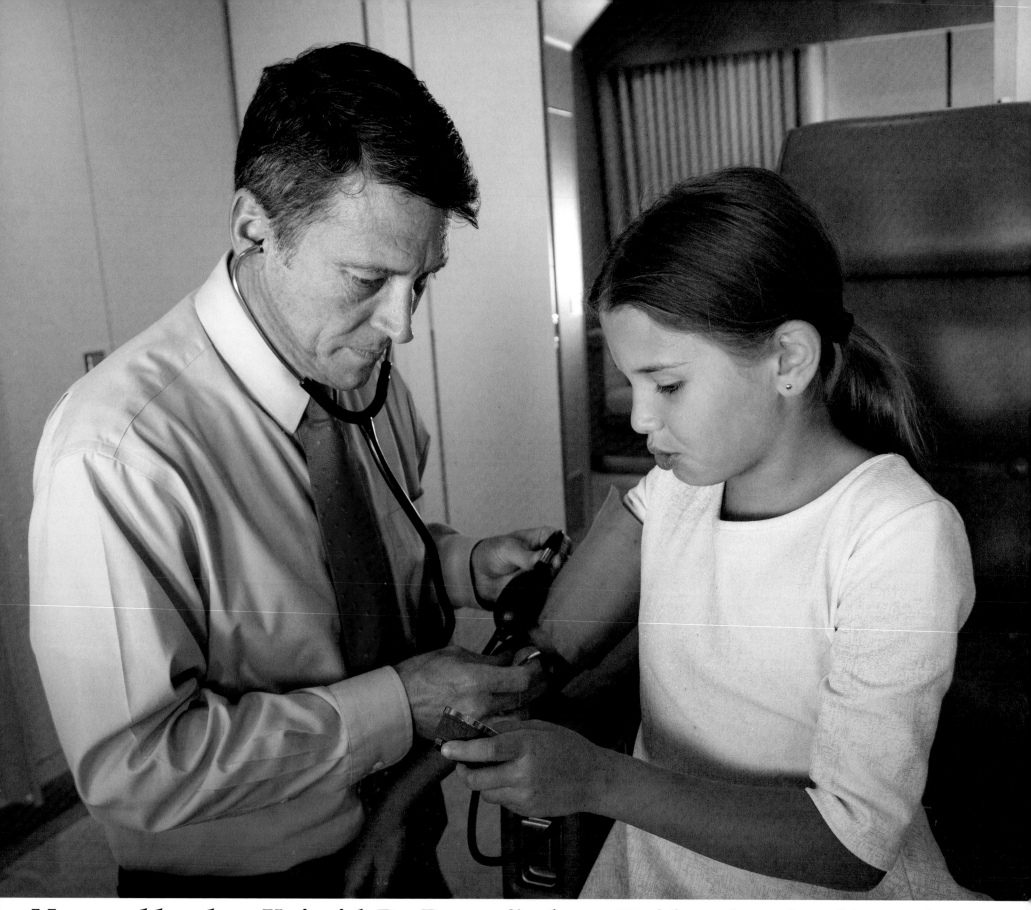

My granddaughter Kai with Dr. Ronny Jackson. Kai has thought of becoming a physician herself. Dr. Ronny is teaching her how to take proper blood pressure.

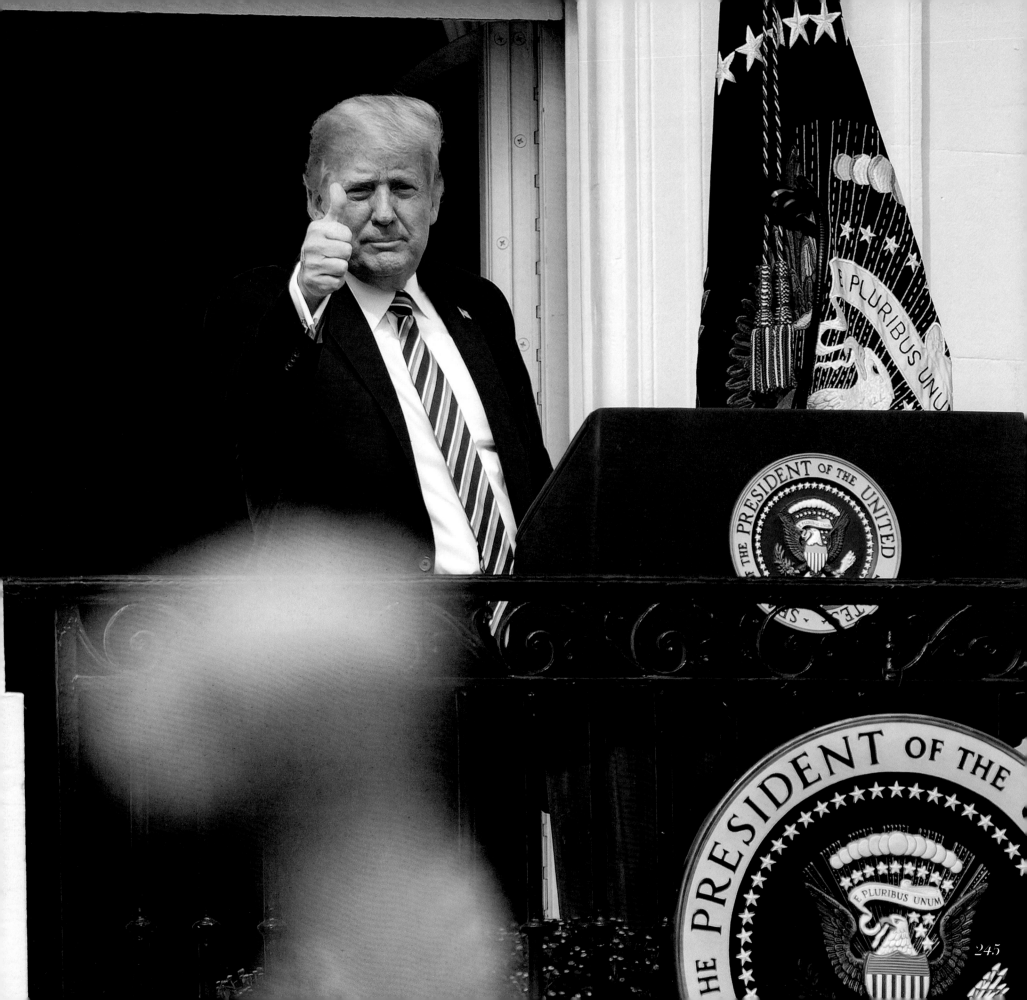

245

In my administration we celebrated America; we didn't condemn it!

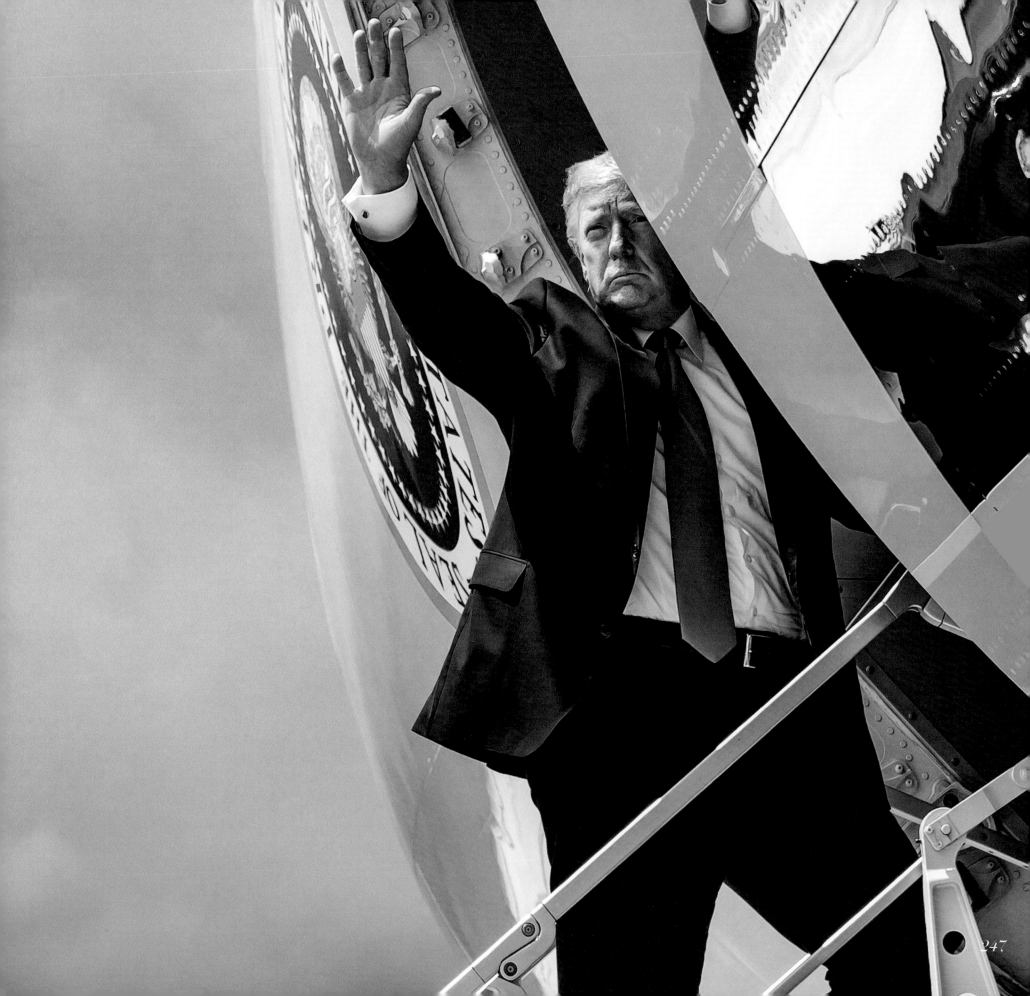

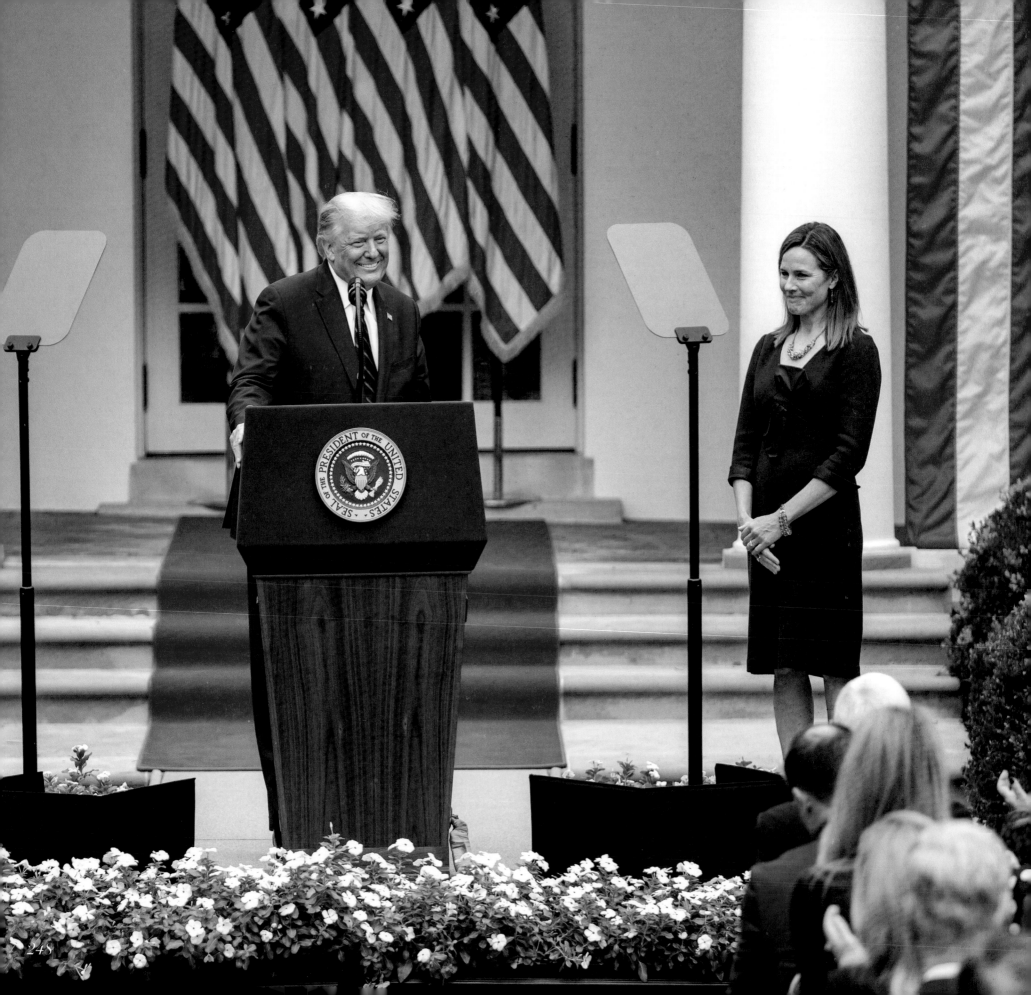

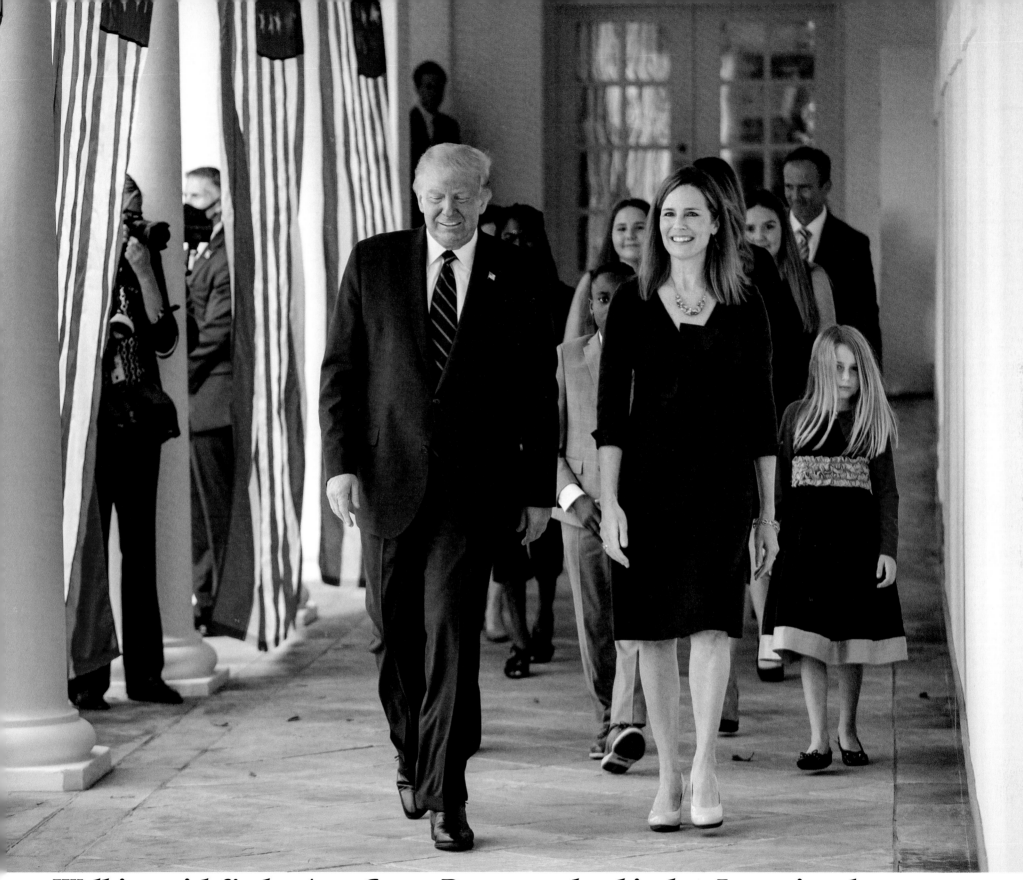

Walking with Judge Amy Coney Barrett on her big day. I appointed not one, not two—but three conservative Supreme Court Justices! Hopefully we turned the tide of the court for many years to come! America will be better for it.

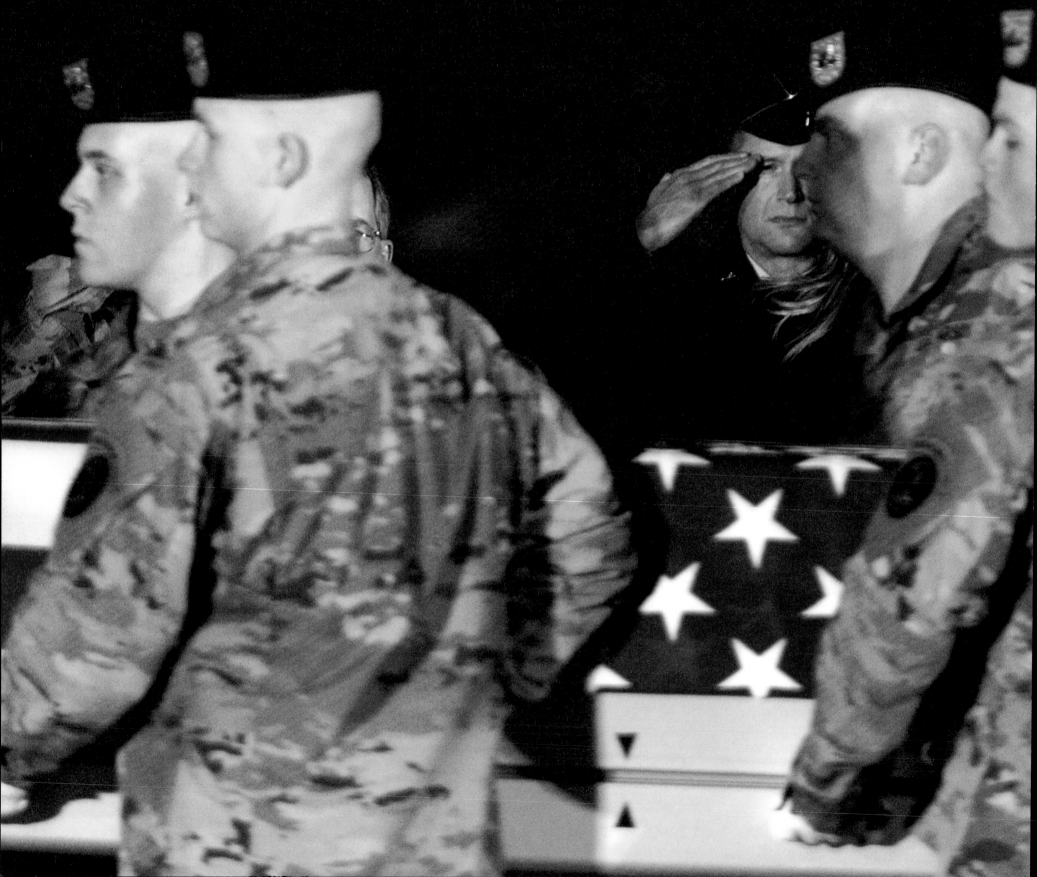

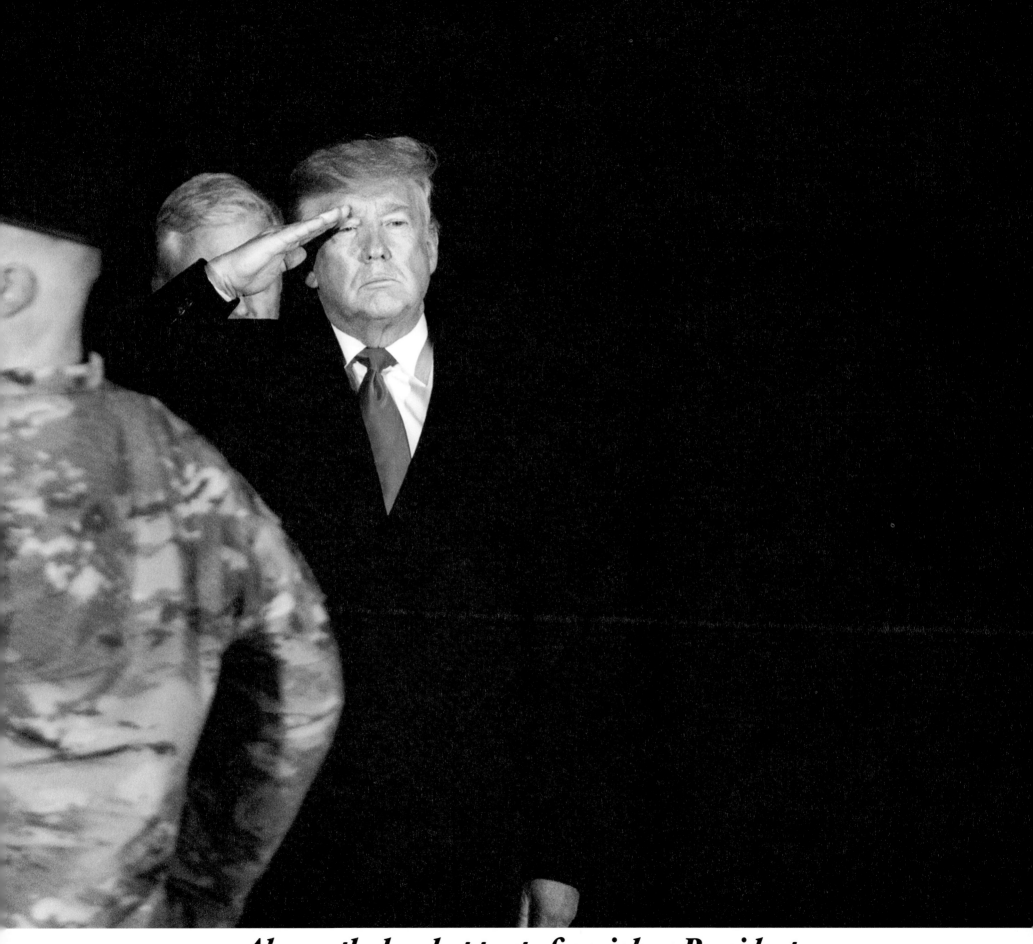

Always the hardest part of my job as President.

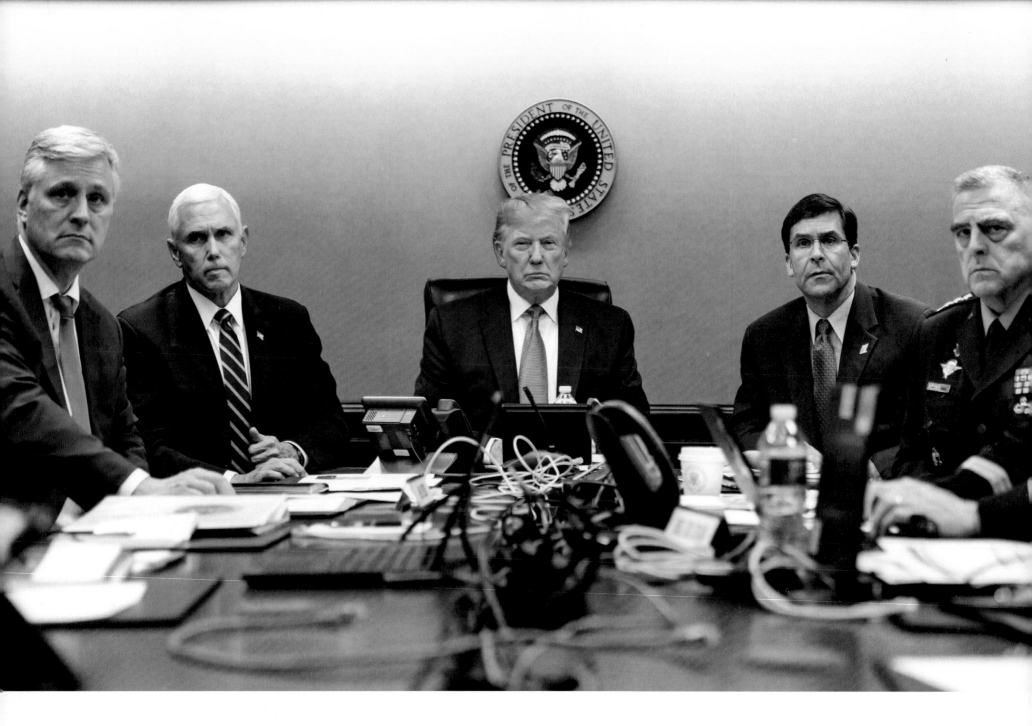

The night we got Abu Bakr al-Baghdadi. We destroyed ISIS under my watch. Now terrorists are back in the Middle East.

Approaching New York City on Marine One.

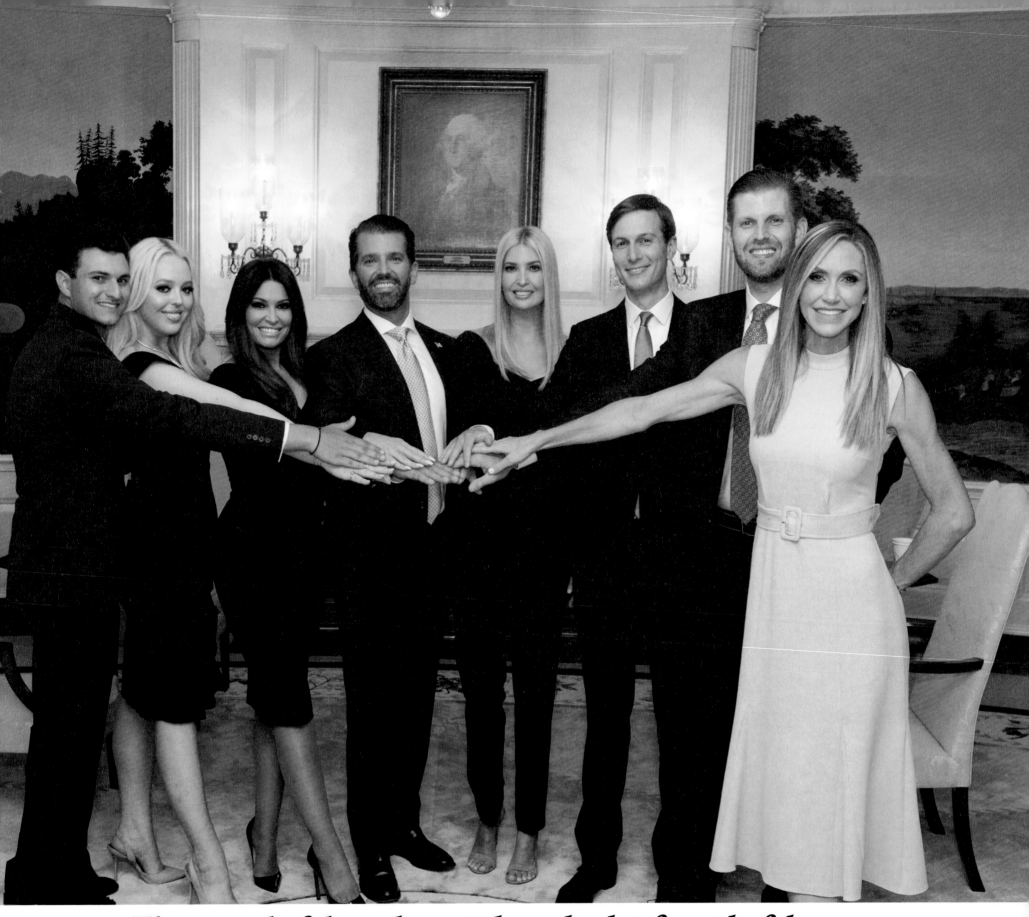

These wonderful people went through a lot, from the fake news and the crazy left. They stood with me all the way.

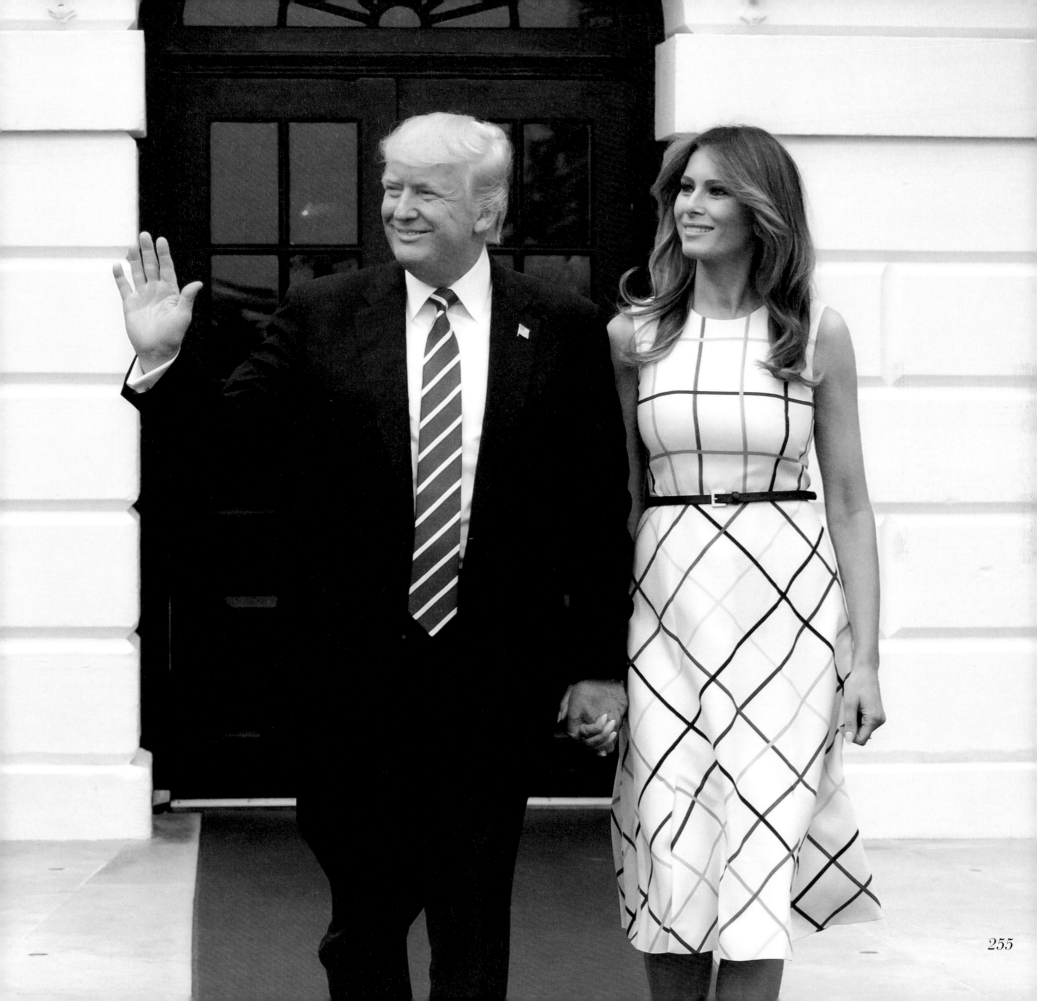

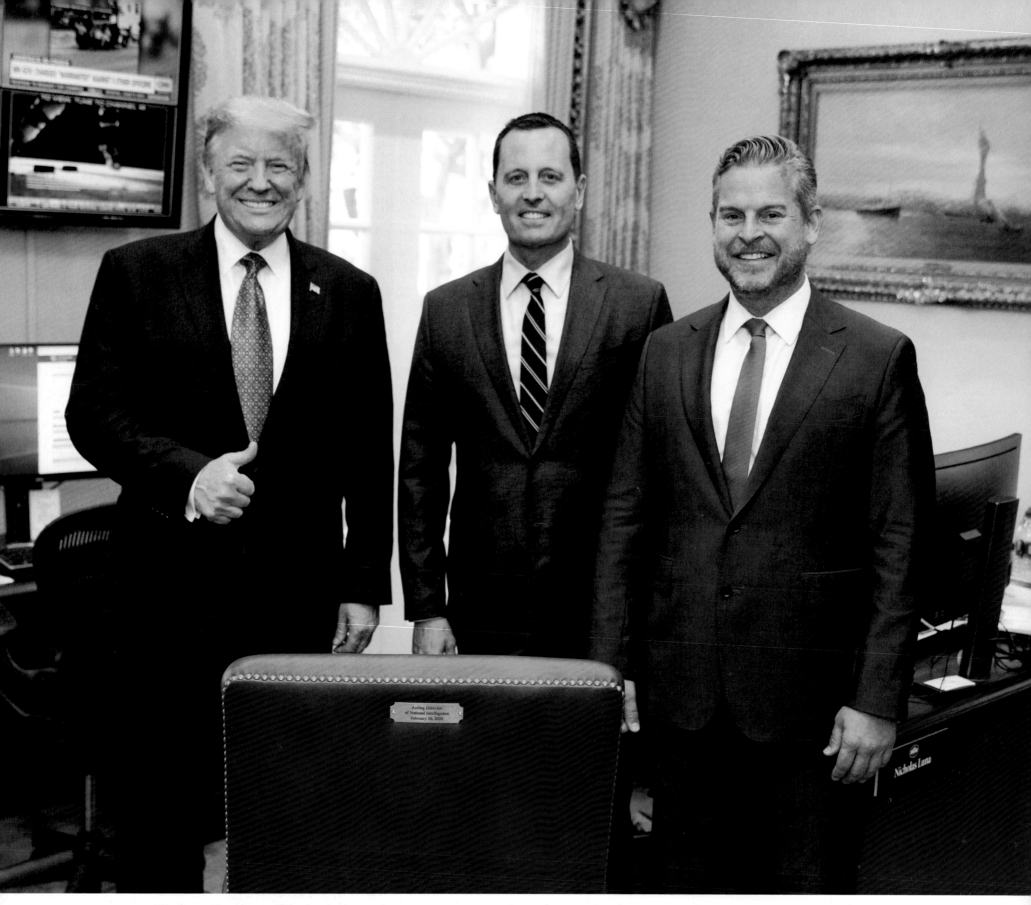

Ric Grenell (center) was our Ambassador to Germany and Director of National Intelligence. One of the best choices I made.

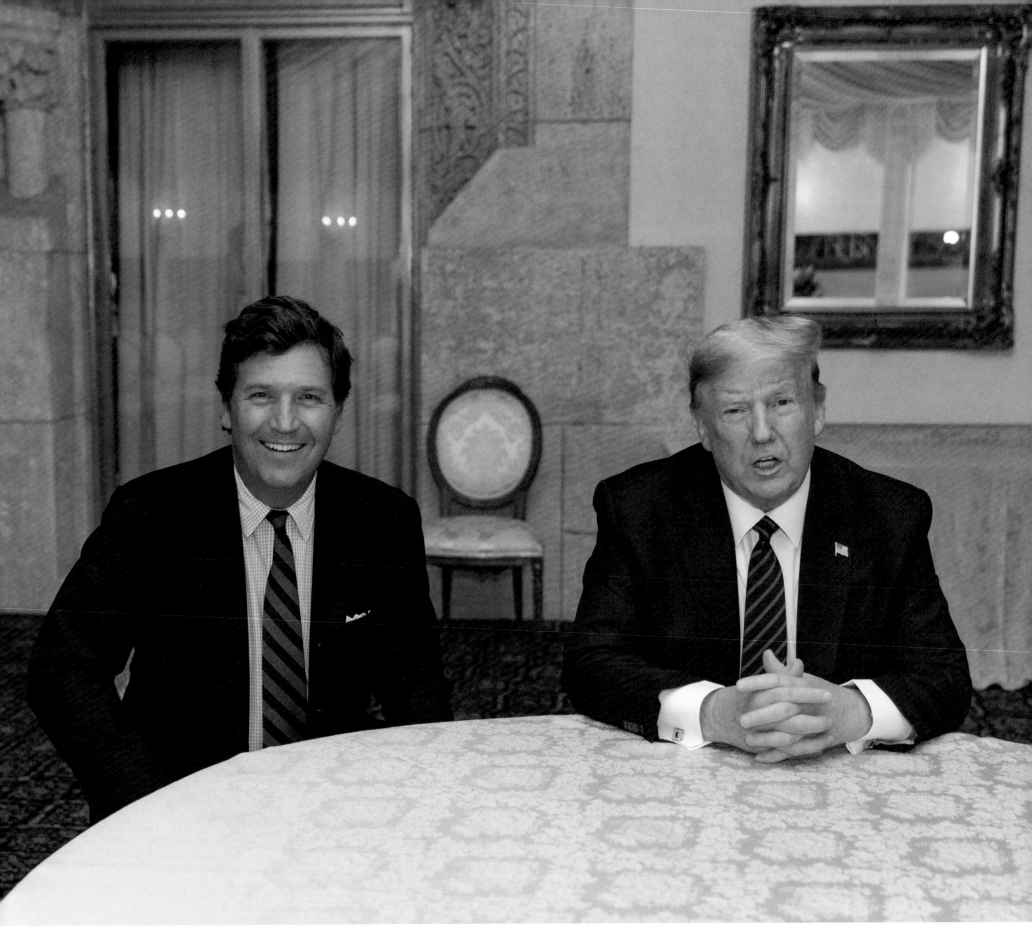

Tucker Carlson, one of the best there is on television.

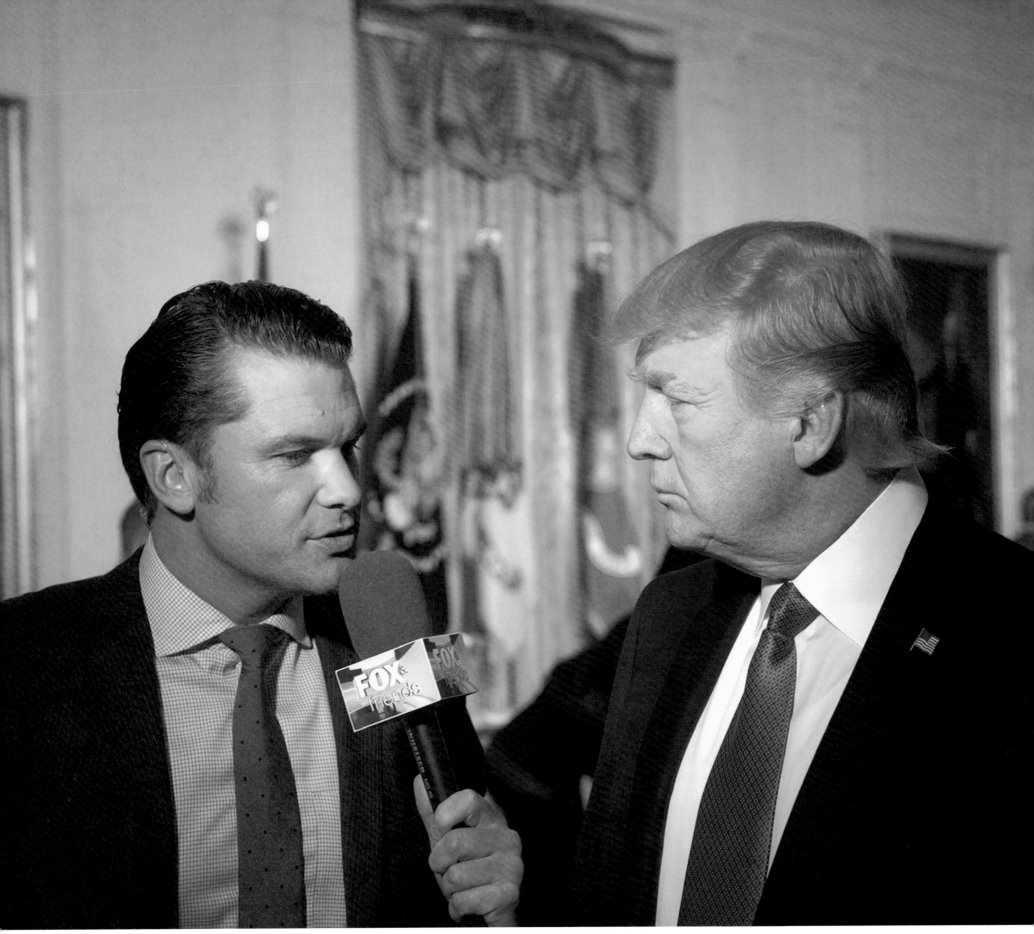

Pete Hegseth, a patriot, interviews me.

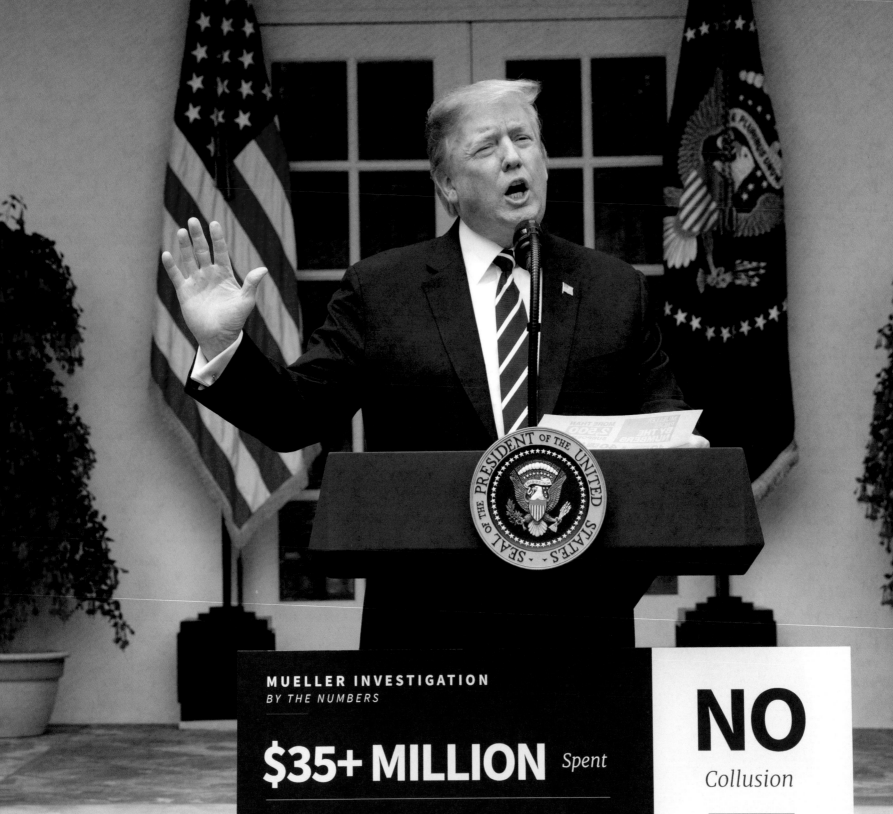

MUELLER INVESTIGATION
BY THE NUMBERS

$35+ MILLION Spent

2,800+ Subpoenas | 675 Days

500+ Witnesses | 18 Angry Democrats

NO
Collusion

NO
Obstruction

260

All that money and time spent on a total hoax.

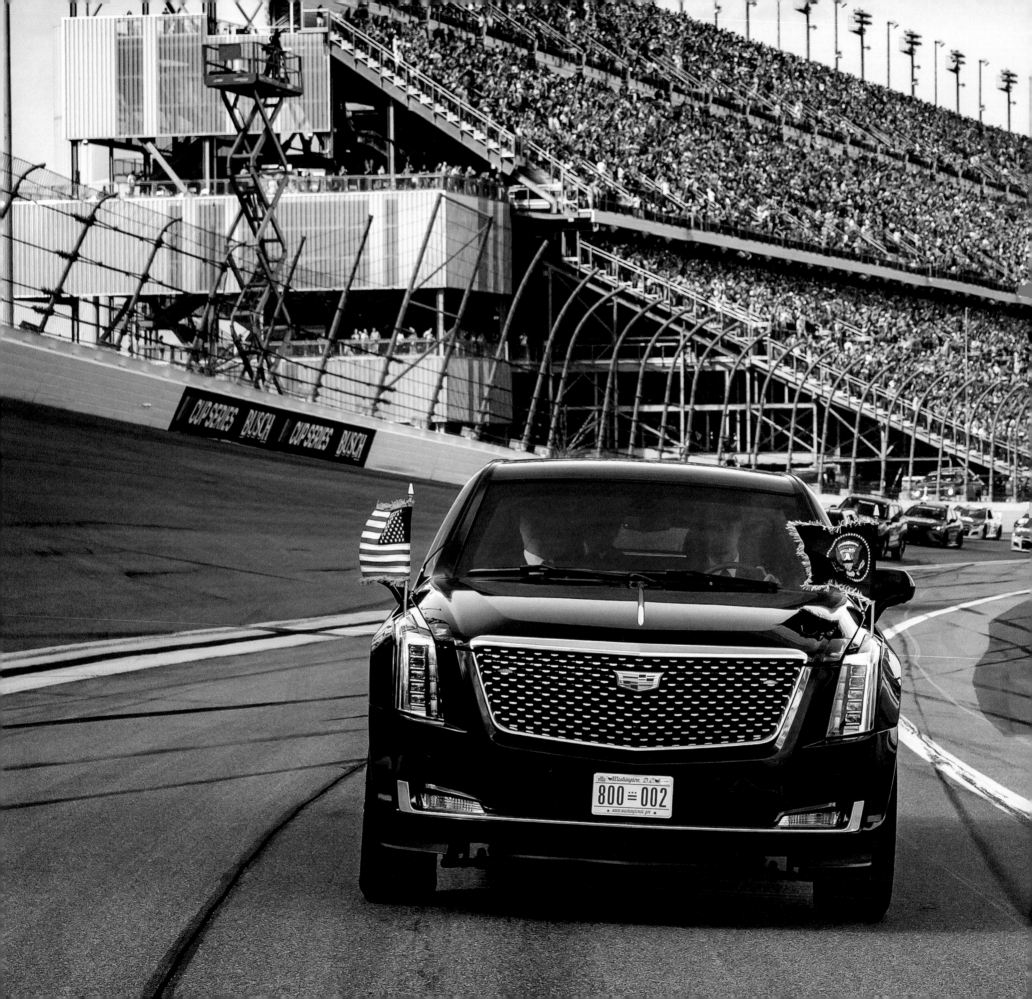

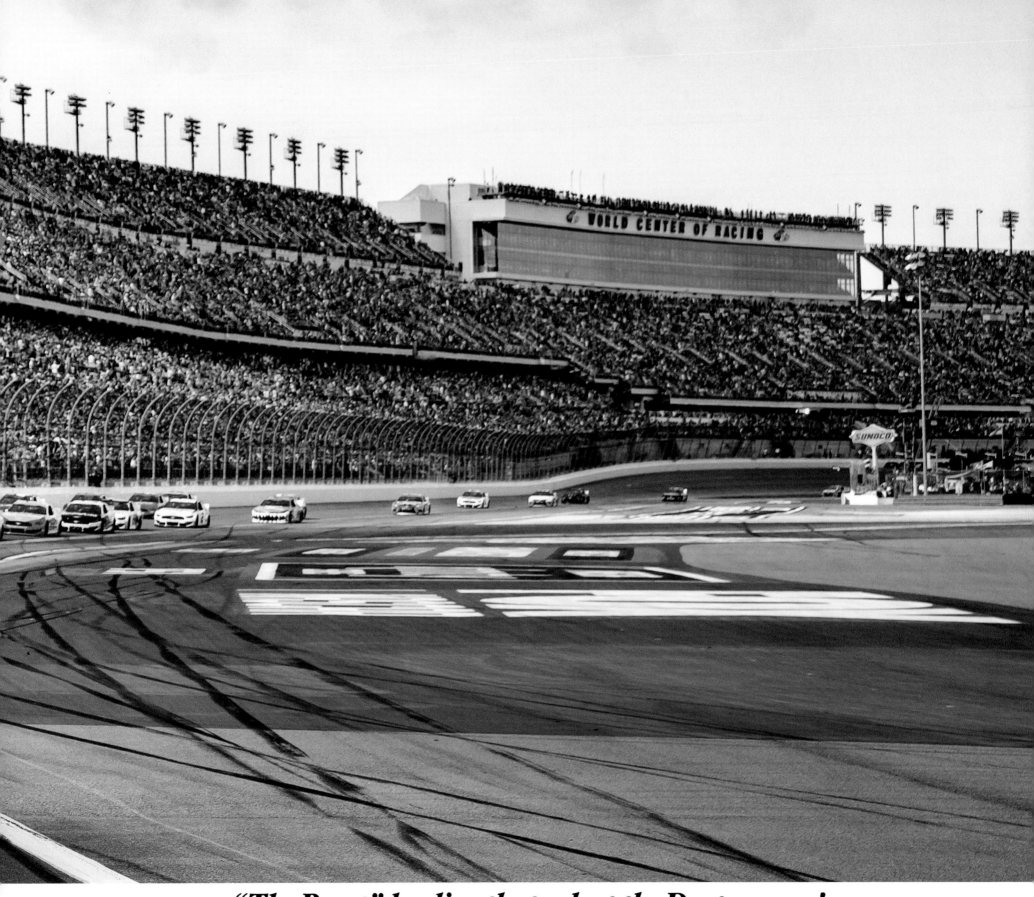

"The Beast" leading the pack at the Daytona 500!
The crowd was filled with American patriots.

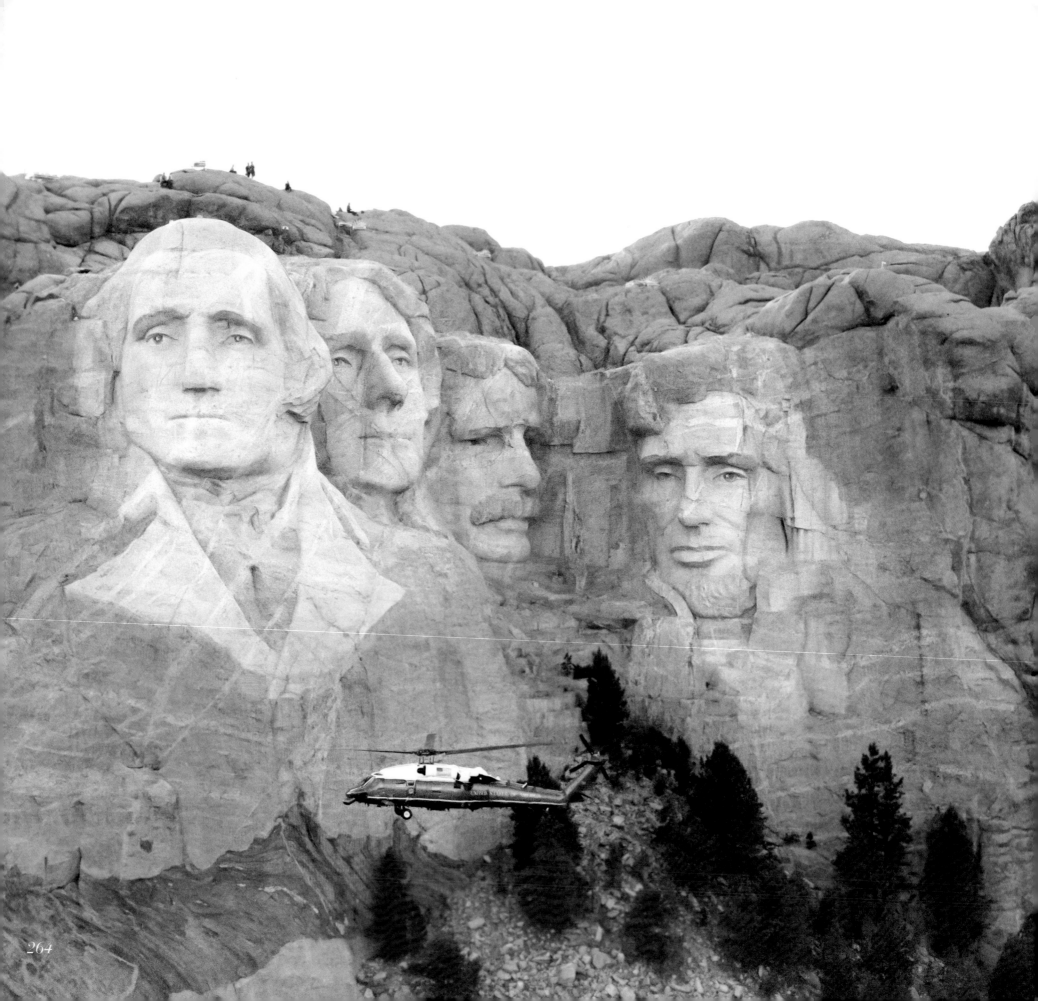

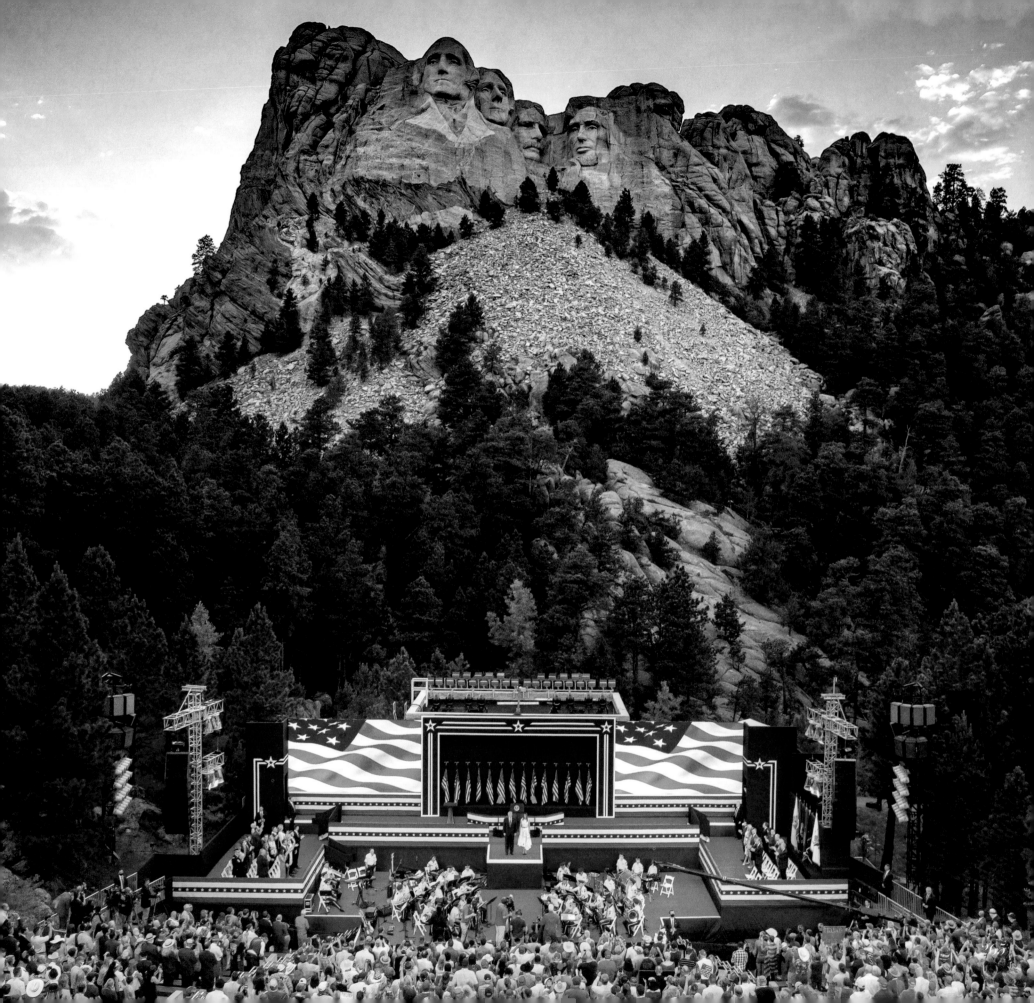

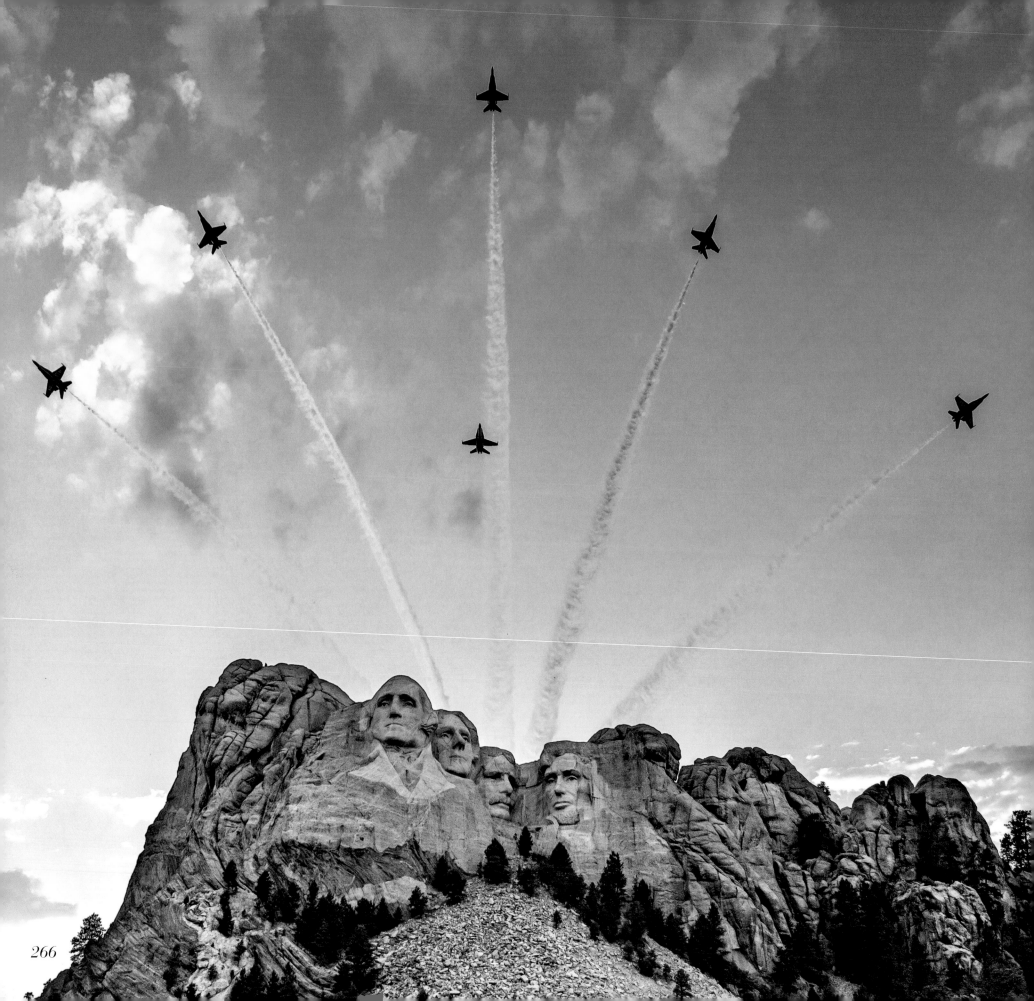

266

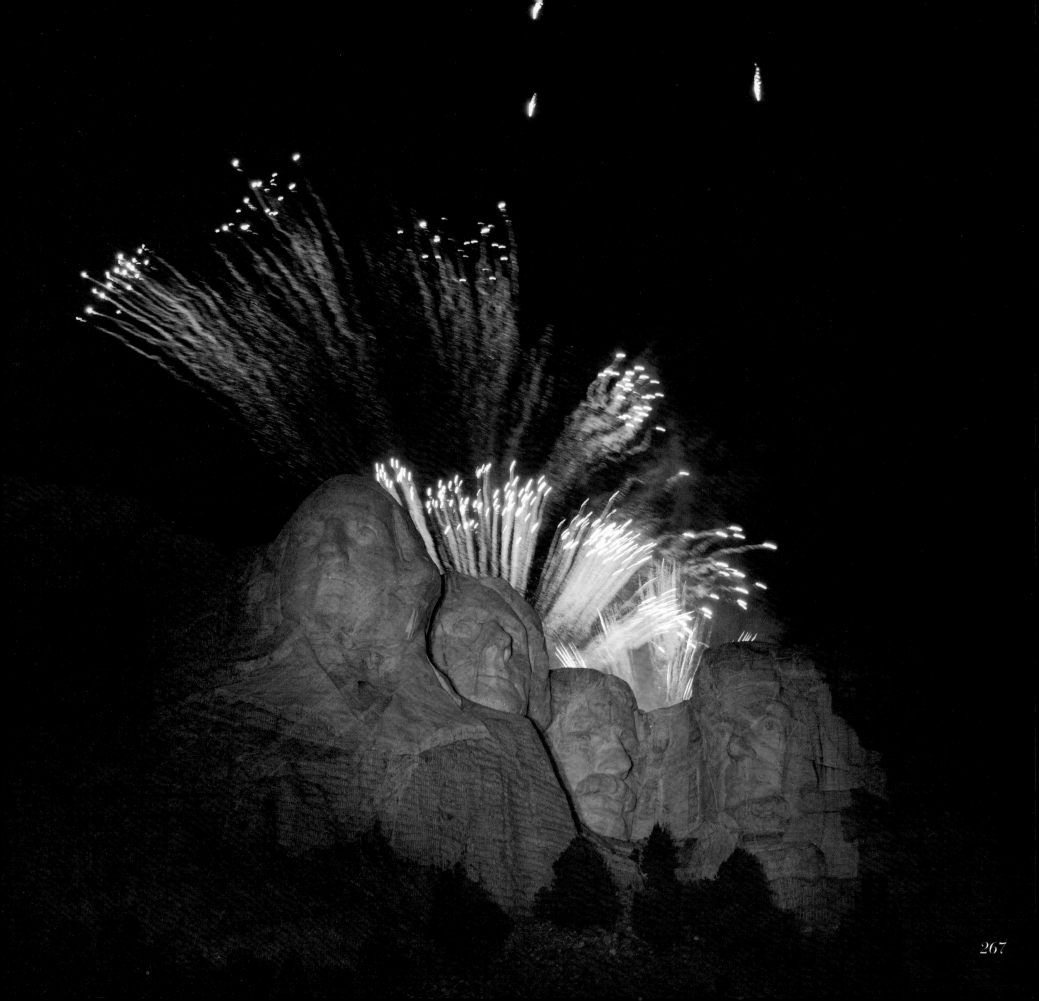

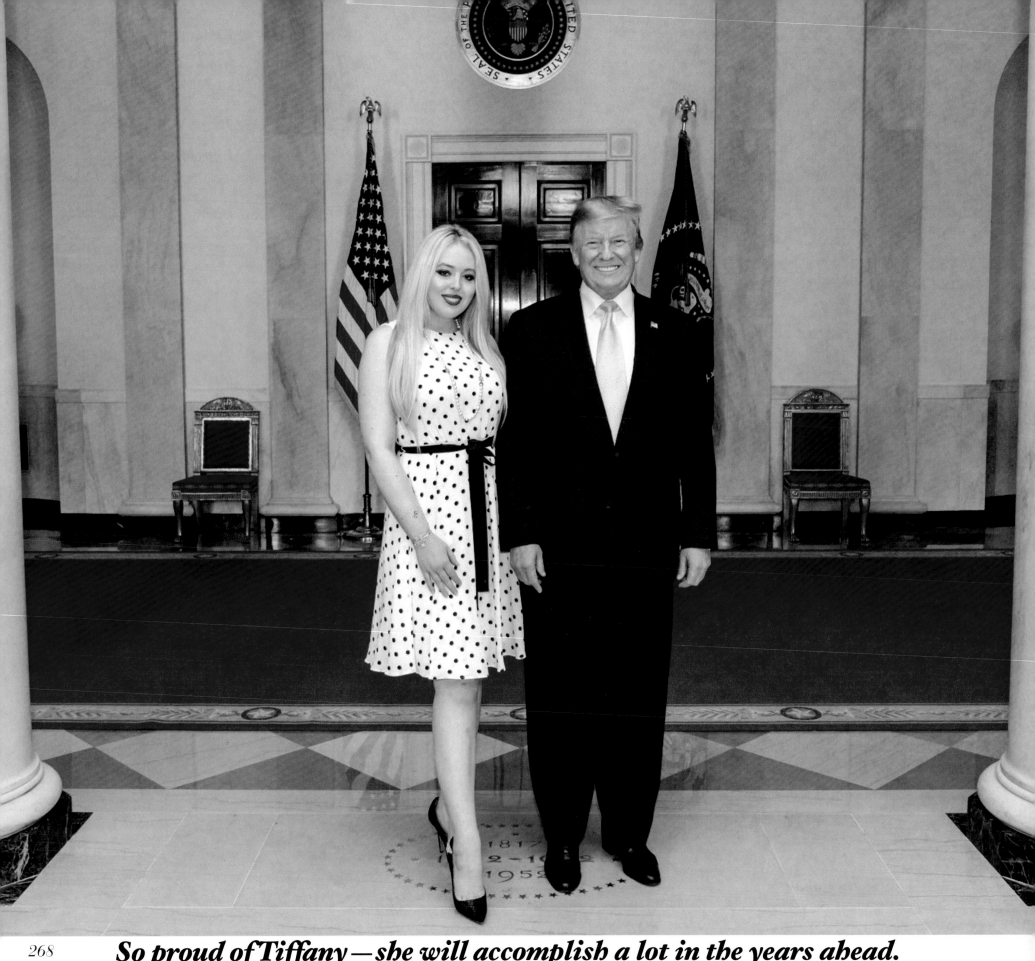

So proud of Tiffany — she will accomplish a lot in the years ahead.

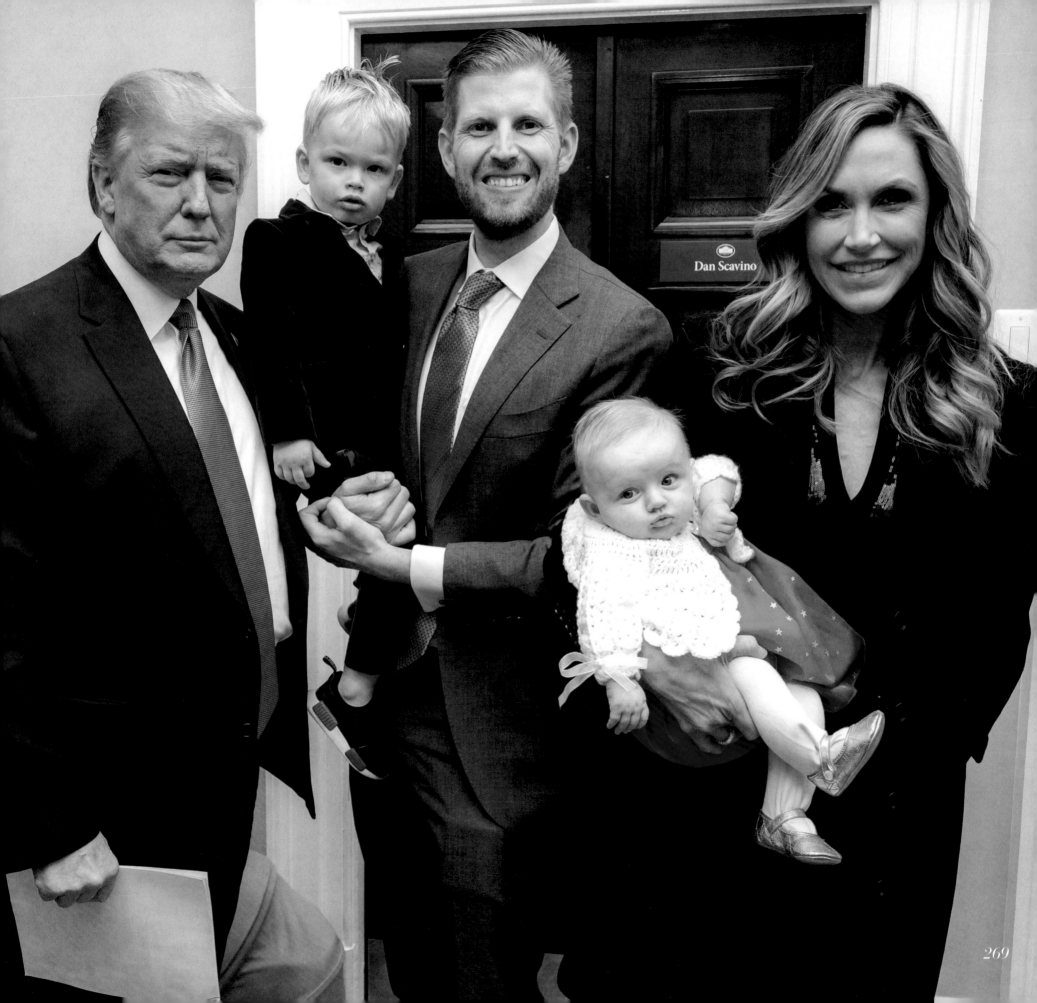

269

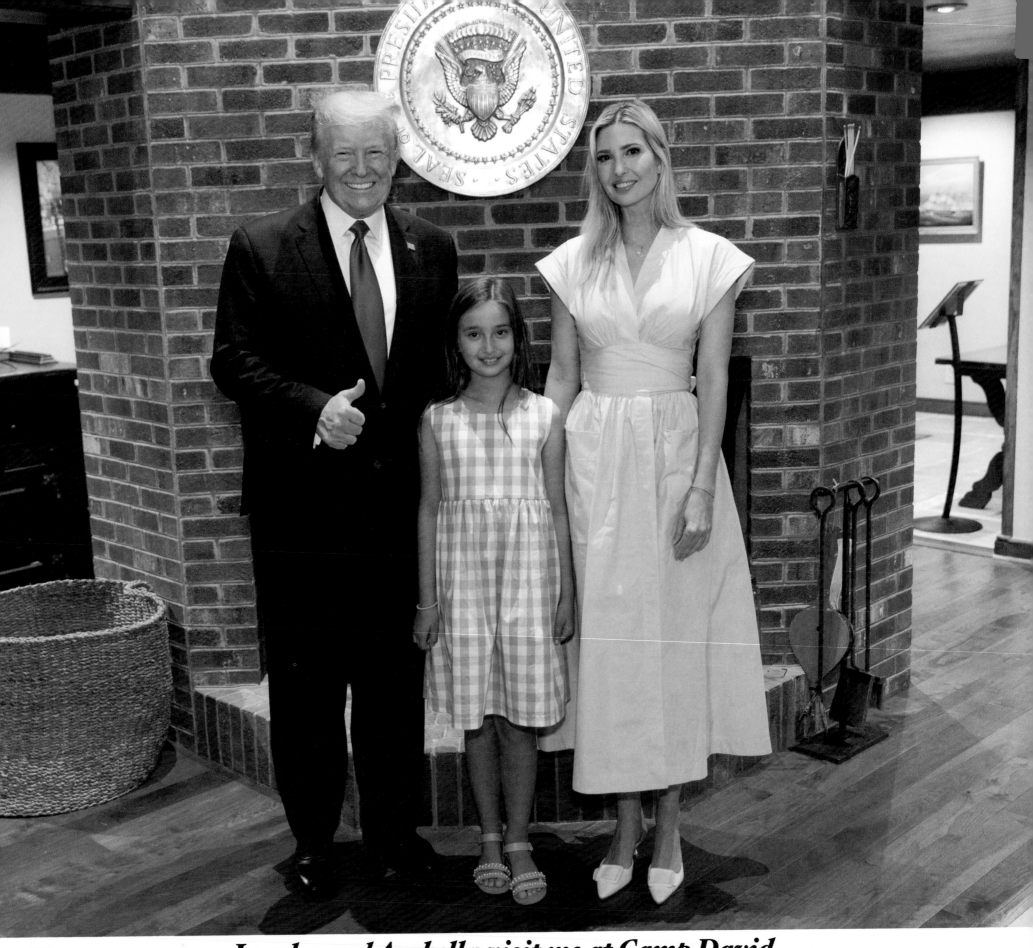

Ivanka and Arabella visit me at Camp David.

Laura Ingraham's show took off in the ratings. It will stay there. She is terrific!

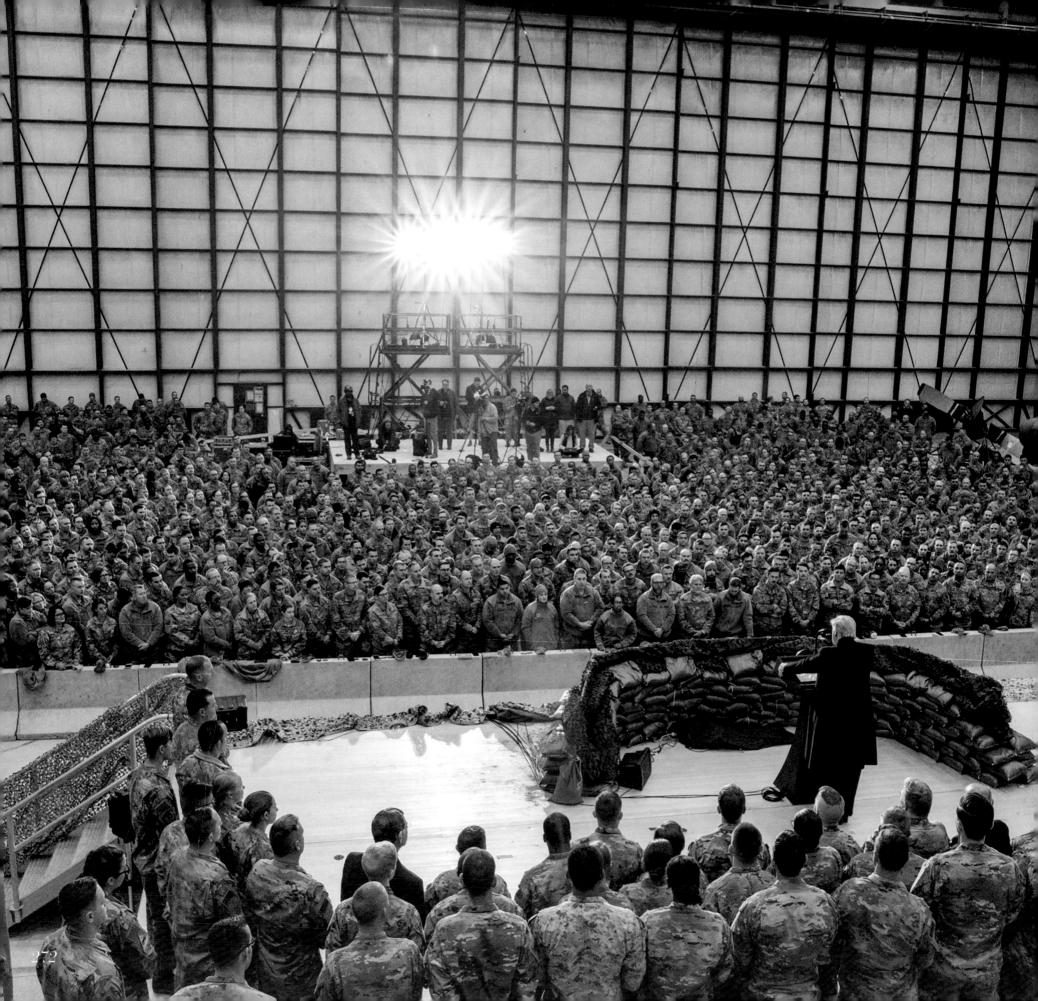

COLOSSAL REBUILDING OF THE MILITARY

Rebuilt the military and created the Sixth Branch, the United States Space Force.

Completely rebuilt the United States military with over $2.2 trillion in defense spending, including $738 billion for 2020.

Secured three pay raises for our service members and their families, including the largest raise in a decade.

Established the Space Force, the first new branch of the United States Armed Forces since 1947.

Modernized and recapitalized our nuclear forces and missile defenses to ensure they continue to serve as a strong deterrent.

Upgraded our cyber defenses by elevating the Cyber Command into a major warfighting command and by reducing burdensome procedural restrictions on cyber operations.

Vetoed the FY21 National Defense Authorization Act, which failed to protect our national security, disrespected the history of our veterans and military, and contradicted our efforts to put America first.

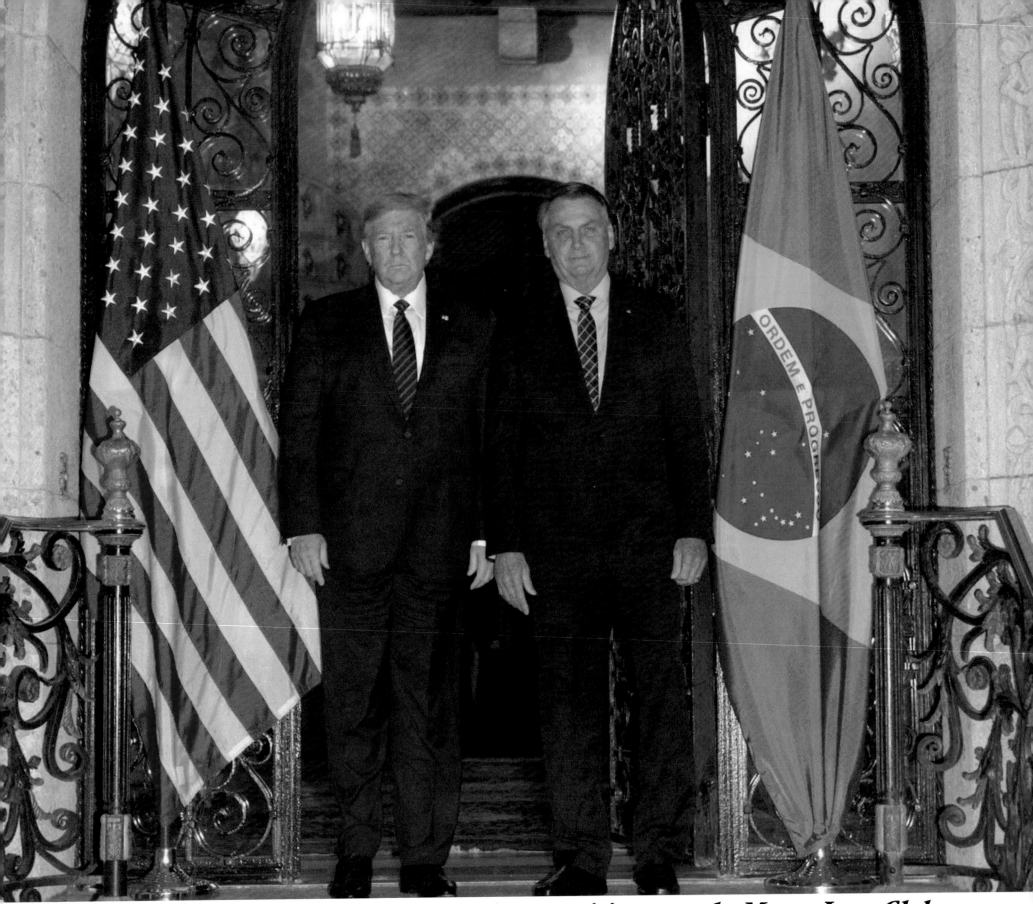

My great friend President Jair Bolsonaro visits me at the Mar-a-Lago Club, always standing up for his nation of Brazil.

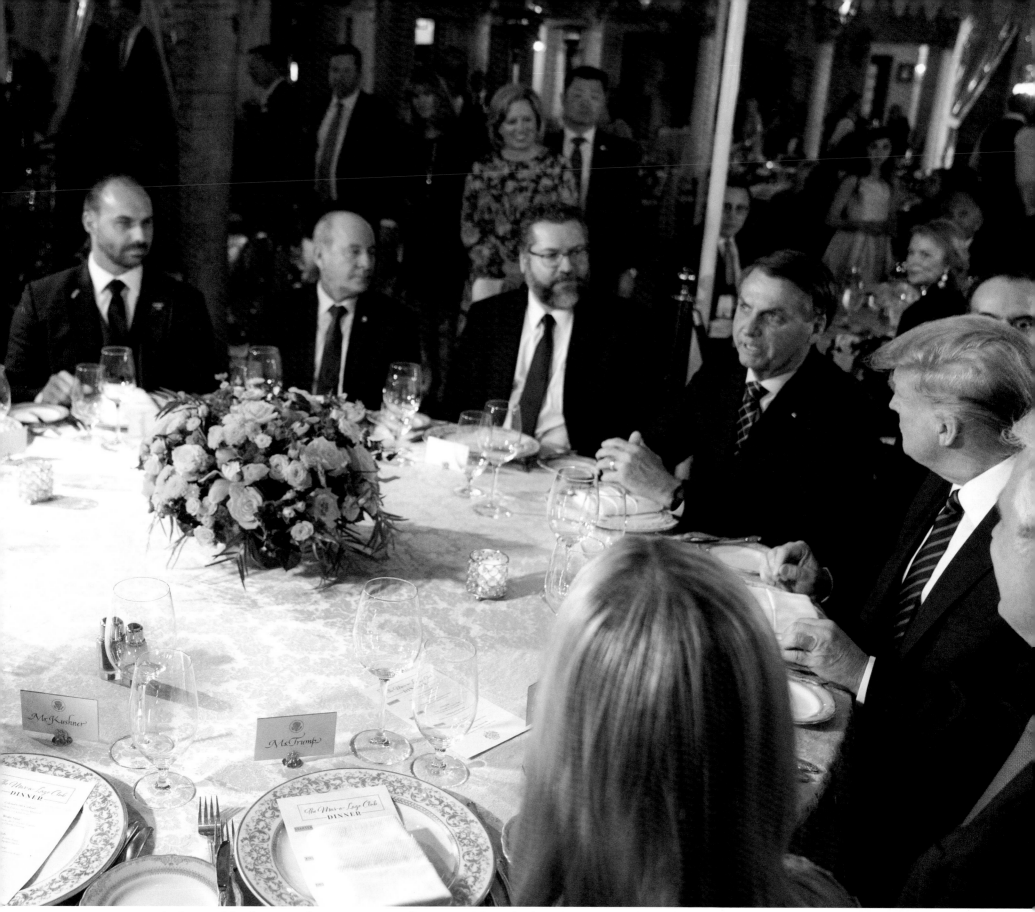

President Jair Bolsonaro of Brazil with his wonderful son Eduardo (far left). President Bolsonaro fights so HARD for Brazil, he loves his country and his people.

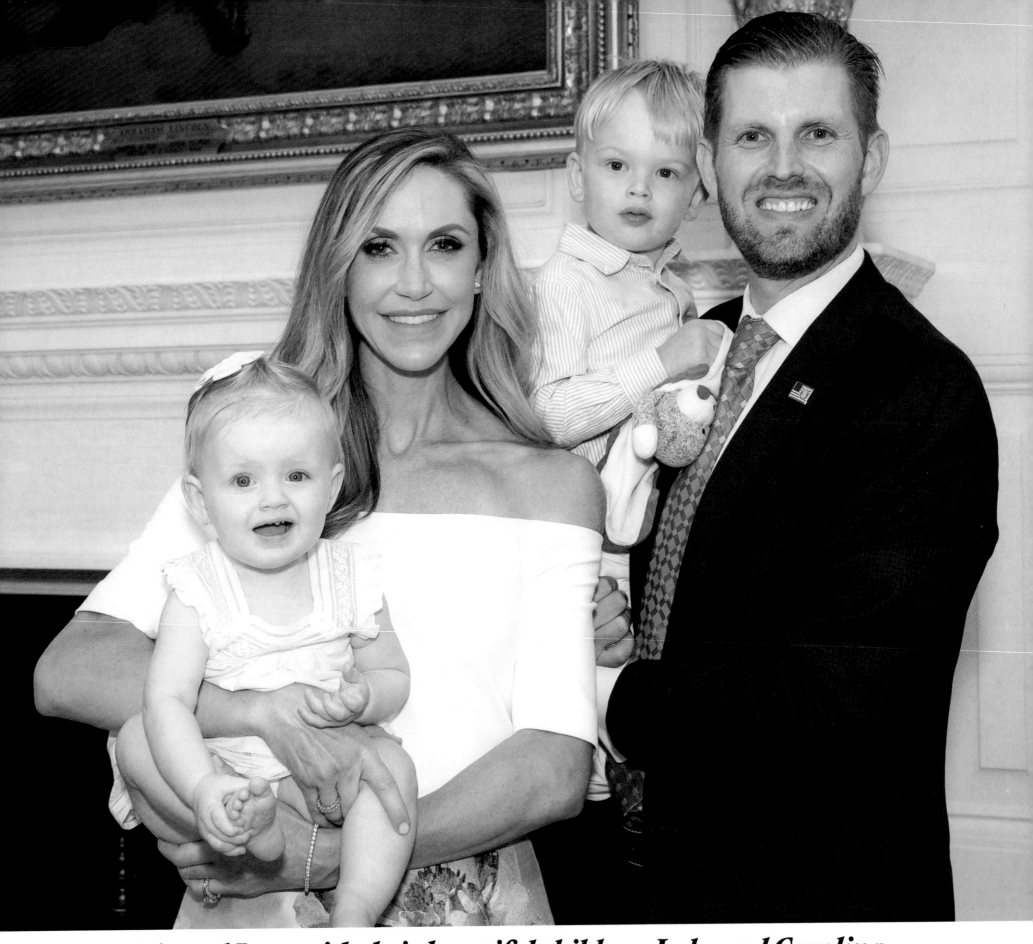

Eric and Lara with their beautiful children, Luke and Carolina.

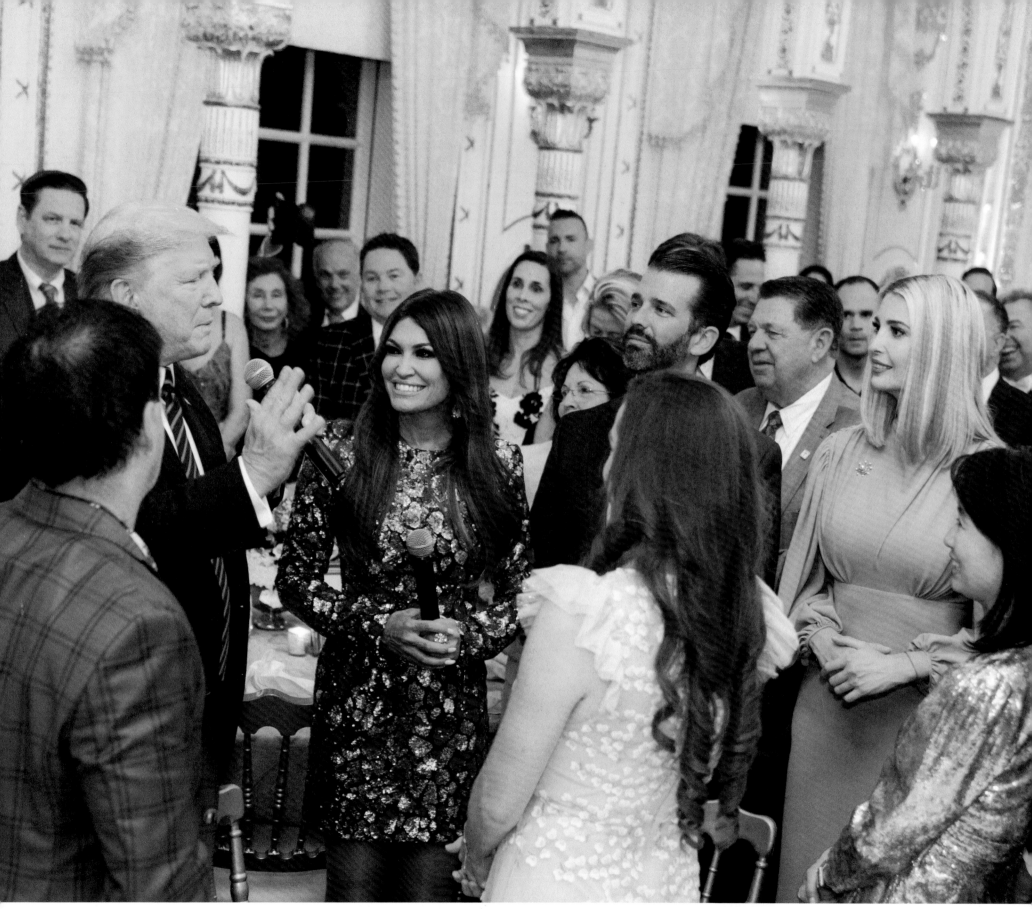

A special evening at the Mar-a-Lago Club!
We celebrated Kimberly Guilfoyle's birthday.

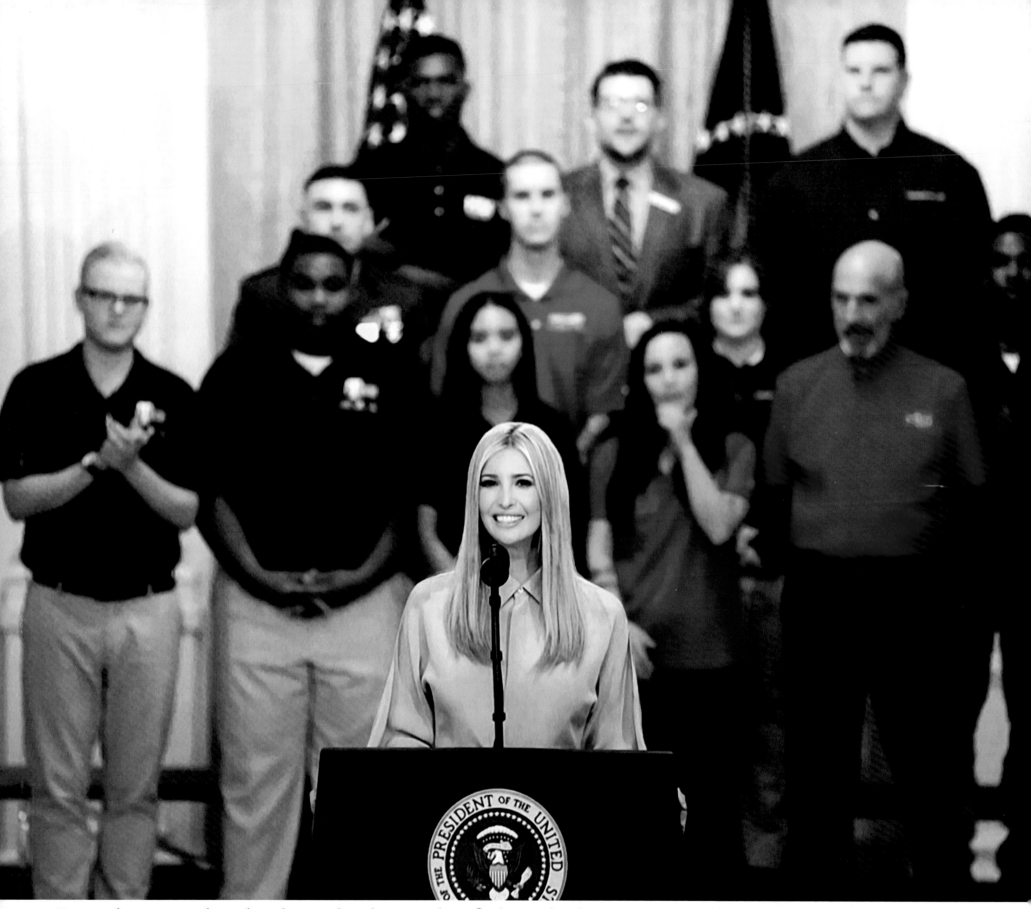

Ivanka speaks during the launch of the Pledge to America's Workers Initiative. We did everything to create jobs in AMERICA.

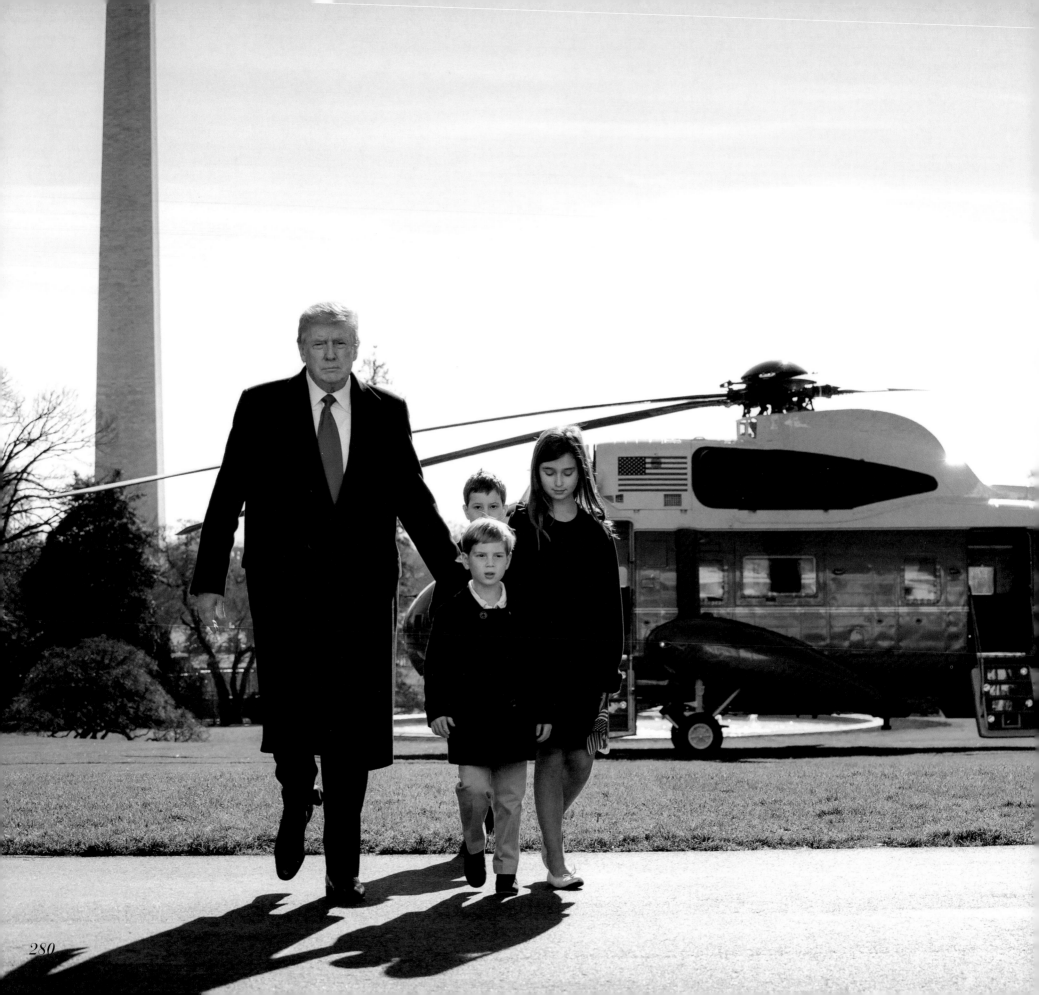

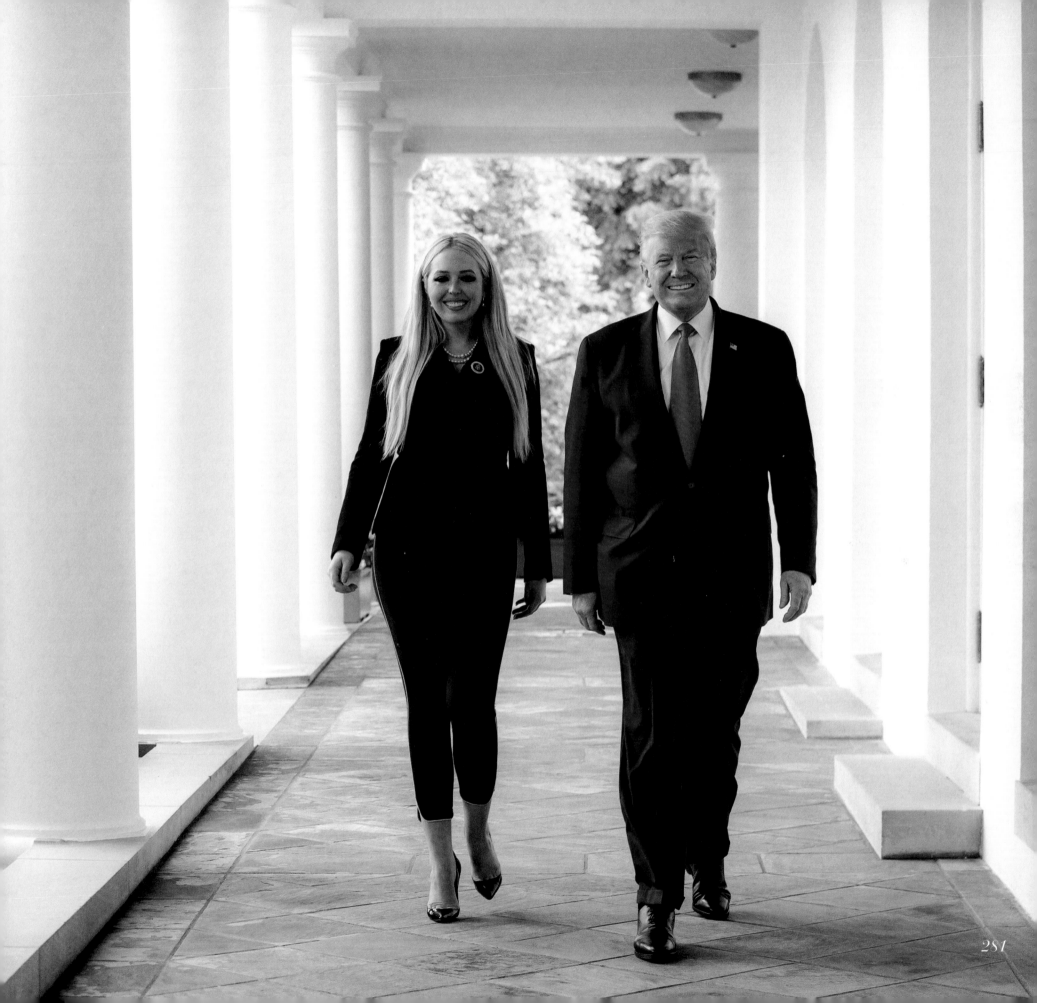

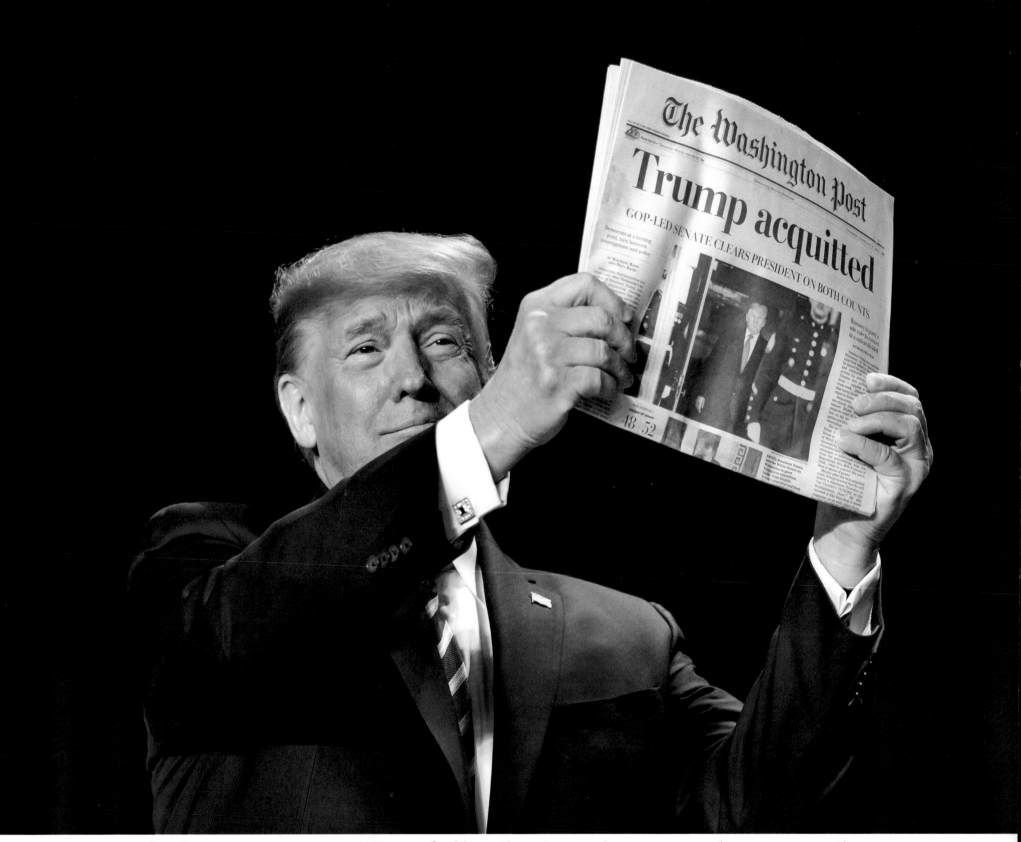

*The hoax was over. Hopefully, the American people are awake
to the corruption taking place in our government.*

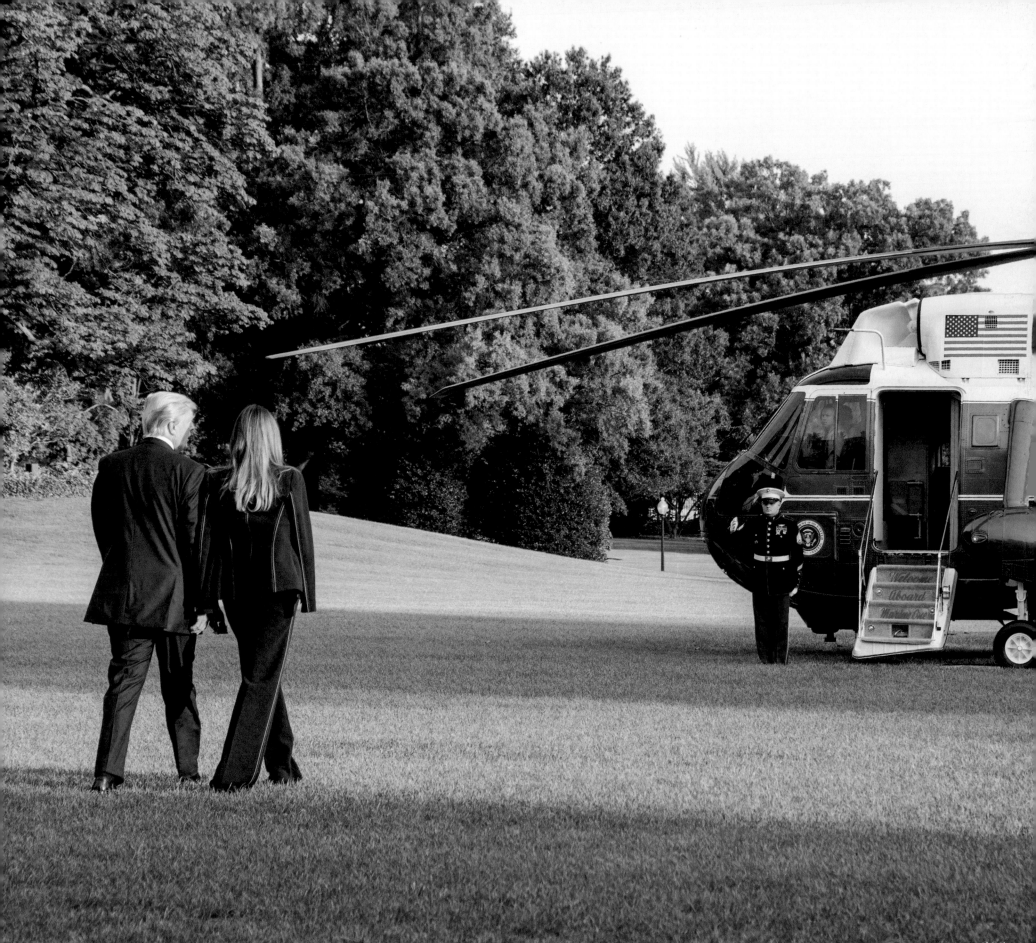

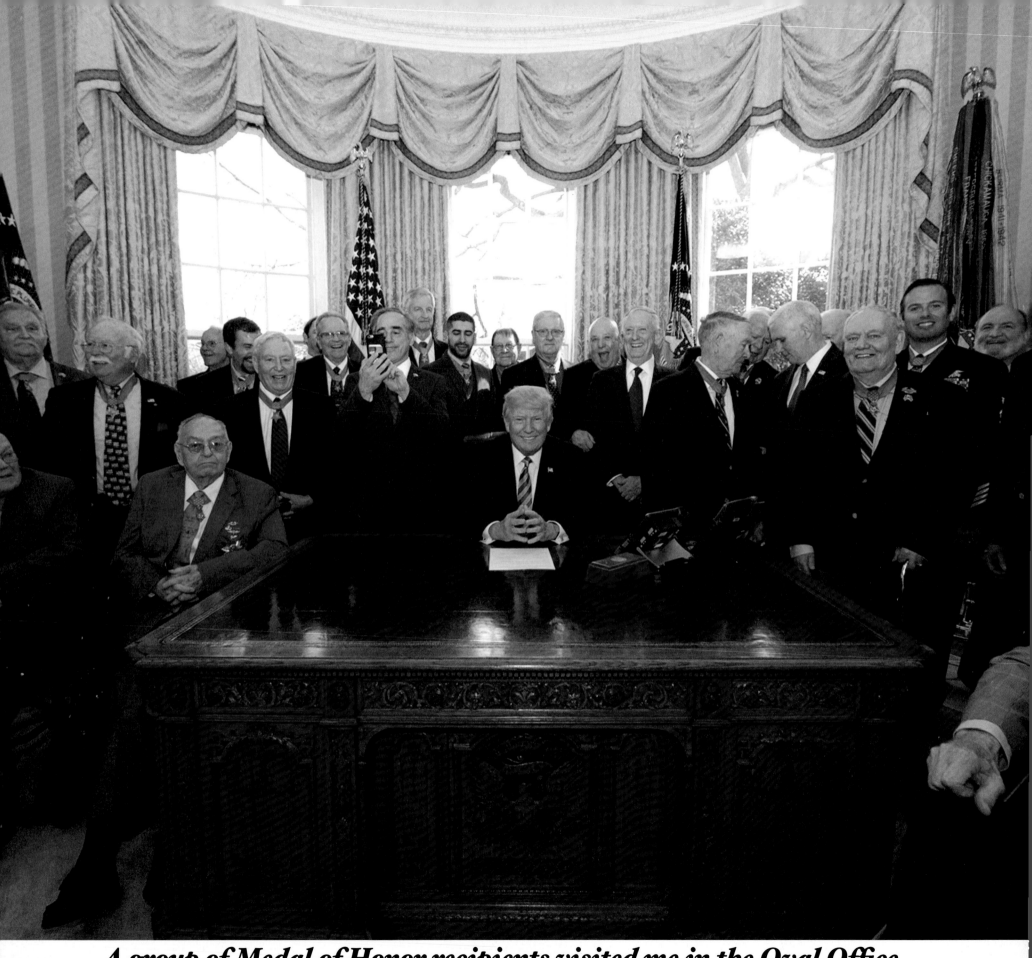

A group of Medal of Honor recipients visited me in the Oval Office.

SERVING AND PROTECTING OUR VETERAMS INFO SHEET

Reformed the Department of Veterans Affairs (VA) to improve care, choice, and employee accountability.

Signed and implemented the VA Mission Act, which made permanent Veterans CHOICE, revolutionized the VA community care system, and delivered quality care closer to home for Veterans.

The number of Veterans who say they trust VA services has increased 19 percent to a record 91 percent, an all-time high.

Offered same-day emergency mental health care at every VA medical facility, and secured $9.5 billion for mental health services in 2020.

Signed the VA Choice and Quality Employment Act of 2017, which ensured that veterans could continue to see the doctor of their choice and wouldn't have to wait for care.

During the Trump Administration, millions of veterans have been able to choose a private doctor in their communities.

Expanded Veterans' ability to access telehealth services, including through the "Anywhere to Anywhere" VA healthcare initiative leading to a 1000 percent increase in usage during COVID-19.

Signed the Veterans Affairs Accountability and Whistleblower Protection Act and removed thousands of VA workers who failed to give our Vets the care they have so richly deserve.

Signed the Veterans Appeals Improvement and Modernization Act of 2017 and improved the efficiency of the VA, setting record numbers of appeals decisions.

Formed the PREVENTS Task Force to fight the tragedy of Veteran suicide.

During my time at Walter Reed National Military Medical Center, I was always in control. The fake news was hysterical the entire time.

A quick recovery from COVID, and back to work for America!

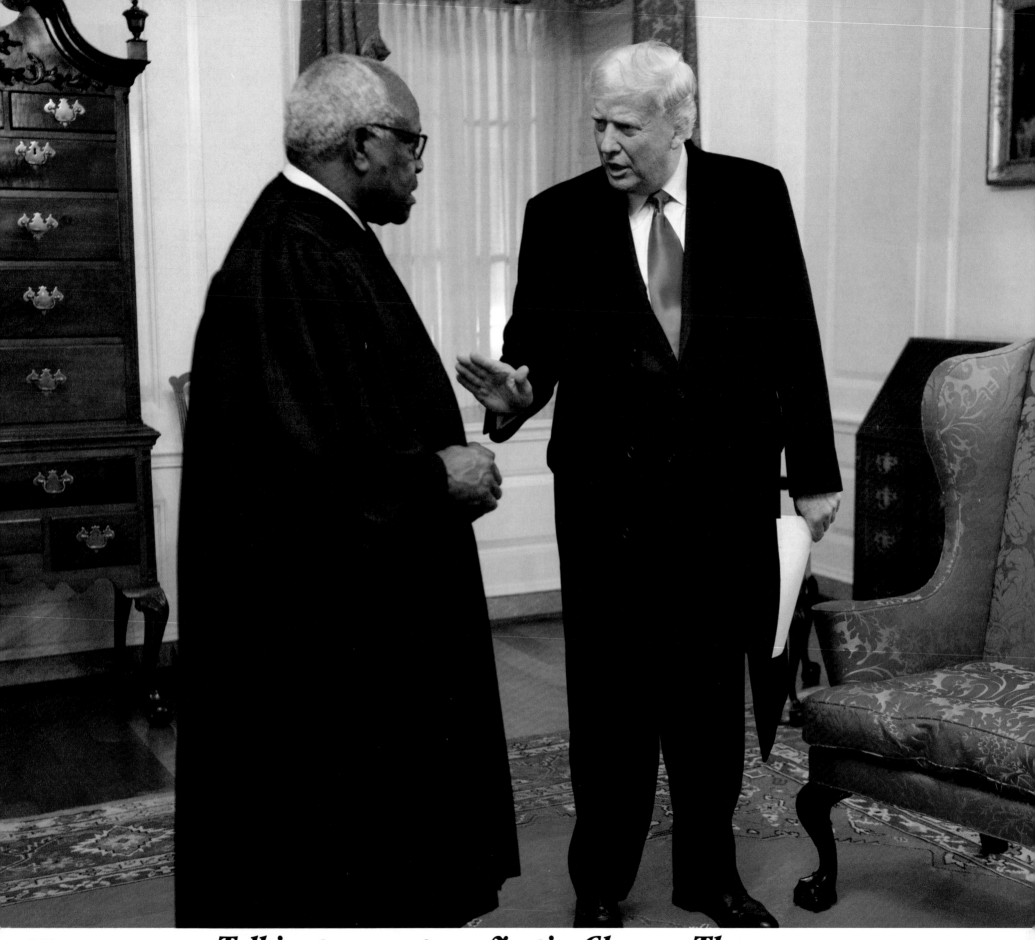

Talking to a great guy, Justice Clarence Thomas.

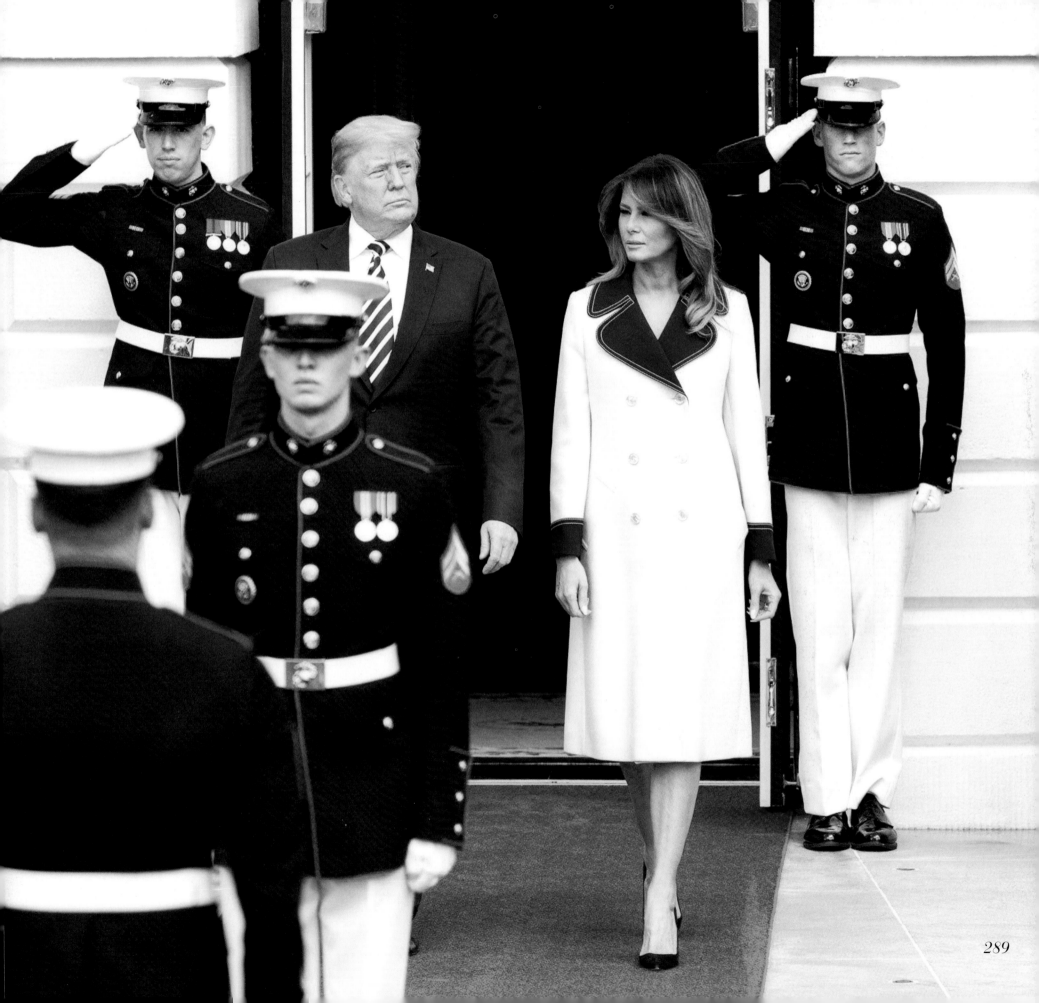

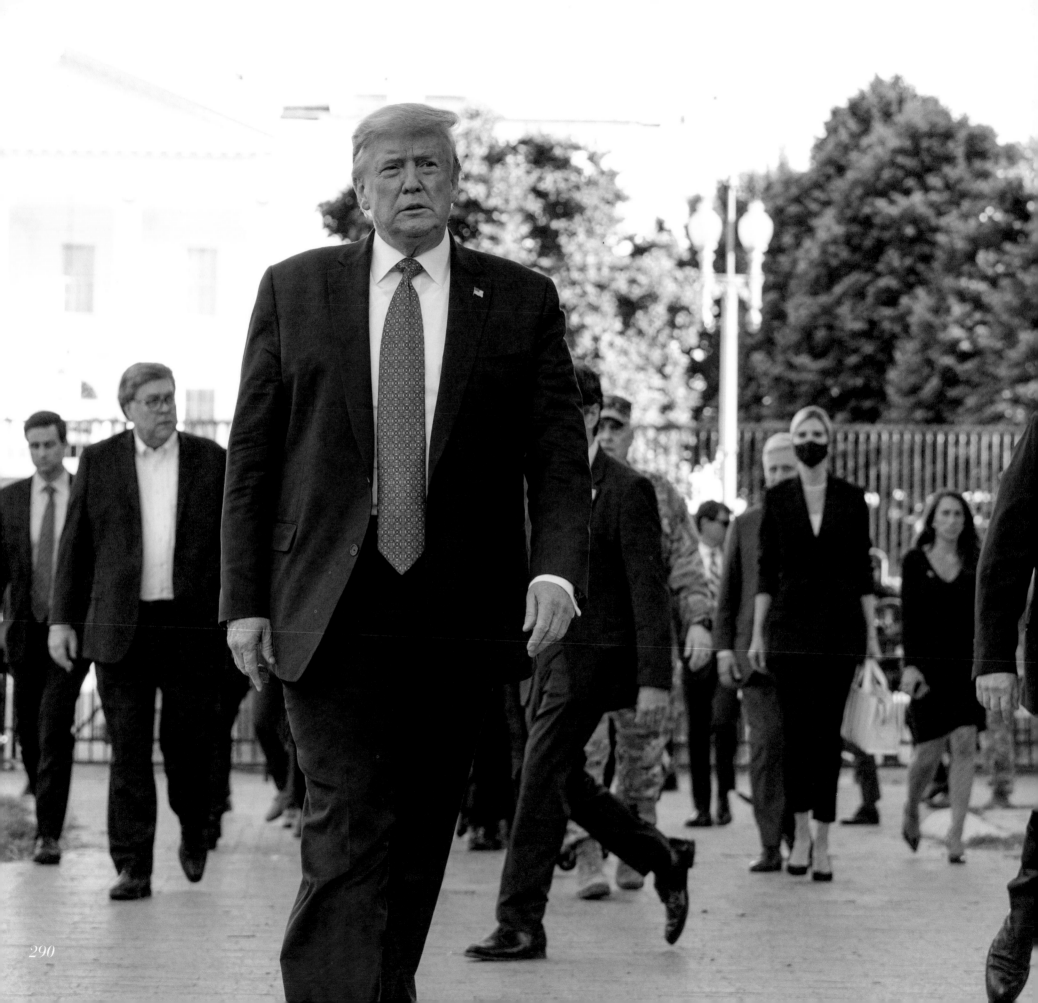

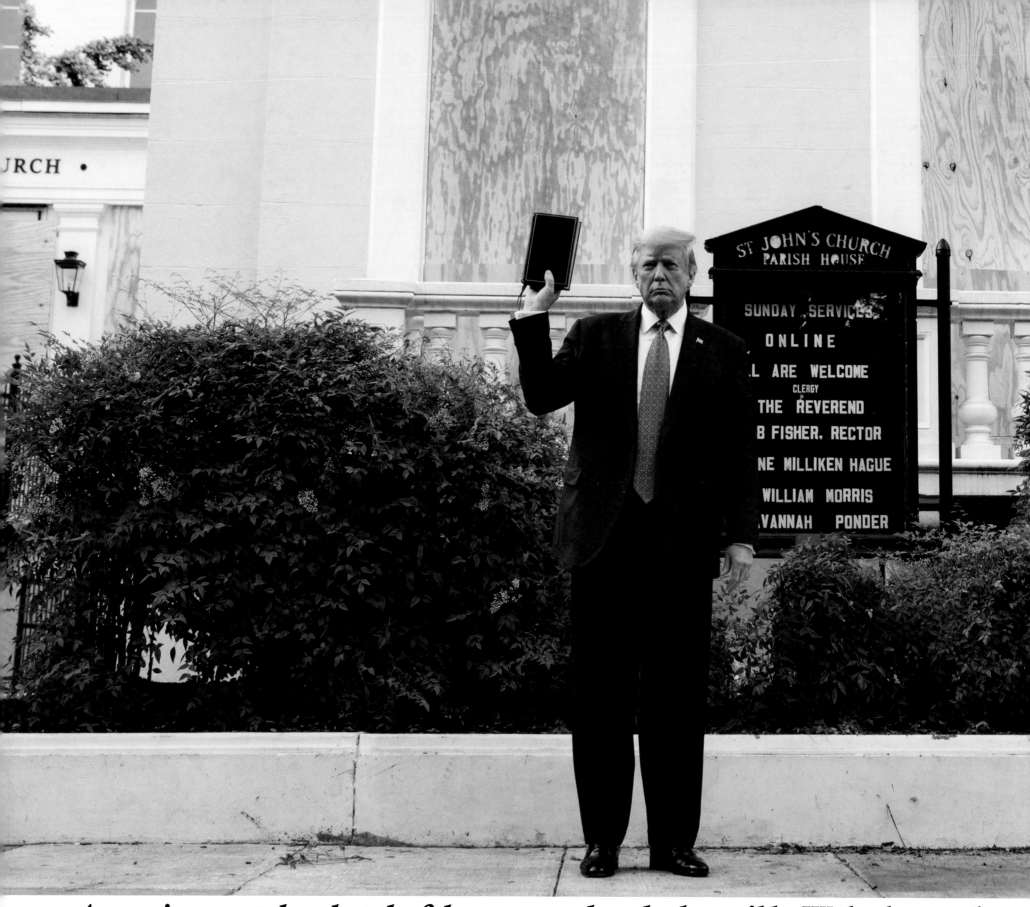

A very innocent day that the fake news made to look terrible. We had to send a message that looting and burning of churches would not be tolerated.

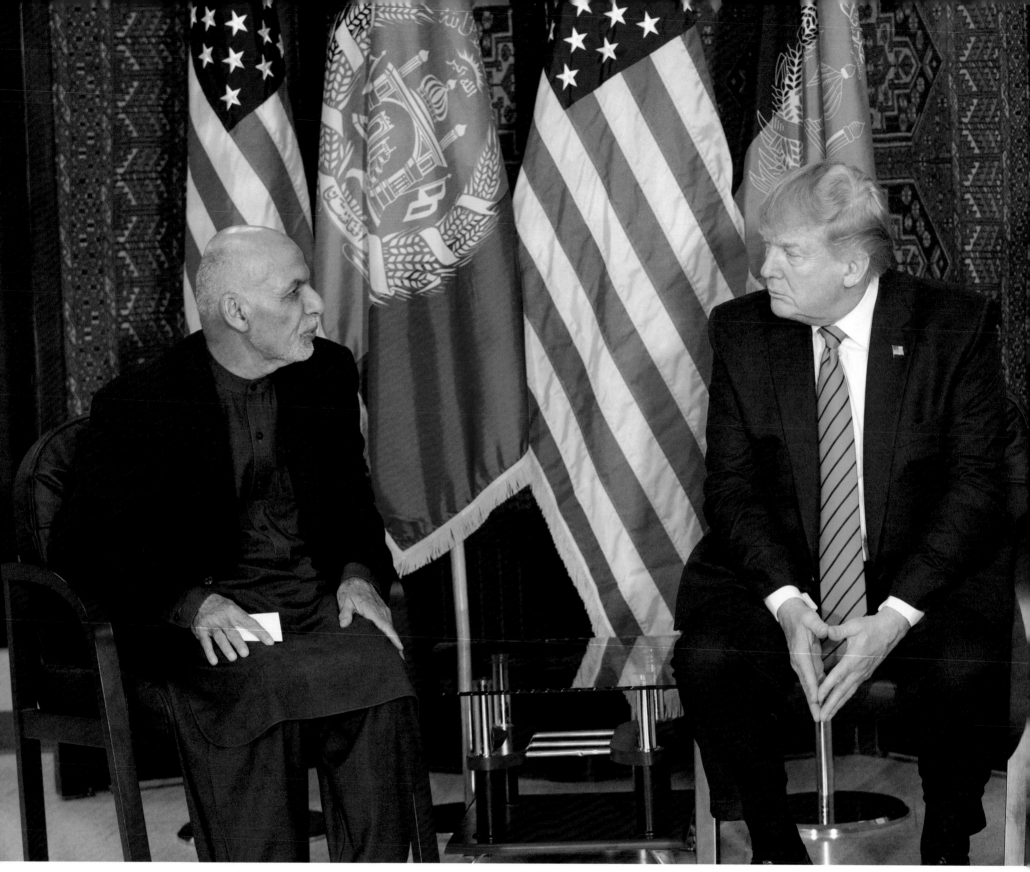

I was preaching against Ashraf Ghani long before I was President. He conned America into giving Afghanistan billions of dollars a year to pay for people who weren't with us. He ended up fleeing Afghanistan with plenty of cash.

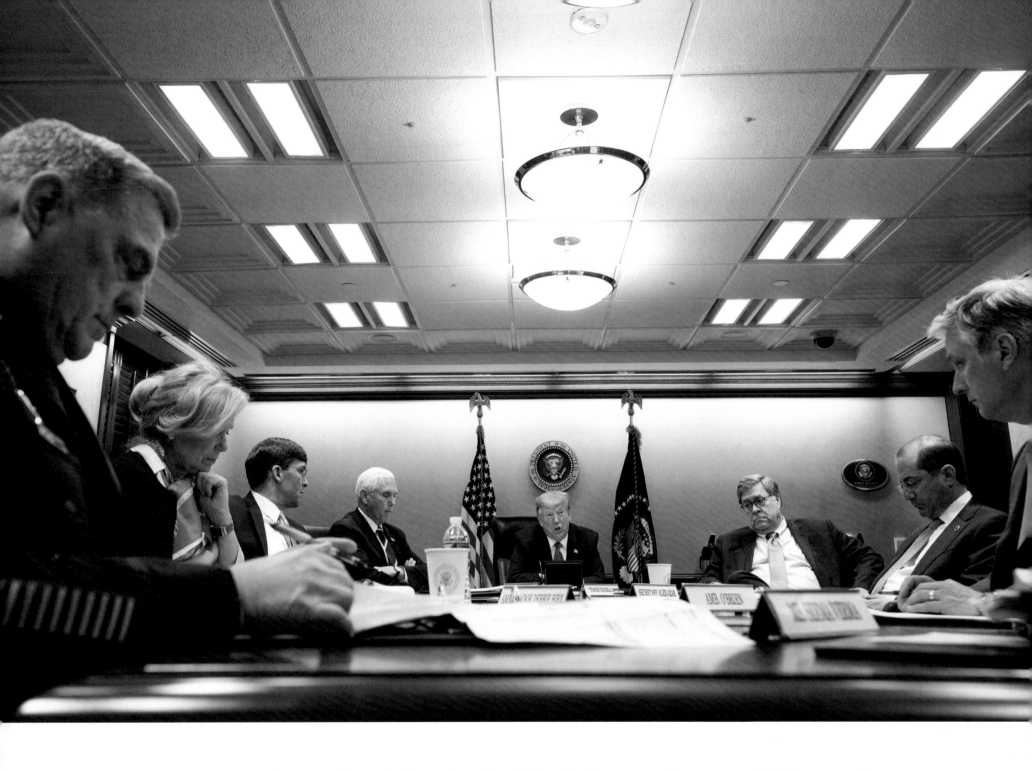

**General Mark Milley looks like he's praying and "Yesper"
(who said "yes" to everything) doesn't know if he's alive. Milley was so
overrated, and his conversations with China were absolutely disgraceful.**

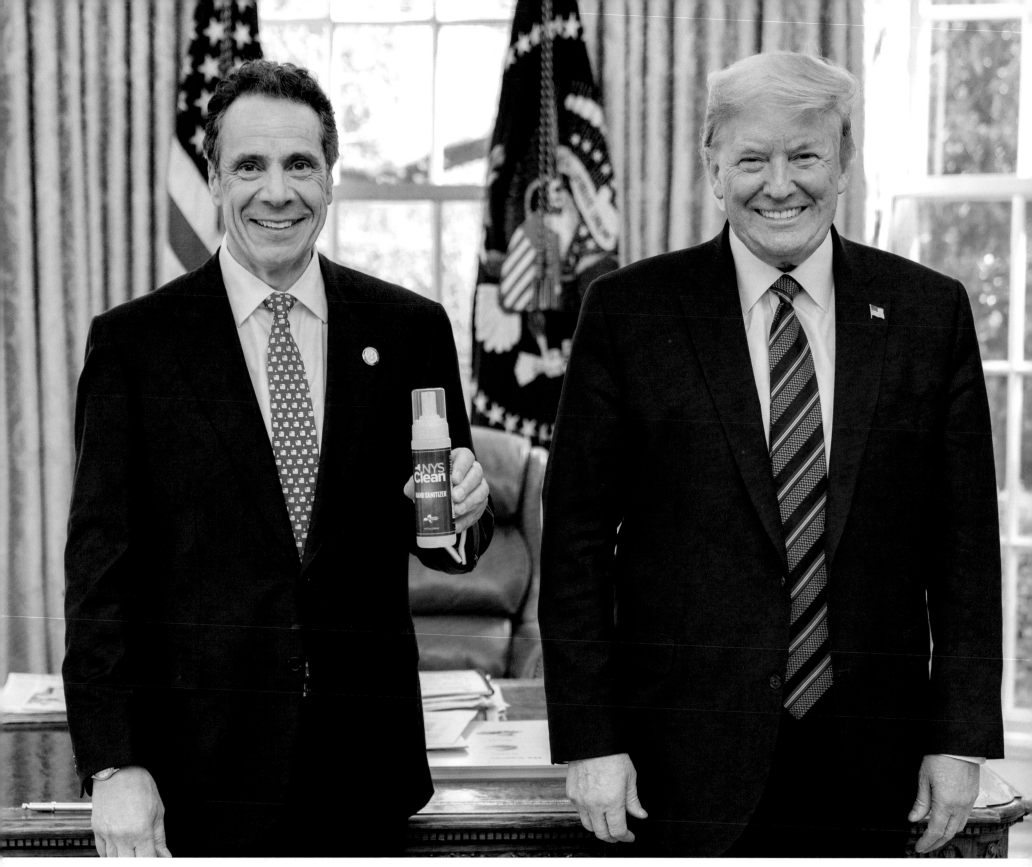

Then-Governor Andrew Cuomo of New York who was forced out of office without, surprisingly, much of a fight. I gave New York everything it wanted, including hospital ships, rooms, thousands of ventilators, and ultimately, vaccines.

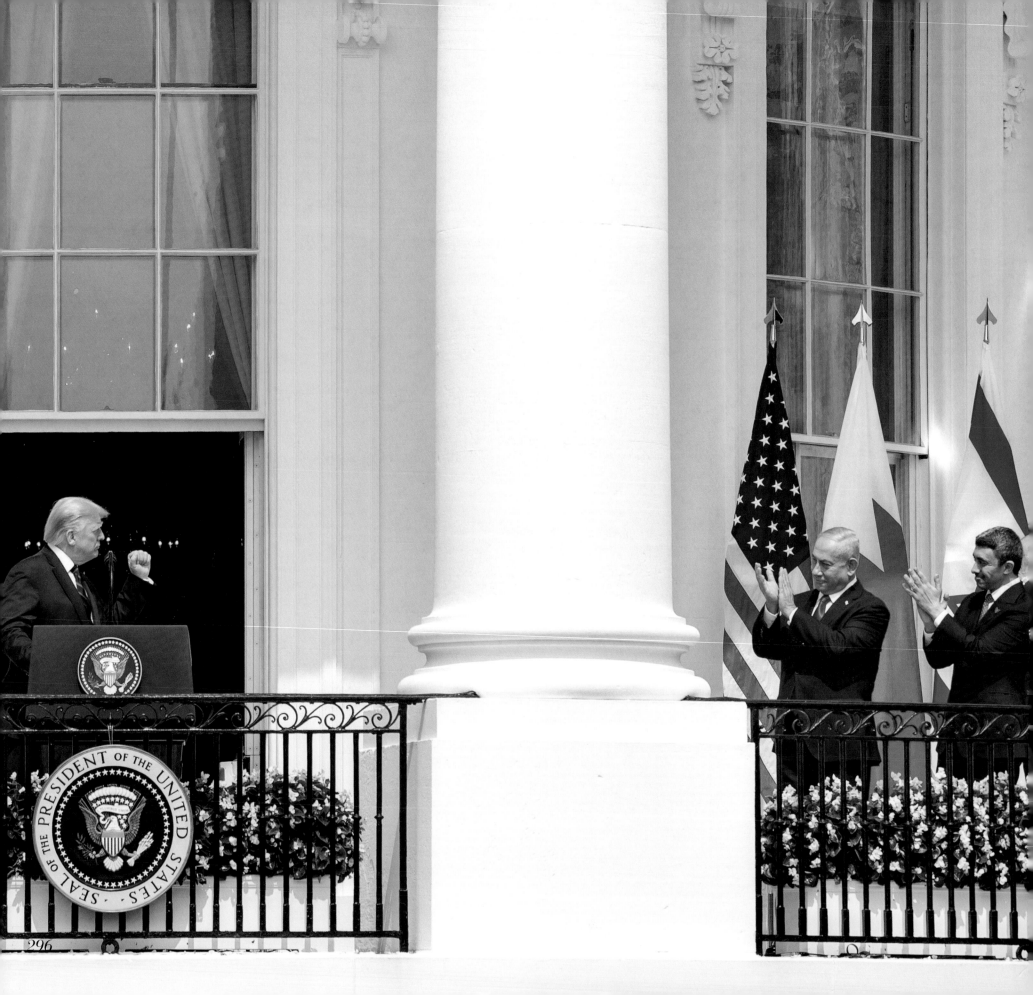

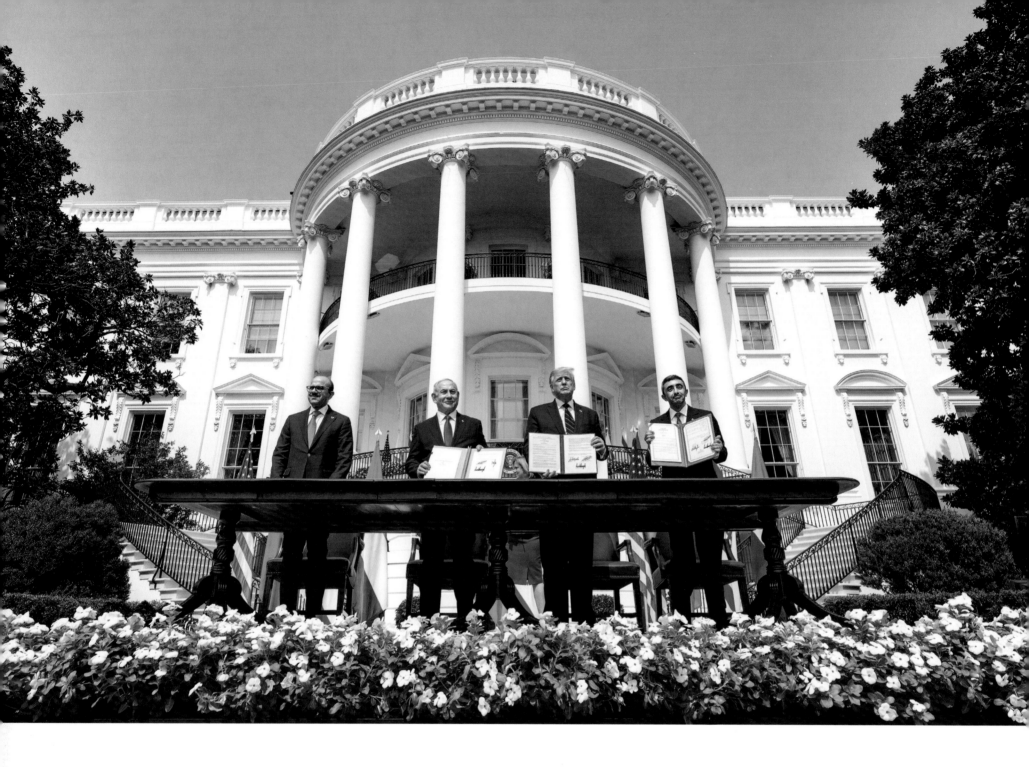

I DELIVERED PEACE IN THE MIDDLE EAST THROUGH THE ABRAHAM ACCORDS.

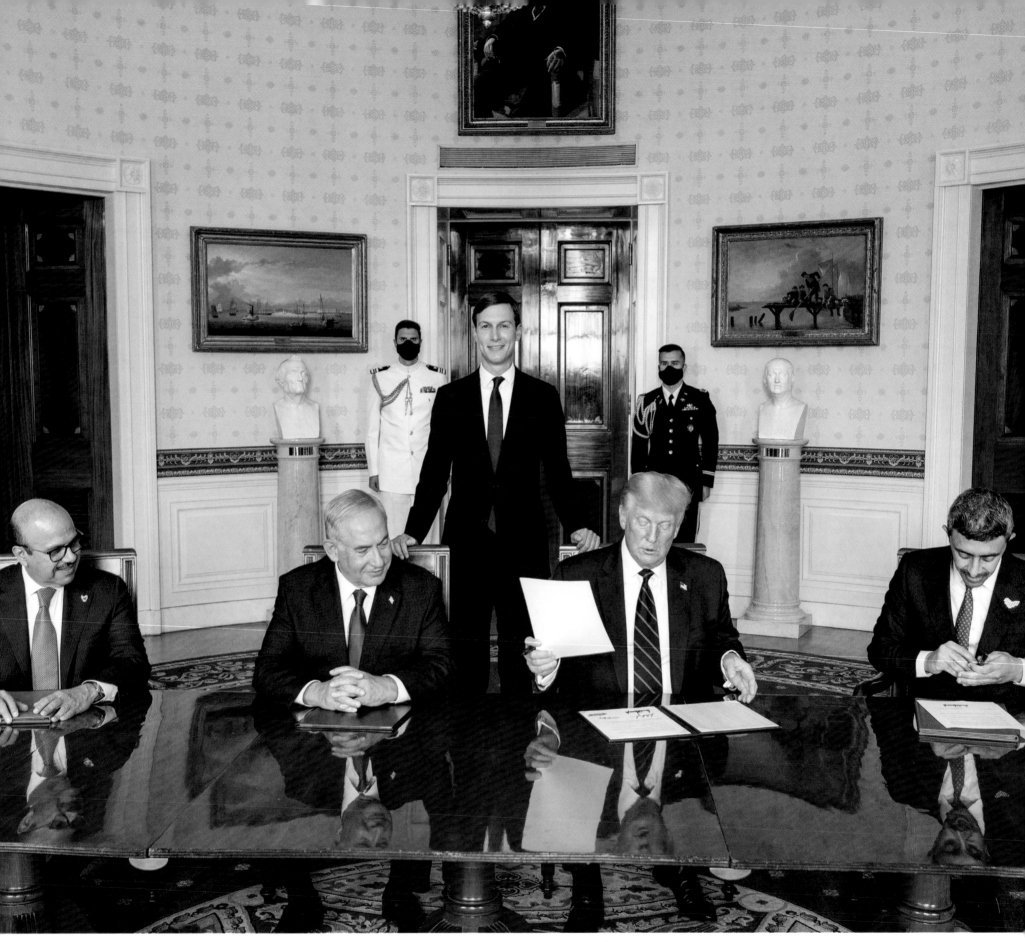

Signing the Abraham Accords, which led to great peace.

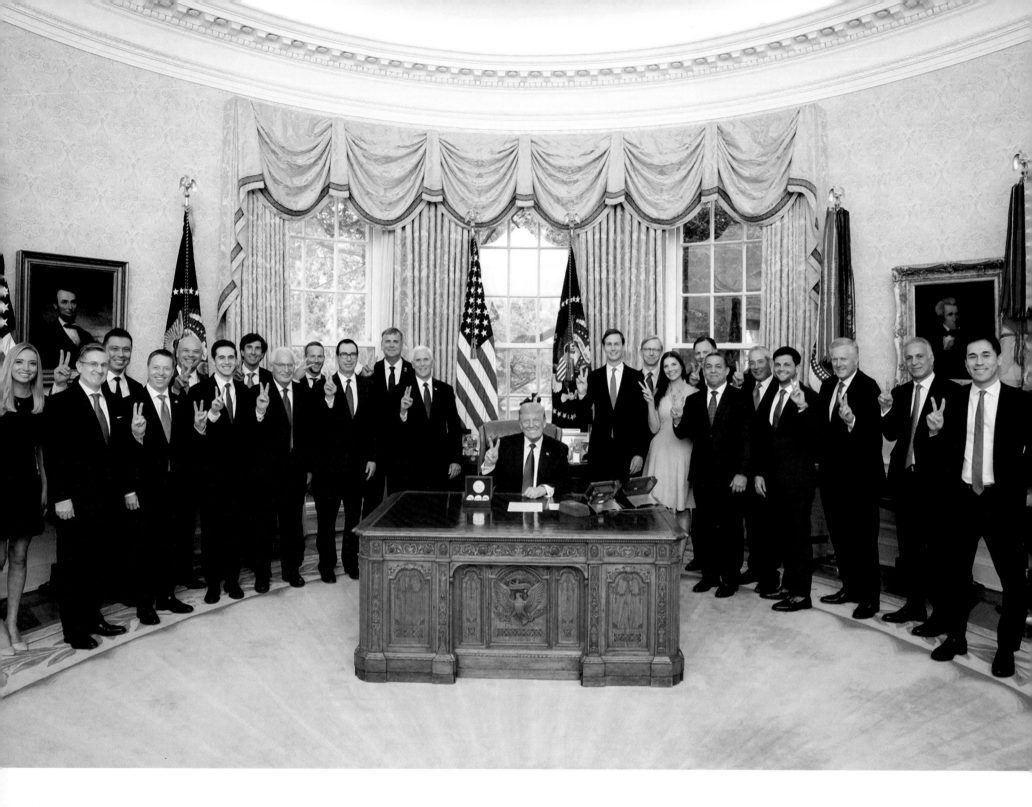

A big day for peace in the Middle East. Jared and the team that was responsible for the success of the Abraham Accords.

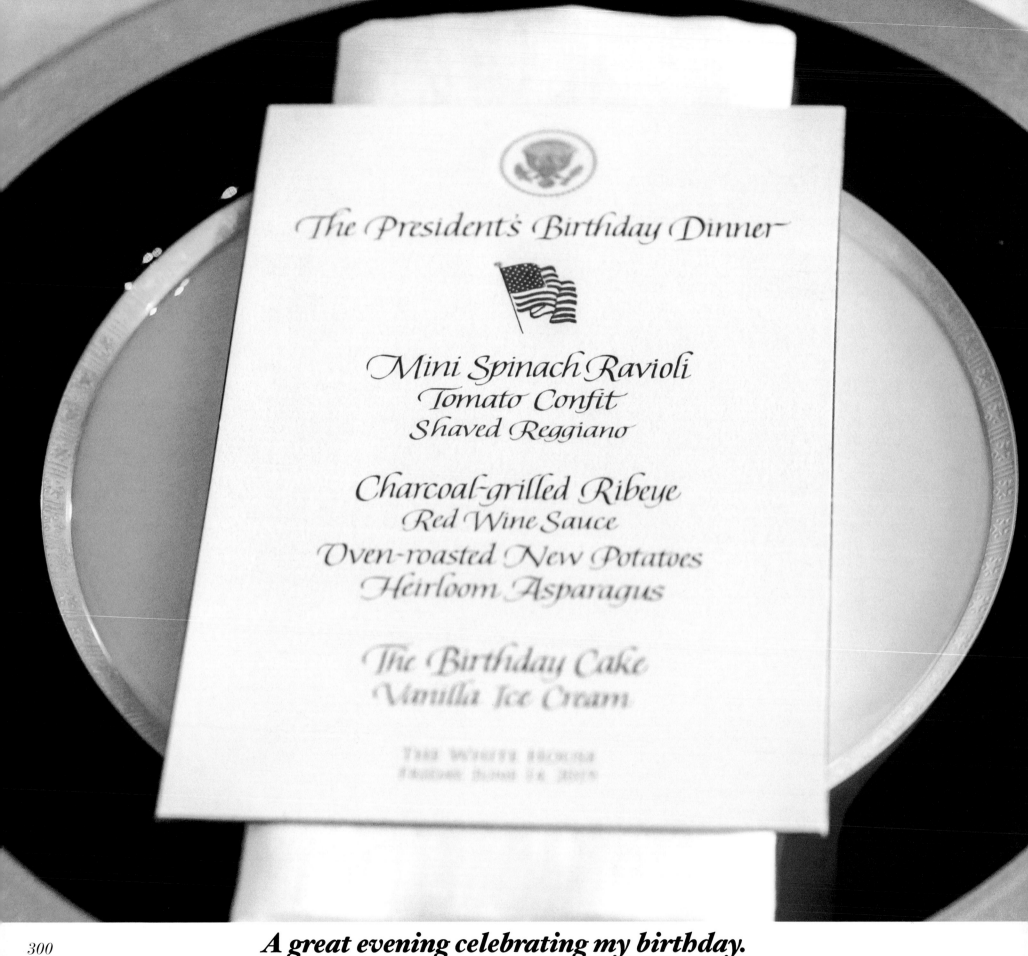

The President's Birthday Dinner

Mini Spinach Ravioli
Tomato Confit
Shaved Reggiano

Charcoal-grilled Ribeye
Red Wine Sauce
Oven-roasted New Potatoes
Heirloom Asparagus

The Birthday Cake
Vanilla Ice Cream

THE WHITE HOUSE
FRIDAY JUNE 14, 2019

A great evening celebrating my birthday.

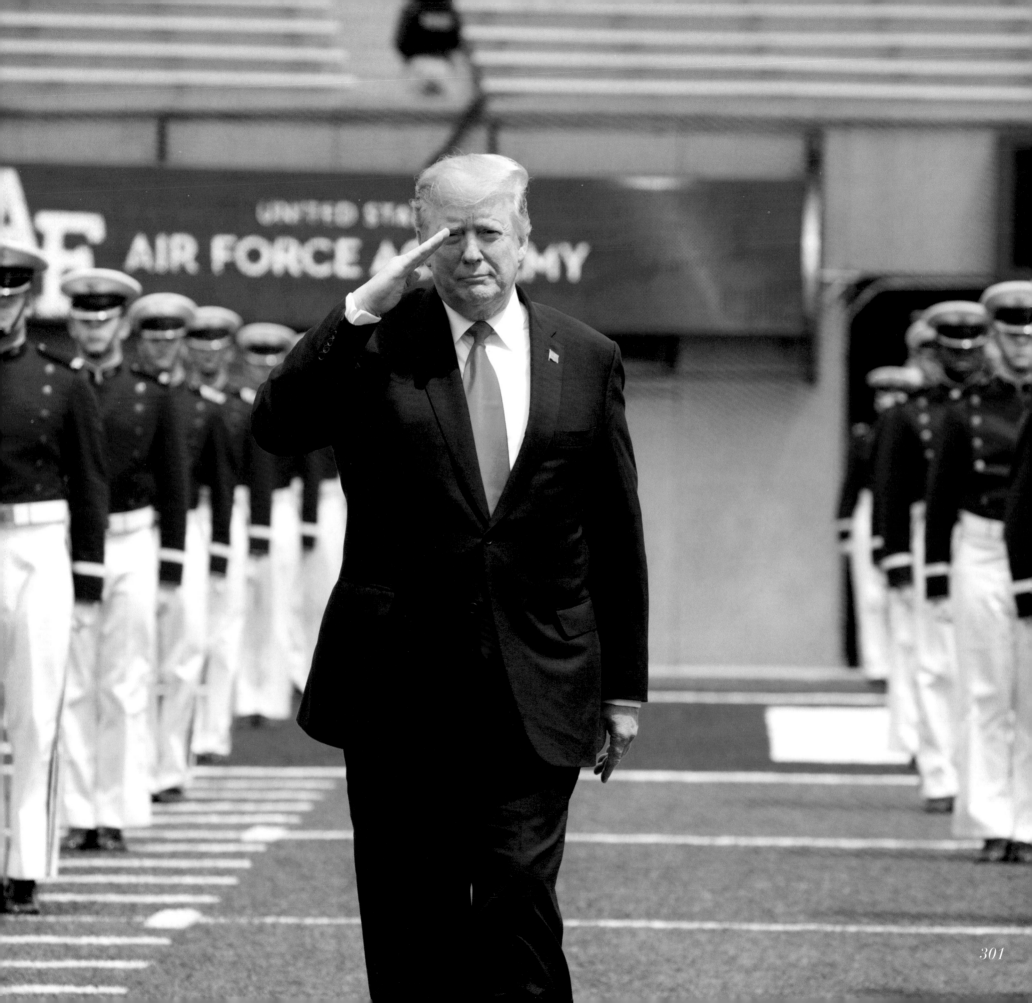

AMERICAN ENERGY INDEPENDENCE

Unleashed America's oil and natural gas potential.

For the first time in nearly 70 years, the United States has become a net energy exporter.

The United States is now the number one producer of oil and natural gas in the world.

Natural gas production reached a record-high of 34.9 quads in 2019, following record high production in 2018 and in 2017.

The United States has been a net natural gas exporter for three consecutive years and has an export capacity of nearly 10 billion cubic feet per day.

Withdrew from the unfair, one-sided Paris Climate Agreement.

Canceled the previous administration's Clean Power Plan, and replaced it with the new Affordable Clean Energy rule.

Approved the Keystone XL and Dakota Access pipelines.

Opened up the Arctic National Wildlife Refuge (ANWR) in Alaska to oil and gas leasing.

Repealed the last administration's Federal Coal Leasing Moratorium, which prohibited coal leasing on Federal lands.

Reformed permitting rules to eliminate unnecessary bureaucracy and speed approval for mines.

Fixed the New Source Review permitting program, which punished companies for upgrading or repairing coal power plants.

The average American family saved $2,500 a year in lower electric bills and lower prices at the gas pump.

Reduced the time to approve drilling permits on public lands by half, increasing permit applications to drill on public lands by 300 percent.

Expedited approval of the NuStar's New Burgos pipeline to export American gasoline to Mexico.

The United States is now among the top three liquefied natural gas exporters in the world.

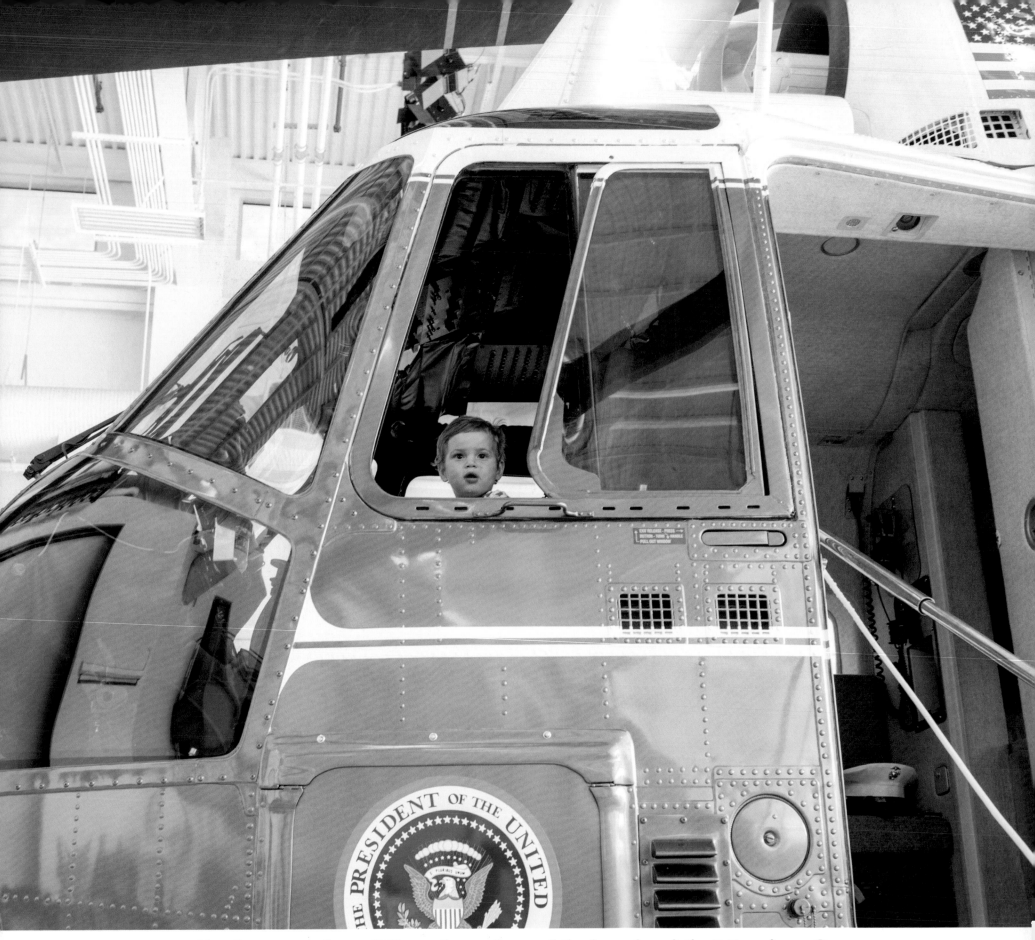

My little grandson Theodore loved being inside Marine One.

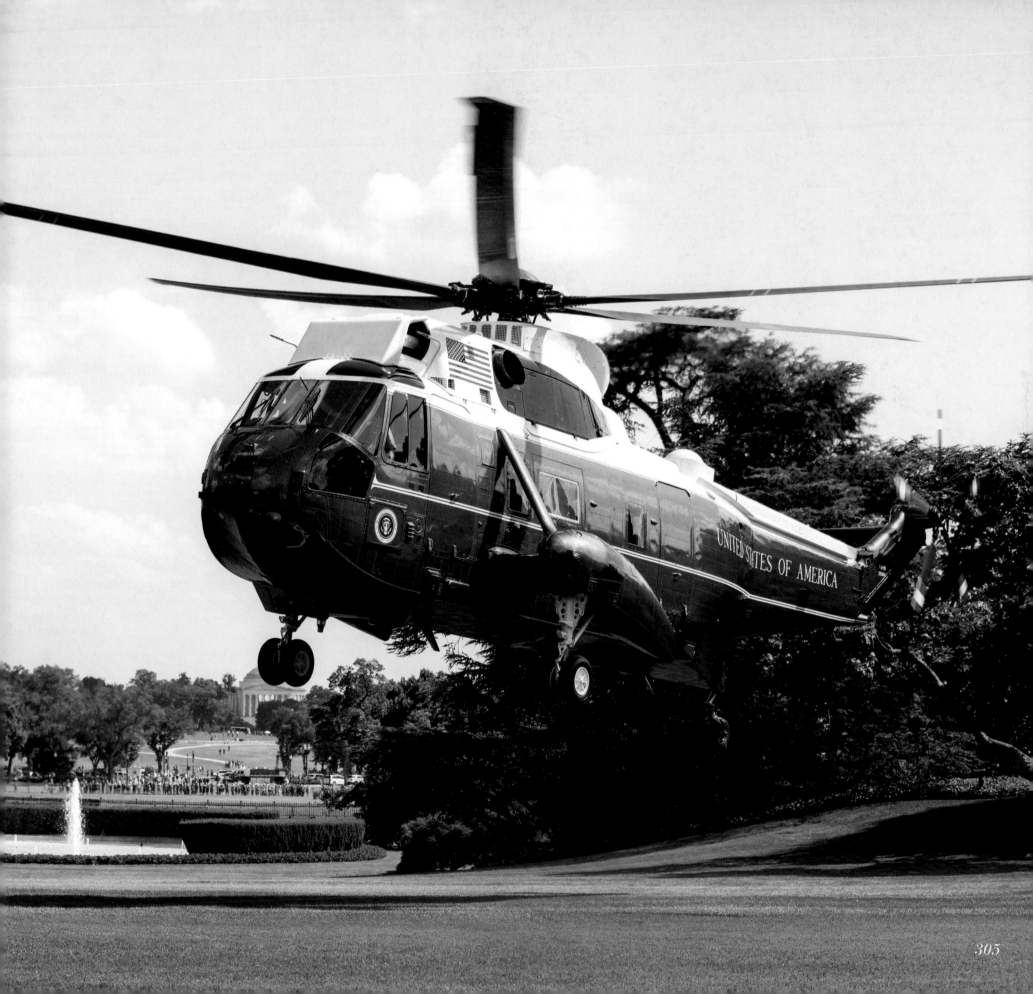

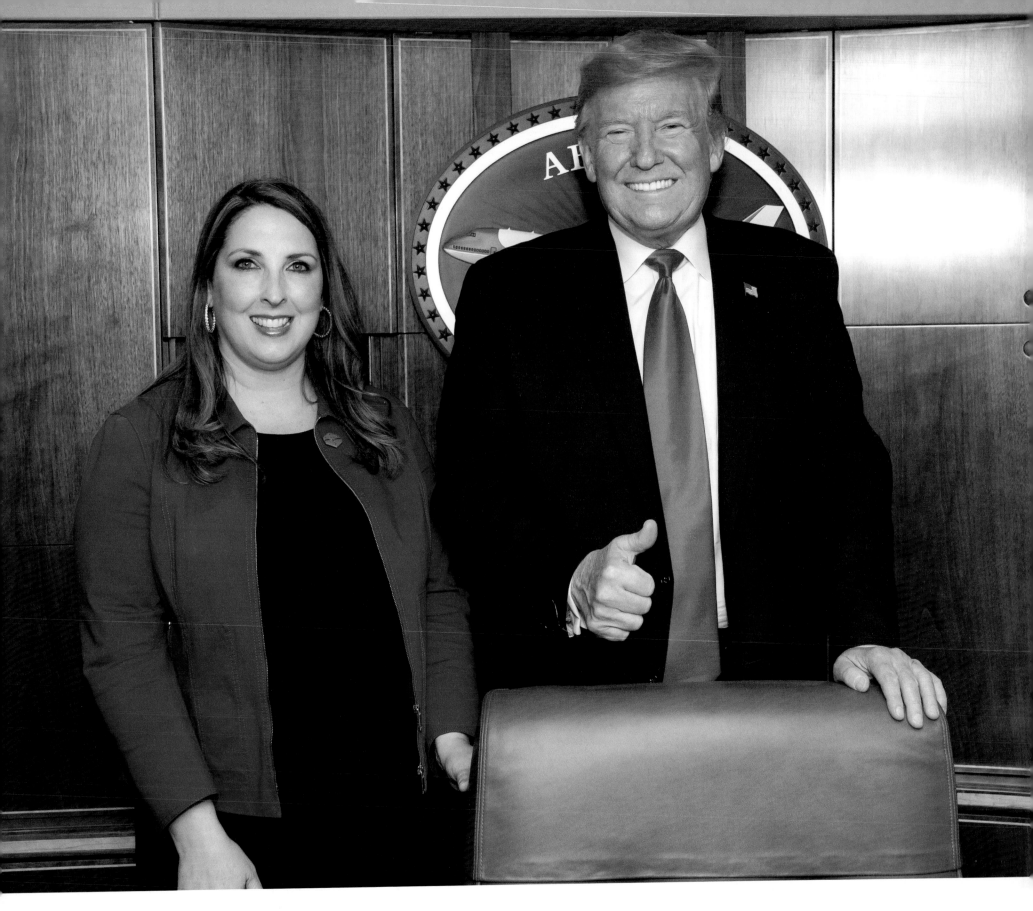

Ronna McDaniel has worked hard and well at the RNC.

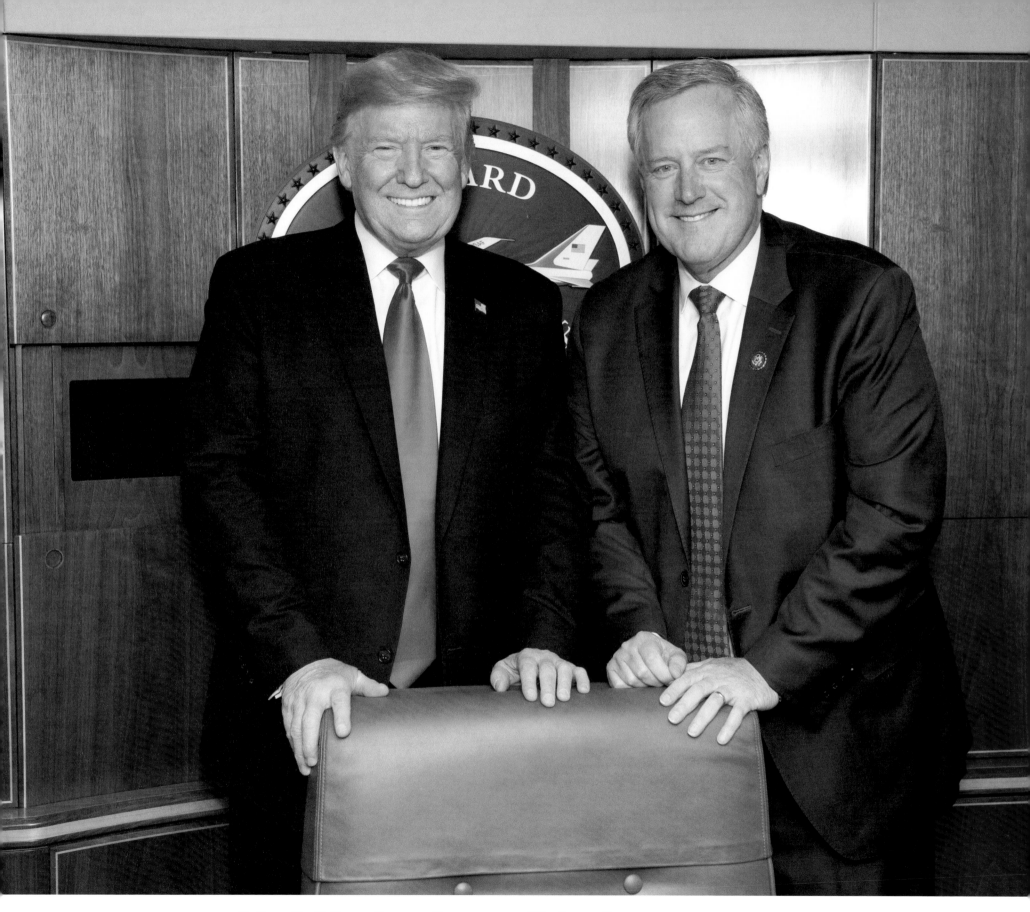

Mark Meadows loves politics, loves our country, and was a natural Chief of Staff.

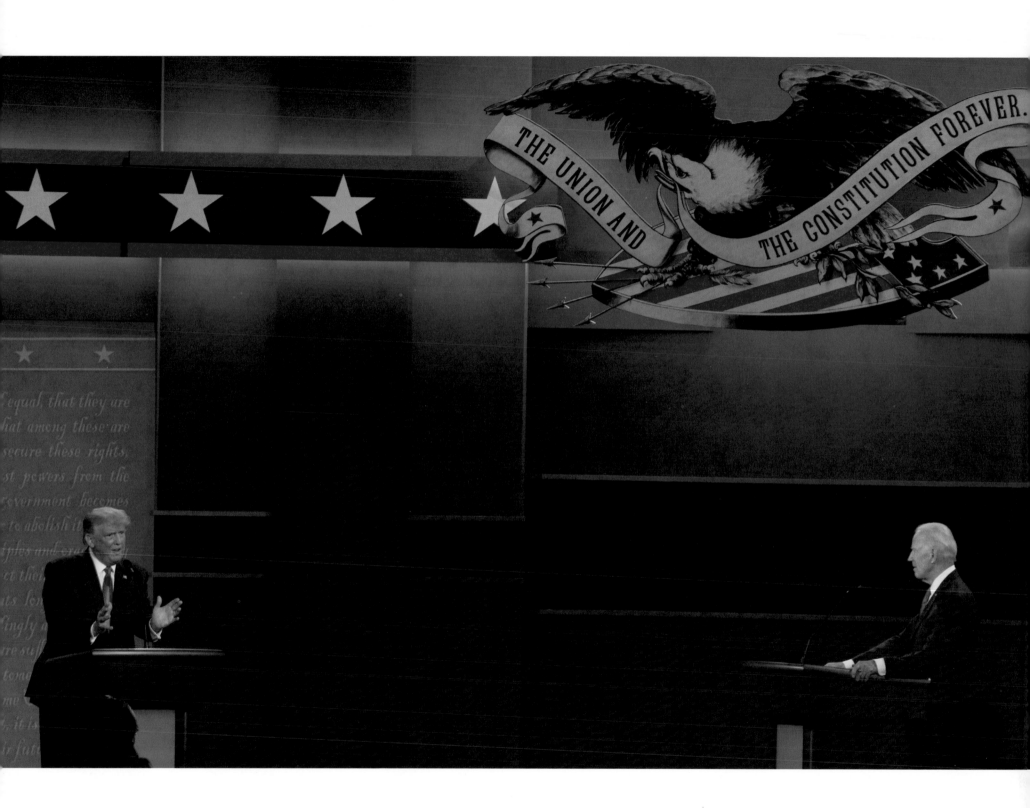

Debating Joe Biden.

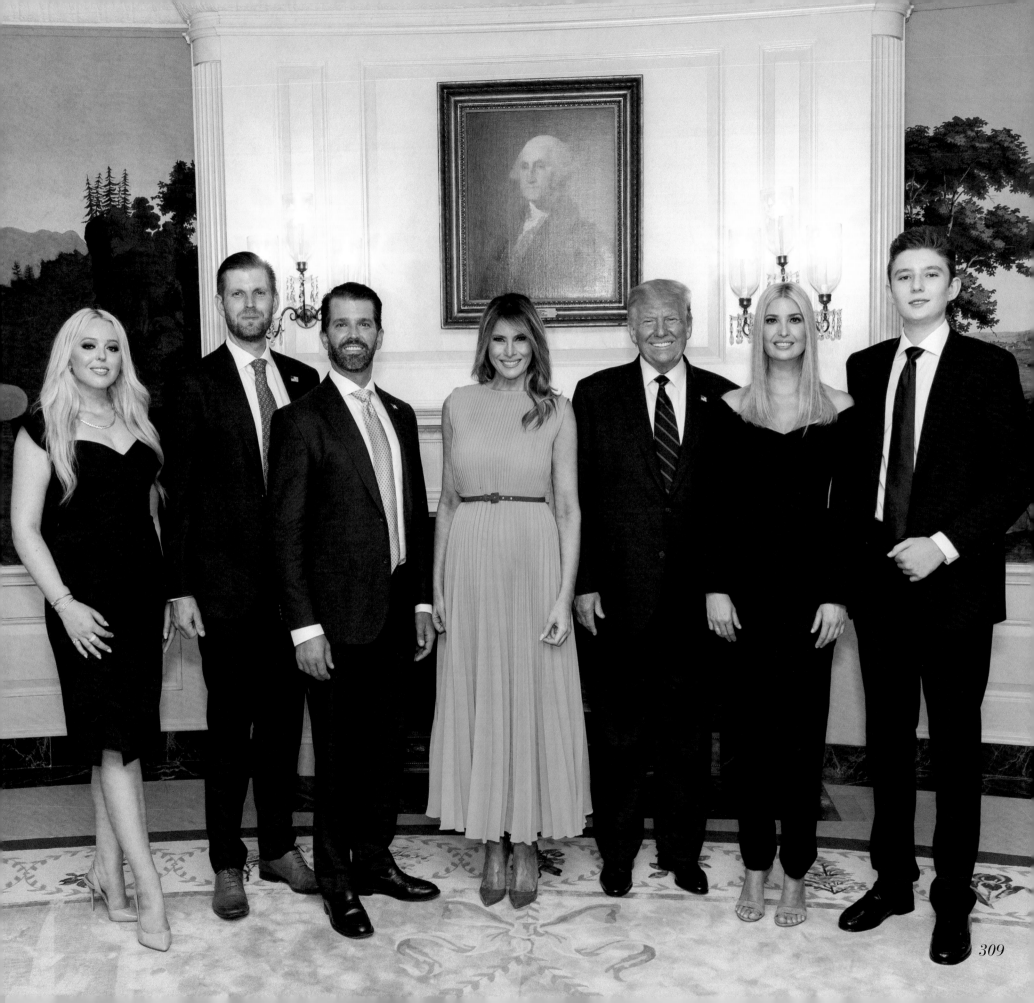

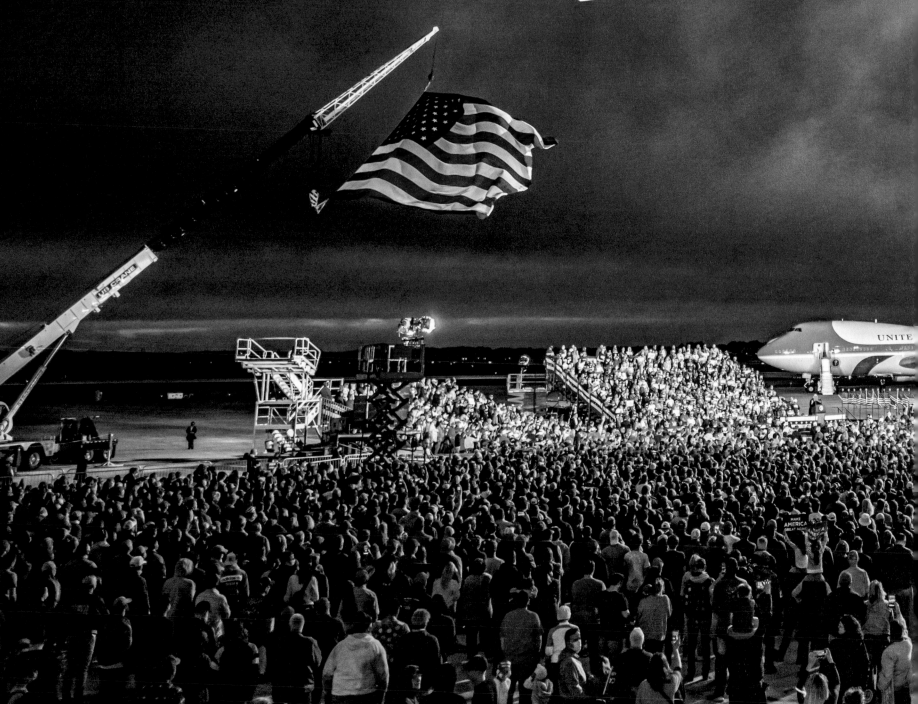

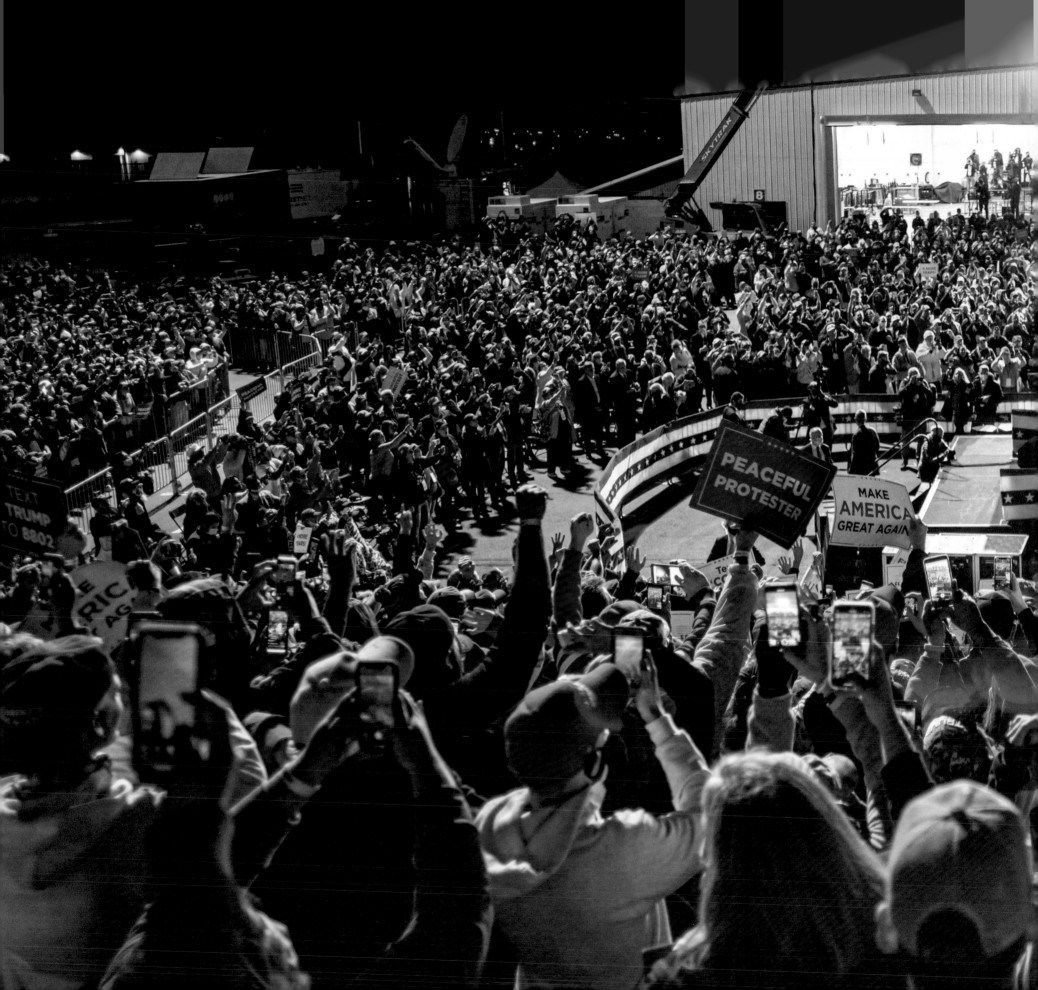

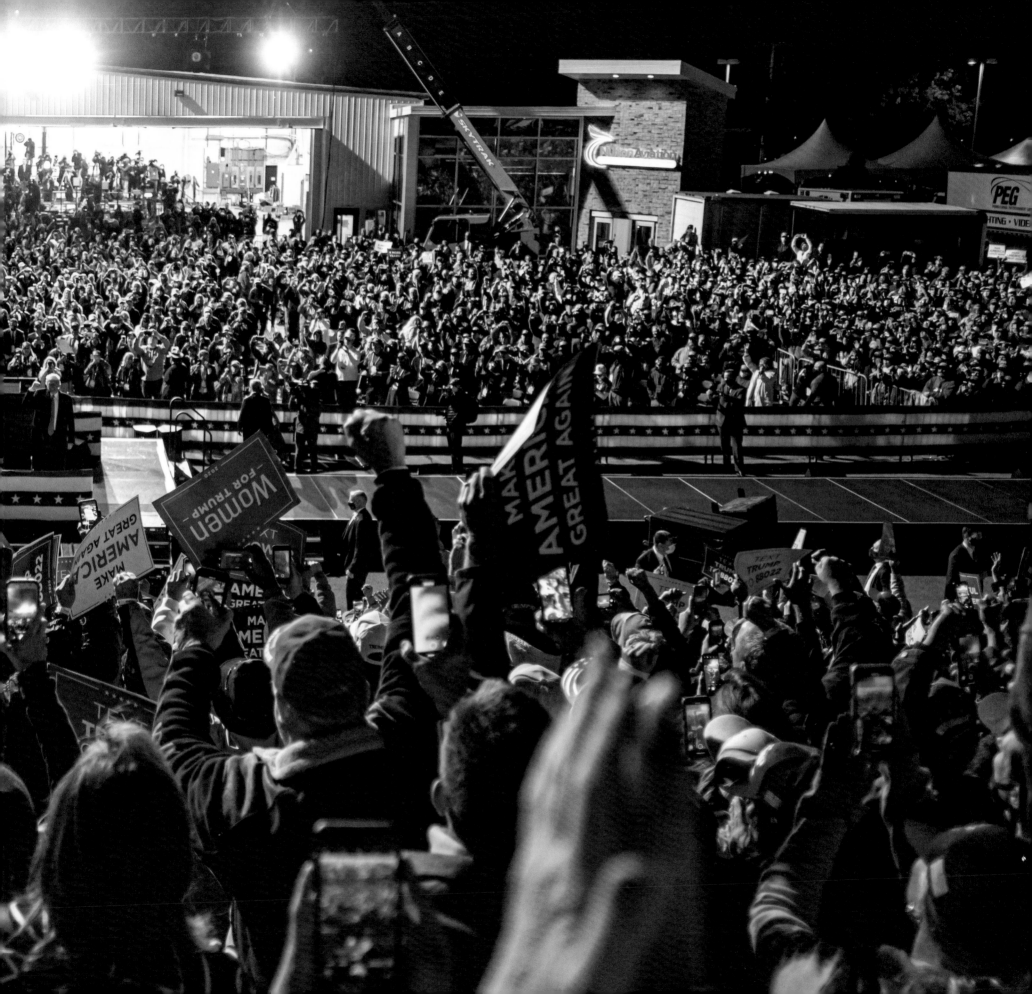

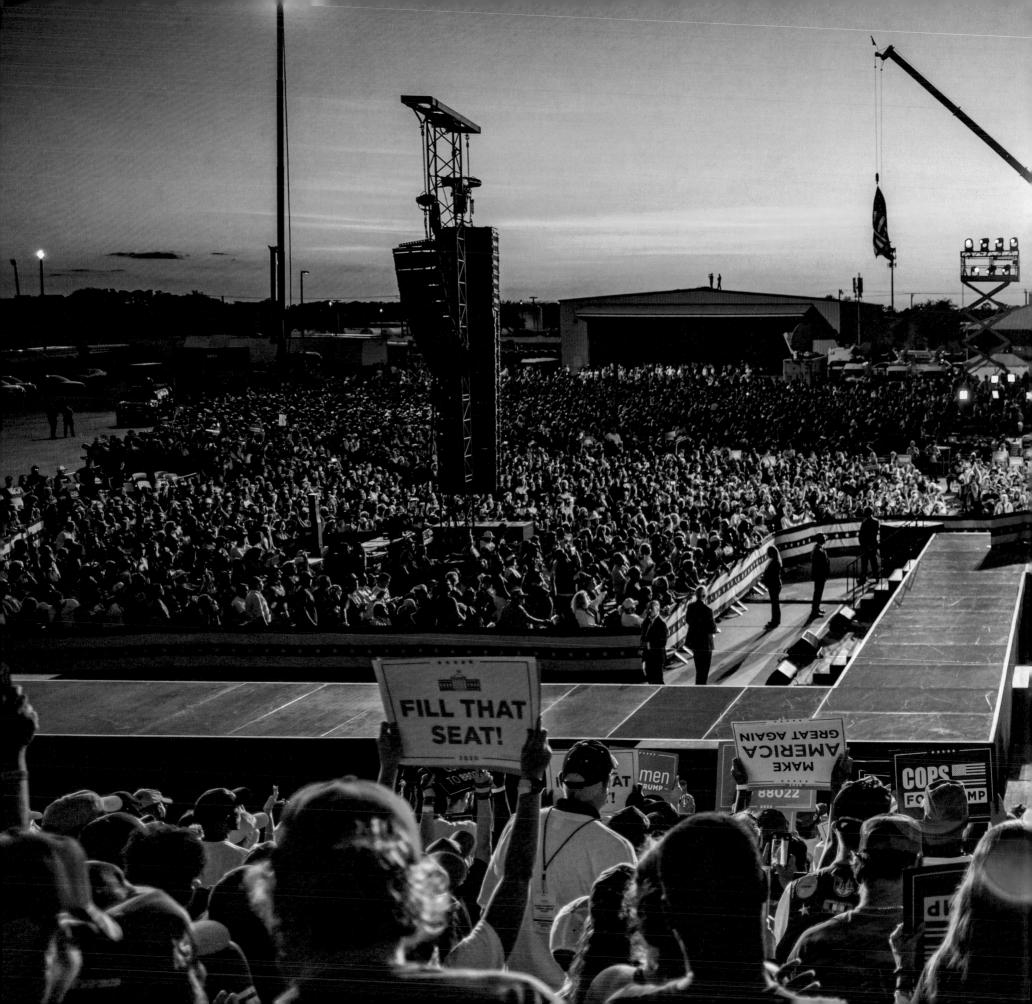

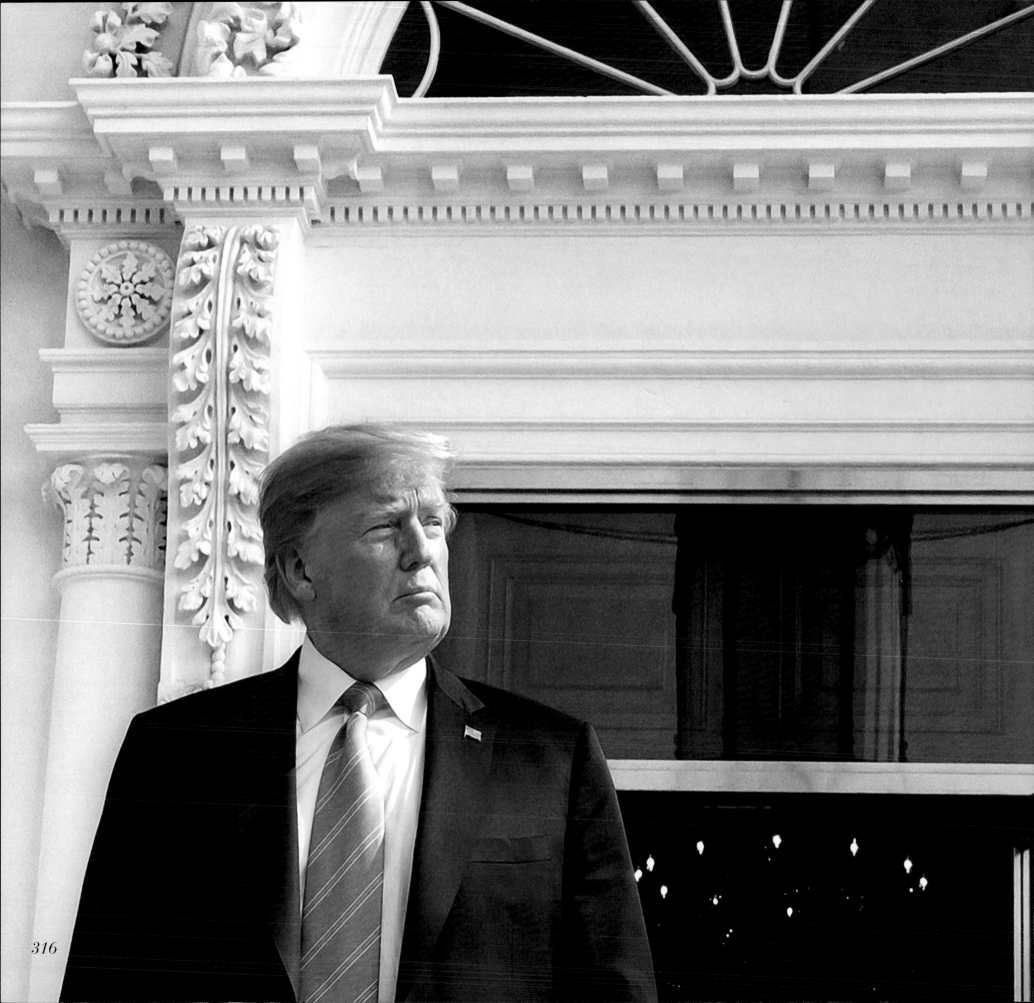

America,
Our Journey
Continues. Together
We will take our
Country back. We
will WIN!

[signature: Donald Trump]

Acknowledgments

I am very grateful to my entire family who made this project happen, especially Melania, Don, Ivanka, Eric, Tiffany and Barron!

To all the American patriots who made this journey possible, the best is yet to come!

A special note of gratitude to Winning Team Publishing for doing a tremendous job. Sergio Gor and the entire team did great!

To the fantastic team at CJK Group. I always wanted to print my book in America, and you did a wonderful job.

I am immensely grateful to all the phenomenal White House photographers. A grateful acknowledgment is made to the White House Photo Office, especially Andrea Hanks, Shealah Craighead, Joyce N. Boghosian, Tia Dufour, India Garrish, D. Myles Cullen, Keegan Barber, Dan Hansen, Paul D. Williams, Benjamin Applebaum, Grant Miller, and everyone else who was involved in documenting our amazing journey together.

A special thank-you to one of our great campaign photographers, Douglas Coulter, who provided the amazing rally shots throughout the book. Thank you also to Michelle McMinn for her beautiful images.

Remember, OUR JOURNEY IS JUST BEGINNING!